Sacred Heritage in Japan

Sacred Heritage in Japan is the first volume to explicitly address the topics of Japanese religion and heritage preservation in connection with each other.

The book examines what happens when places of worship and ritual practices are rebranded as national culture. It also considers the impact of being designated as tangible or intangible cultural properties and, more recently, as UNESCO World or Intangible Heritage. Drawing on primary ethnographic and historical research, the contributions to this volume show the variety of ways in which different actors have contributed to, negotiated, and at times resisted the transformation of religious traditions into heritage. They analyse the conflicts that emerge about questions of signification and authority during these processes of transformation. The book provides important new perspectives on the local implications of UNESCO listings in the Japanese context and showcases the diversity of "sacred heritage" in present-day Japan.

Combining perspectives from heritage studies, Japanese studies, religious studies, history, and social anthropology, the volume will be of interest to scholars and students who want to learn more about the diversity of local responses to heritage conservation in non-Western societies. It will also be of interest to scholars and students engaged in the study of Japanese religion, society, or cultural policies.

Aike P. Rots is Associate Professor of Asian Studies at the University of Oslo. His research interests include religion and the environment, ritual and sacred space, human–nature relations, and the politics of religion in contemporary East and Southeast Asia.

Mark Teeuwen is Professor of Japanese Studies at the University of Oslo. His field of research is the history of religion in Japan.

Routledge Research on Museums and Heritage in Asia

www.routledge.com/Routledge-Research-on-Museums-and-Heritage-in-Asia/book-series/RRMHA

Sacred Heritage in Japan

Edited by Aike P. Rots
and Mark Teeuwen

Routledge
Taylor & Francis Group

LONDON AND NEW YORK

First published 2020
by Routledge
2 Park Square, Milton Park, Abingdon, Oxon OX14 4RN

and by Routledge
52 Vanderbilt Avenue, New York, NY 10017

Routledge is an imprint of the Taylor & Francis Group, an informa business

British Library Cataloguing-in-Publication Data
A catalogue record for this book is available from the British Library

Library of Congress Cataloging-in-Publication Data
Names: Rots, Aike P., editor. | Teeuwen, Mark, editor.
Title: Sacred heritage in Japan / Aike P. Rots and Mark Teeuwen.
Description: Abingdon, Oxon; New York: Routledge, 2020. |
Series: Routledge research on museums and heritage in Asia |
Includes bibliographical references and index.
Identifiers: LCCN 2019053269 (print) | LCCN 2019053270 (ebook) |
ISBN 9780367217709 (hardback) | ISBN 9780429265976 (ebook)
Subjects: LCSH: Cultural property–Protection–Japan–Religious aspects. |
Historic preservation–Social aspects–Japan. | Religion and culture–Japan.
Classification: LCC DS821 .S15 2020 (print) |
LCC DS821 (ebook) | DDC 363.6/90952–dc23
LC record available at https://lccn.loc.gov/2019053269
LC ebook record available at https://lccn.loc.gov/2019053270

ISBN: 978-0-367-21770-9
ISBN: 978-0-429-26597-6

Typeset in Bembo
by Newgen Publishing UK

Contents

Figures

Contributors

Lindsey E. DeWitt is a Flanders Research Foundation (FWO) Postdoctoral Fellow at the Centre for Buddhist Studies, Ghent University. She received her PhD in Asian Languages and Cultures (Buddhist Studies) from UCLA in 2015. DeWitt previously held a one-year appointment as Assistant Professor of Japanese Religions at Kyushu University (2015–2016) and a two-year JSPS Postdoctoral Fellowship (2016–2018), also affiliated with Kyushu University. Her research aims to articulate the social and historical dimensions of Japanese religions, with a focus on the interconnections between gender, sacred space (especially mountains and Shugendō), and modern discourses on tradition and cultural heritage.

Herdis Hølleland holds a PhD from the University of Oslo on the implementation of the World Heritage Convention. In addition to the World Heritage Convention, her research interests include Scandinavian heritage politics and heritage theory. Since completing her PhD she has worked as a researcher at the Norwegian Institute for Cultural Heritage Research, has been a visiting scholar at Stanford University, and has led the process of establishing the Young Academy of Norway. She currently works as a civil servant at the Norwegian Ministry of Education.

Kikuchi Akira is Associate Professor of ethnology at the Institute for Research in Humanities of Kyoto University. His recent publications include *Yanagita Kunio to minzokugaku no kindai: Oku Noto aenokoto no 20-seiki* (author, 2001), *Shintairon no susume* (editor, 2005), *Kon Wajirō "Nihon no minka" saihō* (co-editor, 2012), and *Nihon shūkyōshi no kiiwādo: kindaishugi o koete* (co-editor, 2018).

Paulina K. Kolata is a doctoral researcher in Japanese Studies at the University of Manchester and a lecturer in Religious Studies at the University of Chester, UK. Her PhD thesis focuses on notions of belonging and religious change in local Buddhist temple communities in rural Japan. Her other research interests include material religion, ethnographic research methods, mobility, ageing, tourism, and economics in the Japanese Buddhist context.

Tze M. Loo is Associate Professor of History at the University of Richmond. She is the author of *Heritage Politics: Shuri Castle and Okinawa's Incorporation into Modern Japan, 1878–2000* (2014). She is currently writing a book about transformations to Okinawa's religious landscape in the prewar period. In addition, she is doing research on Japan's attention to the preservation of Manchuria's cultural heritage in the 1930s.

Ian Reader is Professor Emeritus at the University of Manchester, where he was previously Professor of Japanese Studies. He has also held academic positions in Scotland, Hawaii, Denmark, and Japan. His recent books include *Dynamism and the Ageing of a Japanese "New" Religion* (2018, with Erica Baffelli), *Health-Related Votive Tablets from Japan: Ema for Healing and Well-being* (2017, with Peter de Smet), *Pilgrimage: A Very Short Introduction* (2015), and *Pilgrimage in the Marketplace* (2013). His main research areas focus on pilgrimage in global contexts, on religion and violence, and on religious and secularising dynamics in Japan.

Aike P. Rots is Associate Professor of Asian Studies at the University of Oslo. He is the author of *Shinto, Nature and Ideology in Contemporary Japan: Making Sacred Forests* (2017) and the co-editor (with Mark Teeuwen) of *Formations of the Secular in Japan* (special issue of *Japan Review*, no. 30, 2017). He has written articles and book chapters on a variety of topics, including modern Shinto, religious environmentalism, sacred space, religion and politics in Vietnam, and Japanese Christianity. He is the PI of the ERC-funded project *Whales of Power: Aquatic Mammals, Devotional Practices, and Environmental Change in Maritime East Asia* (2019–2023), which focuses on changing human–nature relations and ritual practices in North- and Southeast Asia.

Mark Teeuwen is Professor of Japanese Studies at the University of Oslo. His field is the history of religion in Japan, with a focus on social aspects of religious practice. In 2018, he spent six months as a guest researcher at the Institute for Research in Humanities of Kyoto University. His chapter in this volume, on Kyoto's Gion matsuri, is part of a larger project that aims to analyse the history of this festival from its origins in the tenth century until today. He is currently working on a monograph on this topic.

Acknowledgements

We express our gratitude to the Department of Culture Studies and Oriental Languages at the University of Oslo, which offered funding for a two-day workshop that allowed the editors and contributors to meet and discuss the topic of heritage and religion in Japan in person. The chapters in this volume draw upon these discussions. While working on this book, we have also learned much from conversations with Brita Brenna, Christoph Brumann, Saphinaz Naguib, Oscar Salemink, Marzia Varutti, Tine Walravens, and Morgaine Wood. In addition, we wish to thank Heidi Lowther at Routledge for her enthusiastic support for our book proposal, and the five anonymous reviewers for their helpful feedback and suggestions. Many thanks also to Lindsey E. DeWitt, who not only wrote one of the chapters but also gave expert copyediting assistance.

Abbreviations

ACA	Agency for Cultural Affairs (Bunkachō)
ICH	Intangible Cultural Heritage
ICOMOS	International Council on Monuments and Sites
IHA	Imperial Household Agency (Kunaichō)
IUCN	International Union for Conservation of Nature
MEXT	Ministry of Education, Culture, Sports, Science, and Technology (Monbukagakushō)
MOFA	Ministry of Foreign Affairs (Gaimushō)
OUV	Outstanding Universal Value
UNESCO	United Nations Educational, Scientific and Cultural Organization
WHC	World Heritage Convention

Heritage-making and the transformation of religion in modern Japan

Mark Teeuwen and Aike P. Rots

In Japan, heritage designations are ubiquitous. Signs and information panels identifying "cultural properties" (*bunkazai*)—ranging from local to national and comprising a dazzling variety of sub-categories—meet the eye wherever one turns. The most recent published numbers (as of 1 July 2019) count 13,232 National Treasures and Important Cultural Properties, including artworks like paintings and sculptures, historic documents, and archaeological artefacts; 3,268 Historic Sites, Places of Scenic Beauty, and Natural Monuments; 75 Important Intangible Cultural Properties, in the two categories of performance traditions and crafts; and 533 Important Folk Cultural Properties, divided into tangible and intangible categories.[1] Even this is only a shortlist: the "important" (*jūyō*) cultural properties are a small selection from a veritable ocean of sites, practices, and objects that are deemed worthy of preservation. Below the national level, well over 100,000 regional cultural properties have been designated or selected by prefectures and municipalities.[2] Above the national level, moreover, there is the global arena of UNESCO. Every year, the Japanese government submits nominations to the UNESCO World Heritage List and the Representative List of Intangible Cultural Heritage of Humanity; after the 2019 round of designations, the country boasted twenty-three World Heritage Sites (nineteen cultural and four natural) and twenty-one elements of Intangible Cultural Heritage (ICH).

Heritage also attracts a striking level of attention among the general public. The reports of UNESCO's advisory bodies, the political arm-wrestling at the annual sessions of the World Heritage Committee, and the final decisions taken there are covered at length in Japanese media. Without exception, new listings generate a great deal of public interest, inspiring local pride and high expectations for increasing tourist revenues. Magazines and guidebooks introducing National Treasures and World Heritage Sites are on sale in any bookstore, and even in convenience stores and station kiosks.

This high level of investment and interest in heritage, both domestically and internationally, makes Japan a rich field for the study of heritage policies and their impact. This volume contains eight chapters that offer case studies of "heritage-making in action" at a selection of Japanese sites. Heritage-making

refers to the processes by which designated sites and practices are "made into" heritage by relevant stakeholders (Weiss 2007). The chapters examine ways in which various actors—ranging from diplomats at UNESCO and bureaucrats at the national Agency for Cultural Affairs (Bunkachō, hereafter ACA) to local stakeholders such as performers, priests, and entrepreneurs—give shape to and negotiate notions of heritage on the ground. The settings of these case studies vary from international World Heritage Committee meetings, via places and practices commonly associated with Japanese tradition and national identity, to less well-known and lower-ranked sites in peripheral areas. In particular, we focus on sacred places and ritual practices, some of which have been subject to significant transformations as a result of their reclassification as heritage at a global, national, and/or regional level.

The contributors to this volume investigate the dynamics of heritage-making in context by allowing the material to lead us to the issues and conflicts at stake at each particular site. The chapters build on prolonged ethnographic "attention to localities" (Brumann and Berliner 2016, 2), seeking to go from the concrete to the abstract. Themes that recur across multiple case studies are questions of politically groomed national identity; hopes for economic benefits among local stakeholders, and corresponding disappointments; the expected and unexpected impacts of large-scale tourism; changes in worship practices caused by (campaigns for) heritage listings; worries about a loss of "authenticity," variously defined by different actors; questions of inclusion and exclusion (e.g., based on gender); and grassroots attempts to adapt cultural heritage to the needs of communities in decline. In each case, multiple issues converge in a dynamic that is strictly local, determined by the particular history, configuration, and social setting of the site, and yet profoundly affected by national and international policy-making, tourism trends, and economic changes.

This volume is part of a growing body of inquiries into heritage issues "beyond the West." As pointed out by Tim Winter (2014), ideas and practices related to "heritage" both in the past and in the present have until recently been theorised almost exclusively from European and North American perspectives, in spite of the fact that heritage became a global concern and practice many decades ago. Winter therefore argued for the need to "de-centre Europe" and "explore the conceptualisation of multiple heritages." Winter's article was timely: around the time of its publication, several excellent volumes appeared that focus on heritage in various parts of Asia (Daly and Winter 2012; Silva and Chapagain 2013; subsequently also Matsuda and Mengoni 2016; Hsiao, Hui, and Peycam 2017). As Winter had already foreseen, these studies do not add up to "a canon of non-Western theory," nor do they identify a particular Asian type of heritage thinking, even if they problematise Eurocentric theories of heritage. If anything, they complicate and challenge established notions of heritage by showing that neat conceptual constructions inevitably fall victim to the "messiness of place" (Oakes and Sutton 2010, 20).

The same can be said of the case studies in this volume. The sites and practices described are moulded by management structures, procedures, and ideas current at the national level, but upon close investigation, local factors prove just as decisive in determining what issues are debated and what solutions are chosen. The state affects what happens locally, but it never rules the ground alone. What emerges most strongly from this collection is temporal and regional discontinuity and variety. Policies change rapidly, and differences in timing and local context produce outcomes that at first sight appear contradictory. There is no single "Japanese way" of doing heritage. Our findings echo those of Michael Foster, who notes that:

> in some places a UNESCO designation is seen as a financial boon, in some places it is a point of pride and identity, in some places it is a burden, and elsewhere it is merely an adornment, or, for that matter, not even on the radar screen.
>
> (2015, 152)

Heritage, religion, and sacralisation

The case studies in the volume touch on a wide range of themes that have long been debated in heritage studies, such as questions of heritage management and ownership, the dilemmas of heritage preservation and mass tourism, and the selective nature of the historical narratives presented at heritage sites. First and foremost, however, they address a topic that has not yet received as much scholarly attention, but that, we argue, is in need of further exploration, not least in the East Asian context: the interface between heritage and religion. With the exception of Hølleland's chapter, the sites discussed in this volume are all of a religious nature. DeWitt, Teeuwen, Kolata, and Reader address sites that comprise or contain institutions defined as religious organisations by law. Others discuss places of worship (tumuli that serve as imperial tombs in the chapter by Loo, and a sacred grove in Rots' chapter) and ritual practices (rural harvest rites and an urban festival parade in the chapters by Kikuchi and Teeuwen, respectively) that are not legally classified as "religion," but that nevertheless are widely perceived as "sacred" in the sense that they are associated with notions of faith and practices of worship.

From the time Japan began applying for World Heritage status, a large proportion of listed sites have been religious. Hōryūji in Nara was listed in 1993, followed by sixteen temples and shrines in Kyoto in 1994. This trend continued with the listing of assorted temples and shrines in Nara (1998), Nikkō (1999), Kumano (2004), and Hiraizumi (2011). More recently, the list was complemented with the "Sacred Place" of Mt. Fuji (2013), the "Sacred Island" of Okinoshima and the affiliated Munakata Grand Shrines (2017; see the chapter by DeWitt), and the "Hidden Christian Sites in the Nagasaki Region" (2018). Furthermore, there are semi-religious places of worship such as the tumuli of Mozu-Furuichi

(2019; see the chapter by Loo) and a series of sites related to Okinawa's Ryukyu Kingdom (listed in 2000; see the chapter by Rots). The same trend has applied to practices and performances listed as ICH: Japan's contributions to this list are dominated by folk rituals and shrine festivals, as illustrated in the chapters by Kikuchi and Teeuwen.

The chapters in this volume discuss the relationships between Japanese domestic policies and religious transformations, but they also consider the international dimensions of heritage-making. UNESCO plays a central part in most of the case studies in this volume, both as an institution and as a provider of legitimacy (the only exception is Kolata, who looks at the consequences of heritage designation on a regional level). Loo and Hølleland discuss the politics of World Heritage nomination in Japan, as well as Japan's role in the UNESCO World Heritage Committee. DeWitt and Rots both investigate cases of sacred sites that have been inscribed on the World Heritage List (Mt. Ōmine and Okinoshima in DeWitt's chapter; Sēfa Utaki in Rots' chapter), while Kikuchi and Teeuwen present case studies of ritual practices inscribed as ICH. Reader, finally, focuses on a site that has not (yet) been listed as World Heritage in spite of sustained efforts towards that goal: the Shikoku pilgrimage.

The effects of listing, and indeed of the mere process of applying and securing nomination, differ from site to site. Some places have seen a sudden increase in domestic and "inbound" (international) tourism, while other sites, not so strategically located on tourist trails or not as cleverly marketed, have seen their expectations dashed. Both outcomes cause problems, in different ways. There is much evidence of grand expectations, as well as fear of UNESCO interference, during the nomination process. As it turns out, such fears often prove ungrounded, since UNESCO disappears from the scene as soon as the application process is completed, leaving only its trademark. In some cases, the consequences of World Heritage or ICH designation are far-reaching for local actors, as Kikuchi and Rots illustrate; this is not because of UNESCO interference, however, but because of local dynamics. In all cases, heritage policies have affected religious practices one way or the other.

One of the core questions addressed in this volume is what happens when places of worship and ritual practices are categorised as heritage and subjected to the rules and policies of heritage preservation. The interplay of heritage and religion has long been ignored by heritage scholars and scholars of religion alike, but the topic is rapidly gaining importance now that heritage has become a core societal category worldwide. Heritage production and preservation have an increasingly profound effect on religious institutional and ritual practices today. As a result, heritage is changing contemporary configurations of the categories "religion" and "secularity"—not least in Japan, where these categories are subject to continuous renegotiation (Rots and Teeuwen 2017). Heritage regimes are reshaping established understandings of religion and public ritual, forcing both bureaucrats and scholars to rethink their uses of these terms;

therefore, studies of heritage-making are relevant for the study of religion in general, especially in modern times. We argue that the Japanese cases presented here provide relevant insights for the comparative, transnational study of religion and heritage, and help us understand some of the dynamics of these categories in a global context.

One of the first academic publications to ask how contemporary heritage regimes are affecting religious sites was "Heritage and the Sacred," a special issue of the journal *Material Religion* (Meyer and de Witte 2013). In their introduction, Birgit Meyer and Marleen de Witte address the question of how heritage relates to processes of secularisation and sacralisation. The articles that follow discuss some of the tensions and conflicts that can emerge when religion is made into heritage. Meyer and de Witte point out that:

> while the very setting apart of certain cultural forms as "heritage" taps into religious registers of sacralization, in many instances the reformation of religious forms as "heritage" entails a process of profanization through which their initial sacrality is being lost.
>
> (2013, 277)

In other words, heritage-making constitutes a type of secularisation in which religious objects, sites, and practices acquire new meaning as embodiments of national culture and tradition. This does not, however, mean that these objects, sites, and practices by definition become less sacred. When a heritage site is secularised, it (re)acquires "sacredness" in a Durkheimian sense: it is set apart, physically and discursively, as non-negotiable and out of the ordinary, representing the unity of a community, and perhaps even functioning as a modern totem.

This can play out in many different ways. For example, a statue that is sacred to Buddhists as an embodiment of a Buddhist divinity can become heritage as an object of art and acquire a new sacred character as an expression of Japanese culture. This statue thus assumes two layers of sacredness that may reinforce each other, but that can also get in each other's way. The statue may remain in the temple, where it continues to function as an object of worship; the new layer of sacredness (e.g., as a National Treasure) is prominently displayed on a sign and inspires increased devotion, while also giving the temple access to public subsidies for maintenance. Alternatively, the statue may be removed to a museum, where it is "safe" from candle soot and the hands of devotees who rub it to release its powers of healing. In such a case, the statue's cultural sacredness is deemed so great that it needs a stricter regime of setting-apart, undermining its role as an object of worship and diminishing its religious sacredness. The temple priests, forced to make do with a copy, may disapprove of this outcome. Between these two alternatives, there can be many compromises: the statue may be placed in a safer place in the temple hall, out of reach; it may be made available for museum exhibitions

only occasionally; or it may be put on display in a museum-like setting at the temple (typically in a temple treasure hall, or *hōmotsuden*), in a glass case with a dehumidifier as well as a candle stand. All these solutions can be understood as outcomes of local negotiations about the best way to manage the different forms of sacredness embodied by the statue.

In Japan, the maintenance of religious heritage objects and buildings is complicated by the strict secularism of the Japanese state.[3] The 1947 constitution stipulates that "no public money … shall be expended or appropriated for the use, benefit or maintenance of a religious institution or association" (Article 89). Heritage preservation in Japan therefore by necessity entails a process of secularisation, whereby the religious nature of sites and practices is downplayed. This can be described as a form of "discursive secularisation" (Rots 2017) in practice. Heritage is a public project, funded with taxpayers' money, so the act of turning objects, sites, and practices into heritage requires that they are moved into the public realm. Religion, on the other hand, is strictly confined to the private sphere and cut off from all forms of state support—and also protected from state interference. A striking outcome of the seepage of religion into the public domain by this route is the distinction between "folk beliefs" or "ethnic faith" (both possible translations of *minzoku shinkō*) on one hand, and "religion" on the other. As shown in the chapters of Teeuwen and Reader, the concept of "beliefs/faith" has been used as a category of intangible cultural properties since the 1950s, and features prominently also in recent applications for World Heritage status. Struggles about the boundary between public "beliefs/faith" and private "religion" escalated in the early 1970s (Kikuchi 2001, 45–54), and continue to this day.

As noted, not all sites discussed in this volume are religious in a strictly legal sense. In all cases, however, heritage-making involves navigating choppy waters, and even when legal issues are not in the foreground, the transition of places and practices from the private to the public realm, under the flag of cultural heritage, triggers changes that affront some, appeal to others, but inevitably transform what is being "preserved."

Heritage preservation in Japan: a brief historical overview

As already noted, heritage preservation has a long history in Japan, and most of the sites and practices introduced in this volume have passed through multiple stages of heritage-making at different historical junctures—as cultural properties of various kinds, National Treasures, and World Heritage Sites or ICH. Since there is no space to explain this history in much detail in the chapters, it will be useful to offer at least a brief outline in this introduction. In short, Japan's history of heritage preservation can be divided into three phases: the prewar, postwar, and World Heritage periods.[4]

I The prewar years

Already in 1897, a law was introduced for the "preservation of ancient shrines and temples" (*koshaji hozonhō*), granting the status of Buildings under Special Protection and National Treasures to temple and shrine structures that were particularly valuable as "historical evidence or artistic models" (Nakamura 2013, 64–67). This law was partly inspired by the destruction of Buddhist statues and properties during the anti-Buddhist attacks (*haibutsu kishaku*) in the early years of Meiji, and more directly by the surveys of Buddhist art by Ernest Fenollosa (1853–1908) and Okakura Tenshin (1862–1913) in the late 1880s, which made the government aware of the internationally relevant cultural capital that Japan's religious art might offer. The law came about only two years after the founding of the National Trust in Britain and the American Scenic and Historic Preservation Society in the US (both in 1895); it demonstrates that Japan was among the first countries to extend national protection to historical and artistic "treasures" not only in Asia, but globally.

This first law already displayed many of the characteristics of later Japanese preservation policies. The Ancient Shrine and Temple Preservation Society (Koshaji Hozonkai), an expert body within the Home Ministry, selected buildings and objects of historical and artistic value for national maintenance and repair subsidies, usually in response to a request from the owners. By 1929, as many as 1105 buildings and 2604 objects had been designated. After designation, the selected buildings and objects remained the private property and responsibility of the owners (i.e., in the cases of shrines or temples, the priests who were in charge).[5] Designation came with the obligation to make the treasures available periodically to public museums for exhibition. In this manner, the preservation system turned selected shrine and temple buildings and treasures into public assets, while at the same time allowing them to retain their private, religious nature.

The Buddhist treasures, especially, moved between the religious setting of their home temples, where they served as objects of veneration, and the secular setting of the national or regional museum, where they were presented to the public as emblems of Japanese art and expressions of the Japanese "national spirit." The same can be said of designated buildings: they now doubled as halls of worship *and* as representative samples of Japan's national culture. In ascribing value to temple treasures, the priests were joined by experts, usually trained as historians of art and architecture. Many of the issues that are explored in the chapters of this volume can be traced to the very beginning of heritage politics in Japan: the secular resignification of religious sites and objects by state actors; the balancing of the "exhibition" and exploitation of sites and objects as tourism resources, on one hand, and devotional and ritual uses and demands of scientific preservation, on the other; and the burdens of financial and moral responsibility cast onto the owners of National Treasures and other cultural properties.

In the first decades of the twentieth century, the scope of designation and preservation was widened from its initial focus on temples and shrines to ever new categories of cultural, historical, and natural elements. In 1919, a Law for the Preservation of Historic Sites, Places of Scenic Beauty, and Natural Monuments (*shiseki meishō tennen kinenbutsu hozonhō*) sought to protect selected areas of "scientific value" against modern development: the roads, railway lines, mines, dams, and factories that were transforming the Japanese landscape during and after World War I. An important source of inspiration for such a radical expansion of the scope of preservation was the German movement of *Heimatschutz*, which combined efforts to preserve landscapes and historical townscapes with a concern for folklore and regional cultural traditions.[6] This laid the groundwork for the incorporation of folklore in heritage policies after the war.

By 1940, 1674 sites had been designated under the 1919 law. Half of them were Historic Sites, while most of the remainder were Natural Monuments, selected by biologists and geologists for the rarity of their flora, fauna, or minerals. In 1929, the 1897 law was replaced by the new Law for the Protection of National Treasures (*kokuhō hozonhō*). Under this law, objects of historical or artistic value that were owned by local associations or private persons, rather than shrines and temples, could now also be designated as National Treasures. The law focused on preventing the export of National Treasures to Japan's new colonies or other countries, and it stipulated punishments for those who caused the loss of, or damage to, designated objects and buildings. An improved version of this law was promulgated in 1933 as the Law for the Preservation of Important Art Objects (*jūyō bijutsuhin no hozon ni kansuru hōritsu*).

Modern Japanese heritage laws were not merely of domestic significance. Ever since its beginnings in the late Meiji period, prewar Japanese heritage policy developed in an expanding Japanese empire. Historical sites and archaeological finds in Okinawa, Hokkaido, Taiwan, Korea, and Manchuria were subjected to colonial preservation policies, and often presented as primitive cognates of a superior Japanese civilisation. This discourse then served to legitimise Japanese dominance. Interestingly, such policies influenced postwar heritage preservation in different parts of East Asia.[7] While the focus of this volume is on present-day Japan (including one chapter on an Okinawan case), it is worth pointing out that many of the same dynamics—the proliferation of the "heritage" category, its appropriation by national governments, and the tendency to turn religious sites into public heritage—are also at play in other East Asian states (Rots 2019). A comparison of the situation in different parts of East Asia is beyond the scope of this volume, however.

II The postwar period

The Ministry of Education kept up its preservation activities even during World War II, actively designating new elements with only the briefest of breaks in the most desperate years (1943–1945). After Japan's capitulation, however,

the situation was dire. Even those designated buildings that had escaped the firebombing were in a dismal state of repair. Some were used for shelter by the multitudes who had become homeless; others were vandalised by local residents or by soldiers of the occupation forces (Trifu 2017, 214). In November 1946 a new property tax was introduced that made no exemptions for owners of National Treasures. This caused many to hide or dispose of their heirlooms—if destitution had not forced them to sell these already (Scott 2003, 365–367). The headquarters of the Allied Occupation (SCAP) showed an active concern for heritage in Japan through the so-called Arts and Monuments Branch, an expert body within the Civil Information and Education Section.[8] This Branch, however, had trouble cooperating with (or even obtaining basic information from) the Ministry of Education over preservation issues. One hindrance was the issue of looted art from Japan's former colonies, which SCAP sought to confiscate. Another was SCAP's determination to root out Historic Sites, protected under the 1919 law, that smacked of emperor worship—notably 377 "sacred sites commemorating Emperor Meiji" (*Meiji tennō seiseki*). On the Japanese side, the Ministry of Education drew up an ambitious five-year restoration plan but failed to secure the necessary means from the Ministry of Finance. Meanwhile, the new civilian government frequently appealed to a new vision of Japan as a "cultural state" (*bunka kokka*), a slogan that necessitated a visible commitment to "culture" at home if it was to give credible substance to Japan's turn away from militarism (Robertson 1988).

This commitment could no longer be ignored after a fire destroyed the Golden Hall (Kondō) of the ancient Hōryūji temple in the un-bombed city of Nara (see Figure 3.1 in the chapter by Hølleland). In January 1949, this internationally renowned symbol of Japanese culture was severely damaged during restoration work. The Ministry of Education had already been working on a revision of existing legislation. It advocated enhanced government control over National Treasures at the expense of private owners, and a drastic increase in the number of heritage designations. However, these proposals had been opposed by SCAP as unconstitutional (because they implied a limitation of private property rights), and as unnecessarily costly. A Diet investigation after the Hōryūji fire now put the issue on the political agenda. This resulted in a new legal framework for preservation policies that survives to this day: the Law for the Protection of Cultural Properties (*bunkazai hogohō*), enacted in August 1950.

This law replaced the 1919, 1929, and 1933 laws mentioned above, combining all the disparate elements covered under those laws (from shrine and temple treasures and buildings to secular art, historic sites, and natural monuments) under one umbrella: *bunkazai* or "cultural properties." This term had first come into use in the context of the 1919 law, and was ultimately derived from the *Heimatschutz* concept of *Kulturgut*. In its original context, *Kulturgut* covered a wide range of cultural heritage, from tangible architecture and landscapes to intangible crafts and folklore, extending even to unexcavated archaeological sites defined in Japan as Buried Cultural Properties (*maizō bunkazai*). Although the

zai in *bunkazai* conveys a very tangible image (the character signifies material property or treasures), the usage of this term in the 1950 Law for the Protection of Cultural Properties aligned with the original German meaning: it was now expanded to encompass not only physical sites, buildings, and objects, but also intangible arts and crafts—initially defined as "theatre, music, crafts, and other intangible cultural products of high historic or artistic value for our country" (Nakamura 2013, 75). This radical expansion of the category went against the views of the Arts and Monuments Branch, which held that the government should concentrate its limited budget on fewer cultural properties, rather than spreading it out thinly over a ballooning list of less-than-exceptional elements.

Arguably, the most influential change brought about by the new law was the integration of folklore into the regime of heritage preservation. The field of folklore studies (*minzokugaku*) had become established in the 1930s under the influence of such pioneering figures as Yanagita Kunio (1875–1962), Orikuchi Shinobu (1887–1953), and Shibusawa Keizō (1896–1963), who organised national surveys of folk traditions, beliefs, and artefacts and established an academic discipline that sought to recover the foundations of Japanese culture in the traditions of the common people. It seemed only fitting that in the new democratic Japan, the heritage of the rural poor in traditional occupations would be redefined as the core of national culture. The new law introduced the sub-category of Folk Materials (*minzoku shiryō*) as a form of tangible cultural properties, and some folk elements such as "folk performing arts" (*geinō*), *kagura* dances, and *matsuri* festivals were designated as intangible cultural properties. A revision in 1954 resulted in the creation of the new categories of Tangible and Intangible Folk Materials, which were designated in high numbers in subsequent years.[9]

Japan's heritage preservation regime was strengthened in the late 1960s. A wave of municipal mergers stimulated local authorities to develop their own local designation lists and preservation offices, allowing little-known local temples, objects, and even trees to gain cultural property status (as Kolata's chapter illustrates). On a national level, 1968 saw the creation of the ACA, which did much to coordinate and improve heritage policy. In 1975, this resulted in the most thorough revision of the 1950 law since its promulgation. At this juncture, for example, Folk Materials were upgraded to Folk Cultural Properties (*minzoku bunkazai*), allowing the most "important" among them to qualify for regular financial support, rather than merely project-based subsidies for surveys and recording. *Aenokoto*, discussed in the chapter by Kikuchi, is an example of such an Important Folk Cultural Property. In this case, as in many others, national designation was inspired by the prominent place this local rite had enjoyed in the discourse on Japanese culture in folklore studies since the 1950s. The designation in turn launched new efforts at surveying and recording model performances in the Noto region, which would later be used as manuals for restoring the ritual after *aenokoto* was listed as UNESCO ICH in 2009.

III The "Age of World Heritage"

The 1990s brought two important new developments. One was an increased focus on the exploitation of cultural properties as resources that can be used to stimulate the local economy, turning them into flagships in campaigns to increase domestic and international tourism. In 1992, a law generally known as the "matsuri law" (*omatsuri hō*) encouraged local authorities to use their "regional traditions and arts" for the development of tourism and local trade and industry. Many of these traditions and events are interwoven with religious institutions, and this law provoked an outcry among stakeholders, priests, and heritage professionals regarding what was widely seen as a threat against the traditions that might be commodified in this manner, and as a break with the "scientific," expert-driven heritage regime embodied by the ACA.

More recently, the Japan Heritage (*Nihon isan*) programme, launched in 2015, pursues the same goal of marketing cultural properties to domestic and international tourists, with the upcoming 2020 Olympic Games in Tokyo in mind. The defining strategy of this programme is to re-package existing properties with the help of a simple, attractive "story" (*sutōrii*). These stories, produced by bureaucrats in municipalities and prefectures, at times alienate the same groups that also protested against the matsuri law. In the same vein, 2018 saw a revision of the Law for the Protection of Cultural Properties that gave more freedom to local authorities to make use of cultural properties as tourism resources; this rendered it possible, for example, to redevelop the old Nara prison (an Important Cultural Property) as a hotel. This change of policy, under such slogans as "from preservation to practical use" (*hozon kara katsuyō e*) and "culture that makes money" (*kasegu bunka*), has triggered concerns that national subsidies will increasingly be concentrated on easily exploitable cultural properties, while less tourist-friendly properties of great academic value will suffer.[10]

The second, and arguably even more dramatic new development was Japan's ratification of the UNESCO World Heritage Convention in 1992. Japan was a relative latecomer to the World Heritage Convention, but has since been among its most active and generous supporters. The motivations behind both Japan's reluctance to join this programme in the 1970s and 1980s, and the government's change of mind in the 1990s, are discussed in the chapters by Loo and Hølleland in this volume and need not be repeated here. In short, UNESCO has come to serve as an important stage for cultural diplomacy. This diplomacy includes Japanese assistance to other (particularly Asian) countries in building up their own heritage portfolios and organising their heritage management systems with the help of Japanese experts (Akagawa 2014), as well as adding a further tool to the promotion of international tourism. As outlined by Hølleland, Japan not only joined the World Heritage Convention but also worked to transform it in various ways—notably by challenging "Western" notions of authenticity and contributing to the creation of the ICH Convention (Aikawa 2014). UNESCO is not only an important arena for Japanese diplomacy, however;

its heritage programmes have also exercised considerable influence on sites and practices domestically, as several of the chapters in this volume show. In fact, there is so much interest in UNESCO listings that Japanese scholars have begun to speak of a new "Age of World Heritage" (Iwamoto 2013, 16) starting around the year 2000. For better or worse, UNESCO exploded onto the scene in Japan, and the hectic activity around heritage nomination and marketing makes Japan an ideal site to study its effects.

Beyond Japan

We argue that the chapters in this volume are not merely of interest to scholars of Japanese religion and society, but also to those who study the interplay of religion and heritage in other cultural and geographical settings. Today, places of worship and ritual practices are reconfigured as "heritage" on a large scale—not only in Japan, but also elsewhere in Asia and Europe (Meyer 2019; Rots 2019). Scholars of religion in the contemporary world will increasingly have to study and analyse the discursive, institutional, and material processes by which such places and practices are turned into "heritage," and the consequences of such processes for the various stakeholders involved (e.g., worshippers, clergy, visitors, authorities, and commercial actors). A global comparative perspective is needed in order to grasp the ways in which changes in international governance, religious politics, and tourism trends affect local practices and are negotiated on the ground. Within such a global comparison, we argue, Japan should not function merely as an interesting "comparative Other," useful for testing and fine-tuning theories based on and developed in Euro-American contexts, as is (too) often the case in the study of religion (McLaughlin et al. forthcoming). When it comes to the heritagisation of religion, Japan has been, and continues to be, a global trendsetter. Not only was it one of the first modern states to implement an elaborate domestic system for heritage classification and conservation, as discussed above; it was also instrumental in the establishment and global proliferation of "intangible heritage" as a category of governance that allows secular states to redefine and control ritual practices (Aikawa 2004; Salemink 2016). In sum, if we wish to understand the heritagisation of religion as a global phenomenon, Japan is one of the most important places to investigate, and a good base from which to establish new theory.

We are not suggesting that the chapters in this volume are all theoretically and transnationally oriented. Most of them are not. They take up different themes and issues, based on empirical studies of particular cases and mostly confined to the borders of the modern Japanese state. Two of the chapters, those by Hølleland and Reader, have a transnational comparative component, but these, too, are primarily focused on Japan. All chapters are selective as they zoom in on particular cases and issues rather than providing comprehensive overviews or presenting theoretical interventions. The volume does not offer a single overarching argument; the authors approach the topic of heritage

differently, and have different opinions concerning the consequences and desirability of, say, World Heritage inscription. Thus, the chapters do not speak with a single voice or add up to a single theoretical argument. Their value, we argue, lies in the analyses they present of the empirical material—ethnographic and historical—of particular sites, and of the underlying social, religious, political, and ideological issues at play at those sites. Many of these issues are not unique to Japan, but they are especially pronounced in Japan, and a study of these cases in the Japanese context may help us understand similar issues elsewhere—not only in Asia, but also in Europe.

The cases in this volume offer fertile ground for reflection on a number of issues. For instance, the apparent "politicisation" of UNESCO and the World Heritage Committee has received ample criticism from academics and the general public alike (Meskell 2013; Bertacchini et al. 2016). While the observation that World Heritage is turning increasingly political has now become commonplace, there are few in-depth studies of exactly how and for what strategic and ideological purposes state actors and other stakeholders appropriate heritage. Although Japan currently receives less criticism for its role at the World Heritage meetings than states like China and Saudi Arabia (Hølleland and Wood 2019; Kanji 2019), it was arguably one of the first countries to actively employ heritage conservation as a political tool in international diplomacy (Akagawa 2014). An in-depth analysis of the changing politics of heritage in Japan, therefore, will be helpful for understanding processes of politicisation elsewhere. This is exactly the purpose of the chapters by Loo and Hølleland in this volume, both of which examine the role of state actors in heritage-making, and their underlying motivations, in different contexts. While Loo examines the relevance of heritage in domestic politics, Hølleland provides an analysis of Japan's role on the international stage. These chapters provide relevant insights into the politics of heritage-making in the late twentieth and early twenty-first century, the implications of which extend far beyond Japan.

Another global issue that comes to the fore in this volume is the important question of ownership. DeWitt addresses this topic in her discussion of gender exclusion at two Japanese World Heritage Sites. To qualify for inclusion in the World Heritage List, a site must possess outstanding universal value; does that mean that the site is the property of humanity as a whole, and that everybody should have access to it? Or are local owners free to impose restrictions, even if these are of a discriminatory nature and violate some of UNESCO's foundational principles? Again, these are questions that have ramifications far beyond Japan, and DeWitt's chapter will be an important case study for those who wish to understand issues of ownership and exclusion in relation to World Heritage Sites. Likewise, the chapters by Reader and Rots take up questions of ownership and exclusion in their discussions of processes of transformation and contestation of sacred sites in relation to World Heritage inscription. Reader examines a case of a site that has not (yet) been inscribed, while Rots discusses the debates and conflicts around a site *after* it became World Heritage

listed. While different in size, scope, and institutional formation—the former is a lengthy pilgrimage consisting of eighty-eight temples, while the latter is a single sacred grove managed by a municipality—both case studies show that processes of heritage-making often involve power struggles, conflicts over competing narratives, and flawed expectations.

Mass tourism is an especially contentious issue, as these chapters illustrate. While some stakeholders, such as local authorities, wish to see an increase in tourist numbers, others deplore the transformations brought about by tourism—especially those caused by an influx of the "wrong kind" of visitors, who are seen to behave in ways that undermine the site's sacred nature. It is a double-edged sword: tourism may be a solution to some of the problems discussed by Kolata, such as rural depopulation, temple decline, and a lack of funding for repairing material heritage. In contrast, mass tourism can lead to the exclusion of local worshippers from "their" sacred site, as discussed by Rots, or to the standardisation and commodification of ritual traditions, as Kikuchi and Teeuwen describe. Again, these issues are obviously not unique to Japan; similar tensions between heritage conservation, economic development, mass tourism, and religious identity exist at sacred historic sites throughout the globe, as Reader rightly points out in his chapter. But Japan provides some compelling case studies that may help us understand the dynamics of heritage-making in relation to tourism and rural development.

Furthermore, Japan is an especially important place for studying the formation of ICH, because it was here that the category was originally created, and because Japanese government actors and non-governmental organisations (NGOs) have been instrumental in its universalisation, as we have seen. Our concern in this volume is primarily with the reclassification of ritual traditions as intangible heritage, and the consequences this has for the practices in question. Teeuwen and Kikuchi discuss ritual traditions listed as UNESCO Intangible Cultural Heritage. The cases are different in many respects—one is a famous urban festival that has long attracted large visitor numbers, the other is a rural ritual that was fairly unknown until it was listed by UNESCO—but there are some interesting similarities as well. Both traditions are alive and popular, but have seen some far-reaching transformations in recent years, and it is questionable to what extent there is still place for devotional elements, or whether they have become secular tourist spectacles. Similar processes can be observed in other countries, especially now that the category "intangible heritage" is gaining popularity internationally. Thus, analyses of Japanese ritual traditions—which were among the first in the world to be classified as intangible heritage, and transformed accordingly—will provide important insights that may have wider, global implications.

Last but not least, one aspect of heritage-making in Japan that may strike readers as distinctive relates to the main focus of this volume: the need to negotiate the boundary between the religious and the secular that arises when sites, objects, and practices of religious nature, defined by law as private, are designated

as public cultural properties or heritage. How can the state celebrate religious "culture" and "art" without violating the constitutional separation of state and religion? This issue comes to the fore most clearly in the chapters by Loo, Reader, and Teeuwen, which show how the strategies employed to negotiate this constitutional separation have changed in recent years. An initial concern to separate "secular" historical and artistic value from religious value and to exclude the latter from heritage narratives is giving way to a new understanding that those religious values (referred to in policy documents with the legally innocuous term *shinkō*, "beliefs/faith") are at the core of the "authenticity" and "outstanding universal value" of sites and practices, and therefore should be a central concern of preservation initiatives. The problem is handled differently for different categories of cultural properties and heritage: while religious buildings and objects listed as heritage sites may receive preservation subsidies based on their historical or artistic value, intangible ritual practices can only receive such subsidies if their religious aspects are redefined as non-institutional "beliefs/faith." In Japan, this issue of the place of private religion in public heritage policy within a secular state plays out in a manner that is of particular interest not only to scholars of Japanese religion but also to those who study modern state-religion relations and heritage-making from a comparative, transnational, and theoretical perspective.

Notes

1 These numbers are taken from www.bunka.go.jp/seisaku/bunkazai/shokai/shitei. html. There are also 64 Important Cultural Landscapes, 118 Important Preservation Districts for Groups of Traditional Buildings, and 75 Selected Conservation Techniques.

2 www.bunka.go.jp/english/policy/cultural_properties/introduction/local/.

3 On the secular sphere in modern and contemporary Japan, see Rots and Teeuwen (2017).

4 For more elaborate histories of Japanese heritage legislation, see Nakamura (2013) and Kono (2010).

5 Around a hundred national shrines (*kansha*) were, in theory at least, already public property, although public subsidies for such shrines were being scaled down at this time.

6 In its founding document, the Deutscher Bund Heimatschutz (founded in 1904) asserted that "because 'natural and historical characteristics' together composed Germany's unique character (*Eigenart*), natural objects, folk culture, and traditional architecture all had to be preserved from the 'intrusion of modern life with its brutally one-sided pursuit of practical goals'" (Williams 1996, 347). On the introduction of these ideas to Japan, see Akasaka (1998).

7 For discussions of Japanese heritage preservation policies and practices in the colonies, as well as their influence on postwar policies, see, for instance, Loo (2014) (on the Ryukyu Islands) and Pai (2013) (on Korea).

8 These matters are analysed in detail in Scott (2003) and Trifu (2017). Where Scott emphasises American influence on the new 1950 law, Trifu plays down American influence and stresses Japanese initiatives.

9 On the evolving policies for the preservation of folklore and folk arts, see Hashimoto (1998); Kikuchi (2001), Chapter 1; Thornbury (1994).
10 Wakao Masaki, president of the Special Committee for the Preservation of Cultural Properties of the Japanese Association for Historical Scholarship, expresses this view in a newspaper article titled "Concerns for Preservation as Tourism Is Prioritised" (*Kankō yūsen de hozon ni kenen*). *Mainichi shinbun*, 18 April 2018, 13.

References

Aikawa, Noriko. 2004. "An Historical Overview of the Preparation of the UNESCO International Convention for the Safeguarding of the Intangible Cultural Heritage." *Museum International* 56 (1/2): 137–149.

Akagawa, Natsuko. 2014. *Heritage Conservation and Japan's Cultural Diplomacy: Heritage, National Identity and National Interest*. Abingdon: Routledge.

Akasaka Makoto. 1998. "Senzen no Nihon ni okeru kyōdo hogo shisō no dōnyū no kokoromi." *Randosukēpu kenkyū* 61 (5): 401–404.

Bertacchini, Enrico, Claudia Liuzza, Lynn Meskell, and Donatella Saccone. 2016. "The Politicization of UNESCO World Heritage Decision Making." *Public Choice* 167 (1–2): 95–129.

Brumann, Christoph, and David Berliner, eds. 2016. *World Heritage on the Ground. Ethnographic Perspectives*. New York: Berghahn.

Daly, Patrick, and Tim Winter, eds. 2012. *Routledge Handbook of Heritage in Asia*. Abingdon: Routledge.

Foster, Michael Dylan. 2015. "UNESCO on the Ground: Local Perspectives on Global Policy for Intangible Cultural Heritage." *Journal of Folklore Research* 52 (2/3): 143–156.

Hashimoto, Hiroyuki. 1998. "Re-Creating and Re-Imagining Folk Performing Arts in Contemporary Japan." *Journal of Folklore Research* 35 (1): 35–46.

Hølleland, Herdis, and Morgaine Wood. 2019. "An Emotional Plea for Al-Ahsa: A Case Study on how Discourses of Representativeness, Climate and Discord are Strategized in the World Heritage Regime." *International Journal of Cultural Policy*. https://doi. org/10.1080/10286632.2019.1646734.

Hsiao, Hsin-Huang Michael, Hui Yew-Foong, and Philippe Peycam, eds. 2017. *Citizens, Civil Society and Heritage-Making in Asia*. Singapore: ISEAS Publishing.

Iwamoto Michiya, ed. 2013. *Sekai isan jidai no minzokugaku: Gurōbaru sutandādo no juyō o meguru Nik-Kan hikaku*. Tokyo: Fūkyōsha.

Kanji, Azeezah. 2019. "How Ethnonationalists Use the UNESCO World Heritage Label." *Al Jazeera*, 4 August. www.aljazeera.com/indepth/opinion/ethnonationalists-unesco-world-heritage-label-190802112838549.html (accessed 29 October 2019).

Kikuchi Akira. 2001. *Yanagita Kunio to minzokugaku no kindai*. Tokyo: Yoshikawa Kōbunkan.

Kono, Toshiyuki, ed. 2010. *The Impact of Uniform Laws on the Protection of Cultural Heritage and the Preservation of Cultural Heritage in the 21st Century*. Leiden: Martinus Nijhoff Publishers.

Loo, Tze May. 2014. *Heritage Politics: Shuri Castle and Okinawa's Incorporation into Modern Japan, 1879–2000*. Lanham, MD: Lexington Books.

Matsuda, Akira, and Luisa Elena Mengoni, eds. 2016. *Reconsidering Heritage in East Asia*. London: Ubiquity Press.

McLaughlin, Levi, Aike P. Rots, Jolyon Thomas, and Chika Watanabe. Forthcoming. "Why Scholars of Religion Must Investigate the Corporate Form." *Journal of the American Academy of Religion.*

Meskell, Lynn. 2013. "UNESCO's World Heritage Convention at 40: Challenging the Economic and Political Order of International Heritage Conservation." *Current Anthropology* 54 (4): 483–494.

Meyer, Birgit. 2019. "Religion and/as Heritage: Recycling the Christian Past in the Netherlands." Guest lecture, University of Oslo, 3 October.

Meyer, Birgit, and Marleen de Witte. 2013. "Heritage and the Sacred: Introduction." Special issue, *Material Religion* 9 (3): 274–281.

Nakamura Jun. 2013. "Nihon ni okeru bunkazai hogohō no tenkai." In *Sekai isan jidai no minzokugaku: Gurōbaru sutandādo no juyō o meguru Nik-Kan hikaku,* edited by Iwamoto Michiya, 61–85. Tokyo: Fūkyōsha.

Oakes, Tim, and Donald S. Sutton. 2010. "Introduction." In *Faiths on Display: Religion, Tourism, and the Chinese State,* edited by Tim Oakes and Donald S. Sutton, 1–26. Plymouth: Rowman & Littlefield.

Pai, Hyung Il. 2013. *Heritage Management in Korea and Japan: The Politics of Antiquity and Identity.* Seattle: University of Washington Press.

Robertson, Jennifer. 1988. "*Furusato* Japan: The Culture and Politics of Nostalgia." *Politics, Culture and Society* 1 (4): 494–518.

Rots, Aike P. 2017. "Public Shrine Forests? Shinto, Immanence, and Discursive Secularization." *Japan Review* 30: 179–206.

Rots, Aike P. 2019. "World Heritage, Secularisation, and the New 'Public Sacred' in East Asia." *Journal of Religion in Japan* 8 (1-3): 151-178. https://doi.org/10.1163/22118349-00801011

Rots, Aike P., and Mark Teeuwen, eds. 2017. "Formations of the Secular in Japan." Special issue, *Japan Review* 30.

Salemink, Oscar. 2016. "Described, Inscribed, Written Off: Heritagisation as (Dis)connection." In *Connected and Disconnected in Viet Nam: Remaking Social Relations in a Post-Socialist Nation,* edited by Philip Taylor, 311–346. Canberra: ANU Press.

Scott, Geoffrey R. 2003. "The Cultural Property Laws of Japan: Social, Political, and Legal Influences." *Pacific Rim Law & Policy Journal* 12 (2): 315–402.

Silva, Kapila D., and Neel Kamal Chapagain, eds. 2013. *Asian Heritage Management: Contexts, Concerns, and Prospects.* Abingdon: Routledge.

Thornbury, Barbara E. 1994. "The Cultural Properties Protection Law and Japan's Folk Performing Arts." *Asian Folklore Studies* 53 (2): 211–225.

Trifu, Ioan. 2017. "Reform in Late Occupation Japan: The 1950 Law for the Protection of Cultural Properties." *Journal of Japanese Law* 43: 205–230.

Weiss, Lindsay. 2007. "Heritage-Making and Political Identity." *Journal of Social Archaeology* 7 (3): 413–431.

Williams, John Alexander. 1996. "'The Chords of the German Soul Are Tuned to Nature': The Movement to Preserve the Natural Heimat from the Kaiserreich to the Third Reich." *Central European History* 29 (3): 339–384.

Winter, Tim. 2014. "Heritage Studies and the Privileging of Theory." *International Journal of Heritage Studies* 20 (4): 556–572.

The politics of Japan's use of World Heritage

From ratifying the World Heritage Convention to the Mozu–Furuichi Tumulus Clusters

Tze M. Loo

On 31 July 2017, Japan's Council for Cultural Affairs Special Commission on World Heritage (Bunka Shingikai Sekai Bunka Isan Tokubetsu Iinkai) selected Osaka Prefecture's "Mozu–Furuichi Kofungun Ancient Tumulus Clusters" (hereafter Mozu–Furuichi) as the country's nomination that year for inscription into UNESCO'S World Heritage List. The Mozu–Furuichi property consists of forty-nine tumuli in forty-five locations in the historic Mozu and Furuichi areas of Osaka Prefecture, today the urban centers of Sakai, Habikino, and Fujiidera. Known in Japanese as mounded tombs (*kofun*) and built between ca. 350 and ca. 550 CE, many of them have a distinctive keyhole shape and are thought to be burial mounds for the region's ruling elite. Eleven of the tumuli are monumental structures more than two hundred meters long. The most breathtaking, the Daisen kofun, is 486 meters long and ringed by three moats. It is the world's largest burial mound.

On 6 July 2019, the World Heritage Committee inscribed Mozu–Furuichi into the World Heritage List during its forty-third session. The tumulus clusters became Japan's nineteenth cultural World Heritage Site (its twenty-third overall) and was the culmination of a decade-long effort by Osaka Prefecture, an effort driven in part by the prefecture's unflattering circumstance as the only one in the historic Kansai region lacking a World Heritage Site. For Mozu–Furuichi's advocates, among them local municipal governments and communities, the site's sheer scale, its evocation of the contours of the ancient Japanese polity, and its connections with the wider East Asian world cement its cultural and historical value.

Yet Mozu–Furuichi's path to becoming World Heritage site was neither smooth nor quick. The Agency for Cultural Affairs (Bunkachō, hereafter ACA) had passed over the Mozu–Furuichi dossier three times and counselled revisions to strengthen its case. The site's candidacy, irrespective of its strength on historical and cultural grounds, has also been complicated by the fact that the Imperial Household Agency (Kunaichō, hereafter IHA) contends that several of the tombs are imperial graves of past emperors, sacred spaces where

rites continue to be conducted and whose "tranquility and dignity" (*seian to songen*) must be preserved. For critics, the IHA's management of these tombs are holdovers from the prewar emperor system and in their view, the Mozu–Furuichi's candidacy for World Heritage status afforded an opportunity to revisit—and perhaps to bring a corrective to—echoes of a Japanese nationalism from an earlier, darker time.

The role played by these mounded tombs in prewar Japanese nationalist ideology may, at first glance, seem irrelevant to an analysis of Osaka's quest for a World Heritage Site. This is especially so when considered in light of the World Heritage Committee's implicitly apolitical stance toward preservation captured in the World Heritage Convention, that protection of "cultural and natural property demonstrate[s] the importance, for all the peoples of the world, of safeguarding ... unique and irreplaceable property, to whatever people it may belong" (UNESCO 1972, 1). This chapter, however, argues that the criticisms of Mozu–Furuichi's candidacy become unambiguously relevant when viewed in the larger context and longer history of the place World Heritage has come to occupy vis-à-vis the agendas of the Japanese state. Since ratifying the World Heritage Convention in 1992, Japan's participation in the World Heritage enterprise—which includes getting its own properties inscribed, as well as contributing to aspects of World Heritage preservation—has proved to be a flexible tool for the Japanese state to address concerns that have little inherent connection with cultural heritage. Since the 1970s, Japan used its support of World Heritage as part of a foreign policy strategy to signal its successful rehabilitation from its wartime aggressions and its return as a productive member of the international community (Loo 2007). By the mid-2000s, however, World Heritage had also become a focus of Japanese domestic policy. The Mozu–Furuichi nomination had its genesis in this moment of transition. Its candidacy, in particular, demonstrates how World Heritage became an opportunity for the Japanese state to rehabilitate the IHA's control of imperial tombs, and in so doing, resolve an issue from the prewar emperor-centered state that has endured into the postwar.

Internationalization in the 1970s

Few people will be surprised by the suggestion that World Heritage is often political and politicized or by the contention that Japan's relationship to World Heritage is similarly political. This has become especially clear after Lynn Meskell's (2013) reflections on the fortieth anniversary of World Heritage Convention. Scholars of Japanese diplomacy and foreign policy have long recognized how "cultural policy" (*bunka seisaku*) has been a key element in Japan's postwar foreign relations (Hirano 1985; Matsumura 1996; Ogura 2010). Natsuko Akagawa reminds us that Japan uses "its cultural diplomacy to engage more actively with the international community" and "as a vehicle for the exercise of its influence abroad alongside its rise to economic power" (Akagawa

2016,125; see also Akagawa 2014).These studies have shown how Japan allocates resources to cultural policy to achieve its foreign policy aims and enhance its influence on the international stage. But Japan's specific commitment to heritage preservation is a relatively recent development that began in earnest only in the 1970s.

Following the end of World War II, Japan embarked on cultural initiatives to signal its rehabilitation from its wartime aggression and to demonstrate a commitment to peace. In a sense, these cultural policies were the international manifestation of an undertaking articulated by Japan's first postwar prime minster, Katayama Tetsu (1887–1978), who ended his speech to the first postwar meeting of the Japanese Diet with a pledge to "build a democratic peaceful nation, a cultural state (*bunka kokka*)" that would rejoin the international community (Kokkai 1947). Over the next two decades, the term "nation of culture" surfaced often in Japan's political discourse and, although a solid definition of it remained elusive, it became shorthand for a Japan that rejected militarism and embraced democracy. Over time, conversations surrounding this notion became bifurcated along domestic and international lines. As a domestic concern, the focus was upon possession and protection of Japan's own cultural properties and cultural heritage. In its international manifestation, Japan as a "nation of culture" poured its energies into the restoration of cultural accords (*bunka kyōtei*) with other countries that were interrupted by the war (Gaimushō 1957). For Japan's Ministry of Foreign Affairs (MOFA), international cultural exchange had the potential to "strengthen the cultivation of the connection of hearts between the citizens of different countries, [and could itself become] the basis of international cooperation in politics and economics"—a reflection of Japan's hope that a commitment to "culture" would restore a reputation so badly damaged by its wartime conduct (Gaimushō 1960). Many of these exchanges were bilateral initiatives on a limited scale (e.g., the donation of Japanese language library books or organizing exhibitions to promote Japanese art or film).This outreach frequently focused on Asian countries, as Japan tried to mend relations with those most affected by its wartime aggression. In the 1970s, Japan started to contribute specifically to heritage preservation projects, first with funding for a UNESCO-led campaign to preserve Borobudur (Indonesia) in 1973. Aid for heritage preservation projects continued through the rest of the decade; by the late 1970s, Japan was engaging in other international preservation campaigns (e.g., Moenjodaro in Pakistan) and forging further bilateral arrangements for heritage preservation.[1]

These efforts continued in the 1980s. Japan's commitment to UNESCO's preservation of World Heritage took solid institutional shape in 1992 when Japan finally accepted the World Heritage Convention. Since then, Japan has become a world leader in cultural heritage preservation through its financial backing, technical knowledge and expertise, and leadership in spearheading paradigmatic rethinking of the World Heritage system. In addition to separate Japan Funds-in-Trust (FIT) for the preservation of tangible and intangible cultural

heritage, Japan also organized several major conferences which introduced and codified important new concepts into the operation of World Heritage: the Nara Document on Authenticity (1994), the Yamato Declaration on Integrated Approaches for Safeguarding Tangible and Intangible Cultural Heritage (2004), and the Kyoto Vision (2012), which sought "to orient the implementation of the World Heritage Convention going forward." Matsuura Kōichirō, a Japanese academic and diplomat, served two terms as Director-General of UNESCO, from 1999 to 2009. During his tenure the World Heritage Committee adopted the Convention for the Preservation of Intangible Heritage (2013). In light of these and other contributions, Japan has accumulated and leveraged a sizeable reservoir of "soft power" on the international stage (Akagawa 2014), thanks to its organizational, intellectual, and financial leadership in the World Heritage Committee's work.

But the political nature of Japan's engagement with UNESCO and the World Heritage Committee extends beyond its use of heritage preservation to accumulate diplomatic influence. The UNESCO/World Heritage Committee imprimatur has enabled Japan to use preservation of cultural heritage to confront problems that have little connection to cultural heritage. In fact, the genesis of Japan's involvement with UNESCO's World Heritage was itself embedded in Japan's anxieties from the 1970s onward about its international position.

Japan's high-growth economic policies had made it the world's second largest economy by 1978 but at the cost of international criticism of its protectionism and wariness at the prospect of its increasing economic dominance, especially from Southeast Asian nations. Beyond accusations of predatory economic behavior, critics also attacked Japan's inability to find common ground with other countries and suggested that insularity was hindering its engagement with the international community. The Japanese state's response was yet more active support for cultural initiatives and exchanges, to show that Japan's interests extended beyond economic power and encompassed its neighbors' cultural wellbeing as a mark of international good citizenship. Japan's diplomatic bluebooks beginning in the 1970s demonstrate a realization that it was no longer enough to convince the world of its retreat from militarism. Japan also had to show that it could contribute to the international community even as it pursued its own agenda, in effect "to choose ways to assure its national interests by respecting the national interests of other countries" (Gaimushō 1971). It was in this context that Japan began to cooperate with others on issues of social and economic development, and in the 1970s altered its cultural policy as well. If Japan's cultural initiatives immediately following World War II focused on promoting Japanese culture abroad and exposing Japanese people to other cultures, these initiatives shifted beginning in the 1970s toward aiding other countries in the protection of *their* culture and heritage, as seen in its support of the projects at Borobudur and Moenjodaro.

The Japanese government's reconceptualization of the nation's place in the international community continued into the 1980s, as frictions between

Japan and other countries still smoldered. In September 1985, Japan's Ministry of International Trade and Industry organized the first of eight roundtable discussions on "Japan in the Global Community" to evaluate Japan's international role as it looked toward the future (Murakami and Kosai 1986). These conversations made a strong case for greater and more energetic Japanese engagement with the international community, as well as for greater tolerance for other societies and more accommodation of Japanese values to international ones. These recommendations were evidently taken seriously by the Japanese government. The MOFA policy direction for 1987 reflected much of the roundtable's language, and in the next year, the specific link was made between this policy direction and heritage preservation.[2] In a speech in London on 4 May 1988, Prime Minister Takeshita Noboru introduced his cabinet's goal of fostering world peace and prosperity. Among his three prescriptions to achieve this goal was "the strengthening of international cultural exchange," the significance of which he explained as follows:

> The diverse cultures of the world should be appreciated widely by all nations for the universal values they embody and as the common assets of all mankind. Cultural exchange fosters tolerance of different cultures, thereby leading to the establishment of an open international community and even to the achievement of international harmony and world peace ... I intend to promote interchange among the various cultures of the world, while encouraging the preservation of each nation's precious culture; I will also promote Japan's contribution to the enrichment of the world's cultures as we approach the 21st century.
>
> (Takeshita 1988)

In some ways, Takeshita's celebration of international cultural exchange and his commitment of Japan's energies to heritage preservation were unsurprising given the role of cultural exchange in Japan's postwar foreign policy and the gradual uptick of its contributions to heritage preservation projects. His address also marked a deliberate turn to heritage preservation as an effective way to solve a very specific problem facing Japan: its perceived insularity.[3]

Takeshita's clear embrace of heritage preservation—among Japan's foreign policy options—as an area to which Japan would henceforth devote attention and resources is significant in several ways. Japan understood its frictions with other countries as rooted in inadequate understanding of their cultural differences; the solution, it followed, was in international cultural exchange. Heritage preservation was especially suited for this. While Japan supported it financially, its ultimate goals were explicitly non-economic. This new emphasis furthered the shift in Japan's cultural policy from promoting Japanese culture abroad to fostering the preservation of other cultures. This in turn enabled Japan to capitalize on the proclivity of nation-states, especially newly emerging ones, to view cultural heritage as an important component of a polity's usable past, a

positive good for those in power. By helping other nation-states preserve their own heritage, Japan was perceived as supporting their aspirations (Sōgō Kenkyū Kaihatsu Kikō 1995). This, moreover, had a global dimension, since contributing to World Heritage was tantamount to "preservation of the cultural heritage of mankind" (Takeshita 1988). Japan was effectively endorsing a commitment more profound than self-interest or the forging of bilateral relationships: to work for humanity's benefit. Japan, furthermore, expressed willingness to transfer technical knowledge about heritage preservation to others, which, combined with its substantial financial resources, made Japan an attractive and reliable sponsor of heritage preservation on the international stage.

Following Takeshita's speech, the cabinet established a high-level committee, the Council for the Promotion of International Cultural Exchange (Kokusai Kōryū Suishin Kaigi). Its policy blueprint, the Action Program for International Cultural Exchange (*Kokusai bunka kōryū kōdō keikaku*), outlined eight action areas to enact Takeshita's vision, among them the enhancement of cooperation to preserve cultural heritage with UNESCO as the mechanism to achieve this goal (Sōrifu 1988, 1990, 93). It targeted especially the preservation of cultural heritage sites in Asia and those on UNESCO's list, for which the action program suggested depositing a Japanese Funds-in-Trust with UNESCO.

Motivated by this new direction, Japan finally accepted the World Heritage Convention in 1992. When pressed by the opposition in the Diet to account for the delay in Japan's formal commitment to the World Heritage Convention, the government cited the need to coordinate the working relationship of the World Heritage Convention with Japan's own system of cultural heritage preservation (Kokkai 1992). As a reason for the delay, Japanese officials also offered Japan's solidarity with the United States and the United Kingdom, who withdrew from UNESCO in the mid-1980s to protest perceived exploitation of the organization by third-world countries in political attacks against the Euro-American West. Skeptical of these explanations, some opposition lawmakers wondered whether the long delay reflected the government's lack of commitment to the World Heritage project in the first place (Kokkai 1992). While no doubt aimed at goading the government, these criticisms, by calling attention to the seemingly sudden turn to the preservation of World Heritage after years of inaction, perhaps alluded obliquely to the naked political calculations that animated this new policy direction. These criticisms were ultimately more an annoyance than a threat to the government, and, after years of stasis, activity accelerated sharply in the ministries of Education, Foreign Affairs, and Land, moving Japan to acceptance.

While it was accruing power and influence in the World Heritage enterprise and demonstrating its rehabilitation to the international community, Japan also used the designation of World Heritage sites to shape the nation's image for both international and domestic audiences (Igarashi, Iwatsuki, and Nishimura 2013, 102). Indeed, Japan's list of World Heritage Sites corresponds well to both the time and space of the modern Japanese nation-state. Most periods of Japan's modern historical chronology as found in textbooks or general histories are represented

on Japan's current list of sites (e.g., the Nara and Heian periods). Those not yet on the list (e.g., the Jōmon and Kamakura periods) are slated tentatively for future nomination.[4] Geographically, Japan's current sites resemble a border drawing. The entirety of "Japan" falls inside the physical bounds of the sites, from Hokkaido in the north (the Shiretoko Peninsula) to Okinawa in the south ("Gusuku sites and related properties of the Kingdom of Ryukyu"). In this sense, Japan's World Heritage Sites mirror the history and geography of the modern Japanese nation-state as the dominant Japanese national imagination conceives of it.

A different kind of historical fashioning occurred with the nomination of the Hiroshima Dome (see Figure 2.1). The Dome's inscription onto the World

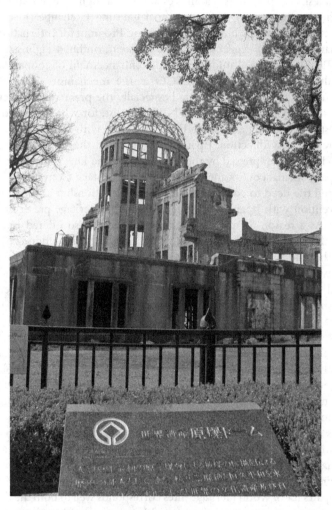

Figure 2.1 The Hiroshima Dome. A sign informs visitors that this is a World Heritage Site. Photo credit: Herdis Hølleland.

Heritage List in 1996 is remembered today largely for the objections lodged against it, namely the Chinese and American critique of the inscription's lack of historical context for the dropping of the atomic bombs and the contention that it might distract from Japan's responsibility for waging aggressive war in Asia (UNESCO 1996). But for some Japanese politicians who championed the Dome's nomination at the time, the inscription would convey a different message: they saw it as an opportunity for Japan to underscore its commitment to peace and signal contrition for its actions in World War II.

Interest in nominating the Dome emerged early; even as the Diet was discussing the acceptance of the World Heritage Convention, politicians were already considering that possibility. In a meeting of the Committee for Foreign Affairs of the Upper House of Councilors on 18 June 1992, Kamitani Shinnosuke, a member of the Japanese Communist Party from Kyoto, raised the question of the preservation of the Hiroshima and Nagasaki atomic bombs sites. He contended that Japan, the only country to have suffered a nuclear attack, was uniquely positioned to tell the story of nuclear destruction and to contribute to the movement for a lasting peace, and that the nation also bore a responsibility to preserve these sites for this reason (Kokkai 1992).

Not long afterward, Hiroshima launched the opening volley of a concerted campaign to persuade the central government to support the Dome's nomination. After Japan accepted the World Heritage Convention, the Hiroshima City assembly quickly requested the Dome's addition to the country's inaugural list of nominations (Hiraoka 1998, 1). The city assembly noted that while Hiroshima had already committed to preserving the Dome in perpetuity as a symbol of peace, it would be "very meaningful" for the Dome to be inscribed into the World Heritage List as a "symbol of the vow [of a commitment to peace] by humanity who live in a nuclear age" (Zwigenberg 2014; Hiraoka 1998, 1). The city thus called on the central government to support the Dome's nomination as a way for Japan to demonstrate its particular commitment to realizing a lasting peace for itself and the world.

By early 1994, both houses of the Diet supported Hiroshima's case, but the Dome's nomination did not move forward immediately. The World Heritage Committee's Operational Guidelines required that all World Heritage Sites be protected by domestic heritage preservation legislation, protection the Dome did not enjoy in 1994. Japan's system of heritage preservation was at the time concerned with pre-twentieth-century historical properties and was not disposed to consider the early twentieth-century Hiroshima Prefectural Commercial Exhibition Hall, which housed the Dome (Kokkai 1994a). Despite the groundswell of popular support for the Dome's nomination, the ACA would only commit to investigating the possibility of the Dome's future inclusion within the framework of existing preservation laws. A turning point for the Dome's nomination came in mid-1994, when Prime Minister Hata Tsutomu, during his brief two months in office, publicly supported the Dome's nomination because it would enable Japan to "make an appeal to the world for peace" (Hiraoka 1998, 1).

Hata's intervention in the nomination process is significant because it marked the emergence of the Japanese government's very public linking of itself with what the Dome and its preservation represented. The prime minister's public support was perhaps key in motivating the ACA to rethink its exclusive focus on pre-twentieth-century buildings. During the ordinary session of the Japanese Diet on 20 July 1994, Hata (now out of office) called on his successor Murayama Tomiichi to support the Dome's nomination as a way to demonstrate "reflection and apology (*owabi*) for the suffering caused by the war" and to promise never again to wage "miserable war" (*fukō na sensō*) during commemoration of the fiftieth anniversary of the end of World War II the following year (Kokkai 1994b). Two days later, in a session of the Upper House, Diet member Kubo Wataru similarly appealed to Murayama regarding the Dome's nomination. Noting that "war responsibility" meant the prevention of amnesia and building a foundation for peace, Kubo suggested that the Murayama cabinet had to demonstrate a different historical understanding and sense of responsibility from previous governments if it wished Japan to become a pacifist country (*heiwashugi kokka*). Pointing to Asian countries' continuing distrust of Japan over the question of war responsibility, Kubo suggested that the Dome is "a piece of historical heritage that can convey to later generations thoughts of peace of a humanity that hopes for the end of nuclear weapons," and he advised the Murayama cabinet to make a public commitment to nominate the Dome for inclusion into the World Heritage List during its tenure (Kokkai 1994c). Indeed, during Murayama's time in office, the ACA designated the Dome an Important Historic Site, which opened the way for its addition to Japan's tentative list and eventual nomination for World Heritage status. Murayama's government in effect employed the World Heritage List to articulate a political position: Japan's regret for its wartime conduct and a commitment to peace.

Japan, however, has shown itself to be equally willing to use the World Heritage List for less salutary purposes. The recent inscription of the "Sites of Japan's Meiji Industrial Revolution," mired in controversy over Japan's failure to mention forced Korean and Chinese labor, exemplifies use of the list to normalize less savory moments in its history. Despite an agreement between Japan and Korea on how to address the issue of forced labor at the site, the dominant narrative as told by the Meiji industrial sites qua World Heritage Site is nevertheless the story of Japan as the first non-Western industrialized nation. Ignoring what this industrialization ultimately enabled and entailed, this narrative is at best incomplete, at worst willfully mute on darker elements of Japan's modern history (Siemons and Underwood 2015; Takazane 2015; Underwood 2015).

The nomination of the Mozu–Furuichi Tumulus Cluster

If the first fifteen years after ratifying the World Heritage Convention saw Japan use its involvement in World Heritage to fashion a presence on the international

stage, there was then a shift in what it was deemed useful for in the mid-2000s. This came into sharp relief around 2006, when the Japanese state took steps that brought World Heritage closer to local communities in tangible ways, and World Heritage assumed a larger role in Japanese domestic policy.

The first change came in how Japan's tentative list would be filled. Until this time, the ACA had prepared Japan's tentative list but, in 2006, the Ministry of Education, Culture, Sports, Science, and Technology (Monbukagakushō, here-after MEXT) announced that the ACA henceforward would solicit proposals from local governments, communities, and organizations and draw selections for Japan's tentative list from them (Monbukagakushō 2006). Twenty-four dossiers were submitted that year, from which four properties were imme-diately selected and added to Japan's tentative list (Bunkachō 2008a).[5] The remaining twenty dossiers were retained and joined thirteen new submissions in 2007. The ACA then selected five additional properties for Japan's tentative list from these in 2008.

There were several reasons for this new approach. Japan's tentative list needed replenishment after more than a decade of successful nominations to the World Heritage List. The mid-2000s, moreover, saw the World Heritage Committee refine the meaning of "outstanding universal value" (OUV) both to diver-sify the list and to ensure that inscribed properties were indeed outstanding examples of World Heritage. Realizing that World Heritage designations likely would become harder to win, MEXT wanted to create "a list [of properties] that could respond strategically" to these new challenges (Monbukagakushō 2006). By underscoring the uniqueness of local areas and sites to diversify—and thus strengthen—the competitiveness of its nominations, Japan planned to meet a more stringent standard of OUV by offering radically local cultural forms for which there were unlikely to be comparable properties elsewhere.[6] One result of this new strategy was that local governments and communities became active stakeholders in what had hitherto been a top-down process in which they had little access and voice.

The decentralization of the process of compiling the tentative list coincided with evolving domestic policy in which cultural heritage, especially World Heritage, was viewed as a means to revitalize local economies. In 2007, the Japanese government announced a "Strategy for revitalizing regional areas" (*Chihō saisei senryaku*) to counter the vicious cycle brought about by a rapidly aging population and the flow of people into urban areas (Chiiki Kasseika Tōgō Honbu Kaigō 2007). Ostensibly built around the three pillars of "strengthening regional growth," "securing regional life networks," and "creating a society with a low carbon footprint," this strategy in fact largely hinged on creating appealing locales able to attract both tourists and new permanent residents. A locale's unique historical resources—cultural properties like "castle sites, kofun grave mounds, historical buildings"—were posited as an important way to do this (ibid., 31). In the same year, the Japanese government unveiled its "National tourism promotion plan" (*Kankō rikkoku suishin kihon keikaku*)

spotlighting tourism as a major pillar in Japan's economic strategy for the twenty-first century. Endeavoring to transform Japan into a "tourism nation" (*kankō rikkoku*), this plan shared the regional revitalization strategy's conviction that a region's unique attributes represented tourism resources that could create enticing locales and draw visitors. Heading the plan's priorities was "the protection, cultivation, and development of tourism resources related to cultural properties," both domestic properties and potential World Heritage Sites (Kankōchō 2007, 15).

At the heart of these strategies lay a concern for stimulating local and regional economies, and both included acquisition of World Heritage Sites as an element of this. These new domestic priorities, alongside local governments' newfound ability to participate in selecting potential sites, transformed bidding for World Heritage status into a strategy for local economic development. Indeed, as evidenced by the response to the ACA's call for proposals, many local governments have enthusiastically embraced the use of World Heritage Sites to increase regional tourist traffic. They are encouraged to do so by academics, think tanks, and government ministries who feed their optimist belief that World Heritage Sites benefit local economies.[7] This robust support extends to government-led networks that help localities cope with surging tourism and forestall damage to sites once World Heritage status has been granted (Kankōchō n.d.). In addition, the central government has enabled local governments to pursue these overlapping aims of local economic revitalization, boosting tourism, and greater local involvement in the pursuit of World Heritage status by offering tangible assistance in the form of grants-in-aid and subsidies as part of the state's regional revitalization strategy. Some locales have received such assistance for preparing new World Heritage Sites or augmenting existing ones.[8]

It was in this context that Osaka submitted its proposal for Mozu–Furuichi, which was initially titled "Mozu–Furuichi Mounded Tomb Clusters—The monumental tomb clusters beginning with the imperial mounded tomb of the emperor Nintoku" (Osaka Prefecture et al. 2007). Mozu–Furuichi was among the five proposals selected in 2008 for addition to Japan's tentative list, but the ACA highlighted several issues that had to be resolved as the property progressed towards formal nomination (Bunkachō 2008b). It was important, the ACA noted, that Osaka iron out the details of how the property could meet the obligations related to preservation and reporting as required by the World Heritage Committee's Operational Guidelines, while adequately respecting the "special character of the imperial mausolea" (*ryōbo no tokusei*) as they were managed by the IHA. The ACA asserted that the IHA's management of the mounded tombs was the premise upon which the property was being proposed, and it was concerned with ensuring that World Heritage status would not affect the mounded tombs in their function as imperial graves.

The mounded tombs are complicated, contested, and contradictory sites. Of the many thousands spread throughout mainland Japan (a 2016 study by the

ACA found 137,625 extant kofun), only a fraction—899 kofun in 460 distinct locations—are managed by the IHA (Bunkachō 2017, 36; Kunaichō n.d.). The IHA administers those kofun it deems tombs and mausolea of emperors, empresses, and other imperial family members, as well as "satellite tombs" (*baichō*), smaller mounds near larger tombs thought to contain persons with connections to imperial interments. The IHA also oversees so-called "reference sites" (*sankōchi*), tomb mounds the IHA considers to be possible mausolea but whose occupants remain unidentified.

The IHA does not oversee all the kofun in the Mozu–Furuichi nomination. However, included in it are some of the best-known "imperial tombs" in Japan: Daisen kofun (designated by the IHA as the tomb of Emperor Nintoku), Kamiishizu Misanzai kofun (designated as the tomb of Emperor Richū), and Kondagobyōyama kofun (designated as the tomb of Emperor Ōjin). These are the three largest mounded tombs in Japan and the crown jewels of the Mozu–Furuichi nomination (see Figure 2.2). Of the twenty-three kofun in the Mozu cluster located in Sakai City, the IHA oversees eight as imperial or satellite tombs. Ten others—designated as Historic Sites—are protected by national legislation and municipal ordinances. The IHA and Sakai City government administer and maintain the remaining five kofun jointly. For example, the front square area and moat of Magodayūyama kofun are managed by Sakai City, while its round tomb mound is administered by the IHA because the IHA regards it as a satellite of Daisen kofun. The moat of the Gobyōyama kofun was

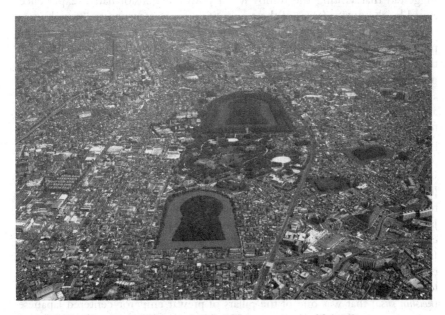

Figure 2.2 The Mozu tumulus cluster in Sakai. Photo courtesy of Sakai City.

designated a National Historic Site in 2018 and comes under national cultural property legislation, but the tomb mound is managed by the IHA as a reference site (*sankōchi*), possibly the tomb of Emperor Ōjin.

The IHA's management of these tombs is a holdover from the prewar Imperial Household Ministry's use of the imperial graves to prove unbroken imperial lineage from the sun goddess Amaterasu and embellish the power of the Imperial House (Toike 2007; Takagi 2010; Takagi and Yamada 2010). Scholars exploring the prewar Japanese state's use of kofun emphasize that these prewar efforts were merely a continuation of a longer tradition during the late Tokugawa and early Meiji periods of identifying tombs to bolster the court's power (Toike 2005; Edwards 2007, 40–44). The Meiji government simply inherited a project already in progress and added to it what James Edwards calls "a systematic program from the mid-1870s to locate and restore the as yet unidentified tombs of imperial family members" (Edwards 2000, 377). At the end of the Tokugawa period, the graves of eighteen emperors were reportedly still unknown, but by 1918 (if not sooner), every emperor in the line from the mythical Jimmu to Meiji had an officially designated grave site (Uchida 1918).

The prewar state's management of the imperial mausolea went further than just the identification of graves. These tomb mounds were transformed into sacred spaces that Japanese people were encouraged to visit in order to convey their respect and gratitude to the Imperial House and its ancestors as part of the political conduct of loyal Japanese subjects (Ueno 1921). Uchida Haikyō, for example, the author of a Taishō-period guidebook to imperial mausolea, suggested that visiting the tombs was a powerful transformative experience. Awed by the purity (*seijō*) of the tombs, visitors are returned to "pure human beings" (*junshin na ningen*) and they come to the realization that the actions and progress of the Japanese empire is centered on the "august spirits enshrined in these tombs" (Uchida 1918, 2). This new awareness, triggered by being in the presence of the tombs, also allows visitors to realize that the emperor is always at the center of Japanese history in any age. With this, they see Japanese history anew and "the facts of national history appear vividly." For Uchida, imperial tombs had the power to focus the emotional energies of Japanese citizen-subjects properly on the Imperial House; once aware of the profound debt they owed to the emperor, deep gratitude and reverence was the appropriate response. Uchida implored all national subjects to "worship at the imperial tombs nearest [to you] and ensure that there is no room for impure thoughts" (ibid., 5). Any tomb would suffice since each would be a reminder of where "the real spirit of Japanese history" was located, and it was appropriate to offer to the great spirit enshrined in the tomb one's commitment to the cause of the nation and the Imperial House. Imperial tombs then became sites for the expression of gratitude and loyalty to the emperor and his ancestors, key elements in the ideological configuration of "revering the deities and worshipping the ancestors" (*keishin sūso*) that was one of the pillars of prewar emperor-centered Japanese nationalism. In this way, the imperial tombs assumed functions akin to Shinto

shrines; indeed, in etiquette books like the 1924 volume *Sahō yogi*, worship at shrines and at imperial tombs was discussed in the same section and consisted of the same practices (Tōkyō Furitsu Dairoku Kōtō Jogakkō 1924, 49).

There was, however, a paradox in the attitude toward the imperial tombs in the prewar era. Even as texts like Uchida's were making them into highly public, visible objects in the service of the emperor-centered ideology of the state, the Imperial Household Ministry's management of these tombs as sacred sites imposed a regime of surveillance and restricted public access to them. Restriction of access and control of what could be done with lands designated as or suspected to be imperial tombs was codified as early 1874, when the Council of State (Dajōkan) issued an ordinance instructing prefectures not to "needlessly excavate" sites that might be tombs while investigations to ascertain their provenance were ongoing (Kunaishō Shoryōryō 1912, 1). These restrictions did not simply limit development of these sites. In some cases, designating sites as imperial tombs effectively limited communities' access to wood and water resources on lands that had been part of long-standing commons arrangements; in others, it entailed removing whole communities from the lands where they lived (Toike 2000, 78, 98; Takagi 2002, 113). In addition, these restrictions also hampered archaeological research, even as the field was emerging in the prewar period (Edwards 2007, 43–44). Subsequent ordinances underscored the requirement that anyone wishing to excavate mounded tombs, or inadvertently encountering one while developing land, first had to inquire with the Imperial Household Ministry and provide detailed sketches and drawings. In this way the Imperial Household Ministry consolidated its control over tomb sites while simultaneously enlisting Japanese people to contribute—whether they wanted to or not—to the accretion of knowledge that strengthened that control.

Restriction of access to kofun designated as imperial tombs remains in place to this day. In the postwar period, such tombs were classified as part of the Imperial Household's private property under the State Property Act, and the IHA is responsible for the upkeep of the sites where it conducts regular rites. The extent and solidity of the IHA's present control were illustrated in an exchange between Yoshii Hidekatsu of the Japanese Communist Party and the IHA in 2010 (Kokkai 2010a, 2010b). When Yoshii posed questions about the nature of the IHA's relationship to the tombs and access to the kofun under IHA control, the IHA in its responses revealed that its control of the sites cleaved closely to its *own* regime of knowledge and claims of truth about the tombs' occupants, a stance seemingly impervious to new research or revision.

The IHA reaffirmed that the imperial tombs and reference sites were "objects of worship and reverence for the imperial family and Japanese people" at which rites continued to be conducted. For this reason, it was of utmost importance that the "tranquility and dignity of the sites" be maintained. Responding to queries about the identity of the interred, the IHA simply acknowledged that "competing theories" on these issues existed but reasserted its position that identifications of occupants determined by the IHA were based on the *Nihon*

shoki (Chronicles of Japan, 720) or other historical documents. Barring discovery of new and "reliable" materials, the IHA would retain existing designations. Yoshii's suggestion that the management and preservation of kofun be transferred to the ACA and MEXT was simply ignored. When Yoshii asked further questions in rebuttal, the IHA was vague. It sometimes shunted a question aside as difficult to answer, sometimes replied with bare generalities, and sometimes pleaded ignorance.

Given the nature of the IHA's control of the tombs and their history of implication in the prewar emperor system, it was not surprising that criticism of the Mozu–Furuichi nomination emerged, leveled by scholars who historicize the tombs or who are insistent on adherence to modern archaeological standards in acquiring knowledge about them. These criticisms echo the Japanese Archaeological Association's (JAA) public call in 1972 for the kofun designated as imperial tombs to be brought under the Law for the Protection of Cultural Properties as a means to provide for adequate preservation of the sites as cultural properties (*bunkazai*) and to open them to academic study in recognition of their importance for archaeological exploration and historical education (Mogi 2017, 202–203). Some central themes appear in these critiques: how invented traditions can affect even relatively recent efforts to preserve and identify tombs in the late Tokugawa and early Meiji period, and how problems arise from reliance on texts like the *Nihon shoki*, *Kojiki* (Record of Ancient Matters, 712), and *Engi shiki* (Procedures of the Engi Period, 927), and on oral accounts or legends for the location of imperial graves. The historians who question the veracity of accounts of the early imperial succession, like Imao Fumiaki who sees "artificiality" (*sakui*) in the *Nihon shoki* or *Kojiki* accounts of succession until the twenty-sixth emperor Keitai, emphasize how the tombs have been politicized in the service of making ideological claims about the prewar state (Imao 2017, 27). For archaeologists, the tombs are themselves inherently legitimate objects of research, but they also want access to the mounds to test the IHA's identification of the entombed. Even those who allow that the Imperial Household Ministry made prewar designations according to the academic standards of its day find it problematic that the tomb mounds remain largely off-limits to scholars to this day and have not undergone reassessment based on postwar methods, technology, and knowledge (Ueda 2017, 125).

The question of how the tombs are labeled captures the heart of these critiques of the Mozu–Furuichi nomination. Ever since Mori Kōichi's interventions in the 1970s, the scholarly consensus has been to refer to tomb mounds by geographical names rather than by names of emperors as a reflection of scholarly uncertainty about the tombs and their occupants, instead of the IHA's system of referring to the tombs as "the mausoleum of the XX emperor." The Mozu–Furuichi nomination, however, uses the IHA-style nomenclature for the kofun. As a result, one critique, for instance, contends that the IHA's naming system "not only contradict[s] archaeological and historical knowledge acquired in the

postwar period, but actually leads to people being given false information …
[and the] liability for distorting the history of the state formation in Japan must
be constantly questioned" (Imao and Takagi 2017, xiii). For critics, this prac-
tice points uncomfortably to the continuity of elements of prewar nationalist
ideology into the present, and also weakens the academic authenticity of the
Mozu–Furuichi nomination, since these names ascribe academically unverifi-
able identities to the tombs' occupants.

Yet these critics also perceive in the process of World Heritage nomination an
opportunity for a renegotiation of these very issues. This accounts for an under-
current of hopefulness in these critiques that the Mozu–Furuichi bid would
compel changes in the IHA's management of the kofun tombs by making them
public cultural properties and opening them to research. However, Mozu–
Furuichi's progress to nomination gave little cause for optimism, for the nomin-
ation instead solidified the IHA's control of the tombs by linking the property's
uniqueness and potential as a World Heritage Site to the IHA's management
and to the kofun's relationship with the Imperial House.

In the initial proposal submitted to the ACA in 2007, Osaka Prefecture
broached the issue of the IHA's management when it discussed the property's
future administration (Osaka Prefecture et al. 2007, 40). The prefecture did not
think that the lack of protection by national legislation for some of the kofun
as cultural properties was a problem. Osaka was satisfied that the IHA had
consulted scholars and experts in its study of the tombs and had adequately
based its methods on the techniques of archaeological investigation and excava-
tion. In Osaka's view, the IHA's management of the tombs had "given attention
to and had taken the surest measures in the cultural property-sense of preserva-
tion and protection"; "from the point of view of cultural properties protection,
there was no problem" with the IHA's practices. Underscoring its approval
of the IHA's managerial regime, prefectural authorities emphasized that they
had no intention of changing the administration of these sites by, for instance,
calling for their designation as cultural properties and putting them under the
ACA's oversight (Osaka Prefecture et al. 2007, 40).

The ACA itself also played a role in de-problematizing the IHA's manage-
ment of the tombs and incorporating it into Mozu–Furuichi's bid for World
Heritage status (Bunkachō 2010). When reporting on Mozu–Furuichi's add-
ition to Japan's tentative list, the ACA suggested that, in contrast to other
monumental tomb structures already inscribed into the World Heritage List,
the tranquility and dignity of the Mozu–Furuichi tombs has been preserved as
part of a living burial tradition. Unlike the Chinese imperial tombs in Xi'an
or the pyramids in Egypt, the Mozu–Furuichi tombs continue to function as
imperial tombs, thanks to their management by the IHA. The ACA in effect
embraced both the IHA's narrative of the tombs and its management of them,
and essentially recast the IHA's definition of the kofun as imperial tombs as
a factor in Mozu–Furuichi's unique cultural value that could strengthen the
property's nomination.

Even the IHA-managed tombs' lack of status as cultural properties in domestic Japanese law, a deviation from the stipulations in the Operational Guidelines, was transmogrified into a potential strength for the nomination. To be clear, even insiders to the process like Matsuura Kōichirō, the former Director-General of UNESCO, wondered how this absence of standing in Japanese domestic law could be satisfactorily explained to an international audience (Igarashi, Iwatsuki, and Nishimura 2013, 88). But in 1998, the World Heritage Committee revised the Convention's Operational Guidelines to include "customary and/or traditional practices" as adequate arrangements for management and preservation. This change arose from Matsuura's leadership at UNESCO of efforts to diversify the World Heritage List by acknowledging the "involvement of communities and local management systems, emanating from those who live on the land" and rejecting formal legislation as the only kind of protection that satisfied the Operational Guidelines' requirements (Cameron and Rössler 2016, 93). Nishimura Yukio has offered the inscription of North Korea's Koguryŏ tombs, which include unexcavated royal tombs, as an example of the World Heritage Committee's recognition of customary management predicated on regard for the tombs' sanctity (Igarashi, Iwatsuki, and Nishimura 2013, 88). While recognizing that these revisions were directed at the preservation practices of developing countries, he asserted that it "should not be a problem" that the kofun at Mozu–Furuichi were not protected by domestic legislation if the nomination dossier could show that the "IHA has different rules which are kept to strictly" (Igarashi, Iwatsuki, and Nishimura 2013, 89). In this way, Nishimura offered a reinterpretation of the Operational Guidelines that opened a way to cast the IHA's control of imperial tombs as a form of customary preservation and management, regardless of its departure from the World Heritage Committee's initial intentions in recognizing traditional management.[9]

The IHA for its part showed cool support for Mozu–Furuichi's nomination, while conveying a firm sense of the limits to change it would permit to its current management of some of the tombs. Soon after the property was put on Japan's tentative list, for instance, an investigator from the IHA stated in a newspaper interview that the IHA did not oppose the bid as long as it did not contradict existing IHA-controlled management (*Nikkei Style* 2010). Indeed, the IHA reiterated this position after the Japanese cabinet approved the nomination of Mozu–Furuichi in 2017. In a meeting of the Committee on Budget in Japan's House of Representatives on 22 February 2017, Mozu–Furuichi's World Heritage bid came up during a discussion of the imperial family's budget. When asked for the IHA's position on this recent development, the IHA's deputy commissioner Nishimura Yasuhiko reiterated the agency's understanding of the kofun in question as imperial tombs and he reported that, in preparing for the nomination, local governments had "worked hard" (*doryoku sareta*) to ensure that the tranquility and dignity of the kofun would not be compromised (Kokkai 2017). Furthermore, the IHA had heard, he said,

from both the local government and the ACA that the nomination would not require any change to the IHA's existing management.

This exchange between the IHA and the Committee on Budget is noteworthy in two other ways. First, the IHA demonstrated its willingness to engage with scholars on the issue of access by mentioning the instances in which it had conducted joint research on certain sites with local governments and scholars, and by expressing a desire to continue this kind of cooperation. Indeed, there seems to be a modest increase in the frequency and scope of joint investigations of sites with scholars and local stakeholders. In October 2018, for instance, parts of the Daisen kofun were investigated by a team of experts from the IHA and local government personnel. The IHA is also opening its considerable archive regarding the kofun to the public by digitizing the IHA's main research bulletin, *Shoryōbu kiyō*, and making it freely accessible online (Mogi 2017).

At the same time, however, this exchange also signaled the IHA's imperviousness to any challenge to its definition of the kofun as imperial tombs. When responding to a question by a Diet member about the kofun in which he referred to three kofun by their geographical names—Nagayama, Maruhoyama, and Hakayama kofun—the head of the IHA's Archives and Mausolea Department (Kunaichō Shoryōbu) pointedly prefaced his reply by referring to the kofun with the IHA's imperial designations:

> as you have pointed out, the satellite site (*tobichi*) numbered "*to*" of the imperial burial mound of Emperor Nintoku, the so-called Nagayama kofun; the satellite site numbered "*he*" of the imperial burial mound of Emperor Nintoku, the so-called Maruhoyama kofun; and the satellite site numbered "*ho*" of the imperial burial mound of Emperor Ōjin, the so called Hakayama kofun.
>
> (Kokkai 2017)

By introducing the qualification "so-called" (*iwayuru*) when referring to the kofun's geographical names, the IHA deftly relegated the nomenclature used by academics and others to an inferior position. The performative power of this moment also lay in how the IHA publicly schooled Diet members on the "appropriate" manner of referring to the mounded tombs, an assertion of confidence in its monopolistic dominance in affairs regarding the mounded tombs.

The IHA's management of kofun has also been normalized in the course of promoting Mozu–Furuichi's bid for World Heritage status. After Mozu–Furuichi entered the tentative list in 2010, the "Conference Headquarters for the Promotion of Mozu–Furuichi Kofungun Tumulus Cluster for World Cultural Heritage Inscription" was established to shepherd the property's official nomination. In addition to working with local stakeholders and the private sector to build support for Mozu–Furuichi's bid for World Heritage status, the Conference Headquarters also oversaw preparation of the property's nomination dossier. To raise the site's profile, especially among the members of the

property's local communities, and to mobilize the entire Osaka Prefecture to rally behind the bid, the Conference Headquarters ran a broadly based, long-term public relations campaign to foster domestic and international awareness of the property. The IHA's management of some of Mozu–Furuichi's tombs was rarely, if ever, mentioned. Instead, the IHA serves as a source of knowledge about Mozu–Furuichi, for instance when representatives from the agency participate in academic symposia sponsored by the Conference Headquarters to disseminate information about the property.[10]

The degree of entrenchment and acceptance of the IHA's management of some of the kofun in the Mozu–Furuichi bid is reflected in Sakai City's website about the nomination, updated on 26 March 2018, after the nomination file had been submitted to the World Heritage Committee (Sakai City n.d.). Sakai City confirmed its approbation of the IHA's management, deferred to the IHA in "the preservation of tranquility and dignity" of the imperial mausolea, and used the IHA's names for the kofun. Sakai City defended this stance by asserting that "many different ways of thinking are available academically," a tactic emulating the IHA's rebuffing of claims that it linked tombs to emperors without hard proof. The city also explained how the IHA's management of the kofun was not necessarily incompatible with World Heritage status for Mozu–Furuichi since the World Heritage Committee emphasizes preservation rather than public access as central to inscription into the World Heritage List. This essentially removed the IHA's management of the kofun from the conversation. In the view of the local authorities, a mounded tomb remains a mounded tomb of archaeological value regardless of its occupant's identity, and uncertainty of the tomb's occupants ought not to pose any obstacle to potential inscription. This effectively cast aside scholarly and other critical objections as unnecessary distractions and as irrelevant to Mozu–Furuichi's bid to become a World Heritage site. In its last comment, Sakai City asserted that World Heritage status would connect the people of Japan in treasuring the imperial tombs and developing pride in them. This kind of rhetoric contains uncanny echoes with how the tombs were celebrated in prewar emperor-centered nationalist ideology.

Conclusion

The World Heritage Committee considered Mozu–Furuichi's nomination on 6 July 2019 during its forty-third session in Baku, Azerbaijan. Central to its deliberations were recommendations from the International Council on Monuments and Sites (ICOMOS), which conducted its on-site evaluation in September 2018. At a press conference on 18 September 2018, held to announce the completion of ICOMOS' week-long visit, the ACA was cautiously but clearly optimistic. Noting that the ICOMOS expert listened "enthusiastically" (*nesshin ni*) to explanations of the mounded tombs' state of preservation, the tombs' relationship to local communities, and Japan's kofun culture, the ACA

reported that it thought "a degree of understanding had been achieved" (*Asahi shinbun* 2018).

As it turned out, the ACA's optimism was not misplaced. ICOMOS' assessment agreed with Japan about Mozu–Furuichi's significance as cultural heritage: that the nominated kofun were distinct even among the burial mounds of East Asia, presenting as they did "exceptional testimony to the culture of the Kofun period of Japan's ancient history ... [and] the period's sociopolitical structures, social class differences and highly sophisticated funerary system" (ICOMOS 2019, 148). ICOMOS also acknowledged the significant role that the IHA played in the preservation of the kofun tombs, especially in the face of heavy pressure from urban development surrounding many of the sites. These pressures are managed through "legal restrictions applied to the components and their buffer zones." Noting that "no development or public access is permitted to the *Ryobo* (other than for the officials of the IHA and occasionally for researchers for specific purposes)," ICOMOS singled out the IHA's control of access as contributing to the tombs' preservation (ICOMOS 2019, 147). ICOMOS also registered its approval of the property's proposed management system, to be coordinated by the "Mozu-Furuichi Kofun Group World Heritage Council" made up of representatives of the IHA and local governments (ICOMOS 2019, 152).

ICOMOS' evaluation was concerned with whether Mozu-Furuichi's dossier satisfied the criteria for outstanding universal value, authenticity, and integrity. However, ICOMOS' assessment effectively naturalized the role that the IHA played in the preservation and management of some of the kofun, echoing—and in so doing, reproducing—an IHA-centered conception of the kofun as imperial mausolea. This can be seen in ICOMOS' use the IHA's labels (i.e., "Nintoku-tenno-ryo Kofun" and "the Ojin-tenno-ryo Kofun") in its description of the Daisen kofun and the Kondagobyōyama kofun. Echoes of this imperial focus also surfaced in ICOMOS' description of kofun themselves. ICOMOS wrote:

> All kofun are considered to be sacred places, particularly the *Ryobo* [the imperial tombs], placing importance on a respectful ambience and setting. Since the Meiji Period, access to the *Ryobo* has been restricted to the Imperial family and the Imperial Household Agency. The rituals conducted by the Imperial Family include the 'Shoshin-sai' (that marks the date of the death of the deceased emperor) and 'Shikinen-sai' (conducted every 100 years). Many of the *Ryobo* have facilities for worship (including *torii* gates, lanterns, stone fences and wash basins).
>
> (2019, 146)

The issue with this description is not its accuracy per se, but rather that it is a particular interpretation of the kofun that privileges their relationship to the Imperial House. It fails to indicate that the association of some kofun with

the imperial family and the construction of "facilities for worship" was the result of a relatively recent moment (dating from the late Tokugawa period), in which Japanese political actors appropriated and deployed the tombs for their own political agendas. Nor is there any mention of the fact that many of the kofun existed outside circuits of political concern and were not objects of reverence for much of their existence. Moreover, ICOMOS treats many of the very issues raised by academics who consider the IHA's continued control over the mounded tombs to be problematic as integral and natural to the tombs as objects of cultural heritage.

ICOMOS registered its awareness of the debates within Japan about the tombs' naming in its written evaluation, counselling that this issue could be addressed through interpretative strategies at the site (ICOMOS 2019, 150). However, no similar reservations were raised during the World Heritage Committee's deliberations in Baku. During the discussion of the nomination, committee members uniformly lauded Mozu–Furuichi's excellent nomination dossier and the site's impressive state of preservation. One state party referred in particular to "the tombs of the ancestors of the royal family" and made special mention to the kofun's "sacred status and the respect they are afforded."

It was surely not the World Heritage Committee's intention to enter into an existing debate in Japan about the IHA's role in postwar Japanese society, or about the continuities of Japan's prewar political structures into the present. But giving World Heritage status to a property not only supplies the World Heritage List with a new addition, but can also affect members states in ways that have little to do with the preservation of "world heritage of mankind as a whole."[11] By inscribing Mozu–Furuichi into the World Heritage List, the World Heritage Committee effectively extended international recognition to the IHA's management of this site as an integral aspect of the site's cultural value. Likely this will not silence critics who see IHA's management of kofun as problematic for the production of accurate knowledge about Japan's ancient history, but the World Heritage Committee's recognition of the IHA's role in the preservation of Japan's cultural heritage may change the way future interrogations of the IHA's role will occur. If the IHA's management is recognized internationally as a valuable mechanism for cultural preservation, then the IHA's management regime of kofun—along with the IHA's rationales for its practices—will become harder to dislodge. Taken together with Japan's decision to become involved with the preservation of World Heritage as a matter of official policy and with the example of Hiroshima Dome, Mozu–Furuichi demonstrates the politics of World Heritage from a different angle. The World Heritage Convention can, inadvertently or otherwise, become entangled in the domestic agendas of its member states in unexpected ways, and serve as a means through which states—or vested interests within those national communities—pursue ends that would otherwise be difficult to attain.

Notes

1 Japan contributed to dating archaeological finds in Ban Chiang, Thailand (1972), and to the preservation of Bagan in Burma (1978), Sukothai in Thailand, and Buddhist sites in Pakistan (1979).

2 For example:

> Working to overcome the insularity in the Japanese economy and society will obviously have considerable ramifications throughout society … However, accepting other people, products, and values is not only a Japanese responsibility in the international community but may also be said to be an indispensable prerequisite to the economic and social revitalization of Japan and hence to ensuring our medium and long-term prosperity and … enabling us to realize our rightful place in the international community.
>
> (Gaimushō 1987)

3 Takeshita introduced the notion of international cultural exchange in the following manner:

> Japan must make further efforts in the area of exchanges between diverse cultures, both in response to the heightened interest that the countries of the world are showing in Japan and to promote Japan's own internationalization. At the same time, I consider that Japan should make a positive contribution, cooperating with appropriate international organizations, to the preservation of the cultural heritage of mankind and the promotion of culture.
>
> (Takeshita 1988)

4 In July 2019, the Agency for Cultural Affairs announced its decision to nominate the "Jōmon Archaeological Sites in Hokkaido and Northern Tohoku" for inclusion in the World Heritage List in 2021.

5 These were the Tomioka Silk Mill and Related Sites; Mt. Fuji; Asuka-Fujiwara: Japan's Ancient Capitals and Related Properties; and the Hidden Christian Sites in the Nagasaki Region.

6 Events soon after proved Japan right about the difficulties of the process. In 2007–2008, Japan encountered pushback from the system when ICOMOS recommended to defer inscription for its nominations—the Iwami silver mines and Hiraizumi—in both years. In both instances, ICOMOS found that the properties did not adequately meet the standards of OUV in the criteria under which Japan had nominated them and raised questions about how well both properties satisfied the standards for authenticity. ICOMOS further found that Hiraizumi's comparative analysis failed to justify its inscription into the list. The World Heritage Committee overruled ICOMOS' recommendation regarding the Iwami mines at its annual meeting in 2007 after Japan submitted additional information, but Hiraizumi did not enjoy a similar reversal of fortunes. Hiraizumi was eventually inscribed into the World Heritage List in 2011 after submitting a significantly revised nomination dossier. In 2013, ICOMOS recommended that Kamakura "not [be] inscribed" into the World Heritage List, a reflection of ICOMOS' conclusion that the property was not of outstanding universal value.

7 The reality is more complicated. The spread of economic effects based on visitor numbers is uneven, with the more recently inscribed properties lagging in visitor numbers (Chiba 2014; NHK 2017; see also the chapter by Aike Rots in this volume).

8 For instance, Sakai City received a grant-in-aid in 2017 for a project to enhance visitor support services and facilities for the area around the Mozu tumulus clusters (Naikakufu Chihō Sōsei Suishin Jimukyoku 2017). Likewise, Isezaki City, Munakata City, and Nara, Aomori, and Wakayama Prefectures have also acquired grants for World Heritage-related projects as "regional regeneration plans" (*chiiki saisei keikaku*).

9 Without access to the nomination file, it is impossible to know how Japan explained the IHA's role in the management of the property. According to an email response from Conference Headquarters for the Promotion of Mozu–Furuichi Kofungun Tumulus Cluster for World Cultural Heritage Inscription, the ACA intended to post the nomination dossier on its website, but ICOMOS asked the ACA to limit public access to the dossier while assessments of the property were still ongoing. Direct communication by email, 22 October 2018.

10 For example, representatives of the IHA presented research and participated in the panel discussion at a symposium, "The significance and aim of inscription as a World Heritage Site," organized by the Conference Headquarters on 14 May 2017.

11 This is a point that James Hevia (2001) made powerfully in his examination of the impact of World Heritage status for sites in Chengde and Chinese discussions of its national culture.

References

Akagawa, Natsuko. 2014. *Heritage Conservation and Japan's Cultural Diplomacy: Heritage, National Identity and National Interest.* Abingdon: Routledge.

Akagawa, Natsuko. 2016. "Japan and the Rise of Heritage in Cultural Diplomacy: Where Are We Heading?" *Future Anterior* 13 (1): 124–139.

Asahi shinbun. 2018. "ICOMOS Kofungun shisatsu shūryō." 19 September 2018.

Bunkachō. 2008a. *Waga kuni no sekai isan zantei ichiran hyō e no bunka shisan no tsuika kisai ni kakaru chōsa shingi no kekka ni tsuite.* Accessed 10 February 2019, www.bunka.go.jp/seisaku/bunkashingikai/bunkazai/sekaitokubetsu/shingi_kekka/index.html.

Bunkachō. 2008b. *Besshi 7 sekai isan zantei ichiranhyō kisai bunka shisan.* Accessed 10 February 2019, www.bunka.go.jp/seisaku/bunkashingikai/bunkazai/sekaitokubetsu/shingi_kekka/besshi_7.html.

Bunkachō. 2010. *"Mozu Furuichi kofun gun" zantei ichiranhyō kosshi.* Accessed 10 February 2019, www.bunka.go.jp/seisaku/bunkashingikai/bunkazai/sekaitokubetsu/20/pdf/shiryo_4.pdf.

Bunkachō. 2017. *Maizō bunkazai kankei tōkei shiryō.* Accessed 10 February 2019, www.bunka.go.jp/seisaku/bunkazai/shokai/pdf/h29_03_maizotokei.pdf.

Cameron, Christina, and Mechtild Rössler. 2016. *Many Voices, One Vision: The Early Years of the World Heritage Convention.* Abingdon: Routledge.

Chiba Akihito. 2014. "Sekai isan to chiiki keizai: Hiraizumi no kankō machizukuri o taishō to shite." *Keizai chiri gakunen hō* 60 (2): 137–145.

Chiiki Kasseika Tōgō Honbu Kaigō. 2007. *Chihō saisei senryaku.* Accessed 10 February 2019, www.kantei.go.jp/jp/kakugikettei/2008/1219tihousaisei.pdf.

Edwards, Walter. 2000. "Contested Access: The Imperial Tombs in the Postwar Period." *Journal of Japanese Studies* 26 (2): 371–392.

Edwards, Walter. 2007. "Japanese Archaeology and Cultural Properties Management: Prewar Ideology and Postwar Legacies." In *A Companion to the Anthropology of Japan*, edited by Jennifer Robertson, 36–49. Malden, MA: Blackwell.

Gaimushō. 1957. *Waga gaikō no kinkyō.* Accessed 10 February 2019, www.mofa.go.jp/mofaj/gaiko/bluebook/1957/s32-contents.htm.

Gaimushō. 1960. *Kokusai bunka no kōryū.* Accessed 10 February 2019, www.mofa.go.jp/mofaj/gaiko/bluebook/1960/s35-2-6.htm.

Gaimushō. 1971. *Diplomatic Bluebook for 1971.* Accessed 10 February 2019, www.mofa.go.jp/policy/other/bluebook/1971/1971-contents.htm.

Gaimushō. 1987. Diplomatic Bluebook for April 1986 to March 1987. Accessed 10 February 2019,www.mofa.go.jp/policy/other/bluebook/1987/1987-contents.htm

Hevia, James. 2001. "World Heritage, National Culture, and the Restoration of Chengde." Positions: East Asia Cultures Critique 9 (1): 219–243.

Hirano Ken'ichirō. 1985. "Sengo Nihon gaikō ni okeru 'bunka.'" In *Sengo Nihon no taigai seisaku: Kokusai kankei no hen'yō to Nihon no yakuwari*, edited by Watanabe Akio, 339–366. Tokyo: Yūhikaku.

Hiraoka Takashi. 1998. "Genbaku dōmu hatsu sekai e no messēji." *Hiroshima Yunesuko*, 5 January 1998.

ICOMOS. 2019. *Evaluations of Nominations of Cultural and Mixed Properties. ICOMOS report for the World Heritage Committee 43rd ordinary sessions, Baku, 30 June – 10 July 2019.* Paris: ICOMOS International Secretariat. https://whc.unesco.org/archive/2019/whc19-43com-inf8B1-en.pdf.

Igarashi Takayoshi, Iwatsuki Kunio, and Nishimura Kunio. 2013. *Kofun bunka no kirameki: Mozu furuichi kofungun o sekai isan ni.* Tokyo: Bukkuendo.

Imao Fumiaki. 2017. "Tennōryō kofun o dono yō ni yobu ka: Mori Kōichi no kiseki to senkuteki yakuwari." In *Sekai isan to tennōryō kofun o tou*, edited by Imao Fumiaki and Takagi Hiroshi, 3–29. Kyoto: Shibunkaku Shuppan.

Imao Fumiaki, and Takagi Hiroshi, eds. 2017. *Sekai isan to tennōryō kofun o tou.* Kyoto: Shibunkaku Shuppan.

Kankōchō. 2007. *Kankō rikkoku suishin kihon keikaku.* Accessed 10 February 2019, www.mlit.go.jp/kisha/kisha07/01/010629_3/01.pdf.

Kankōchō. n.d. *Sekai isan samitto.* Accessed 10 February 2019, www.mlit.go.jp/kankocho/page05_000075.html.

Kokkai. 1947. *Minutes to House of Representatives ordinary session.* 1 July 1947. Accessed 10 January 2020, https://kokkai.ndl.go.jp/minutes/api/v1/detailPDF/img/100105254X00819470701

Kokkai. 1992. *Minutes to House of Representatives Committee on Foreign Affairs meeting.* 26 May 1992. Accessed 10 February 2019, http://kokkai.ndl.go.jp/SENTAKU/sangiin/123/1110/12306181110010.pdf.

Kokkai. 1994a. *Minutes to House of Councilors Committee on Education meeting.* 20 June 1994. Accessed 10 February 2019, http://kokkai.ndl.go.jp/SENTAKU/sangiin/129/1170/12906201170004.pdf.

Kokkai. 1994b. *Minutes to House of Representatives ordinary session.* 20 July 1994. Accessed 10 February 2019, http://kokkai.ndl.go.jp/SENTAKU/syugiin/130/0001/13007200001002.pdf.

Kokkai. 1994c. *Minutes to House of Councilors ordinary session.* 22 July 1994. Accessed 10 February 2019, http://kokkai.ndl.go.jp/SENTAKU/sangiin/130/0010/13007220010003.pdf.

Kokkai. 2010a. *Kunaichō ni kanri sareta kofun no saishi to chōsa ni kansuru shitsumon shuisho.* 3 June 2010. Accessed 10 February 2019, www.shugiin.go.jp/internet/itdb_shitsumon.nsf/html/shitsumon/a174535.htm.

Kokkai. 2010b. *Kunaichō ni kanri sareta kofun no saishi to chōsa ni kansuru shitsumon shuisho.* 4 August 2010. Accessed 10 February 2019, www.shugiin.go.jp/internet/itdb_ shitsumon.nsf/html/shitsumon/a174585.htm.

Kokkai. 2017. *Minutes to House of Representatives Committee on Budget meeting.* 22 February 2017. Accessed 10 February 2019, http://kokkai.ndl.go.jp/SENTAKU/ syugiin/193/0031/19302220031001.pdf.

Kunaishō Shoryōryō, ed. 1912. *Kofun oyobi maizōbutsu ni kansuru sho kitei.* Tokyo: Kunaishō Shoryōryō.

Kunaichō. n.d. "Ryōbo." Accessed 10 February 2019, www.kunaicho.go.jp/about/ shisetsu/others/ryobo.html.

Loo, Tze M. 2017. "Escaping its Past: Recasting the Grand Shrine of Ise." *Inter-Asia Cultural Studies* 11 (3), 375–392.

Matsumura Masayoshi. 1996. *Kokusai kōryūshi: Kingendai no Nihon.* Tokyo: Chijinkan.

Meskell, Lynn. 2013. "UNESCO's World Heritage Convention at 40: Challenging the Economic and Political Order of International Heritage Conservation." *Current Anthropology* 54 (4), 483–494.

Mogi Masahiro. 2017. "Ryōbo kōkai undō to kongo no arikata." In *Sekai isan to tennōryō kofun o tou,* edited by Imao Fumiaki and Takagi Hiroshi, 201–236. Kyoto: Shibunkaku Shuppan.

Monbukagakushō. 2006. "Heisei 18nen 9gatsu 15nichi daijin kaiken gaiyō." Accessed 10 February 2019, www.mext.go.jp/b_menu/daijin/06091906.htm.

Murakami, Yasusuke, and Yutaka Kosai, eds. 1986. *Japan in the Global Community: Its Role and Contribution on the Eve of the 21st Century.* Tokyo: University of Tokyo Press.

Naikakufu Chihō Sōsei Suishin Jimukyoku. 2017. "Mozu kofungun shūhen chiiki no omotenashi kankyō no sōshutsu." Accessed 10 February 2019. www.kantei.go.jp/jp/ singi/tiiki/tiikisaisei/dai44nintei/plan/047.pdf.

Nikkei Style. 2010. "Kunaichō chōsakan ga akasu '896 no seiiki' tennōryō no shinjitsu." 27 November 2010. Accessed 10 February 2019, https://style.nikkei.com/article/ DGXBZO18843180V21C10A1000000.

NHK. 2017. "Sekai isan risō to genjitsu ga kairi suru riyū." 4 October 2017. Accessed 10 February 2019, www.nhk.or.jp/ohayou/digest/2017/10/1004.html.

Ogura Kazuo. 2010. *Nihon no bunka gaikō.* Tokyo: Kokusai Kōryu Kikin.

Osaka Prefecture, Sakai City, Habikino City, and Fujiidera City. 2007. "Sekai isan zantei ichiranhyō kisai shisan kōho teiansho Mozu Furuichi kofungun: Nintoku-ryō kofun o hajime to suru kyodai kofungun." Accessed 10 February 2019, www.pref.osaka. lg.jp/bunkazaihogo/bunkazai/teiansyo.html.

Sakai City. n.d. "Sekai isan tōroku ni kan suru Q&A." Accessed 10 February 2019, www. city.sakai.lg.jp/kanko/rekishi/sei/sekaiisanQA.html.

Siemons, Mark, and William Underwood. 2015. "Island of Horror: Gunkanjima and Japan's Quest for UNESCO World Heritage Status." *The Asia-Pacific Journal: Japan Focus* 13 (26/3): 1–5. https://apjjf.org/Mark-Siemons/4333.html

Sōgō Kenkyū Kaihatsu Kikō. 1995. *Bunka kyōroku ni okeru minzoku to kokka.* Tokyo: Sōgō Kenkyū Kaihatsu Kikō.

Sōrifu. 1988. "Kokusai bunka kōryū ni kansuru kondankai (chūkan hōkoku)." *Toki no ugoki* 32 (16): 83–87.

Sōrifu. 1990. "Chiikibetsu kunibetsu bunka kōryū no suishin." *Toki no ugoki* 34 (1), 80–95.

Takagi Hiroshi. 2002. "Kindai ni okeru shinwateki kodai no sōzo: Unebiyama, Jinmu ryō, Kashihara Jingū san'i ittai no Jinmu 'seiseki'." In *Bunkazai to kindai Nihon*, edited by Suzuki Ryō and Takagi Hiroshi, 111–142. Tokyo: Yamakawa Shuppansha.

Takagi Hiroshi. 2010. *Ryōbo to bunkazai no kindai*. Tokyo: Yamakawa Shuppansha.

Takagi Hiroshi and Yamada Kunikazu. 2010. *Rekishi no naka no tennōryō*. Kyoto: Shibunkaku Shuppan.

Takeshita, Noboru. 1988. "Statement by Prime Minister Takeshita on the Occasion of the Luncheon Given by the Rt. Hon. the Lord Mayor and the Corporation of London at the Mansion House." Accessed 10 February 2019, www.mofa.go.jp/policy/other/bluebook/1988/1988-appendix-2.htm.

Takazane, Yasunori. 2015. "Should 'Gunkanjima' Be a World Heritage Site? The Forgotten Scars of Korean Forced Labor." Translated and introduced by Tze M. Loo. *Asia-Pacific Journal: Japan Focus* 13 (28/1): 1–7. https://apjjf.org/2015/13/28/Takazane-Yasunori/4340.html

Toike Noboru. 2000. *Tennōryō no kindaishi*. Tokyo: Yoshikawa Kōbunkan.

Toike Noboru. 2005. *Bunkyū sanryōzu*. Tokyo: Shin Jinbutsu Ōraisha.

Toike Noboru. 2007. *Tennōryō ron: seiiki ka bunkazai ka*. Tokyo: Shin Jinbutsu Ōraisha.

Tōkyō Furitsu Dairoku Kōtō Jogakkō. 1924. *Sahō yogi*. Tokyo: Tōkyō Furitsu Dairoku Kōtō Jogakkō.

Ueda Hisao. 2017. "Dare ga ryōbo o kimeta no ka: Bakumatsu Meiji ki no ryōbo kōshō no jittai." In *Sekai isan to tennōryō kofun o tou*, edited by Imao Fumiaki and Takagi Hiroshi, 109–127. Kyoto: Shibunkaku Shuppan.

Uchida Haikyō. 1918. *Kōryō sanpai no shiori*. Osaka: Nihon Jitsugyō Shinbunsha.

Ueno Takejirō. 1921. *Sanryō yōhaichō*. Tokyo: Sanryō Sūkeikai.

Underwood, William. 2015. "History in a Box: UNESCO and the Framing of Japan's Meiji Era." *Asia-Pacific Journal: Japan Focus* 13 (26/2): 1–14. https://apjjf.org/William-Underwood/4332.html

UNESCO. 1972. "Convention Concerning the Protection of the World Cultural and Natural Heritage." Accessed 5 August 2019, https://whc.unesco.org/archive/convention-en.pdf.

UNESCO. 1996. "World Heritage Committee: Report of the 20th Session, Merida 1996." Accessed 10 February 2019, http://whc.unesco.org/archive/repco96x.htm#annex5.

Zwigenberg, Ran. 2014. *Hiroshima: The Origins of Global Memory Culture*. Cambridge: Cambridge University Press.

Chapter 3

An introduction to multilateral heritage politics

Japan and the World Heritage Convention

Herdis Hølleland

Introduction

Japan formally joined UNESCO in 1951 (Saikawa 2016), and was among the states that adopted UNESCO's *Convention concerning the protection of the world cultural and natural heritage* (henceforth the Convention) during the General Conference in 1972. However, it took another twenty years for Japan to ratify the Convention. Becoming a state party to the Convention in 1992, Japan entered the World Heritage arena as the Convention embarked on its third decade of operation. Moreover, Japan joined at a point in time when the Convention was ripe for reform: the biases of the World Heritage List were becoming increasingly evident, and the criteria used to determine the so-called "outstanding universal value(s)" were up for debate, as was the notion of authenticity (e.g., Cleere 2001; Beazley 2006; Labadi 2007; Cameron and Rössler 2013; Gfeller 2013, 2015, 2017; Hølleland 2013). This context of reform is central for understanding Japan's swift rise within the international heritage community. In the early 1990s heritage professionals from state parties, the official advisory bodies of ICCROM, ICOMOS and IUCN, and the new World Heritage Centre all recognised the need to look beyond Europe in order to broaden the scope of the Convention. Consequently, there was an opportunity for Japan to take an active role from the very beginning. As will be discussed, Japan grasped the opportunity to serve the international heritage community, providing international resolutions that simultaneously served Japan's self-interest.

The aim of this chapter is to situate the state party of Japan within the international context of the Convention. It draws on the extensive body of existing research on this Convention, and uses the statutory records and audio-visual material available on UNESCO's webpages as primary sources. In terms of structure, the chapter starts with an introduction to the Convention and the legal backdrop for the *Intergovernmental committee for the protection of the world cultural and natural heritage* (henceforth the World Heritage Committee or just the Committee). This is followed by a brief overview of Japan's entry into the international World Heritage arena, i.e., Japan's ratification, its early World

Heritage initiatives, and its entrance into the World Heritage Committee. The following sections examine how Japan's tenures on the Committee fit with general trends identified in Committee research, including patterns of nominations and delegation composition. While Japan, internationally, largely comes across as an exemplary player that plays by the rules, there are certainly nominations that have caused international tensions. These are sites where Japan's history intersects with that of other nations, in particular sites related to the colonial period and World War II (see also Loo in this volume). Moving on from the Committee analysis, the final section draws attention to how international relations came to the fore in the nomination of "Sites of Japan's Meiji Industrial Revolution: Iron and Steel, Shipbuilding and Coal Mining" and how this nomination may signal a shift in how Japan uses the Convention to frame itself internationally.

Introducing the World Heritage Convention and its Committee

Adopted at UNESCO's General Conference in 1972, the World Heritage Convention was born out of a growing concern for the pressures heritage sites faced in the mid-twentieth century, highlighting how threats were increasingly caused by social and economic conditions (UNESCO 1972, preamble). In order to ensure the protection of heritage sites of "outstanding universal value,"[1] the Convention notes that states are responsible for putting forward nominations of sites to be added to World Heritage List. However, while individual states select what sites to nominate for World Heritage listing, it is up to the World Heritage Committee to decide which sites may be listed on the World Heritage List and the List of World Heritage in Danger (UNESCO 1972, article 11). Additionally, the Committee establishes its smaller Bureau,[2] it administers the requests to the World Heritage Fund, and it follows up the so-called state of conservation reports of World Heritage Sites.[3] Thus, it is the Committee that is the governing body of the Convention; neither UNESCO nor the advisory bodies make any of the decisions regarding Convention matters. The World Heritage Centre, based at UNESCO's headquarters in Paris, serves as the Committee's secretariat and the advisory bodies are to provide scientific advice, on, for example, nominations that the Committee is to act on.

Articles 8–14 of the Convention describe how the Committee is to be composed and run. In addition to the Convention text, the World Heritage Committee follows the frequently updated Operational Guidelines' part I.E (UNESCO 2017), and has its own rules of procedure, which also are updated on a semi-regular basis (UNESCO 2015b). The Committee consists of twenty-one members, elected every other year during UNESCO's General Conference. In order to ensure equitable representation and rotation on the Committee, states now normally sit for four rather than six years. Consequently, half the Committee members are replaced biannually.

Furthermore, while article 8.2 states that elections are to ensure an equitable representation of the different regions and cultures of the world, the World Heritage Committee has not followed UNESCO's region-based electoral system. The World Heritage Committee is supposed to be a committee of experts, and was originally set up to have representatives based on their expertise rather than regional grouping (Meskell, Liuzza, and Brown 2015). This principle is expressed in article 9.3, which highlights that states are "to choose as their representatives, persons qualified in the field of the natural or cultural heritage." This has over the years caused a lot of tension and debate and not least very long election processes, as a two-thirds majority is needed for states to be elected. Thus, elections in the past could take several rounds, hours and even days (e.g., Musitelli 2002; Strasser 2002; Cameron and Rössler 2013; Meskell, Liuzza, and Brown 2015; Hølleland and Phelps 2019). This has since changed; in 2014 a new regional election system, with only a smaller number of seats up for open elections, was introduced at the very first extraordinary session of the General Assembly (UNESCO 2014). Structured around the issue of just geographical representation, these internal debates highlight how the Convention operates within the logics of international relations, thereby exposing the shortcomings of viewing World Heritage as a field largely dominated by heritage experts and expertise (as assumed by Smith 2006, for instance; see also Meskell 2012, for a similar point). Rather, research on the Committee has illustrated how heritage expertise is but one form of expertise needed to navigate and make an impact on the World Heritage arena. In the rush to inscribe and in the battles over In Danger listings, states' political and economic inter-state relations, legal and procedural knowledge and negotiation skills are equally, indeed often more, important than the heritage arguments put forward (e.g., Meskell 2012, 2018; James 2016; James and Winter 2017; Hølleland, Hamman, and Phelps 2019; Hølleland and Skrede 2019). As such, it is also important to take note of the composition of state delegations and identify potential shifts over time.

The legal backdrop of the Convention provides a description of how things are to be. The Committee should be composed of experts who act on the advice of the advisory bodies, which also consist of experts. Yet as this brief overview of the formalities shows, the set-up is not static, and the Committee does not act in a vacuum. Rather, the Committee's actions are often convoluted, due to internal traditions as well as inter- and intrastate relations quite unrelated to the field of heritage. The latter relates to the important fact that the Committee is intergovernmental: it consists of state representatives. States are the crux, but seemingly also the curse of the Convention (e.g., Musitelli 2002; Strasser 2002; Askew 2010; Jokilehto 2011; Meskell 2014; Meskell et al. 2015; Hølleland and Phelps 2019). Despite being a relative latecomer to the Convention, Japan provides a good case for exploring how states can become the agenda-setters for reform by balancing national interests and international concerns.

Japan's entry onto the international World Heritage stage

Scholars have offered different explanations for Japan's late ratification. Some draw attention to contextual issues related to World Heritage, such as:

1. The intrastate controversies surrounding the nomination of the Hiroshima Peace Memorial in the mid-1980s

 With the Japanese Communist Party lobbying to have the Hiroshima Peace Memorial nominated as a World Heritage site, the Ministry of Foreign Affairs kept ratification at bay, fearing that this nomination would sour relations with the United States—which it later did. The latter did not, however, stop the memorial from being listed in 1996 (Beazley 2010; Gfeller 2017, 767).
2. Showcase solidary toward the US and UK

 As Loo (in this volume) notes, the late ratification can also be read as Japan showing solidarity towards the US and the UK following both states' withdrawal from UNESCO in the 1980s.
3. The World Heritage Fund

 As has been the case in several other nations, contributions to the World Heritage Fund were a concern. In Japan this played out as an intrastate battle over whether its Ministry of Foreign Affairs, Agency for Cultural Affairs, or Environment Agency was to pick up the bill upon accession (Nishiyama 2015, 90; Gfeller 2017, 767).[4]
4. Negotiating national and international legislation

 As Loo (this volume) also points out, the Takeshita government's official argument for the delay was that it was due to the difficulty of settling on how an international convention could function alongside Japan's pre-existing national legislation.[5]

Japan's ratification must also be seen as part and parcel of its shifting foreign policy. Following World War II, the notion of Japan as a "nation of culture" was being coined nationally and cultural exchange programs were being launched as a means to restore Japan's war-torn international image. This strategy was further strengthened in the 1980s when Japan set out to redefine its role in the international community, in response to international criticism of insularity and a lack of willingness to take an active role internationally. Having become one of the world's leading economic powers, Japan was encouraged by the international community to develop greater tolerance towards other cultures by developing a stronger position in securing global welfare. Japan's resolution was to promote cultural exchange and focus attention on the preservation of the world's cultures (see Loo this volume). As acquiring soft power became an increasingly important avenue for Japan's international activities in the 1990s, cultural heritage outreach became a cornerstone of its foreign relations

policy. Rebranding itself as a cultural and peaceful nation, Japan saw the World Heritage Convention as a useful stepping stone to enter and gradually take a leading role in the international heritage community (Akagawa 2015, 2016a; Gfeller 2017, 766–767).

Yet in order to make its mark on the international stage, Japan saw the need to extend one of the key concepts of the Convention: authenticity. In Europe there is a long tradition for material authenticity to be given weight over form: the original materials of, for example, buildings are given priority in heritage conservation. Furthermore, the evolution of authenticity is prioritised; in addition to the original building, any later modifications are also to be preserved. In Japan, on the other hand, form and style have tended to trump material authenticity. This is partly a reflection of the fact that many of Japan's historic buildings are made of wood. As an ephemeral material, vulnerable to fire and fungal and insect attacks, wood decays more quickly and is more diffi-cult to preserve than stone. In Japan this challenge has led to a practice whereby damaged wooden buildings are partly reconstructed and the wooden elements of standing buildings are replaced at (ir)regular intervals, in order to preserve the original form of the building (Larsen 1994). Acutely aware that Japan's con-servation practices were at odds with the European principles underscoring the Convention, Japanese heritage specialists feared their wooden heritage would fall short in a Europe-biased conservation environment dominated by stone and mortar. They were concerned that potential World Heritage Sites would fail to meet the "test of authenticity" and be deemed "inauthentic," preventing Japanese heritage from being internationally recognised (e.g., Stovel 2008, 9; Akagawa 2015, 69–70, 2016b; Gfeller 2017). Thus, Japan took on the role of an assistant reformer when the opportunity presented itself shortly after its ratifi-cation. Japan's role of reformer went hand in hand with its own aspirations for recognition, and is worth exploring in further detail.

The very first World Heritage Committee session Japan attended as signatory, held in Santa Fe, New Mexico (USA) in December 1992, captures the spirit of the time. A new category of cultural landscapes was introduced and, more importantly from a Japanese angle, the Committee decided to undertake a crit-ical evaluation of "the criteria governing the cultural heritage and the criteria governing authenticity and integrity, with a view of their possible revision" (UNESCO 1992, recommendation 19). This latter decision enabled Japan to fully enter the international World Heritage arena. The origins of the initiative have, however, longer routes that need to be spelt out briefly. Since the 1980s, the issues of authenticity and wood conservation had developed in tandem. The field of wood conservation had become one where the advisory bodies of ICOMOS and ICCROM, and UNESCO as well, could move away from the conservation centre of Rome; meetings and courses were held in states rich in "wooden heritage," such as Norway and Canada (Gfeller 2017; Hølleland and Phelps 2019). By the early 1990s, the president of ICOMOS, Roland

Silva, encouraged ICOMOS' International Wood Conservation Committee to move completely outside of Europe and North America, with the result that its eighth meeting was held in Nepal in November 1992 (just ahead of the 1992 World Heritage session), financed by one of the dominant nations of wood conservation, Norway (Larsen and Marstein 1994). This meeting proved pivotal for Japan's involvement, as the Japanese head of the Cultural Heritage Division at UNESCO, Noguchi Hideo, argued for the need to develop measures for wood conservation and launched the idea of a conference to be held in 1994–1995 (Noguchi 1994). One is very much reminded of Noguchi's Japanese background and the Japanese concerns about authenticity. Noguchi insisted on freely expressing his "personal opinions which do not necessarily reflect those of the Organization [i.e., UNESCO]" in order to secure professionally productive discussions, and raised the question of whether the Venice Charter's article 7, banning "the moving of all or part of a monument," could not "be justified in many cases" (Noguchi 1994, 15–16).

The re-evaluation of the notion of authenticity was followed up at a Bureau meeting in June 1993 where the Secretary General of ICOMOS, Canadian Herb Stovel, argued for the usefulness of hosting a series of meetings on authenticity. This was also prompted by his recent visit to Japan's governmental Agency for Cultural Affairs (ACA), where he had proposed that ACA host a colloquium on authenticity and the Convention. However, due to something as prosaic as different funding cycles, it was resolved that the first meeting was to be hosted in early 1994 in Norway, co-funded by Canada and Norway, followed by the colloquium in Japan in late 1994 (Lunde 1994). An alliance between Canada, Norway, and Japan was nurtured through the 1994 meetings on authenticity. These meetings strengthened the already strong ties between the Norwegian architect Knut Einar Larsen and Japanese conservation expert Itō Nobuo, and enabled Larsen to become an international spokesperson for Japanese approaches to conservation. Moreover, Herb Stovel was central in the preparatory stages for the meeting and not least in engineering its outcome, the Nara Document on Authenticity (Gfeller 2017). Noting that "[a]ll cultures and societies are rooted in the particular forms and means of tangible and intangible expression which constitute their heritage, and these should be respected" (ICOMOS 1994, item 7), the document acknowledges the culture-specific nature of the concept of authenticity. The document was critical because it opened up for cultural relativism to coexist alongside the universalism that guides the World Heritage Convention (Larsen 1995, xiii; Stovel 2008). The fact that the meeting was hosted outside Europe, and that the document was named after its location, Nara, gave international weight to the document, and a status as an international change-maker to Japan.

Moreover, Japan's willingness to shoulder responsibilities for the international heritage community by hosting the Nara conference was essential for its election on the World Heritage Committee in October 1993. One can argue

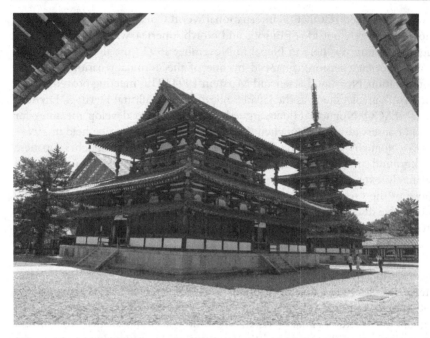

Figure 3.1 Hōryūji temple in Nara, one of Japan's first World Heritage Sites, inscribed in 1993. A year later, the groundbreaking Nara Document on Authenticity was produced in this city. Photo credit: Aike P. Rots.

that the very promise of the Nara conference served as a "status enhancing event" for Japan (Leira 2015, 35; Hølleland and Phelps 2019). It showcased that Japan was ready and willing to take on international tasks, enabling the country to be elected onto the World Heritage Committee, while the other conference organisers and committee candidates, Norway and Canada, failed to do the same (UNESCO 1993). The combination of the election to the World Heritage Committee and the Nara conference kick-started Japan's World Heritage involvement, and enabled it to have an immediate impact by helping to address older contentious issues facing the international heritage community while balancing this with its own interests. The following sections aim to situate some of Japan's later patterns of practice on the World Heritage Committee, by drawing on the growing body of research literature on the Committee and the statutory records from the Committee sessions.

Patterns of Committee practice

Academic interest in the World Heritage Committee has expanded tremendously since 2010, and recent research includes ethnographic accounts of the Committee as well as aggregated, quantitative studies that track developments

over time, drawing on the statutory records of the Committee.[6] Taken together, this research has identified several trends, and serves as a basis for drawing comparative light to Japan's Committee tenures from 1992 to 2017.

Committee tenures and patterns of World Heritage nominations

One of the patterns exposed through an aggregated study of the relationship between the Committee tenures and nominations between 1980 and 2006 is that states that were on the Committee on average put forward more nominations than those that were not (e.g., Bertacchini and Saccone 2012, 333). Consequently, being on the Committee increases the likelihood of having sites inscribed on the World Heritage List—partly because of the higher number of nominations, but also because Committee members have a lobbying advantage compared to states that are not on the Committee (e.g., Meskell et al. 2015). The opposite is the case with regards to the List of World Heritage in Danger; sites are more commonly listed on the In Danger List when states are not represented on the committee (Hølleland, Hamman, and Phelps 2019). How does Japan fit into this pattern?

Since its ratification, Japan has served three terms on the Committee; first from 1993 to 1999, then from 2003 to 2007, and lastly from 2011 to 2015. That is, Japan has held a position on the Committee for fourteen of the twenty-eight years since ratification. This is considerably more than most states and creates a bias. In total Japan has twenty-three World Heritage Sites, with on average almost one listing per year. Regarding the timing of the nominations, Japan has followed the pattern identified earlier: 86 percent of the sites have been nominated when Japan has held a seat on the Committee. This places Japan among the top ten countries for correlation between Committee tenure and nominations (Roders and Grigolon 2015, 57–58). Roders and Grigolon (2015, 58) also explore tendencies over time, divided per decade: The global average correlation between tenures and nominations is 26 percent for 1984–1993, 32 percent for 1994–2003 and 21 percent for 2004–2014. For Japan the figures are: 24 percent for 1984–1993, 35 percent for 1994–2003 and 41 percent for 2004–2014. Hence, Japan nearly meets the average for the first decade and exceeds the global average for two latter periods.

Leaving the decennial analysis aside and focusing only on tenures, the high concordance between nominated sites and committee tenures is clearly linked to Japan's first tenure on the Committee. During its first tenure almost half of Japan's World Heritage Sites were listed. It should be noted that this was possible because at the time there was no restriction on how many sites a state could nominate per year. Aimed at ensuring a more representative World Heritage List while also creating a manageable workload for the Committee, the advisory bodies and the World Heritage Centre, the

so-called Cairns decision of 2000 introduced ceilings for the number of nominations per session and nominations per state party per year (UNESCO 2000). This meant that as a state party with numerous sites on the World Heritage List, Japan could no longer put forward an unlimited number of nominations, but was restricted to two nominations per year, provided one was a natural site and the other a cultural landscape (UNESCO 2017, paragraph 61).[7] This is reflected in Japan's nomination patterns after 2000, where a maximum of only one nomination has been put forward per year, with the exception of 2006, when one cultural site and one cultural landscape were put forward. Indeed, the timing of Japan's nominations also reflects the shift in priorities following the Cairns decision. Whereas wooden architecture, in particular temples, dominated before 2000, a new diversity of sites representing "un- or less represented categories" such as industrial heritage, modern architecture and sacred landscapes have characterised Japan's post-2000 nominations (UNESCO 2000, 2018b). Putting forward nominations that comply with new focus areas, Japan comes across as an "exemplary" nominator which structures nominations to fill identified "gaps" of the World Heritage List. Moreover, as it has never had any sites listed on the List of World Heritage in Danger, Japan also prides itself as a state with excellent preservation policies. All in all, Japan comes across as a state that seeks recognition internationally by "playing by the rules" rather than engaging in excessive political pacting.

Sidelining the advisory bodies and upgrading nominations

Another pattern that has invited increasing scrutiny is the Committee's tendency to sideline the recommendations of the advisory bodies. This is generally explained as a result of the "increased politicization" of the World Heritage Committee in the last decade (e.g., Hølleland 2015; Meskell et al. 2015; Bertacchini et al. 2016).

Addressing the extent to which the Japanese nominations form part of this practice requires an explanation of the different recommendations that nominations can receive. All nominations are evaluated by the advisory bodies, the recommendations of which are drawn up by the World Heritage Centre as draft-decisions for the World Heritage Committee to consider and act upon. In short, there are four possible outcomes of nominations:

1. *Inscribe* means that a nomination merits inscription, and the site is most commonly inscribed without further delays.
2. *Refer* means that a nomination is sent back to the state for minor revisions, to be returned within a given time frame.
3. *Defer* means that a nomination is sent back for major revisions. This is a polite way of requesting a complete revision, without a time limit. When resubmitted, the nomination is evaluated afresh.

4. *Not inscribe* means that the proposed site is not seen as meeting the criteria
 for outstanding universal value(s). If the decision of "not inscribed" stands,
 the site cannot be nominated again.

In addition to these alternatives, a fifth outcome is that states *withdraw* proper-
ties if the advisory bodies recommend against listing.

As noted earlier, the Committee is to act on the recommendations of the
advisory bodies. Yet, over the last decade the Committee has increasingly
challenged the advisory bodies and established a practice for "upgrading"
draft-decisions. It has become increasingly common that the Committee alters
recommended referrals and deferrals to inscriptions and referrals, respectively
(e.g., Jokilehto 2011; Meskell et al. 2015; Bertacchini et al. 2016, Hølleland
and Wood 2019). Over the last decade this has become part and parcel of the
nomination circus, and it is not unusual that up to 50 percent of the decisions
are "upgraded" following the Committee deliberations over amendments
proposed by Committee members (e.g., Hølleland 2013, 185). The practice
of upgrading reached a new level in 2018, with five states[8] choosing not to
withdraw nominations recommended as "not inscribed" but rather opting for
upgrading. The gamble payed off: all were upgraded and two[9] even inscribed
on the World Heritage List. While this new tradition of upgrading is a result of
political relations taking priority over expert advice, it is in part due to the fact
that there is considerable room for interpretation, and thereby negotiation, as
to what constitutes outstanding universal value(s) (e.g., Brumann 2017). How
does Japan fit into this pattern of upgrading?

Generally speaking, Japan's nominations have been recommended for
inscription. In fact, 82 percent of its nominations were recommended to be
inscribed following the advisory bodies' evaluations. Only four of Japan's
twenty-three World Heritage Sites received a less favourable evaluation. "Iwami
Ginzan Silver Mine and its Cultural Landscape" was upgraded from a deferral
to an inscription in 2007. "Hiraizumi—Temples, Gardens and Archaeological
Sites Representing the Buddhist Pure Land" was deferred in 2008, then listed
in 2011 following a resubmission. The transnational serial nomination "The
Architectural Work of Le Corbusier, an Outstanding Contribution to the
Modern Movement" was first recommended deferred in 2009.[10] Subsequently
the decision was upgraded to refer, but the nomination was deferred again in
2011 and then inscribed in 2016, following a resubmitted nomination. Finally,
the nomination "Hidden Christian Sites in the Nagasaki Region" was first with-
drawn in 2015, then resubmitted in 2017, and inscribed in 2018. Hence, while
the number of deferrals and referrals has been small, Japan does not generally
challenge the decisions of the advisory bodies. Rather, Japan has been willing to
accept recommendations and revise nominations. At a point in time when this
is becoming increasingly rare, Japan was indeed commended by the Norwegian
delegation when it congratulated Japan on the listing of the "Hidden Christian
Sites in the Nagasaki Region" in 2018. As another state that prides itself upon

playing by the rules, Norway thanked Japan for its good practice—following the principles of the Convention, seeking advice from ICOMOS on how to restructure the nomination following its 2015 withdrawal, and returning with a successful nomination in 2018.[11]

Patterns of Committee representation

Another issue that is often linked to the politicisation of the World Heritage Committee is that of Committee representation. As noted earlier, the Convention's article 9.3 calls for representatives with a background in cultural or natural heritage. Whether this is followed is another matter. The first decade of operation (i.e., prior to Japan's ratification) is commonly remembered as a time when the Bureau meetings held prior the World Heritage Committee sessions were "technical meetings," attended by "experts in cultural and natural heritage" (Cameron and Rössler 2013, loc. 4387 of 7868, Kindle edition). Yet within the first decade there was a shift in representation at the Bureau meetings as the number of diplomats grew, reaching a majority by the late 1980s (Hølleland and Phelps 2019, 894). By the time Japan entered the World Heritage arena, the Convention had come to serve the dual purpose of being an arena for heritage and for international relations, where the heritage experts were increasingly "given the back seat" (Cameron and Rössler 2013, loc. 4437 of 7868, Kindle edition). Moreover, there has been a tremendous increase in the overall number of delegates attending the World Heritage Committee sessions. Looking just at the period in which Japan has been active, the list of participants in the World Heritage Committee sessions has grown from fifteen pages in 1992 to 120 pages in the top year of 2015. Japan has had a similar development; looking only at the delegates that form part of the national delegation of Japan (i.e., excluding non-state party observers), Japan's delegation has grown from three delegates in 1992 to its peak in 2015 with forty-four delegates (see Figure 3.2).

Coding the lists of Japanese delegates, one gains a sense of how the composition of the delegation has developed over time. This exercise should not be viewed too rigidly, as delegates have been classified according to their institutional home rather than their educational background. To exemplify, a delegate working at the Nature Conservation Bureau or the ACA has been classified as a "heritage professional." Similarly, a delegate working at the Ministry of Foreign Affairs or the Permanent Delegation of Japan to UNESCO has been classified as a "diplomat." "Others" refers to delegates who cannot easily be classified within one of these two categories. These may be delegates who represent nominated sites. Overall, we can see that Japan has to a large degree complied with article 9.3, always sending heritage professionals as part of their delegations (Figure 3.3). However, in the last decade the number of "other" delegates has increased, as has the number of diplomats. As a result, as Figure 3.4 shows, there has been as significant drop in the overall number of heritage professionals in

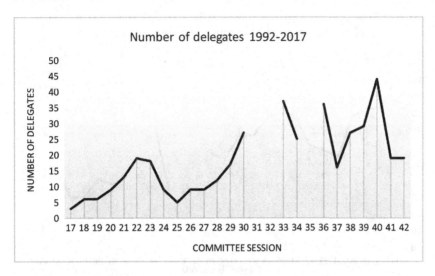

Figure 3.2 Size of the Japanese delegation, 1992–2017. Raw data are lacking for Committee sessions 31, 32, and 35. Figure developed by the author based on data from the statutory records of the World Heritage Convention.

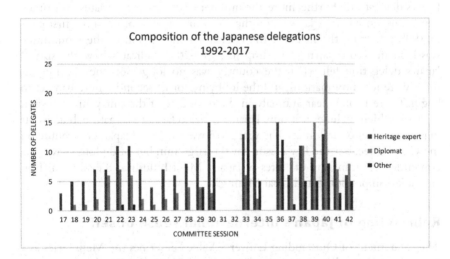

Figure 3.3 Composition of the Japanese delegation, 1992–2017. Raw data are lacking for Committee sessions 31, 32, and 35. Figure developed by the author based on data from the statutory records of the World Heritage Convention.

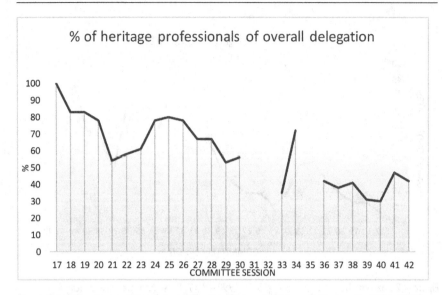

Figure 3.4 Percentage of the delegation classified as heritage professionals, 1992–2017. Figure developed by the author based on data from the statutory records of the World Heritage Convention.

Japan's delegations. Furthermore, the number of delegates fluctuates over times, depending on whether Japan is on the Committee and not, with the first peak in 1998 reflecting the fact that the twenty-second session of the Committee was held in Kyoto, Japan. The drop in 2000–2001 indicates how the size of Japan's delegation fell when the country was no longer on the Committee, there were few nominations, and the lobbying for its second tenure had yet to begin. There is one clear anomaly in the data; that of the thirty-ninth session in 2015, which includes not only Japan's hitherto largest delegation, but also its highest number of diplomats. The year 2015 was the last of Japan's last tenure on the Committee, but the key reason for the large number of diplomats was the contentious nomination of "Sites of Japan's Meiji Industrial Revolution: Iron and Steel, Shipbuilding and Coal Mining."

Rebranding of Japan's international sense of self

The "Statement of Outstanding Universal Value" describes the Meiji series as a "series of industrial heritage sites, focused mainly on the Kyushu–Yamaguchi region of south-west Japan, represent[ing] the first successful transfer of industrialization from the West to a non-Western nation" (UNESCO 2018c). As such, the Meiji nomination can be read as celebrating Japan as a nation with a long history for technological advancement. As in the early 1990s, it can be linked to shifts in Japan's foreign policy: whereas Japan's ratification in the early

1990s represented a shift in foreign policy focusing on Japan as a cultural nation (Akagawa 2015), Lynn Meskell (2018, 152) argues that the Meiji sites signal "a move away from Japan's former passivity and acquiescence," rather highlighting Japan's history as a "great power, having a long history of technological sophistication" (see also Akagawa 2016b, alluding to a similar shift). The political nature of this nomination became particularly conspicuous in its last and decisive phase; following the election of the conservative Liberal Democratic Party and Abe Shinzō as prime minister in 2012, the cabinet itself took the lead in finalising the nomination dossier (Trifu 2018, 207–208).[12] The particular political interest for the nomination not only stems from its usefulness in framing a more proactive Japan, but is also linked to the fact that several of the twenty-three sites included in the serial nomination are located in the home precincts of prime minister and his deputy prime minister (Meskell 2018, 152; Trifu 2018, 208).

One of the more intricate political aspects of the Meiji nomination file is how it was consciously drafted *not* to include the sites' imperial history (Underwood 2015). Very much aware that several of these sites were locations for the forced labour of Korean and Chinese in the 1940s, the nomination's focus is confined to the period of circa 1850–1910 (thereby somewhat confusingly also including the period predating the 1868 Meiji Restoration), the latter year marking Japan's annexation of Korea (Trifu 2018, 207). The political nature of the nomination and the tensions it was likely to cause are also signalled by another move of the Japanese government: keeping in mind the ceiling of one nomination per state per year, the government chose to recommend the Meiji nomination

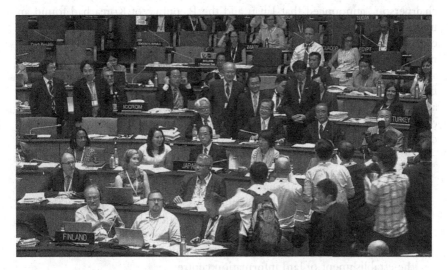

Figure 3.5 The inscription of Sites of Japan's Meiji Industrial Revolution: Iron and Steel, Shipbuilding and Coal Mining at the 39th World Heritage Committee meeting in Bonn in 2015. Credit: Screenshot from the streaming of the session, Herdis Hølleland.

over the "Churches and Christian Sites of Nagasaki" in 2014 (Trifu 2018, 208). Submitted in 2014, the Meiji nomination would be on the agenda of the 39th session of the World Heritage Committee—the last year of Japan's third term on the Committee. Had it been nominated the following year, Japan would no longer have the benefit of being on the Committee, whereas the Republic of Korea would. Furthermore, Japan had help from British and Australian experts on industrial heritage in compiling the nomination dossier, in the hope that this would secure a favourable recommendation from ICOMOS and increase the likelihood of inscription (Meskell 2018, 150).

As Japan announced ICOMOS' recommendation for inscription in the spring of 2015, Japan's failure to acknowledge the full history of the sites and their connection to forced labour meant that the conflict with the Republic of Korea intensified. The nomination quickly grabbed the attention of the international media, leading the Chinese to express their support to the Koreans (Trifu 2018, 209). Proponents argued that the opponents' attention to the colonial period and the events of World War II was irrelevant in this context, referring to the 1850–1910 timeframe of the nomination, and highlighted the positive evaluation from ICOMOS. Meanwhile, ICOMOS pointed out the need for an interpretation strategy to show how each site related to the overall series and contributed to its outstanding universal values (ICOMOS 2015). This provided an entry point for negotiation, of which only traces are visible to the public; the extremely staged nature of the live-streamed World Heritage Committee deliberations in Bonn, Germany, reveal little more than the fact that its structure was agreed upon in advance. Following ICOMOS' oral presentation of the property, the German chairperson "announced that Japan and the Republic of Korea had found an understanding" and "requested the Committee to respect the proceeding laid out" (UNESCO 2015c, 220). In contrast to common practice, there would be no debate on the nomination, and the Committee would proceed directly to a decision. The only Committee member given the chance to speak from the floor was Germany, reading out an already-agreed upon amendment to be added as a footnote, stating that the interpretation strategy must enable *the full history* of each site to be told (UNESCO 2015a). Once this was unanimously adopted, the chairperson congratulated Japan, before Japan stated it was

> prepared to take measures that allow an understanding that there were a large number of Koreans and others who were brought against their will and forced to work under harsh conditions in the 1940s at some of the sites, and that, during World War II, the Government of Japan also implemented its policy of requisition. Japan is prepared to incorporate appropriate measures into the interpretive strategy to remember the victims[,] such as the establishment of [an] information centre.
>
> (UNESCO 2015a)

The Republic of Korea was thereafter given the chance to comment, and thanked the members of the Committee and particularly Germany for

working "together to uphold the spirit of the World Heritage Convention." Taking note of Japan's statement, Korea argued it marked "another important step toward remembering the pain and suffering of the victims, healing the painful wounds of history, and reaffirming that the historical truth of the unfortunate past should also be reflected in an objective manner" (UNESCO 2015c, 223). In Japan, however, emphasis was put on the fact that being "forced to work" was not the equivalent of "forced labour," thereby leaving doubts about the extent to which the interpretation strategy would really be implemented (Trifu 2018, 2010). In following up on the recommendation, Japan sent as requested a State of Conservation report in 2017, to be discussed at the 2018 World Heritage session. At the latter, Japan was commended for its "substantial progress" on the conservation program for Hashima Island, but also encouraged to

> take into account best international practices for interpretation strategies when continuing its work on the interpretation of the full history of the property, both during and outside of the period covered by its OUV, and in the digital interpretation materials.
>
> (UNESCO 2018a)

Summing up, there is no doubt that Japan was aware that it entered muddy waters when putting forward the Meiji nomination. However, after the United States' withdrawal Japan became the largest contributor to UNESCO. This puts Japan in a particularly powerful situation; not afraid of UNESCO, it can move forward with contentious nominations (Meskell 2018, 152). Such nominations can in turn serve the Abe government's agenda of rebranding of Japan as a global economic and technological power.

Conclusion

Situating Japan with the international context of the Convention, this chapter has shown how Japan has taken full advantage of the important role states can play within such a system. While it is far from the only example of states seeking to match national interests with international brokerage (see, e.g., Hølleland 2013; Hølleland and Phelps 2019; Gfeller 2013, 2015, 2017), Japan has been particularly successful. Akagawa (2016a, 136) argues that this is a result of how Japan has strategically used its international policy as "an extension of Japanese character and ideals." Equally important, it reflects Japan's ability to provide solutions to pre-existing problems within the international heritage community. The Meiji nomination represented a break with this dual tradition, causing more tension than it resolved; a cost Japan, at least for now, can live with due to its role as a major contributor to UNESCO. Moving forward, it will be interesting to see whether Japan will continue its new, more confrontational line or return to its previous practice of balancing self-interest with its role of international problem solver.

Notes

1 In order for sites to be included on the World Heritage List, sites must be of out-standing universal value (OUV). That "means cultural and/or natural significance which is so exceptional as to transcend national boundaries and to be of common importance for present and future generations of all humanity" (UNESCO 2017, item II.A, paragraph 49). In order to demonstrate OUV, sites must meet one of ten criteria outlined in the operational guidelines.

2 The Bureau of the World Heritage Committee consists of seven of the states on the Committee; a chairperson, five vice chairs and a rapporteur. The Bureau coordinates the work of the Committee, fixing dates of the sessions, orders of business, and so on. A Bureau is elected at the end of the World Heritage session and sits for one year at a time.

3 In order to monitor the state of conservation of World Heritage Sites, states are to report potential developments impacting the sites' outstanding universal value. This is done through so-called state of conservation reports (SOC reports). For more information, see https://whc.unesco.org/en/soc/.

4 The fund was one of the main controversies during the adoption of the Convention in 1972, leading states such as New Zealand and Norway to abstain from voting and delaying their ratifications following concerns of the states' capacity to contribute and what governmental bodies may carry the cost of participating (e.g., Batisse and Bolla 2005; Hølleland 2013; Hølleland and Phelps 2019).

5 Similar reasons also figured in, for example, the Norwegian ratification process of the 1970s (Hølleland and Phelps 2019).

6 See, e.g., Bertacchini and Saccone (2012), Bertacchini et al. (2016), Bertacchini, Liuzza, and Meskell (2017), Brumann (2012, 2014, 2016, 2017, 2018), Buckley (2014), Gfeller (2013, 2015, 2017), Hølleland (2015), Hølleland and Phelps (2019), James (2016), James and Winter (2017), Meskell (2012, 2013, 2014, 2015a, 2015b, 2016, 2018), Meskell et al. (2015), and Meskell, Liuzza, and Brown (2015).

7 The original Cairns decision put the ceiling at one nomination per state party already represented on the list. This was since amended to two provided one was a natural site or a cultural landscape. From February 2018, only one complete nomination per state party is allowed.

8 China, Germany, Iran, Italy, and Saudi Arabia.

9 The two inscribed were "Al-Ahsa Oasis, an Evolving Cultural Landscape" (Saudi Arabia) and "Naumburg Cathedral" (Germany).

10 A transnational serial nomination includes sites that are thematically linked and located in different states. These are known to be notoriously difficult to compile and are often deferred or referred prior to inscription. The Le Corbusier nomination included seventeen sites in Argentina, Belgium, France, Germany, India, and Switzerland, in addition to Japan. Japan is home to one of these sites, the National Museum of Western Art in Tokyo. The nomination was initiated and led by France and Japan's involvement was modest.

11 Video recording from the session 30 June, morning session, at 1:33:26–34:50. http://whc.unesco.org/en/sessions/42COM/records/?day=2018-06-30.

12 Trifu also draws up the longer nomination history since 2003.

References

Akagawa, Natsuko. 2015. *Heritage Conservation and Japan's Cultural Diplomacy: Heritage, National Identity and National Interest*. London: Routledge.

Akagawa, Natsuko. 2016a. "Japan and the Rise of Heritage in Cultural Diplomacy: Where Are We Heading?" *Future Anterior: Journal of Historic Preservation, History, Theory, and Criticism* 13 (1): 124–139.

Akagawa, Natsuko. 2016b. "Rethinking the Global Heritage Discourse—Overcoming 'East' and 'West'?" *International Journal of Heritage Studies* 22 (1): 14–25.

Askew, Marc. 2010. "The Magic List of Global Status. UNESCO, World Heritage and the Agendas of States." In *Heritage and Globalisation*, edited by Sophia Labadi and Colin Long, 19–44. London: Routledge.

Batisse, Michel, and Gérard Bolla. 2005. *The Invention of the "World Heritage."* Paris: Association des anciens fonctionnaires de l'Unesco (AAFU).

Beazley, Olwen. 2006. "Drawing a Line Around a Shadow? Including Associative, Intangible Cultural Heritage Values on the World Heritage List." PhD dissertation, Australian National University.

Beazley, Olwen. 2010. "Politics and Power. The Hiroshima Peace Memorial (Genbaku Dome) as World Heritage." In *Heritage and Globalization*, edited by Sophia Labadi and Colin Long, 45–65. London: Routledge.

Bertacchini, Enrico, Claudia Liuzza, and Lynn Meskell. 2017. "Shifting the Balance of Power in the UNESCO World Heritage Committee: An Empirical Assessment." *International Journal of Cultural Policy* 23 (3): 331–351.

Bertacchini, Enrico, Claudia Liuzza, Lynn Meskell, and Donatella Saccone. 2016. "The Politicization of UNESCO World Heritage Decision Making." *Public Choice* 167 (1): 95–129.

Bertacchini, Enrico, and Donatella Saccone. 2012. "Toward a Political Economy of World Heritage." *Journal of Cultural Economics* 36 (4): 327–352.

Brumann, Christoph. 2012. "Multilateral Ethnography: Entering the World Heritage Arena." Working Papers no. 136, Max Planck Institute for Social Anthropology Working Papers. www.eth.mpg.de/pubs/wps/pdf/mpi-eth-working-paper-0136.

Brumann, Christoph. 2014. "Shifting Tides of World-Making in the UNESCO World Heritage Convention: Cosmopolitanisms Colliding." *Ethnic and Racial Studies* 37 (12): 2176–2192.

Brumann, Christoph. 2016. "Conclusion. Imagining the Ground from Afar: Why the Sites Are So Remote in World Heritage Committee Sessions." In *World Heritage on the Ground. Ethnographic Perspectives*, edited by Christoph Brumann and David Berliner, 294–317. New York: Berghahn.

Brumann, Christoph. 2017. "The Best of the Best: Positioning, Measuring and Sensing Value in the UNESCO World Heritage Arena." In *Palaces of Hope: The Anthropology of Global Organizations*, edited by Ronald Niezen and Maria Sapignoli, 245–265. New York: Cambridge University Press.

Brumann, Christoph. 2018. "Slag Heaps and Time Lags: Undermining Southern Solidarity in the UNESCO World Heritage Committee." *Ethnos* 84 (4): 719–738. https://doi.org/10.1080/00141844.2018.1471514.

Buckley, Kristal I. 2014. "The World Heritage Convention at 40: Challenges for the Work of ICOMOS." *Historic Environment* 26 (2): 38–52.

Cameron, Christina, and Mechtild Rössler. 2013. *Many Voices, One Vision: The Early Years of the World Heritage Convention*. Farnham: Ashgate Publishing. Kindle edition.

Cleere, Henry. 2001. "The Uneasy Bedfellows: Universality and Cultural Heritage." In *Destruction and Conservation of Cultural Property*, edited by Robert Layton, Peter G. Stone, and Julian Thomas, 22–29. London: Routledge.

Gfeller, Aurélie Elisa. 2013. "Negotiating the Meaning of Global Heritage: 'Cultural Landscapes' in the UNESCO World Heritage Convention, 1972–92." *Journal of Global History* 8 (3): 483–503. https://doi.org/10.1017/S1740022813000387.

Gfeller, Aurélie Elisa. 2015. "Anthropologizing and Indigenizing Heritage: The Origins of the UNESCO Global Strategy for a Representative, Balanced and Credible World Heritage List." *Journal of Social Archaeology* 15 (3): 366–386.

Gfeller, Aurélie Elisa. 2017. "The Authenticity of Heritage: Global Norm-Making at the Crossroads of Cultures." *American Historical Review* 122 (3): 758–791.

Hølleland, Herdis. 2013. "Practicing World Heritage: Approaching the Changing Faces of the World Heritage Convention." PhD dissertation, University of Oslo.

Hølleland, Herdis. 2015. "35.COM 8B.27. Refleksjoner rundt verdensarvbeslutninger." In *Inn i fortida—ut i verden—i museet*, edited by Jon Anders Risvaag, Ragnhild Berg, and Terje Brattli, 106–128. Trondheim: Museumsforlaget.

Hølleland, Herdis, Evan Hamman, and Jessica Phelps. 2019. "Naming, Shaming and Fire Alarms: The Compilation, Development and Use of the List of World Heritage in Danger." *Transnational Environmental Law* 8 (1): 35–57.

Hølleland, Herdis, and Jessica Phelps. 2019. "Becoming a Conservation 'Good Power': Norway's Early World Heritage History." *International Journal of Cultural Policy* 25 (7): 886–903.

Hølleland, Herdis, and Joar Skrede. 2019. "What's Wrong With Heritage Experts? An Interdisciplinary Discussion of Experts and Expertise in Heritage Studies." *International Journal of Heritage Studies* 25 (8): 825–836. https://doi.org/10.1080/13527258.2018.1552613.

Hølleland, Herdis, and Morgaine Wood. 2019. "An Emotional Plea for Al-Ahsa: A Case Study on How Discourses of Representativeness, Climate and Discord Are Strategized in the World Heritage Regime." *International Journal of Cultural Policy*, Online First. https://doi.org/10.1080/10286632.2019.1646734.

ICOMOS. 1994. *Nara Document on Authenticity*. Accessed 8 May 2019, www.icomos.org/charters/nara-e.pdf.

ICOMOS. 2015. *Evaluations of Nominations of Cultural and Natural Sites to the World Heritage List* (WHC-15/39.COM/INF.8B1). Accessed 8 May 2019, https://whc.unesco.org/archive/2015/whc15-39com-inf8B1-en.pdf.

James, Luke. 2016. "The Symbolic Value of Expertise in International Heritage Diplomacy." *Future Anterior: Journal of Historic Preservation, History, Theory, and Criticism* 13 (1): 83–96.

James, Luke, and Tim Winter. 2017. "Expertise and the Making of World Heritage Policy." *International Journal of Cultural Policy* 23 (1): 36–51.

Jokilehto, Jukka. 2011. "World Heritage: Observations on Decisions Related to Cultural Heritage." *Journal of Cultural Heritage Management and Sustainable Development* 1 (1): 61–74.

Labadi, Sophia. 2007. "Representations of the Nation and Cultural Diversity in Discourses on World Heritage." *Journal of Social Archaeology* 7: 147–170.

Larsen, Knut Einar. 1994. "A Note on the Authenticity of Historic Timber Buildings With Particular Reference to Japan." In *ICOMOS International Wood Committee (IIWC)*

8th International Symposium. Kathmandu, Patan and Bhaktapur, Nepal, 23–25 November 1992, edited by Knut Einar Larsen and Nils Marstein, 155–180. Oslo: Tapir forlag.

Larsen, Knut Einar. 1995. "Preface." In *Nara Conference on Authenticity. Conference de Nara sur l'authenticité*, edited by Knut Einar Larsen, xi–xiii. Paris: UNESCO/Agency for Cultural Affairs (Japan)/ICCROM/ICOMOS.

Larsen, Knut Einar, and Nils Marstein. 1994. "Introduction From the Management Group of IIWC." In *ICOMOS International Wood Committee (IIWC) 8th International Symposium. Kathmandu, Patan and Bhaktapur, Nepal, 23–25 November 1992*, edited by Knut Einar Larsen and Nils Marstein, 7–12. Oslo: Tapir forlag.

Leira, Halvard. 2015. "The Formative Years: Norway as an Obsessive Status-Seeker." In *Small State Seeking Status. Norway's Quest for International Standing*, edited by Benjamin de Carvalho and Iver B. Neumann, 22–39. London: Routledge. Kindle edition.

Lunde, Øivind. 1994. "Introduction." In *Conference on the Authenticity in Relation to the World Heritage Convention. Preparatory Workshop. Bergen, Norway, 31 January–2 February 1994*, edited by Knut Einar Larsen and Nils Marstein, 7–8. Oslo: Tapir forlag.

Meskell, Lynn. 2012. "The Rush to Inscribe: Reflections on the 35th Session of the World Heritage Committee, UNESCO Paris, 2011." *Journal of Field Archaeology* 37 (2): 145–151.

Meskell, Lynn. 2013. "UNESCO's World Heritage Convention at 40: Challenging the Economic and Political Order of International Heritage Conservation." *Current Anthropology* 54 (4): 483–494.

Meskell, Lynn. 2014. "States of Conservation: Protection, Politics, and Pacting Within UNESCO's World Heritage Committee." *Anthropological Quarterly* 87 (1): 217–443.

Meskell, Lynn. 2015a. "Gridlock: UNESCO, Global Conflict and Failed Ambitions." *World Archaeology* 47 (2): 225–238.

Meskell, Lynn. 2015b. "Transacting UNESCO World Heritage: Gifts and Exchanges on a Global Stage." *Social Anthropology* 23 (1): 3–21.

Meskell, Lynn. 2016. "World Heritage and WikiLeaks." *Current Anthropology* 57 (1): 72–95.

Meskell, Lynn. 2018. *A Future in Ruins. UNESCO, World Heritage, and the Dream of Peace.* Oxford: Oxford University Press.

Meskell, Lynn, Claudia Liuzza, Enrico Bertacchini, and Donnatella Saccone. 2015. "Multilateralism and UNESCO World Heritage: Decision-Making States Parties and Political Processes." *International Journal of Heritage Studies* 21 (5): 423–440.

Meskell, Lynn, Claudia Liuzza, and Nicholas Brown. 2015. "World Heritage Regionalism: UNESCO from Europe to Asia." *International Journal of Cultural Property* 22 (4): 437–470.

Musitelli, Jean. 2002. "Opinion: World Heritage, Between Universialism and Globalization." *International Journal of Cultural Property* 11 (2): 323–336.

Nishiyama, Noriaki. 2015. "Heritage Management in Present-Day Japan." In *The SAGE Handbook of Modern Japanese Studies*, edited by James Babb, 80–99. London: Sage.

Noguchi, Hideo. 1994. "UNESCO's Activities Within the Field of Wood Conservation." In *ICOMOS International Wood Committee (IIWC) 8th International Symposium. Kathmandu, Patan and Bhaktapur, Nepal, 23–25 November 1992*, edited by Knut Einar Larsen and Nils Marstein, 15–18. Oslo: Tapir forlag.

Roders, Anna Pereira, and Anna Beatriz Grigolon. 2015. "UNESCO to Blame: Reality or Easy Escape?" *Archnet-IJAR* 9 (1): 50–66.

Saikawa, Takashi. 2016. "Returning to the International Community: UNESCO and Post-war Japan, 1945–1951." In *A History of UNESCO: Global Actions and Impacts,*

edited by Poul Duedahl, loc. 2884-3270 of 9184. UK: Palgrave Macmillan. Kindle edition.

Smith, Laurajane. 2006. *Uses of Heritage*. London: Routledge.

Stovel, Herb. 2008. "Origins and Influence of the Nara Document on Authenticity." *APT Bulletin* 39 (2/3): 9–17.

Strasser, Peter. 2002. "Putting Reform Into Action Thirty Years of the World Heritage Convention: How to Reform a Convention without Changing Its Regulations." *International Journal of Cultural Property* 11 (2): 215–266.

Trifu, Ioan. 2018. "Dealing with a Difficult Past: Japan, South Korea and the UNESCO World Heritage List." In *Cultural Contestation: Heritage, Identity and the Role of Government*, edited by Jeroen Rodenberg and Pieter Wagenaar, 197–217. Cham: Springer International Publishing.

Underwood, William. 2015. "History in a Box: UNESCO and the Framing of Japan's Meiji Era." *The Asia-Pacific Journal* 13 (26/2): 1–14.

UNESCO. 1972. *Convention Concerning the Protection of the World Cultural and Natural Heritage*. Accessed 8 May 2019, https://whc.unesco.org/archive/convention-en.pdf.

UNESCO. 1992. *Report of the Rapporteur on the Sixteenth Session of the World Heritage Committee. 7-14.12.1992 Santa Fe (USA)* (WHC-92/CONF.002/12). Accessed 8 May 2019, https://whc.unesco.org/archive/1992/whc-92-conf002-12e.pdf.

UNESCO. 1993. *Ninth General Assembly of the States Parties to the Convention Concerning the Protection of the World Cultural and Natural Heritage* (WHC-93/CONF.003/6). Accessed 8 May 2019, http://whc.unesco.org/archive/1993/whc-93-conf003-6e.pdf.

UNESCO. 2000. *Cairns Decisions—Work of The World Heritage Reform Groups* (Decision: CONF 204 VI). Accessed 8 May 2019, https://whc.unesco.org/en/decisions/1218.

UNESCO. 2014. *First Extraordinary Session of the General Assembly of States Parties to the Convention Concerning the Protection of the World Cultural and Natural* (WHC-14/1 EXT.GA/INF.4). Accessed 8 May 2019, https://whc.unesco.org/archive/2014/whc14-1EXTGA-4-en.pdf.

UNESCO. 2015a. *Sites of Japan's Meiji Industrial Revolution: Iron and Steel, Shipbuilding and Coal Mining, Japan* (Decision: 39 COM 8B.14). Accessed 8 May 2019, https://whc.unesco.org/en/decisions/6364.

UNESCO. 2015b. *Rules of Procedure. UNESCO Intergovernmental Committee for the Protection of the World Cultural and Natural Heritage* (WHC-2015/5). Accessed 8 May 2019, https://whc.unesco.org/en/committee/.

UNESCO. 2015c. *Summary Records of the 39th Session of the World Heritage Committee* (WHC-15/39.COM.INF.19). Accessed 8 May 2019, https://whc.unesco.org/archive/2015/whc15-39com-19-en.pdf.

UNESCO. 2017. *Operational Guidelines for the Implementation of the World Heritage Convention* (WHC-2017/1). Accessed 8 May 2019, https://whc.unesco.org/en/guidelines/.

UNESCO. 2018a. *Sites of Japan's Meiji Industrial Revolution: Iron and Steel, Shipbuilding and Coal Mining (Japan) (C 1484)* (Decision: 42 COM 7B.10). Accessed 26 October 2018, http://whc.unesco.org/en/decisions/7239.

UNESCO. 2018b. *Japan*. Accessed 25 October 2018, http://whc.unesco.org/en/statesparties/jp.

UNESCO. 2018c. *Sites of Japan's Meiji Industrial Revolution: Iron and Steel, Shipbuilding and Coal Mining*. Accessed 25 October 2018, https://whc.unesco.org/en/list/1484.

Chapter 4

World Cultural Heritage and women's exclusion from sacred sites in Japan

Lindsey E. DeWitt

Introduction

Who or what do heritage designations privilege? Alternatively, who or what is excluded? Can the study of a premodern religious tradition or a putative religious tradition inform our study of the modern formation of cultural heritage? Scholarship from a range of disciplines has exposed the invented and contrived aspects of tradition, the highly constructed and contested nature of heritage, and the labor involved in producing and maintaining sacred space. In parallel, scholars in history and cultural studies have raised important questions concerning understandings and negotiations of the past after the advent of modernity. Western scholarship on Japan mirrors these larger moves to deconstruct tradition, heritage, and modernity, but key aspects of their interconnections and *in situ* contours remain underexplored. Little published scholarship to date, for example, has scrutinized the discrepancies between the religious and historical record of Japanese heritage sites and their presentation in scholarly and public discourses.

The present endeavor queries this contradiction: women's exclusion from sacred sites (*nyonin kekkai, nyonin kinsei*) appears frequently in scholarly and public discourses as a time-honored cultural practice in Japan and can be observed on the ground, yet it is consistently deleted from the nation's official heritage narratives. Women's exclusion is actively enforced at two Japanese sites recognized by UNESCO as World Heritage: Mt. Ōmine of "Sacred Sites and Pilgrimage Routes in the Kii Mountain Range" (designated in 2004) and Okinoshima of "Sacred Island of Okinoshima and Associated Sites in the Munakata Region" (designated in 2017).[1] Proponents of the ban at both sites claim legitimation from ancient sources, and many advocates boldly present the custom as a special determinant of the sacredness of the place. At the same time, World Heritage documentation written by Japanese authorities expunges altogether or greatly diminishes the fact of male-only access in its presentations of the sites. In contrast to the Japanese cases, the religious exclusion of women from another sacred mountain site recognized as World Heritage, Mt. Athos in Greece, is clearly stated in all documentation.[2] I begin this chapter with a brief

consideration of tradition, heritage, and the place of women's exclusion in those discourses.

Tradition, heritage, exclusion

"Tradition" (*dentō*) forms part of the discourse on Japan's entry into modernity in the Meiji period (1868–1912), a time of great social and political upheaval when practices of the past—many religious in nature—were either carefully protected and maintained or redefined and reformulated in the interests of a new juxtaposition of past and present. Since the 1980s, a robust body of research has made strides in clarifying the dynamics of tradition-making (e.g., Hobsbawm and Ranger et al. 1983; Graburn 2001), but many studies by Japanese authors that mention tradition remain largely under the purview of folklore studies, with concomitant limitations, and critical perspectives are often ignored by tradition-makers—not least those who create heritage. The nativist ethnological work of Yanagita Kunio (1875–1962) marks the beginning of Japanese discourse on tradition and, as part of it, the first study of women's exclusion. Traversing a landscape of great social change and intermittent warfare, Yanagita longed to find the origins of Japanese culture. In remote mountain communities, he claimed to have found an original, unadulterated, and unrecorded Japan that was grounded in "ancient communal beliefs that local people held firm in their hearts" (Yanagita 1936, 232). Behind Yanagita's efforts looms a strong consciousness of Japan's modern nation-state and a clear aim to excavate a "Japanese" ethos. The Yanagita folklore mentality has been vulnerable to methodological criticism on numerous grounds, but parts of it have not yet been unraveled.

The earliest Japanese works on tradition per se (e.g., Hariu 1966; Dentō to Geijutsu no Kai et al. 1968) focus on clarifying the "Japanese mentality" of the performing arts using sociological methods. More recent works by philosopher Umehara Takeshi (2010) and literary critic Ōtsuka Eiji (2004) claim to take a distanced historical approach to studying tradition. Umehara argues that much of what has been recognized as "Japanese tradition" since the late nineteenth century is little more than nationalism in disguise. Ōtsuka traces the indigenous consciousness of "Japanese traditions" to the early Shōwa period (1926–1989), in connection with the scholarly lineage of Yanagita. Yet these works, too, indulge in a kind of modernist nostalgia in their attempt to parse the foreign from the Japanese. In 2001 Suzuki Masataka wrote, "since its inception, [the field of folklore studies] has firmly upheld the standpoint of Japanese observing and reflecting upon themselves" (2001, 69). Critical studies of tradition in Japan have been impeded by these particularizing and emic approaches to understanding Japanese cultural practices.

Most global research on heritage, on the other hand, has referred to Western contexts and concepts. A few recent works by international scholars have contributed important insights on heritage in East Asia, but they contain scant

discussion of religion, gender, or World Heritage Sites.[3] In contrast, a wealth of scholarship in Japanese addresses the technical aspects of tangible heritage objects—often religious in nature—such as buildings, statues, and paintings within fields like archaeology and architectural conservation. In these works, there is little room for issues like gender, social setting, religious practice, or sacrality. Studies of this kind, and those published under the auspices of national research institutes or government-sponsored World Heritage promotional committees, represent "authorized heritage discourse" (Smith 2006, 299). As a general observation, most Japanese research fails to critically engage the meanings and practices of "tradition" and "heritage" or the historical conditioning of those meanings and practices.

Nearly all Japanese scholarship that mentions women's exclusion, for instance, presents the phenomenon as an ancient and unchanged fact of Japan's religious and cultural landscape.[4] Women's exclusion is generally conceptualized in terms of two similar-sounding four-character phrases: *nyonin kekkai* and *nyonin kinsei*. The terms convey a variety of gender-based proscriptions, including barring women's entry from certain sites (e.g., shrines, temples, festival floats) or from certain occupations (e.g., sumo wrestling, sake brewing, kiln firing, sushi chef). Of course, some of the foregoing gender differentiations are not unique to Japan. Many global sporting, fishing/boating, and hunting cultures, for example, either did or still do maintain exclusionary practices. In Japan, some evidence of exclusionary practices can be found at nearly every mountain site with historical ties to Buddhist and/or Shinto worship traditions, but most territorial proscriptions were dissolved in 1872, when a Meiji government edict legally opened all mountain shrine and temple land to women.[5] The two focal points of this chapter, Mt. Ōmine and Okinoshima, are often touted as the last bastions of women's exclusion in Japan.[6]

Mt. Ōmine

Unlike Mt. Fuji, immediately discernible for its grand conical shape, Mt. Ōmine denotes a surreptitiously vast assemblage of peaks in southern Nara Prefecture. The name Mt. Ōmine is also synonymous with Sanjōgatake, a 1719-meter peak located in the central part of the range.[7] The term "religious tradition" (*shūkyōteki dentō*) is ubiquitous at the mountain; one finds it on signboards and it recurs often in conversation to describe and explain the ban on women. This mode of historical summation presents the practice of restricting access to the Sanjōgatake peak as ancient and little changed since the time of En no Gyōja (634?–701?), a layman who legendarily "founded" the mountain by establishing a body of ascetic practices and beliefs later defined as Shugendō.[8]

Shugendō practitioners revere Sanjōgatake as their spiritual heartland, for on its craggy precipices En no Gyōja is said to have summoned the wrathful deity Zaō Gongen. Extant diaries, and also objects found at the peak such as bronze sutra containers and gold buddha statues, confirm that the peak was

a pilgrimage destination for elite male courtiers since the late Heian period (around the year 1000).[9] Local literature and scholarly accounts routinely cite a tenth-century Chinese encyclopedia, known in Japanese as the *Giso rokujō*, as even earlier—and continental—substantiation of the mountain's exceptional and exclusive features. The Chinese account characterizes Sanjōgatake (here called Kinpusen) as a "supreme other world" where the bodhisattva Zaō resides; it then enumerates austerities men must undertake in preparation for climbing it (three months without alcohol, meat, or sex) and states in no uncertain terms that women cannot ascend the holy peak (Yichu and Fushu 1979, 459).[10] Yet this account provides little evidence of whether an ancient practice of women's exclusion actually existed, and some even question the authenticity of the entire *Giso rokujō*.[11]

Previous scholarship on women's exclusion focuses on origins and early development, presenting a range of theorizations based on a small body of premodern texts (e.g., literary sources, hagiographies, temple regulations), which includes the *Giso rokujō*.[12] We know very little about the broader context of these sources, however, such as for whom they were written, who was aware of them, or how they reflected practices on the ground. All we really know is who penned them: aristocratic men and male clerics. Material evidence (e.g., stone pillars, steles, halls) related to *nyonin kekkai/nyonin kinsei* at Mt. Ōmine traces back only as far as the eighteenth century. A stone pillar on the Yoshino side of the mountain dates to 1865 and bears an inscription noting that it replaced a stone from 1754, but a mountain guidebook from 1671 that describes the same place makes no mention of the ban or the stone marker. As far as I am aware, the Meiji government edict that legally abolished women's exclusion in fact constitutes the first documentary evidence that discusses the practice in contemporary terms, neither locating it in the past nor referring to it as an ancient custom. In short, owing to a paucity of historical and material sources, many of the premodern contours of women's exclusion from Sanjōgatake and other mountain locales remain shrouded in mystery (e.g., its origins, enforcement, reception, and fluctuation over time).[13]

At the same time, women's exclusion is not simply a poorly understood relic of the past—it is also immediately discernible in the present. Wooden boundary gates and stone pillars stand at the four trailheads to Sanjōgatake, accompanied by bilingual signage warning women against advancing further toward the summit (see Figure 4.1).[14] The mountain's male-only access was a topic of lively and sometimes heated debate throughout the twentieth century. The ban was also regularly contested by both men and women on various occasions. The three main Shugendō-affiliated temples (Kinpusenji in Yoshino and Shōgoin and Daigoji in Kyoto) even attempted to lift the ban in 1999, as part of commemorative efforts related to the sacred founder En no Gyōja's 1300th Death Anniversary in the year 2000.[15]

A movement to designate a collection of sacred sites in the Kii Peninsula (Nara, Wakayama, and Mie Prefectures), including Sanjōgatake, as a World

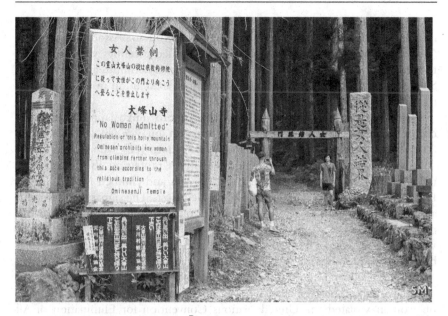

Figure 4.1 Sanjōgatake trailhead, Mt. Ōmine. Photograph courtesy of Sebastian Mayer on assignment with the author, 2015.

Heritage Site took shape in the early 2000s. Wakayama prefectural authorities first sought to promote Nachi Waterfall and Nachi Taisha Grand Shrine (one of the three Kumano Sanzan shrines) to World Heritage status in the early 1990s (Fujii Yasuo, in discussion with the author, 10 January 2017). Following the 1995 designation of "Routes of Santiago de Compostela: Camino Francés and Routes of Northern Spain" (the routes in France were added in 1998), however, which set a precedent for including pilgrimage routes in addition to single properties, priests at Kinpusenji (a Buddhist temple in Yoshinoyama and one of the aforementioned three main Shugendō–affiliated Buddhist temples connected to Mt. Ōmine) and local authorities concocted a new plan to include the shrines of Kumano, Mt. Kōya, Yoshino–Mt. Ōmine, and six pilgrimage routes connecting them (McGuire 2013, 331). Japan's Agency for Cultural Affairs (Bunkachō, hereafter ACA) added "Sacred Sites and Pilgrimage Routes in the Kii Mountain Range" (*Kii sanchi no reijō to sankei michi*) to its tentative list in 2000; the nomination was added to the UNESCO World Heritage Tentative List the following year.

The World Heritage campaign received broad support from religious devotees and local community members, but not all supported the endeavor—some people, in fact, mobilized in opposition to it. In 2001, the Nara Women's History Research Group (Nara Joseishi Kenkyūkai, founded in 1996), for example, organized a symposium with local residents, mountain devotees, and the tourism board of Dorogawa, a small village at the southern base of Sanjōgatake,

to discuss gender discrimination in the context of tradition and custom at the mountain (Okura 2001, 32). In 2003, the I-Net Women's Association of Nara (Ai-netto Josei Kaigi Nara, founded in 1962) called meetings with Nara prefectural authorities, the World Heritage promotional committee, and the three Shugendō temples cited above to discuss women's exclusion in the context of the World Heritage designation (Usui 2005, 208).

That same year, scholar and advocate Minamoto Junko launched an association with the specific aim of lifting the ban on women at Mt. Ōmine ("Ōminesan Nyonin Kinsei" no Kaihō o Motomeru Kai). Minamoto's group collected more than twelve thousand signatures protesting the designation, ranging from women who had flaunted the ban and climbed Mt. Ōmine to Dorogawa local people and even male temple priests. The signatures were sent along with a petition to review the legality of women's exclusion to various national, prefectural, and local parties engaged in the World Heritage effort, as well as to the World Heritage Centre. A large sum of public tax money had been used to promote the World Heritage campaign, the petition asserted, and several roads and trails within the restricted realm occupy public land and had received public funds for repairs.[16] The document also charged that the ban on women violated the United Nations Convention for Elimination of All Forms of Discrimination against Women (adopted in 1979 and ratified by Japan in 1985), the Japanese Constitution, the 1999 Fundamental Law on Gender Equality (Danjo kyōdō sankaku shakai kihonhō), and numerous other prefectural and local regulations.[17] On the ground, moreover, small protests erupted at the trailheads to Sanjōgatake and on the temple steps in Yoshino and Dorogawa. Others opted for less polite means of expressing disapproval, as evidenced by the vandalization of the gates and signposts meant to stop women from climbing the restricted peak.

None of the opposition efforts were effective in halting the bid. Citing "tradition" and rejecting the notion that exclusionary practices were discriminatory or illegal, Mt. Ōmine's managing bodies, local community leaders, prefectural authorities, and other major stakeholders in the effort responded by reaffirming with a united voice that the mountain would remain closed to women. In the months leading up to the World Heritage decision, the managing bodies of Sanjōgatake (a collective of five area temples) installed a new signboard at all four gates of the bounded realm declaring that the ban would "resolutely" remain in place. Women's exclusion, the notice read, was a religious tradition constructed by a myriad people—including many women—over the course of a thousand years and must be respected.[18]

Whereas parties on both sides of the issue openly acknowledged the existence of (and ongoing controversy over) women's exclusion, the 260-page nomination dossier for "Sacred Sites and Pilgrimage Routes in the Kii Mountain Range" authored by the ACA and accepted by the World Heritage Committee makes not a single mention of it (Government of Japan 2004). The document describes Mt. Ōmine as "the most important sacred mountain" whose

reputation "had reached as far as China" by the tenth century, clearly referencing the Chinese encyclopedia (ibid., 21). The carefully crafted dossier, which marks the culmination of over a decade of planning and approval at various levels of authority, consciously omits one of the most significant features of Mt. Ōmine.

Okinoshima

We find a similar state of affairs in the case of Okinoshima. Okinoshima rises from the rough waters of the Genkai Sea roughly sixty kilometers from the coast of northern Kyushu, a tiny speck of land barely four kilometers in circumference (see Figure 4.2). The island is small, remote, and uninhabited, save for a single male priest of Munakata Grand Shrine, yet it occupies a central node in current representations of Japan's cultural and religious heritage. The twentieth-century excavation of a massive cache of archaeological remains on the island catapulted it to global fame, inspiring grand narratives about Japan's premodern polity and modern nation.[19] Unlike many other ancient sacred sites in Japan, moreover, the significance of Okinoshima and Munakata in the mythology of the early Yamato rulers' imperial-style sphere (fifth to eighth centuries) can be documented. Japan's official dynastic history, the *Nihon shoki* (Chronicles of Japan, compiled 720), and two other premodern texts purported to record

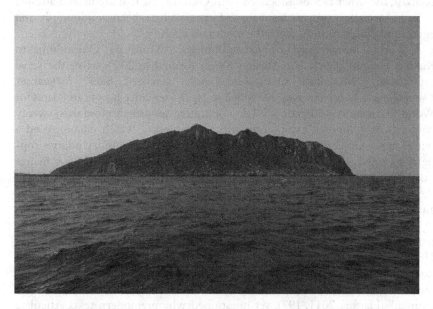

Figure 4.2 Okinoshima photographed by the author, a woman who received permission from Munakata Grand Shrine to circle the island by boat from a distance of two kilometers, 2017.

ancient histories of the gods, the *Kojiki* (Record of Ancient Matters, compiled 712?) and the *Kujiki* (Record of Matters from the Past, compiled tenth century?), characterize Okinoshima (here referred to as Okitsushima) as the abode of one of the three Munakata goddesses who are today worshipped at the three locations of Munakata Grand Shrine: Okinoshima, Ōshima, and Tashima.[20]

Munakata Grand Shrine presently enforces a set of religious taboos on the island: taboos regarding water purification, speaking about the island, removing anything from the island, and women accessing the island. Okinoshima's least understood and most sensitive taboo concerns the exclusion of women. Female deities are worshipped at the three Munakata Shrines, yet shrine authorities prohibit all women from landing ashore. According to one popular perspective, women's bodily impurities would defile the island, anger its female deity, and provoke calamities. Lore concerning jealous and angry female deities can also be heard at other sacred sites in Japan that did or do prohibit women, including Mt. Ōmine. Although it is a binding regulation today, and despite the widely repeated claim that no woman has ever touched foot on Okinoshima's rocky shores, this taboo is surprisingly difficult to historicize. To my knowledge, no premodern sources (including detailed accounts of the island and its associated taboos written in the eighteenth century) make any mention of women's exclusion from the island. Available sources, drawn mostly from oral accounts, suggest that the ban crystallized in the modern period and has more to do with the professions of fishermen and military matters than anything else. In contrast, the other taboos associated with Okinoshima that are indeed attested to in historical documents from the Edo period have been continuously and egregiously broken throughout the twentieth century.

A World Heritage promotional committee ("Munakata, Okinoshima to Kanren Isangun" Sekai Isan Suishin Kaigi) formed in 2009, when the serial nomination "Munakata, Okinoshima and Associated Sites" (*Munakata, Okinoshima to kanren isangun*) was added to Japan's tentative list of candidates for World Heritage consideration.[21] The committee sponsored more than twenty conferences, symposia, exhibitions, and study reports, which encompassed a wide range of disciplines (e.g., archaeology, history and prehistory, politics, topography, regional exchange and comparison, religion and ritual).[22] A manga titled *Umi no tami Munakata: Genkainada no mamorigami* (Munakata, people of the sea: the gods who protect the Genkai Sea) was published in 2015 under the auspices of the promotional committee as well.

Little evidence of discussion or debate—disclosure even—regarding women's exclusion can be found in materials related to Okinoshima's World Heritage effort. Within the 1092 pages of study reports published between 2011 and 2013, for instance, women's exclusion appears only a handful of times. Historian Hattori Hideo wrote that "the Munakata goddesses are tender to women" (Hattori 2011, 197), yet questioned why premodern texts articulate all other taboos except for the prohibition of women. Kawakubo Noriko of Munakata Grand Shrine acknowledged that "it is difficult to find answers about

the psychological and chronological origins of the system of not allowing women on the island according to the religious faith in the Three Goddesses of Munakata" (Kawakubo 2011, 335). Shinto scholar Norman Havens offered the intriguing proposition that female shamans (*miko*), who held an important role in "proto-Shinto," may have been riding on board ships with male priests and could have even had a presence on Okinoshima in the early ritual phases, but were subsequently banned from the island after the introduction of Buddhism (Havens 2012, 90–91). The ban on women is mentioned in passing on four other occasions in the extensive study reports (Akimichi 2012, 164; Kaner 2012, 52; Mori 2011, 285; Mori 2013, 103).

The 2015 promotional manga discusses women's exclusion in the most detail. One episode weaves together a historical event—the offering of Munakata Amako no Iratsume, daughter of Munakata no Kimi Tokuzen, as a consort to Prince Ōama no Miko (631–686), a young man who would later ascend the throne as the Heavenly Sovereign Tenmu (r. 673–686)—with a fictional account of a young girl learning the "rule" (*okite*) of women's exclusion from Okinoshima. The girl's father refuses to take her to the island, instructing her to learn from her mother how to cook while he and the other men go to sea. The episode climaxes with the girl standing alone, looking out to sea, with tears streaming down her face. "Why was I not born a boy?" she asks the gods (Ōga and Munakata City World Heritage Promotion Committee 2015, 172) (see Figure 4.3).

なんであたし
男に生まれ
なかったんだろ

そしたらこんな
思いしなかったのに…

Figure 4.3 Iratsume lamenting her female birth. In *Umi no tami Munakata: Genkainada no mamorigami* (Ōga and Munakata City World Heritage Promotion Committee 2015), 172. Photo courtesy of the promotion committee.

In other forums unrelated to the World Heritage effort, the shrine's access policies gained steady attention from July 2015, when Okinoshima's tentative World Heritage status was publicly announced. Countless news reports, domestic and international, questioned outright whether a male-only island should be confirmed as World Heritage. As an example, the US-based Universal Society of Hinduism issued a written appeal to the World Heritage Committee, urging them to reject the inscription unless women were permitted the same status as men on the island. The society's president, American-Indian Rajan Zed, pointed out that gender equality is one of UNESCO's two "Global Priorities," and that the organization ought not reward sites that "refused to treat women with [the] equality and respect they deserved" (*Eurasia Review* 2017).[23]

In July 2017, the World Heritage Committee decided to inscribe "Sacred Island of Okinoshima and Associated Sites in the Munakata Region" on the World Heritage List. The external advisory body evaluation by the International Council on Monuments and Sites (ICOMOS) noted twice that no women are allowed on the island (ICOMOS 2017, 137, 147). Two passing mentions of women's exclusion can be found buried within the 291-page nomination text, which was prepared by the ACA and accepted by the World Heritage Committee. First, the description of the nominated properties notes Okinoshima's taboos and states that "women are not allowed to visit the island" (Government of Japan 2017, 32). Second, the section titled "Faith and taboos today" states that "historical documents from the seventeenth century mention the island and its taboos, such as the prohibition of women visiting the island, and the prohibition of visitors removing any object from the island, even a tree branch or a pebble" (Government of Japan 2017, 92). To my knowledge, no historical documentation about Okinoshima and Munakata shrine exists from the seventeenth century at all. In the early eighteenth century, Kaibara Ekken (1630–1714) published two new histories of the Chikuzen region (present-day Munakata) and the shrines, and in those histories stipulated taboos associated with Okinoshima, but women's exclusion is not included among them.[24]

Neither the "Executive Summary" of the site's nomination file written by the Japanese government nor the "Statement of Outstanding Universal Value" adopted by the World Heritage Committee—in short, the official World Heritage descriptions of Okinoshima—disclose the fact that women specifically are excluded.[25] The "Executive Summary" notes that "the people of the Munakata region today still uphold strict taboos limiting access to the island and worshipping it from afar" (Government of Japan 2017, 5). The "Statement of Outstanding Universal Value" states only that "[e]xisting restrictions and taboos contribute to maintaining the aura of the island as a sacred place" (UNESCO 2017, 19).

At the forty-first session of the World Heritage Committee in July 2017, just before the inscription of Okinoshima was affirmed, the Japanese delegation was asked to explain the island's male-only access. The response, read by Satō Kuni, the sole female Ambassador of the Permanent Delegation of Japan

to UNESCO, was brief: "As a matter of principle, the access to the island of Okinoshima has been restricted to the priests of the Munakata Grand Shrine and priests are male by its tradition."[26] Men's access to Okinoshima is indeed also strictly limited today, but this was not always the case. From the late nineteenth century until 1952, the island was owned by the Japanese government and used for military purposes, to which end more than two hundred soldiers were stationed on Okinoshima at points during the Russo-Japanese and Pacific Wars. From 1963, men were permitted on the island once a year (27 May) to commemorate a 1905 naval battle. Munakata Grand Shrine canceled this event in perpetuity on 15 July 2017, six days after the World Heritage inscription was confirmed, stating that they would like to plan a commemorative event open to all.

Creating heritage, erasing tradition?

How can we account for the paradoxical exclusion of women's exclusion from World Heritage documentation on Mt. Ōmine and Okinoshima? Although a full explanation for the omission is beyond the scope of this chapter, here I will briefly explore two avenues of investigation, one specific to women's exclusion and one more general concerning the meaning and practice of heritage.

First, I draw attention to the predominant framing of women's exclusion by academic, religious, and political authorities in Japan. The interpretive model put forth by Yanagita Kunio, the famous folklorist mentioned above, continues to influence scholarly and public perspectives. Yanagita argued that "natural and universal" (Yanagita 1916, 1) differences exist between men and women, and that a fundamental gender divide dictates which realms men and women can inhabit. Furthermore, Yanagita contended that, on the one hand, men fear women's power and so suppress their role in religious rituals, while, on the other hand, sacred space itself (or the deities that occupy it) possesses supernatural powers and a woman's transgression could literally turn her into a stone or a twisted tree. The "history" of women's exclusion that followed, penned by a string of male Japanese folklore scholars following Yanagita's lead, highlights these underlying symbolics and relies upon traditional literary accounts to explain and in some cases defend women's prohibition from certain "traditional" practices and sites.[27]

Palpable traces of Yanagita's essential (and essentializing) views of gender and space continue to circulate, especially at conservative religious establishments. Consider, for example, the framing of women's exclusion by Buddhist and Shinto authorities who participated in the World Heritage campaigns at Mt. Ōmine and Okinoshima. Gojō Kakugyō, former chief abbot of Kinpusenji (a Buddhist temple in Yoshinoyama and one of three main Shugendō-affiliated Buddhist temples connected to Mt. Ōmine) who also served a term as head priest of Ōminesanji (the temple on the restricted peak Sanjōgatake), writes of the prohibition as a religious matter rooted in gender distinction (*kubetsu*)

rather than discrimination (*sabetsu*) (Gojō 1998, cited in McGuire 2013, 347–348). According to Tanaka Riten of Kinpusenji, the former head regent of the temple and chancellor of religious affairs of the Kinpusen lineage of Shugendō who led the drive for Mt. Ōmine's 2004 inscription, it is the man's role to conduct "training" (*shugyō*) at Sanjōgatake and then return home and bestow religious purification upon his wife and children (Tanaka 2015).

Nearly a century earlier, in 1936, Miyagi Shinga, former head priest of the temple Shōgoin in Kyoto (headquarters of the Honzan lineage of Shugendō), advanced a similar argument. In 1936, Miyagi described Sanjōgatake as a physical domain that mirrored "heavenly endowed differences between men and women" (Miyagi 1936, 3). He stated that stripping the mountain of its defining characteristic—a 1200-year-old religious tradition of male-only access—would destroy its sacredness and uniqueness. At the time Miyagi wrote this, Sanjōgatake (and the entire Ōmine mountain range) had just been designated as part of Yoshino-Kumano National Park (designated in 1936), a process that sparked heated debate over the mountain's access policies. Shortly after the designation, local residents and Shugendō devotees decided to recognize female climbers to Sanjōgatake so long as they did not enter the main hall at the mountaintop, but the decision was stopped by area mountain ascetics (*yamabushi*) who, armed with swords, formed a human chain to block the passage of women (Masutani, in discussion with the author, 19 July 2014). Then, after two newspaper articles falsely claimed that the mountain would be open to women for the first time that climbing season, powerful proponents of the ban (thirty-one men, including temple priests, leaders of powerful climbing guilds, headmen of the towns of Yoshino and Dorogawa, and National Park officials) banded together and with the approval of the governor of Nara Prefecture established women's exclusion as a "mountain rule" (*sanki*) in April 1936 ("Ōminesan nyonin kaihi mondai to kinsei iji ketsuji" 1936, 7). With eerie similarity to the events of 2004, National Park officials chose not to disclose women's exclusion in park literature, thus rendering invisible one of the park's most famous (and infamous) features.[28] Other conflicting matters, including private land ownership, logging on proposed park grounds, and industry interests, were resolved by simply redrawing the park map to exclude affected areas.

We can gauge the framing of women's exclusion on the Shinto side by looking at the position taken by the Association of Shinto Shrines (Jinja Honchō), a religious organization founded in 1946 with the explicit aim of "preserv[ing] Japanese religious tradition" (Jinja Honchō 2018). The Association wields considerable power, acting as a political lobbying group and as a religious organization that administratively guides the majority of the nation's shrines through such activities as setting ritual standards and appointing priests (the current head priest of Munakata Grand Shrine, Ashizu Takayuki, received his appointment from the Association). Through its affiliate political group Shintō Seiji Renmei (Shinto Association of Spiritual Leadership), Jinja Honchō actively lobbies to repeal the 1999 Fundamental Law on Gender Equality. It strongly advocates

for "distinctions based on sexual difference" (*danjokan no seisa no kubetsu*) and opposes the 1999 law because it promotes gender equality "without regard to sex" (*seibetsu ni kakawari naku*) (Hardacre 2005, 241–242).[29]

Women's exclusion is presented as a neutral form of differentiation—not discrimination—in publications from UNESCO as well, despite the fact that the organization "promises" gender equality. *UNESCO's Promise: Gender Equality, a Global Priority*, a digital publication, emphasizes that UNESCO employs an approach of "gender mainstreaming in all programmes and activities" (UNESCO 2014, 3) and defines gender equality as situations in which "women and men equally enjoy the right to access, participate and contribute to cultural life" (UNESCO 2014, 14). In the preface to "In Focus: World Heritage and Gender Equality" (UNESCO 2016), a special edition of *World Heritage*, the journal of the World Heritage Centre, Centre Director Mechtild Rössler writes of "separate access for men and women only" at Japanese mountains (UNESCO 2016). In the same publication, mountaineer and comparative religion scholar Edwin Bernbaum recounts his journey up sacred Sanjōgatake and his wife's trek up a nearby peak, Inamuragatake, which is occasionally (although not historically) referred to as "Women's Ōmine" (*Nyonin Ōmine*) (Bernbaum and Inaba 2016, 23). Bernbaum fails to mention that Inamuragatake is enjoyed as a popular day hike by men and women alike, or that, unlike Sanjōgatake, no worship facilities or ritual sites can be found along the trail or at the summit (see DeWitt 2015, 152–155). In a second piece on Mt. Ōmine, heritage studies scholar Nobuko Inaba states that "Shugendo makes gender distinctions that place restrictions on women" and argues that the ban "should be dealt with primarily by its religious administration and their supporting local communities and followers" (Bernbaum and Inaba 2016, 24). Yet the claim of gender restrictions in Shugendō is false. Female Shugendō practitioners are widely acknowledged as a substantial (and continually rising) demographic today, comprising between thirty and fifty percent of instructors at Daigoji, Shōgoin, and Kinpusenji (Bunkachō 2018b). The head priests of those same temples even attempted to lift the ban on women in 1999, as noted above.

Echoing Yanagita and the folklore studies approach, the foregoing modes of interpretation reify the persistent and problematic perception of women's exclusion as an ancient and unchanged—indeed, unchangeable—religious tradition. By presenting women's exclusion as a strictly religious matter (as opposed to a social or political matter), religious and political authorities, who are simultaneously powerful heritage stakeholders, can explain the ban away or circumvent discussion of it altogether.

Second, we can cast light on the erasure of women's exclusion by zooming out and looking more generally at the forces at work in the promotion and maintenance of cultural heritage. Japan's Ministry of Foreign Affairs (Gaimushō) defines cultural heritage as "a symbolic presence that integrates the history, traditions and culture of a country, region, or community" (Gaimushō 2016). The UNESCO definition of cultural heritage sites spans "works of man or

the combined works of nature and man, and areas including archaeological sites which are of outstanding universal value from the historical, aesthetic, ethnological or anthropological point of view" (UNESCO 2008).Yet the realities of cultural heritage, in Japan or elsewhere, extend far beyond "symbolic presence" and "outstanding universal value." Countless studies of cultural heritage in Western contexts have clarified the deeply intertwined nature of heritage, power, and wealth.

Today, Japanese governmental agencies pour substantial resources into creating heritage. Funding from the ACA allocated to "preservation, utilization and succession of Japan's precious cultural properties," which supports tangible World Heritage Sites and domestic designations, amounted to 4.6 billion yen for the 2017 fiscal year and 4.7 billion yen for the 2018 fiscal year (Bunkachō 2018a). Prefectural and municipal as well as corporate and private revenues supplement national efforts and vary from case to case. As noted above, the three prefectural governments involved in the 2004 "Sacred Sites and Pilgrimage Routes in the Kii Mountain Range" inscription, which includes Mt. Ōmine, contributed roughly 182 million yen of public tax money to the effort over the three years leading up to the designation. Considering both the substantial financial costs and the expected financial rewards of a successful World Heritage designation, the disregard or silencing of oppositional voices might be expected.

Furthermore, because an elite cultural accolade like World Heritage status secures soft power and prestige for the nation, States Parties (in UNESCO terminology) tend to present selective and aggrandized visions of history, in particular those that reinforce national narratives and identities. As an example, Korea was largely marginalized in the World Heritage presentation of Okinoshima, but many of the ancient artifacts found on the island originate from the Korean peninsula, and transregional and transcultural interaction can be documented from the earliest phase of Okinoshima rituals.[30] In short, state instruments support and manage the vast majority of established cultural heritage resources, and thus cultural heritage ends up serving state interests. As a consequence, alternative or competing aspects of history that do not aid in and could in fact jeopardize the ultimate goal of securing World Heritage status are frequently airbrushed or ignored. Heritage and geography scholars John Tunbridge and Greg Ashworth discuss this as "dissonance" and argue that it forms an intrinsic part of heritage, one that "keeps at the forefront the ideas of discrepancy and incongruity" (Tunbridge and Ashworth 1996, 20). Notably, heritage studies scholar Sophia Labadi's examination of World Heritage nomination dossiers discerns a clear marginalization of women, finding them positioned "at the margin of the text, history and heritage" and rendered "invisible, secondary and forgettable" (Labadi 2013, 92).

In addition to women's exclusion, the dossiers on Mt. Ōmine and Okinoshima omit other important elements of each site's biography. As noted above, the World Heritage presentation of Okinoshima privileges a particular narrative about Japan and diminishes the significance of Korea. The dossier on

Mt. Ōmine ignores key historical moments, such as the Meiji government's forced separation of Buddhist and Shinto practices (*shinbutsu bunri*) in the late nineteenth century and its devastating effects on Mt. Ōmine, and disregards the matter of discontinuous and unsubstantiated pilgrimage routes, which have been a topic of interest in Japan and appeared in the ICOMOS evaluation as potentially impinging upon the integrity of the nomination (ICOMOS 2004, 39). The ACA and Nara Prefecture have resisted bestowing domestic heritage status on the trail because it cannot be sufficiently documented as a historical route, largely due to the Meiji-era prohibition of Shugendō and the loss of the original routes (McGuire 2013, 331; DeWitt 2015, 35, 113–114). Here, as documented in many other general studies of heritage, cultural continuity supersedes historicity. Why, then, omit women's exclusion, which supporters consider as a valuable marker of cultural continuity?

Conclusion

Sketching the modern trajectory of women's exclusion within social and political discourses on tradition and heritage allows us to discern two distinct yet overlapping mobilizations of the past. First, the past denotes that against which the modern is measured: women's exclusion represents an anachronistic and inappropriate custom, precisely as charged by opponents. Second, specific cultural practices from the past come to be regarded as bearers of cultural continuity: women's exclusion represents a unique and unquestionable Japanese tradition, the position taken by religious and political authorities. Curiously, however, both mobilizations of the past can be observed simultaneously in contemporary cultural heritage discourse. On the one hand, the handling of women's exclusion in World Heritage documentation recalls the Meiji government's legal abolition of it (and of other religious practices, too) as a means to position Japan favorably vis-à-vis Western nations. On the other hand, by permitting the practice on the ground and framing it as an accepted form of religious gender differentiation, the current administration's understanding of religion (as set apart, beyond the realm of politics) contrasts the Meiji situation and instead recalls the Shōwa-era folklore studies perspective.

Just what do the cases presented in brief here enable us to say about religion, tradition, and the assessment and designation of Japan's cultural heritage, especially at the level of UNESCO World Heritage? Three points stand out. First, they divulge a disjuncture between putative ancient origins, historical and material records, observable present-day practices, and selective heritage presentations. Second, they demonstrate how certain aspects and agents of history and culture are highlighted and others softened (if not erased completely) in the creation of a coherent and compelling heritage narrative. Third, they reveal the lingering presence of early-twentieth-century conceptions of "tradition," and specifically "Japanese tradition," which have in other contexts been

exposed as problematic and nationalistic. Further research will, I hope, enrich our understanding of how the documented history and scrutiny of a single religious practice, women's exclusion, can inform our study of broader discourses on modernity, tradition, and heritage—and vice versa.

Notes

1 The material presented here forms part of a larger manuscript project, which includes two additional case sites: Mt. Fuji, where women were banned from religious pilgrimage until 1860 by male climbing guilds and shrine authorities, and Sēfa Utaki in Okinawa, where men were banned from religious ritual sites until the late twentieth century. On the latter site, see also the chapter by Aike P. Rots in this volume.

2 Mt. Athos is a remote, mountainous peninsula home to an Orthodox monastic community of more than two thousand monks. The twenty monasteries are only accessible by boat, and with advance permission. Athonite monks uphold the *avaton* rule, a prohibition of women (and female animals), as a longstanding religious tradition they trace back to the Virgin Mary herself, who purportedly claimed exclusive rights to the area. See, e.g., Alexopolous and Fouseki (2016).

3 See, for example, Brumann and Cox et al. (2010), Pai (2014), Akagawa (2015), and Matsuda and Mengoni et al. (2016).

4 To my knowledge, the phenomenon of men's exclusion developed only in the Ryukyu Islands, where female spirit mediums (*yuta*) served as ritualists. These women were classed with prostitutes by the Meiji government following Japan's annexation of Okinawa in 1879. See Barske (2013).

5 According to Grand Council of State Edict 98 (*dajōkan fukoku dai 98 gō*) of 4 May 1872, "Any sites of women's boundaries on shrine and temple lands shall be immediately abolished, and mountain climbing for the purpose of worship, etc., shall be permitted" (Naikaku kanpōkyoku 1974, 82). For more on the edict and its reception, see DeWitt (2015, 59–88). Note that female climbers were already permitted at Mt. Fuji by 1860; they were not welcomed at the sacred Buddhist Mt. Kōya in Wakayama Prefecture until 1906.

6 This widely repeated claim of exceptionalism is not entirely true. Mt. Ushiro in Okayama Prefecture, Mt. Uzō in Ōita Prefecture, and Mt. Ishizuchi in Shikoku also officially maintain male-only policies in certain areas and on certain occasions.

7 Adding to the confusion, both Mt. Ōmine (a region and a route) and Sanjōgatake (a single peak) in today's Yoshino District appear in premodern sources as the "Gold-Peak Mountain" (Kinpusen) or "Peak of Gold" (Mikanenotake).

8 Shugendō is a practice of spiritual attainment. It roughly translates as a way (*dō*) of a method (*shu*) to attain "signs" or "evidence" (*gen*). Whether classified as "Shugendō" or not, Shugendō-like practices and beliefs have long proliferated in Japan's mountains. They embrace gods and nature, esoteric Buddhist rituals and deities, and Daoist elements, all selectively emphasized and locally adapted.

9 Four sutra containers belonging to Fujiwara no Michinaga (966–1028) and his successors have been excavated from the peak and are today recognized as National Treasures (*kokuhō*). On Mt. Ōmine in the premodern period, see Blair (2015).

10 The encyclopedia is also known as *Shishi liutie* (Jp. *Shakushi rokujō*). See Yichu and Fushu (1979). For the Chinese original, see Yichu (1990).

11 As an example, Kyōtani Tomoaki, head of the Tenkawa Study Club in Dorogawa, believes that much of the text is exaggerated, if not fabricated, and most likely a product of later generations. Kyōtani, interview with the author, 2 August 2015.

12 See Suzuki (2002); Ushiyama (2009); Katsuura (2009); Taira (1992).

13 Caleb Carter's research on women's exclusion from Mt. Togakushi in Nagano prefecture, for instance, similarly finds a "highly ambiguous picture of the policy, its physical boundaries and the degree of consensus" (Carter 2014, 40).

14 A four-meter-tall stone pillar inscribed with the words *kore yori nyonin kekkai* ("women's restricted zone from this point on") stands at the main trailhead to Sanjōgatake. Accompanying it is a wooden gate approximately three meters tall bearing the words *nyonin kekkai mon* ("women's restricted zone gate") and a two meter-tall signboard stating in English and Japanese, "'No Woman [sic] Admitted': Regulation of this holly [sic] mountain Ominesan prohibits any woman from climbing farther through this gate according to the religious tradition."

15 For more on this attempt to open the mountain to women, see the official publication of the temple consortium (En no Gyōja 1300-nen Go-onki Kiroku Hensan Iinkai 2003). See also DeWitt (2015, 116–129, 166).

16 As charged in the petition, the prefectural budgets for World Heritage Site promotion and related commemorative projects amounted to roughly eighty-two million yen in 2002, seventeen million yen in 2003, and eighty-three million yen in 2004 (DeWitt 2015, 110). See also www.on-kaiho.com/action/20040828.html.

17 For a list of the other regulations noted, see the website of the association: www.on-kaiho.com/action/action_top.html.

18 At the time of writing (July 2019), the notice remained posted at all four gates. The full text of the notice, titled "Request to Mountain Climbers," has been posted online on various personal blogs, including https://ameblo.jp/tribune-ns0731/entry-11554757994.html.

19 Three intensive rounds of archaeological excavations (1954–1955, 1957–1958, and 1969–1971) yielded some eighty thousand artifacts that date from the fourth to the ninth century and attest to robust and flourishing trade between the archipelago, the Korean peninsula, and the continent. The ritual goods range from a miniature golden loom to gilt-bronze horse trappings, bronze mirrors, iron swords, comma-shaped beads, ceramics, and much more, the entire lot of which is collectively designated a National Treasure.

20 Okitsumiya on Okinoshima enshrines Takiribime no mikoto. Nakatsumiya on Ōshima, eleven kilometers off the coast, enshrines Takitsuhime no mikoto. Hetsumiya in Tashima on the Kyushu mainland enshrines Ichikishimahime no mikoto.

21 The campaign to make Okinoshima World Heritage gained speed from 2002, when Waseda University archaeologist Yoshimura Sakuji affirmed publicly at a symposium held in Munakata that "Okinoshima is worthy of World Heritage" (Maeda 2017). The same year, the locally formed "Committee to Realize 'The Okinoshima Story'" (Okinoshima Monogatari Jikkō Iinkai) organized the "Munakata Grand Shrine Great National Treasures Exhibition" (*Munakata Taisha dai kokuhō ten*). When the ACA sought proposals from local governments for candidates to be added to the World Heritage Tentative List in 2006, Fukuoka Prefecture, Munakata City, and Fukutsu City submitted "Okinoshima and Associated Sites" (*Okinoshima to kanren isangun*) for consideration.

22 See, for example, "Munakata, Okinoshima to Kanren Isan-gun" Seikaiisan Suishin Kaigi (2011–2013).

23 Zed, an outspoken American Hindu man who delivered the first ever Hindu prayers at the United States Senate in 2007, has been a vocal critic of gender inequality in India and of the misappropriation of Hindu symbolism.

24 See Kaibara (1709, 1973 [1711]).

25 "Outstanding universal value" (OUV) the central concept of the World Heritage Convention, has been rigorously questioned and challenged over the past thirty years. On contested definitions of OUV, see Jokilehto (2006) and Cleere (2001).

26 Video recording from the 41st Session of the World Heritage Committee, Krakow, Poland, 9 July 2017, morning session, 1:14:06–51. https://youtu.be/-qz3hmdMiMg.

27 See, for example, Iwashina (1968), Miyake (1988), and Suzuki (2002). At the same time, Yanagita and others also wrote idealistic and exotic accounts of female ritual power (onarigami) in Okinawa. On this, see Wacker (2003) and Kawahashi (2000).

28 The official line celebrates Mt. Ōmine as a "profound" and "protected" mountainous area, regarded since ancient times as "the sacred dwelling places of holy spirits and ancestral souls," where "pilgrims ascend" and many ruins and cultural artifacts can be found. See www.env.go.jp/park/yoshino/guide/view.html. For a detailed account of the National Park campaign and the setting of women's exclusion as mountain rule, see DeWitt (2015), 92–120.

29 According to Hardacre, the Association also seeks to bar married women from using their maiden names, to prevent the enthronement of a female emperor, and to thwart gender equal education (2005, 242).

30 The Republic of Korea delegation, dismayed at the nationalist presentation of Okinoshima at the World Heritage Committee session, openly questioned whether "politically motivated purposes" lay behind the campaign. Nevertheless, the Korean delegation did favor the World Heritage inscription in the end on the condition that Japan make "every effort to implement recommendations made by this committee." Video recording from the 41st Session of the World Heritage Committee, Krakow, Poland, 9 July 2017, morning session, 1:15:40–19:08. https://youtu.be/-qz3hmdMiMg.

References

Akagawa, Natsuko. 2015. *Heritage Conservation and Japan's Cultural Diplomacy: Heritage, National Identity and National Interest.* Abingdon: Routledge.

Akimichi, Tomoya. 2012. "Ocean Civilization in East Asia and the World of Maritime People: Foundation of the Munakata/Okinoshima Sites." In *"Okinoshima Island and Related Sites in the Munakata Region" Study Report II/2,* edited by World Heritage Promotion Committee of "Okinoshima Island and Related Sites in the Munakata Region," 127–144. Fukuoka: World Heritage Promotion Committee of "Okinoshima Island and Related Sites in the Munakata Region."

Alexopoulos, Georgios, and Kalliopi Fouseki. 2016. "Gender Exclusion and Local Values versus Universal Cultural Heritage Significance: the Avaton Debate on the Monastic Community of Mount Athos." *European Journal of Post-Classical Archaeologies* 6: 235–254.

Barske, Valerie H. 2013. "Visualizing Priestesses or Performing Prostitutes? Ifa Fuyū's Depictions of Okinawan Women, 1913–1943." *Studies on Asia* Series IV, 3 (1): 65–116.

Bernbaum, Edwin, and Nobuko Inaba. 2016. "Mountains Divided: Kii Mountain Range." *World Heritage* 78: 20–25.

Blair, Heather. 2015. *Real and Imagined: The Peak of Gold in Heian Japan.* Harvard University Asia Center.

Brumann, Christoph, and Rupert A. Cox, eds. 2010. *Making Japanese Heritage.* London: Routledge.

Bunkachō. 2018a. *Policy of Cultural Affairs in Japan.* Accessed 28 July 2019, www.bunka. go.jp/english/report/annual/pdf/r1394357_01.pdf.

Bunkachō. 2018b. *Shūkyō nenkan Heisei 30 nendo ban.* www.bunka.go.jp/tokei_ hakusho_shuppan/hakusho_nenjihokokusho/shukyo_nenkan/pdf/h30nenkan.pdf.

Carter, Caleb Swift. 2014. "Producing Place, Tradition and the Gods: Mt. Togakushi, Thirteenth through Mid-Nineteenth Centuries." PhD dissertation, University of California, Los Angeles.

Cleere, Henry. 2001. "The Uneasy Bedfellows: Universality and Cultural Heritage." In *Destruction and Conservation of Cultural Property,* edited by Robert Layton, Peter G. Stone, and Julian Thomas, 22–29. London: Routledge.

Dentō to Geijutsu no Kai, ed. 1968. *Dentō to wa nani ka.* Gakugei Shorin.

DeWitt, Lindsey E. 2015. "A Mountain Set Apart: Female Exclusion, Buddhism, and Tradition at Modern Ōminesan, Japan." PhD dissertation, University of California, Los Angeles.

En no Gyōja 1300-nen Go-onki Kiroku Hensan Iinkai. 2003. *Shinjidai ni muketa Shugen sanbonsan no kiseki.* Kokusho Kankōkai.

Eurasia Review. 2017. "Hindu Group Asks UNESCO to Deny Japan's Okinoshima Island Heritage Status." 9 May 2017. www.eurasiareview.com/09052017-hindu-group-asks-unesco-to-deny-japans-okinoshima-island-heritage-status/.

Gaimushō. 2016. *Outline of the United Nations Educational, Scientific and Cultural Organization (UNESCO).* Accessed 27 July 2019, www.mofa.go.jp/policy/culture/coop/unesco/outline.html.

Gojō Kakugyō. 1998. "Kinsei no dentō wa kichō." *Kinpusenji jihō* 372: 6–7.

Government of Japan. 2004. *Nomination of Sacred Sites and Pilgrimage Routes in the Kii Mountain Range for inclusion on the World Heritage List.* Accessed 28 July 2019, https:// whc.unesco.org/uploads/nominations/1142.pdf.

Government of Japan. 2016. *Sacred Island of Okinoshima and Associated Sites in the Munakata Region. Nomination Dossier.* Accessed 28 July 2019, http://whc.unesco.org/document/155964.

Government of Japan. 2017. *Executive Summary of Sacred Island of Okinoshima and Associated Sites in the Munakata Region.* Accessed 28 July 2019, https://whc.unesco. org/document/155966.

Graburn, Nelson H. H. 2001. "What is Tradition?" *Museum Anthropology* 24 (2/3): 6–11.

Hardacre, Helen. 2005. "Constitutional Revision and Japanese Religions." *Japanese Studies* 25: 235–247.

Hariu Ichirō. 1966. *Gendai geijutsu to dentō.* Gōdō Shuppan.

Hattori, Hideo. 2011. "Islands of Munakata: History and Topography of Oronoshima, Okinoshima and Ōshima." In *"Okinoshima Island and Related Sites in the Munakata Region" Study Report I,* edited by World Heritage Promotion Committee of "Okinoshima Island and Related Sites in the Munakata Region," 169–220. Fukuoka: World Heritage Promotion Committee of "Okinoshima Island and Related Sites in the Munakata Region."

Havens, Norman. 2012. "Okinoshima Seen from Shintō." In *"Okinoshima Island and Related Sites in the Munakata Region" Study Report II/2,* edited by World Heritage

Promotion Committee of "Okinoshima Island and Related Sites in the Munakata Region," 83–92. Fukuoka: World Heritage Promotion Committee of "Okinoshima Island and Related Sites in the Munakata Region."

Hobsbawm, Eric J., and Terence O. Ranger, eds. 1983. *The Invention of Tradition.* Cambridge: Cambridge University Press.

ICOMOS. 2004. *Kii Mountain Range (Japan)* (No 1142 Bis). https://whc.unesco.org/document/154802.

ICOMOS. 2017. *Sacred Island of Okinoshima (Japan)* (No 1535). https://whc.unesco.org/document/159733.

Iwashina Kōichiro. 1968. *Yama no minzoku.* Iwasaki Bijutsusha.

Jokilehto, Jukka. 2006. "World Heritage: Defining the Outstanding Universal Value." *City & Time* 2 (2): 1–10.

Kaibara Ekken. 1709. *Chikuzen no kuni zoku fudoki*, 30 vols., 1709 manuscript. www.wul.waseda.ac.jp/kotenseki/html/ru04/ru04_00011/index.html.

Kaibara Ekken. 1973 [1711]. *Chikuzen no kuni zoku shosha engi.*Vol. 5 of *Ekken zenshū*, edited by Ekkenkai. Kokusho Kankōkai.

Kaner, Simon. 2012. "Okinoshima in World Perspective: Weaving Narratives of Ritual, Politics and Exchange." In *"Okinoshima Island and Related Sites in the Munakata Region" Study Report II/2*, edited by World Heritage Promotion Committee of "Okinoshima Island and Related Sites in the Munakata Region," 49–82. Fukuoka: World Heritage Promotion Committee of "Okinoshima Island and Related Sites in the Munakata Region."

Katsuura, Noriko. 2009. "Women and Views of Pollution." *Acta Asiatica* 97: 17–37.

Kawahashi, Noriko. 2000. "Religion, Gender, and Okinawan Studies." *Asian Folklore Studies* 59 (2): 301–311.

Kawakubo, Natsuko. 2011. "Archival Document Collections in Munakata Grand Shrine and Medieval and Modern History of Munakata Grand Shrine." In *"Okinoshima Island and Related Sites in the Munakata Region" Study Report I*, edited by World Heritage Promotion Committee of "Okinoshima Island and Related Sites in the Munakata Region," 293–336. Fukuoka: World Heritage Promotion Committee of "Okinoshima Island and Related Sites in the Munakata Region."

Labadi, Sophia. 2013. *UNESCO, Cultural Heritage, and Outstanding Universal Value: Value-Based Analyses of the World Heritage and Intangible Cultural Heritage Conventions.* Lanham: AltaMira Press.

Maeda Toshio. 2017. "Sekai isan Okinoshima 'ichibu jogai.'" *Mainichi shinbun*, 7 May 2017. https://mainichi.jp/articles/20170507/ddl/k40/040/272000c?ck=1.

Matsuda, Akira, and Luisa E. Mengoni, eds. 2016. *Reconsidering Cultural Heritage in East Asia.* London: Ubiquity Press.

McGuire, Mark. 2013. "What's at Stake in Designating Japan's Sacred Mountains as UNESCO World Heritage Sites? Shugendo Practices in the Kii Peninsula." *Japanese Journal of Religious Studies* 40 (2): 323–354.

Miyagi Shinga. 1936. "Ōminesan kankeisha narabi ni shugendō, shinkō tozansha ni yōbō su." *Shugen* 7 (78): 2–6.

Miyake Hitoshi. 1988. *Ōmine Shugendō no kenkyū.* Kōsei.

Mori, Hiroko. 2011. "Intangible Folk Cultural Properties of Munakata Grand Shrine." In *"Okinoshima Island and Related Sites in the Munakata Region" Study Report I*, edited by

World Heritage Promotion Committee of "Okinoshima Island and Related Sites in the Munakata Region," 253–292. Fukuoka: World Heritage Promotion Committee of "Okinoshima Island and Related Sites in the Munakata Region."

Mori, Kimiyuki. 2013. "Rituals on Okinoshima Island Seen from the History of Exchanges." In *"Okinoshima Island and Related Sites in the Munakata Region" Study Report III*, edited by World Heritage Promotion Committee of "Okinoshima Island and Related Sites in the Munakata Region," 103–137. Fukuoka: World Heritage Promotion Committee of "Okinoshima Island and Related Sites in the Munakata Region."

"Munakata, Okinoshima to Kanren Isangun" Sekai Isan Suishin Kaigi, ed. 2011–2013. *Munakata, Okinoshima to kanren isangun chōsa kenkyū hōkoku.* 4 vols. Fukuoka: "Munakata, Okinoshima to Kanren Isangun" Sekai Isan Suishin Kaigi.

Naikaku kanpōkyoku. 1974. *Meiji nenkan hōrei zensho: Meiji 5nen*, vol. 1. Hara shobō.

Ōga Mika, and Munakata City World Heritage Promotion Committee. 2015. *Manga umi no tami Munakata: Genkainada no mamorigami*. Fukuoka: Azusashoin.

Okura Ayako. 2001. "Kikigaki hōkoku: Tenkawa-mura Dorogawa." *Nara Joseishi Kenkyūkai* 5: 32–34.

"Ōminesan nyonin kaihi mondai to kinsei iji ketsuji." 1936. Shugen 78: 6–8.

Ōtsuka Eiji. 2004. *Dentō to wa nani ka*. Chikuma Shobō.

Pai, Hyung Il. 2014. *Heritage Management in Korea and Japan: The Politics of Antiquity and Identity*. University of Washington Press.

Smith, Laurajane. 2006. *Uses of Heritage*. London: Routledge.

Suzuki, Masataka. 2001. "The Present Situation of Japanese Folklore Studies." *Asian Research Trends* 11: 69–74.

Suzuki Masataka. 2002. *Nyonin kinsei*. Yoshikawa Kōbunkan.

Taira Masayuki. 1992. *Nihon chūsei no shakai to bukkyō*. Hanawa Shobō.

Tanaka Riten. 2015. "Josei to shugendō." *Yamabito no aru ga mama ni*. 21 September 2015. http://yosino32.cocolog-nifty.com/blog/2015/09/post-7a75.html.

Tunbridge, John E., and Greg J. Ashworth. 1996. *Dissonant Heritage: The Management of the Past as a Resource in Conflict*. Chichester: John Wiley.

Umehara Takeshi. 2010. *Nihon no dentō to wa nani ka*. Kyoto: Mineruva Shobō.

UNESCO. 2008. *Operational Guidelines for the Implementation of the World Heritage Convention* (WHC. 08/01 January 2008). Accessed 28 July 2019, http://whc.unesco.org/archive/opguide08-en.pdf.

UNESCO. 2014. *UNESCO's Promise: Gender Equality, a Global Priority*. Accessed 28 July 2019, http://unesdoc.unesco.org/images/0022/002269/226923m.pdf.

UNESCO. 2016. "In Focus: World Heritage and Gender Equality." Special edition, *World Heritage* 78. http://fr.calameo.com/read/0033299727c6f658f66ef.

UNESCO. 2017. *Sacred Island of Okinoshima and Associated Sites in the Munakata Region (Japan)* (Decision: 41COM 8B.19). Accessed 29 July 2019, http://whc.unesco.org/en/decisions/6891.

Ushiyama, Yoshiyuki. 2009. "The Historical Development of the Exclusion of Women from Sacred Places (Nyonin Kinzei) in Japan." *Acta Asiatica* 97: 39–55.

Usui Atsuko. 2005. "Tojiru seichi, aku seichi: 'Nyonin kinsei/nyonin kekkai' o meguru giron kara miete kuru mono." Special issue, Gendai shūkyō: 200–227.

Wacker, Monika. 2003. "Onarigami: Holy Women in the Twentieth Century." *Japanese Journal of Religious Studies* 30 (3/4): 339–359.

Yanagita Kunio. 1916 [1962]. "Rōjo kaseki tan." *Teihon Yanagita Kunio zenshū* 9. Chikuma Shobō.
Yanagita Kunio. 1936. *Yama no jinsei*. Kyōdo Kenkyū sha.
Yichu. 1990. *Shishi liutie*. Hangzhou: Zhejiang Guji Chubanshe.
Yichu and Fushu. 1979. *Giso rokujō*. Kyoto: Hōyū Shoten.

Whose sacred site?

Contesting World Heritage at Sēfa Utaki

Aike P. Rots

Introduction

In 2000, nine historical sites on the island of Okinawa were inscribed on the UNESCO World Heritage List.[1] Their official, collective name is "Gusuku Sites and Related Properties of the Kingdom of Ryukyu" (*Ryūkyū ōkoku no gusuku oyobi kanren isangun*). The best known of these Okinawan World Heritage Sites is undoubtedly Shuri Castle, the centre of power of the Ryukyu monarchy until its abolishment in 1879. In the course of the twentieth century, Shuri Castle has undergone dramatic changes, not only materially but also in terms of the meanings attributed to it (Loo 2014). Until recently, this castle was one of Okinawa's most-visited tourist sites. Sadly, it burnt down in October 2019, and reconstruction is likely to take many years. Three of the other World Heritage Sites located in the immediate vicinity of Shuri are also historically associated with the Ryukyu monarchy: the Tamaudun royal mausoleum, where most of the kings were laid to rest; the Sonohyan Utaki Ishimon, a restored stone gate on the Shuri Castle precincts, located in front of a former sacred grove (*utaki*) of which only a handful of trees remain; and the Shikinaen, an eighteenth-century Chinese-style landscape garden. In addition, the list includes four so-called *gusuku* sites in the centre and north of Okinawa island: the ruins of the Nakagusuku, Katsuren, Zakimi, and Nakijin castles, which date from the thirteenth to fifteenth centuries, and which are characterised by well-preserved curved castle walls and impressive views.

The last of the nine sites is Sēfa Utaki. In many respects, this is the odd one out. Unlike the other eight—in fact, unlike the vast majority of World Cultural Heritage Sites worldwide—Sēfa Utaki has no human-made constructs other than some stone steps. Sēfa Utaki is composed of trees, plants, and rock formations, and it is inhabited by birds, salamanders, and butterflies, yet it is not listed as a World Natural Heritage Site as it would not fulfil any of the criteria set by IUCN. Instead, Sēfa Utaki is classified as a "Cultural Landscape," but unlike most other listings in this category it does not have any buildings.[2] It was included in the application because of its historical significance as the Ryukyu Kingdom's most important place of worship, and because of the archaeological

finds excavated here, which include jewellery and coins from different parts of Asia. Materially and historically speaking, then, Sēfa Utaki is an ambivalent place that resists easy classification as either "nature" or "culture."[3]

Furthermore, Sēfa Utaki is different from the eight other inscribed places as the only one promoted as a "living" sacred site by local authorities and travel agencies. That is, unlike Shuri Castle, the other royal sites in Naha, and the *gusuku* sites further north, Sēfa Utaki is not simply bracketed as a "Ryukyu-period historic site."[4] Although its historical significance is widely acknowledged, local authorities actively frame it as a "sacred site" (*seichi*) of continued significance. There is some truth to this representation: even though it has seen some far-reaching transformations in modern times, Sēfa Utaki still carries meaning as a place of worship where visitors come to say prayers and make ritual offerings. Meanwhile, however, it has acquired new meaning as a popular tourist destination, and the majority of visitors who enter the forest these days do not engage in worship practices. Visitor numbers started rising around 2007, when the site was visited by approximately 140,000 people; three years later, the number had increased to 350,000, and in 2012 there were almost 440,000 visitors. In subsequent years, the site was visited by approximately 400,000 people annually (Nanjō-shi Kyōiku Iinkai 2018, 83). Paradoxically, it is precisely Sēfa Utaki's character as a supposedly "authentic" place of nature worship where "ancient" rituals are preserved that attracts large numbers of tourists. The presence of these tourists, however, causes tensions and affects the ritual practices that are part of the site's appeal. In sum, the ambiguity of Sēfa Utaki lies not only in its hybrid nature–cultural character, but also in the fact that it is simultaneously a historical artefact, exposed to the tourist gaze (Urry 2002), *and* a living ritual site, used by worshippers who may not like the fact that they are surrounded by mainland Japanese and foreign tourists.

One of the main problems of Sēfa Utaki is that there are numerous actors who lay claim to the site, but nobody "owns" it. Legally speaking, Sēfa Utaki is managed by the municipality (Nanjō City), but this is an abstract administrative entity with little popular legitimacy and no authority in ritual matters. In the past fifteen years, Sēfa Utaki has been successfully marketed as a mystical and historically important sacred site of great natural beauty, but this success has had some unforeseen consequences. Local residents and tour guides alike complain about what they perceive as improper behaviour by tourists. Spirit mediums and other ritual practitioners feel that their sacred site has been taken away from them, and they argue that worship areas should be fenced off. And environmentalists are concerned about the loss of biodiversity and influx of invader species apparently caused by mass tourism. What is clear is that Sēfa Utaki is a heavily contested site that carries different meaning to different actors, who all make competing claims concerning the site's proper use and appearance. Thus, although Sēfa Utaki is promoted widely as a "sacred site," there appears to be little consensus on what this "sacredness" entails.

This chapter analyses recent transformations at Sēfa Utaki in relation to issues such as mass tourism, environmental degradation, and competing understandings of Okinawan traditional religion. This is not a historical study, even though I will present and discuss some historical narratives. My purpose is not to present a complete overview of Sēfa Utaki's premodern and modern development, nor do I discuss the processes that have led to the site's World Heritage inscription. Instead, this is a study of what has happened *since* the registration: a story about thwarted expectations, competing interpretations, unexpected consequences, and the continuous quest for solutions that do justice to multiple concerns and interests. World Heritage inscription is the outcome of a long, laborious application process that requires selection, negotiation with various local actors, and exclusion.[5] It is not only an end, however, but also a beginning, as designation can give rise to new processes of signification, changing management structures, the advent of outside actors, and transformations in local livelihoods. Thus, World Heritage inscription does not necessarily "fossilise" sites and cultural practices, and freeze them in time, as some scholars have suggested (e.g., Foster 2011, 82–83; Smith 2006, 111–112). As this chapter shows, it can also give rise to significant transformations and tensions, and to ongoing processes of negotiation and reinvention.

This chapter is structured in a somewhat unconventional manner, divided into short sections that literally follow the steps of a visitor to the site. In the process, it takes up a number of relevant topics: historical narratives, access and ownership, nature conservation initiatives, tourist behaviour, the role of tourist guides, the demarcation and contestation of space, ritual practices, and competing notions of "proper" nature. At first sight, these topics may seem rather disparate and unrelated. However, they are all entangled at this little forest, which carries a variety of meanings, involving a large number of human and non-human actors. So let us look closely. And let us walk, step by step (see Figure 5.1).

Ganjū eki: the story of Sēfa Utaki

Bus 38 arrives at the "Sēfa Utaki entrance" stop in the southeast of Okinawa.[6] The bus stop is located next to a parking lot on Cape Chinen that looks out over the ocean. There are some restaurants and cafes, as well as a visitor centre named Ganjū eki. *Ganjū* is an Okinawan word that means "healthy" (Jp. *genki*), while *eki* is the Japanese word for "station." At the visitor centre, one can rent a bicycle or baby stroller, or dress up in a Ryukyu Kingdom–period costume. Images and cuddly toys of the Nanjō City's *yurukyara* (mascot character) Nanjii-san, a cute elderly goatherd with a disproportionally large head and a heart-shaped moustache, are everywhere.[7] In addition, there is a small photo exhibition, a study area, and a newly built film room. Here, visitors can watch a number of short documentary films on the history of Sēfa Utaki, the Ryukyu

SĒFA UTAKI

Figure 5.1 Map of Sēfa Utaki and surroundings. Copyright Aike P. Rots.

Kingdom, Okinawan religion, and the royal *agari-umāi* pilgrimage in which Sēfa Utaki was included.

The story told by these documentary films is as follows. Sēfa Utaki was the most important worship site of the Ryukyu Kingdom. The Ryukyu state was characterised by a rather unique, gendered division of power, whereby the king, who was in charge of worldly affairs, was assisted by a high priestess (*kikoe-ōgimi*)—his sister or another female relative—who was responsible for ritual affairs and relations with the world of deities and ancestors. This system of dual authority was replicated on regional and local levels, where worldly leaders were assisted by female ritual specialists called *noro*, who performed

some of their most important rituals in sacred groves (*utaki*). The importance of Sēfa Utaki lay in the fact that it was here that the *oaraori* ceremony was conducted: that is, the inauguration of a new *kikoe-ōgimi*. At the time, only *noro* associated with the royal institution could enter the grove. In addition to its importance as the location of the *oaraori* ceremony, Sēfa Utaki also had a prominent place in the *agari-umāi*, a pilgrimage to several royal ancestral worship sites in the south-eastern part of Okinawa Island, undertaken on special occasions by the king, the high priestess, and their entourage.[8] In the documentaries, we see women wearing white robes re-enacting the rituals, while a voice-over explains the meaning of the *oaraori* ceremony and the *noro* system. One gets the image of a ritual system that remained unchanged, uninfluenced by external forces, for the entire 450-year duration of the Ryukyu Kingdom.

In reality, the *noro* system has undergone significant changes in the course of its history, and so has Sēfa Utaki. *Noro* and *utaki* predate the establishment of the Ryukyu Kingdom, and Sēfa Utaki probably functioned as a local place of worship for centuries prior to its incorporation into the ritual-ideological state apparatus created by King Shō Shin (1465–1526). Shō Shin reigned for almost fifty years, from 1477 to 1526, and, as Gregory Smits explains, it was during this time that the *noro* system became intertwined with the monarchy in Shuri. Smits writes that

> although priestesses had participated in state ceremony prior to his reign, Shō Shin established a formal hierarchy of female religious officials that paralleled and supplemented the male hierarchy of central and local government officials. The top post was that of high priestess, to which Shō Shin appointed his sister.
>
> (2000, 96)

As the site of the high priestess' inauguration ceremony, Sēfa Utaki became a core element of the newly created sacred geography of the Ryukyu monarchy. The *agari-umāi* pilgrimage also dates from this period (Beillevaire 2007), and the *Omoro sōshi*, a collection of poems that lists the most important worship sites of the Ryukyu Kingdom, was compiled soon after Shō Shin's reign. Thus, the *noro* system—and its connection to Ryukyu royal power and mythology in particular—was largely the result of an elaborate "invention of tradition" during the late fifteenth and early sixteenth centuries, and it was during this time that Sēfa Utaki gained its significance. During the later years of the Ryukyu Kingdom, it continued to function as a ritual site for the *oaraori* ceremony and *agari-umāi*, but as the rulers looked increasingly to China and Japan for ideological models and the power of the *noro* declined, Sēfa Utaki probably no longer had the importance it had had during the sixteenth century. With the abolishment of the Ryukyu Kingdom in 1879, Sēfa Utaki lost its political significance, even though it continued to be visited by private worshippers such as *yuta* (spirit mediums) and *munchū* (clan groups) doing the *agari-umāi* pilgrimage.

The fact that the *oaraori* and *agari-umāi* were late fifteenth-century political inventions is not part of the narrative at Ganjū eki, and the post-1879 period is not included in the picture either. The documentaries and photo captions here present the Ryukyu Kingdom period as a static spiritual age characterised by "ancient" nature worship practices that had been transmitted more or less unchanged since prehistoric times. In one of the films, we see actresses dressed as priestesses worshipping the sun. Such nature worship is the essence of "Ryukyu Shinto," the audience is told. The suggestion is made that Okinawan worship traditions constitute some sort of pure or original shape of Shinto that has not been subject to the same historical machinations and interventions as mainland Japanese Shinto, but that is part of the same pan-Japanese tradition nonetheless. As I have discussed elsewhere (Rots 2019a, 2019b), such notions have a long pedigree, going back to the works of prewar ethnologists such as Iha Fuyū (1876–1947), Yanagita Kunio (1875–1962), and Orikuchi Shinobu (1887–1953). These scholars applied social-evolutionist models to explain the "primitive Otherness" of the Ryukyu Islands, interpreting them as repositories of ancient Japanese tradition that had supposedly disappeared in the modern centre but remained more or less intact in the underdeveloped periphery (Ivy 1995; Morris-Suzuki 1998). Such notions are historically flawed, and they deny the fact that premodern Ryukyu was a cultural centre in its own right, one shaped by cultural influences from the Korean peninsula, Kyushu, and mainland East Asia—a place subject to just as much historical change as other parts of the region (Okaya 2016; Smits 2018).

At Ganjū eki, however, these ideas linger on. Sēfa Utaki is presented here as a remnant of primordial "Ryukyu Shinto," frozen in time, the essence of which has continued to the present day even though the Ryukyu monarchy has long ceased to exist. Such narratives are not limited to popular educational films or promotional texts, but have also affected ways in which the site is represented in formal documents—including the official report by ICOMOS, which states that Sēfa Utaki "is essentially a densely wooded hill on which the shrines and prayer sites have *an ageless spiritual quality* that derives from their setting rather than manmade symbols" (ICOMOS 2000, 106; my emphasis). The choice to portray the site in such a profoundly ahistorical manner is a clear reflection of the fact that colonial epistemological models continue to influence ways in which Okinawan history is presented to the general public, even if—or precisely because—the storytellers are not usually aware of the colonial embeddedness of their narrative. One is reminded of David Lowenthal's classic argument that "heritage is not history," as heritage "exaggerates and omits, candidly invents and frankly forgets, and thrives on ignorance and error," even when "[using] historical traces and [telling] historical tales" (1998, 7). In other words, heritage production is as much about storytelling as it is about spatial practices, and it is highly selective in nature. Sēfa Utaki is no exception.

The ticket booth: ownership and compromise

The ticket booth is located a few steps beyond Ganjū eki, near the souvenir store. Every visitor is expected to buy an entrance ticket. It was not until Sēfa Utaki became part of the newly created city Nanjō and the municipal authorities decided to develop it as a tourist destination in 2007, several years after the World Heritage inscription, that entrance tickets were introduced (Kadota 2017, 275). An adult ticket costs three hundred yen (less than three euros), so it can hardly be considered expensive. However, charging entrance fees for sacred sites is often a contentious matter, as it directly touches upon questions of authority—who has the power to collect fees and decide what the money is used for—and, ultimately, the separation of state and religion. For instance, in Kyoto in the 1980s, Buddhist temples protested a decision by the city government to collect tax over entrance tickets and so redefined them as "donations" (Rots and Teeuwen 2017, 5–6). Unlike Buddhist temples in Kyoto, at Sēfa Utaki there is no religious juridical person (*shūkyō hōjin*) or other private organisation to collect the entrance fees; this task falls on the Nanjō tourism association (*kankō kyōkai*) on behalf of the municipal culture department (*bunkaka*), which is in charge of heritage management (Kadota 2017, 270). But here, too, debates about entrance tickets reveal tensions concerning ownership and show that neat secularist principles may not always correspond to the complicated and messy reality of everyday ritual life.

When the authorities first introduced entrance tickets (two hundred yen per person, initially), Okinawan worshippers and local residents protested strongly (Kadota 2017, 275–277). No matter the amount, for many of them the fact that all of a sudden they were forced to pay money to enter "their" sacred grove signified that ownership of the site—which had never been clearly defined, at least not since the end of the Ryukyu monarchy—had been taken away from them definitively. By way of compromise, the municipal authorities decided to reduce the entrance fee for worshippers to one hundred yen. This caused new problems, as now the person selling tickets was given the responsibility to decide who counted as "proper" worshippers and who did not. Are mainland Japanese "powerspot pilgrims"—that is, those who want to visit the site because they have read in their spiritual guidebooks that it has a powerful spiritual energy (Carter 2018; Rots 2019a, 2019b)—real pilgrims? Or is their interpretation of the site flawed, as some tour guides and local residents argue, and are only people who conduct proper "Okinawan-style" rituals—that is, those who bring the usual ritual offerings—"real" worshippers who qualify for free entry? If academics cannot even agree on how to distinguish between tourists and pilgrims, how can one expect a ticket clerk to make that distinction? Yet this is the reality today: separation of state and religion notwithstanding, it is the duty of a ticket clerk to decide on the nature of a visitor's motivations. Is the person a pilgrim who conducts "real Okinawan" rituals—which, needless to say, are highly diverse, as there has been no clerical authority who can decide

on these matters since the demise of the *noro* system—or is s/he a mere tourist, regardless of personal convictions or spiritual inclinations? In sum, the solution to differentiate between visitors based on the supposed religious character of their visit (or lack thereof) can hardly be considered sustainable, and it continues to fuel tensions.

The new "green space": butterflies and buffer zones

From Ganjū eki, it is an easy ten-minute walk to Sēfa Utaki. Along the road there are several small shops selling local products, such as handmade Okinawan *shīsā* (guardian lion) statues and spiritual items like power stones and jewellery. There are also some cafes and ice cream shops. Compared to other popular destinations in East Asia, it is all rather low key; for the time being at least, real estate prices are comparatively low, so the people who have set up store here have been able to do so without much prior capital. They are happy to see an increase in visitor numbers, which means more customers, at least potentially. Other residents, however, have complained that the economic benefits of the high tourist numbers for the local community are marginal, while the extra traffic generated by the site (including tour buses) has made the roads more dangerous. Visitors to Sēfa Utaki do not typically spend much time or money in the area; most of them stay in Naha or resorts elsewhere on the island, as tourist accommodation in Nanjō is limited.

Following the road, one arrives at the former parking lot and entrance building, which are situated next to the sacred grove. Today, most visitors park their cars at Ganjū eki and walk from there. The main reason for moving the parking area was that local authorities were concerned about the negative impact the cars—in particular, exhaust gas and noise—might have on forest ecology. As with other World Heritage Sites, the part of Sēfa Utaki inscribed on the World Heritage List is decided to the inch. Only the innermost part of the grove has been awarded this highest honour, and, accordingly, it is this part that is subject to the strictest preservation rules of Japan's Agency for Cultural Affairs (Bunkachō, hereafter ACA). This area is surrounded by a so-called "buffer zone" (Nanjō-shi Kyōiku Iinkai 2018, 48), which is subject to less rigid regulations but which should not be used for activities that negatively impact the site. The former parking lot is located within the buffer zone, so it was decided that it should be moved further away.

Only a few parking places remain today, reserved for people holding a special permit. The remainder of the parking lot has been given a makeover. In 2018, it was turned into a small yet attractive park-like area, with grass, benches, newly planted trees, and a pond (see Figure 5.2). Visually speaking, the change is remarkable. The new entrance area was inaugurated in March 2018 at a tree-planting festival (*shokujusai*), at which local politicians planted trees together with school children and then enjoyed a celebratory *ēsā* dance performance. In modern Japan, tree-planting is a social practice with profound symbolic

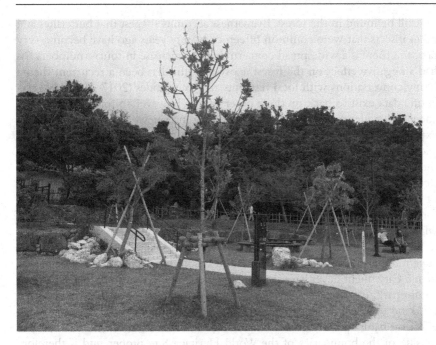

Figure 5.2 Young trees in the newly created green space, with Midori no Yakata Sēfa in the background, 2018. Photo by the author.

meanings, signifying positive values such as "harmony with nature," social cohesion, the cultivation of good citizens, and even community resurrection (Knight 1997; Rots 2019c). Okinawa is no exception in this regard: inviting school children from Chinen to take part in the tree-planting event together with powerful Nanjō City leaders creates a symbolic connection between local residents and "their" World Heritage Site—a connection that had come under pressure in recent years for people who felt the site had been taken away from them, as exemplified by the entrance fee conflict.

As with other tree-planting projects (see Rots 2019c), the choice of species was significant. In this case, the authorities opted for subtropical flowering trees that are favoured by endemic butterfly species and their caterpillars. In the early 2000s, following the World Heritage inscription but prior to the increase in tourist numbers, a large-scale investigation of the forest of Sēfa Utaki (Chinenson Kyōiku Iinkai 2002, 2003[9]) revealed that it was home to 250 different plant species, of which 218 are said to be native to Okinawa (Chinenson Kyōiku Iinkai 2003, 56). It is also home to a similar number of animal species, ranging from snails and butterflies to reptiles and bats, some of which are rare or endangered (Chinenson Kyōiku Iinkai 2003, 58–127; Nanjō-shi Kyōiku Iinkai 2018, 80). There has not been any systematic follow-up research on the ecology of Sēfa Utaki, however, and it is uncertain whether all these plants and animals

can still be found in the forest. Eyewitness accounts suggest that butterflies and other insects that were common fifteen or twenty years ago have become very rare, and there is a widespread concern that the increase in tourist numbers has had a negative effect on the forest ecosystem; this has been a recurrent theme in my conversations with local residents and tour guides (2017–2018). No scientific data exist to back up these observations, however, so for the time being anecdotal evidence is all we have. One of my interviewees at the municipality expressed some scepticism regarding this matter, suggesting that local residents' and tour guides' eyewitness accounts are not necessarily a reliable indicator of the presence or absence of certain species. Nevertheless, the choice to plant trees that attract butterflies clearly shows that biodiversity decline is a matter of concern. Likewise, the purpose of the new pond was to provide a habitat for endemic species of amphibians and insects. Judging from the number of salamanders frolicking in the water today, this has been a success.

Were it not for Sēfa Utaki's status as a World Heritage Site, which propelled large numbers of visitors to the site (all of whom have to pay the entrance fee), Nanjō City might never have invested in redesigning the parking lot into a small nature park. Paradoxically, however, it would not have been possible to make this kind of adaptations to the grove itself, even if these would have a positive effect on nature preservation. The parking area lies within the buffer zone, just outside of the boundaries of the World Heritage Site proper, and is therefore not limited to the same strict maintenance regulations. Consequently, changes in physical appearance are allowed, as long as these do not have a negative effect. By contrast, any minor physical adaptation the Nanjō City authorities might want to make to the *utaki* itself (e.g., repaving the footpath) requires approval by the ACA. Such changes are time-consuming and require ample documentation in the form of research reports, evaluations, and proposals. It is for this purpose that the municipality has set up a committee and commissioned a report for assessing the current state of affairs at Sēfa Utaki, which looks at forest maintenance and physical preservation as well as some of the social and ecological effects of World Heritage inscription and subsequent mass tourism (Nanjō-shi Kyōiku Iinkai 2018). The report, finalised in 2018, is intended as a first step towards solving some of the problems the site has seen in recent years—not only a decline in butterflies and soil erosion as a result of poorly paved and slippery paths, but also, as we shall see, problems related to the behaviour of visitors.

Midori no Yakata Sēfa: manners matter

Next to the park is the small entrance building. It is called Midori no Yakata Sēfa (green cabin Sēfa), and it has a small office used by the tour guides as well as toilets and two video rooms. All visitors must show their entrance ticket, whereupon they receive a colourful pamphlet with a map of the site. The pamphlets are available in Japanese, English, Korean, and Chinese (both traditional and simplified), and staff at the entrance office keep track of the

numbers, as this is used to collect rudimentary data on the visitors' country of origin. This may explain why, on more than one occasion, staff reacted nervously when I told them I did not need a pamphlet, as I already had a few from earlier visits. Of course, the data collected in this way are not necessarily reliable. It is likely that those who ask for a pamphlet in Korean are from South Korea, and those who prefer simplified Chinese are probably from mainland China. Visitors requesting a pamphlet in traditional Chinese are usually from either Taiwan or Hong Kong; staff are encouraged to ask them for their place of origin. More problematically, those who want a pamphlet in English could be from anywhere. Here, too, staff are supposed to ask visitors for their nationality, but this is often forgotten. Thus, according to the latest data, in January 2019 there were 37,055 visitors, 2,675 of whom were non-Japanese (approximately 14 percent). Of these, 41 percent were from South Korea, 39 percent from Taiwan, 9 percent from the United States, 4 percent from Hong Kong, 3 percent from mainland China, and 4 percent other.[10] Even though Okinawa has a sizeable American population because of the military bases, I doubt whether the number of US visitors was really that high; I suspect that staff ticked the box "American" in cases where they had forgotten to ask people for their nationality (including myself, on multiple occasions).

In any case, it is clear that the number of foreign visitors has increased in recent years. Most of these are from Korea and Taiwan, which now have direct budget airline connections to Okinawa. In Taipei, for instance, Okinawa is widely promoted as a tourist destination on billboards and subway advertisements. In the shopping malls of Naha, one hears more Chinese and Korean than Japanese. Some of these tourists take the trip by bus or rental car to Sēfa Utaki. The fact that it is a World Heritage Site no doubt adds to its appeal, as this is widely perceived as a marker of quality, not only in Japan but also elsewhere in East Asia. Yet, as we have seen, the growth in visitor numbers—Taiwanese and Korean, but also mainland Japanese—is not celebrated by all.

When Sēfa Utaki was listed as a World Heritage Site in 2000, the atmosphere in Chinen was festive. The listing gave rise to local pride and celebration (Ōshiro 2001) and was expected to give the village a significant economic boost. Today, opinions are decidedly more mixed; while some local shop owners are happy with the increase in tourist numbers, several residents to whom I have spoken lamented the recent popularisation of the site. Some deplore the fact that the community as a whole has not benefitted much financially, some note that the number of butterflies and other insects has decreased, some are concerned about traffic safety, and some point out that the site has lost much of its spiritual energy since the advent of the tourist masses. Most important, it seems, is the notion that tourists generally do not know how to behave properly in a "sacred site," the so-called "problem of manners" (manā mondai). In the past years, this problem of manners has been the subject of much local debate, even on the municipal level (Nanjō-shi Kyōiku Iinkai 2018). Apparently, depending on the speaker, "manners" can include everything from talking loudly to wearing high

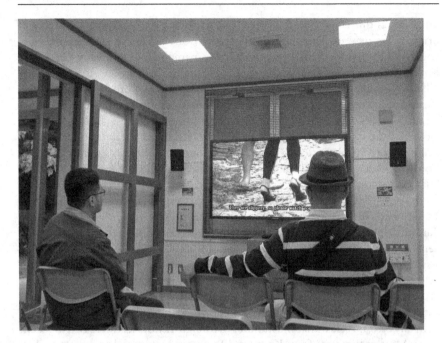

Figure 5.3 Two visitors watch the introductory video at Midori no Yakata Sēfa. Photo by
the author.

heels, from sitting on altar stones to littering, and from taking pictures of ritual
practitioners to picking flowers.

For this reason, all visitors are asked to watch a short introductory video
at Midori no Yakata Sēfa, before they enter the forest (see Figure 5.3). The
video explains that Sēfa Utaki is a "sacred site" and, therefore, visitors should
speak quietly, stay away from the stone altars, and refrain from taking pictures
of worshippers. There is also a warning that the path is unsuitable for women
wearing high heels and may be slippery in rainy weather. It all appears rather
common-sensical, but I have been assured repeatedly by tour guides that this
is necessary, and that problems and conflicts still occur—despite the fact that
the video is shown to all. The fact that the video is in Japanese, with subtitles
in English, is seen as part of the problem; reportedly, those who misbehave
the most are visitors from other Asian countries, and this may be due to the
fact that many of them understand neither Japanese nor English. Of course,
there is no way for me to verify this—although the problem of manners has
been thematised and discussed for the last five years or so (Satō 2016; Kadota
2017), there are no statistics on the type and number of conflicts that occur,
let alone the nationality of the "perpetrators." In any case, the notion that "for-
eign" (mostly Chinese and Korean) visitors are rude and tend to misbehave is
widespread, not only in Okinawa but also in mainland Japan—relatively minor

"offences" such as speaking loudly, jumping a queue or littering are frowned upon, and confirm negative stereotypes that people may have about their continental Asian neighbours.

Ujōguchi and Urōkā: forgotten history

Leaving Midori no Yakata Sēfa, the first thing one comes across is a large stone with the UNESCO logo—definitive proof that this is a World Heritage Site, and the first obligatory photo spot of the route. From there, it is a short walk to the Ujōguchi, an open space on top of a hill, from where the island of Kudakajima is clearly visible in the distance. Located in the east, Kudakajima played a central part in Ryukyu royal mythology; it was long associated with Nirai Kanai, the Other Realm, and with primordial goddess Amamikiyo. The island has attracted the attention of many ethnologists, as it was long seen as a stronghold of traditional Ryukyuan religion, where several *noro* were living who conducted key Ryukyu-period ritual ceremonies (e.g., the *izaihō*) until well into the twenty-first century (Higa 2000; Wacker 2003). Today, only two *noro* are still alive, and Kudakajima is revamped by the Nanjō City authorities as a tourist destination with many spiritual "powerspots" (Rots 2019a). The island features prominently in the historical narrative told at Ganjū eki, on tourist websites, and in travel guidebooks. Like Sēfa Utaki and the other *agari-umāi* sites, Kudakajima is here presented as a timeless, mysterious sacred site where ancient nature worship practices have survived—which serves as an advertising strategy to attract visitors.

During the Ryukyu Kingdom, ordinary visitors were not allowed beyond the Ujōguchi. At the time, pilgrims—including the king and his entourage—would approach the sacred grove from the other side. First, they arrived at the Urōkā, the sacred spring, where they paid their respects to the water deity.[11] From here, they would climb up to the Ujōguchi, where ritual offerings were made. Until recently, the path leading from the Urōkā to the Ujōguchi was fenced off. According to the Nanjō City authorities and the tour guides working for them, the reason for this was that the steps are in poor condition and would constitute a safety risk. In 2018, a new footbridge and some handrails were constructed, and the Urōkā is now accessible. Those who take the walk there will see not only a sacred spring, but also the remnants of artillery constructions used by the Japanese army during World War II.

As mentioned, in documentary films shown at Ganjū eki, in tourist publications, and in the official World Heritage application file, the post-1879 history of Sēfa Utaki is largely ignored. As we have seen, on the one hand, the grove is presented as a Ryukyu Kingdom heritage site, the value of which lies in the fact that Ryukyu-period traditions are preserved here; on the other hand, it is presented as a sacred, timeless place of primordial nature worship that still functions as such. In both narratives, the modern history of the site is absent. In reality, however, Sēfa Utaki underwent significant changes in the twentieth

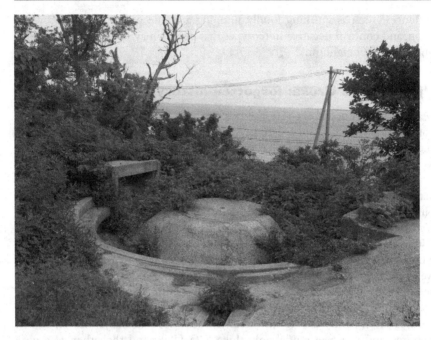

Figure 5.4 Wartime artillery foundations near the Urōkā. Photo by the author.

century, in terms of use as well as species composition. Most notably, in 1942 plans were presented to turn Sēfa Utaki into a prefectural shrine, Sēfa Jinja. This was part of a general policy to transform *utaki* into Shinto shrines, referred to as *utaki saihen* ("reorganisation of *utaki*") (Arakaki 2002; see also Loo 2014, 105–109). The plans never materialised, however, as Sēfa Utaki was appropriated by the Japanese imperial authorities in a different way: in 1941, two large artillery batteries were constructed near the Urōkā, the foundations of which still exist today (see Figure 5.4). Furthermore, the first half of the twentieth century saw far-reaching deforestation because of unrestrained logging and, later, American bombs (Chinenson Kyōiku Iinkai 2003, 31, 56). This is visible on prewar and early postwar photographs, on which Sēfa Utaki looks profoundly different from today. At the time, the vegetation mainly consisted of low shrubs, not the high subtropical trees that characterise the present-day forest (Nanjō-shi Kyōiku Iinkai 2018, 51–55).

Clearly, such modern strategic uses and physical transformations are at odds with the depoliticised image of Sēfa Utaki as a mystical, timeless "sacred site," the image authorities are so eager to promote. Thus, although the artillery foundations can now be visited, little information about them is provided on information panels or in the pamphlet, and guided tours do not visit this part of the grove. Storytelling is an essential part of heritage tourism. Modern imperialism and war are not part of the story that earned Sēfa Utaki its World

Heritage status, and absent from the tourist gaze here—even if traces of it can still be found.

Ufugūi: sacred site, secular managers

From the Ujōguchi, a steep path brings visitors inside the *utaki*. The sacred centre of an *utaki*, where ritual offerings are made to the gods, is called an *ibi*. Most *utaki* have one *ibi*, but Sēfa Utaki has six. We have already encountered the Urōkā and Ujōguchi; now, the path leads us to the Ufugūi and further to the Yuinchi, two impressive rock formations with stone altars. The other two are the Sangūi, a tunnel-shaped rock, and the Shikiyodayuru and Amaduyuru sacred jugs next to it. We will visit these later; first, we climb the path to the Ufugūi. The path has clearly suffered from the large visitor numbers: the stones are largely eroded, and sand bags have been placed to prevent the soil from washing away completely. This problem is acknowledged by the authorities, but at the time of writing, the path had not yet been repaired. Ironically, as mentioned, the fact that we are here in the core zone of the World Heritage Site means that any changes to the physical appearance of the site—including new stone pavement or steps—have to be approved by the ACA, even if such measures contribute to preservation. The path is slippery during rainy weather, and tour guides have expressed a concern for the safety of visitors, which is echoed in the report made by the authorities (Nanjō-shi Kyōiku Iinkai 2018, 87). Apparently, however, the higher the status of a heritage site, the more time-consuming and complicated the bureaucratic procedure required for getting permission from the authorities in Tokyo.

On weekends and during national holidays, the path gets very crowded, as does the Ufugūi. Although it is possible to visit Sēfa Utaki individually, many Japanese tourists join a guided tour. There are hourly guided tours on the weekend and on national holidays, which cost 300 yen per person (on weekdays, it is possible to book a private tour guide for a higher fee). There is a large pool of guides, but none of them speak a foreign language, so there are only guided tours in Japanese. The Nanjō City authorities are currently considering developing audio guides in English, Chinese, and Korean, but there are some practical challenges, such as hygiene (i.e., how to keep headphones clean). An alternative option would be to develop a special audio guide phone app, but that would require Wi-Fi in the entire forest. Nevertheless, such technological solutions are seen as more realistic than simply finding tour guides who speak foreign languages—these are hard to come by, it seems (interview data, 2017 and 2018).

It is hard to overestimate the significance of the tour guides at Sēfa Utaki, which, as we have seen, is a worship centre without clergy, a religious place that is not legally religious, a ritual site ruled by secular authorities. Filling this void, the tour guides are now playing the role of *de facto* managers, some more zealous than others. They are the site's main storytellers, they man the office

at Midori no Yakata Sēfa, they do minor maintenance work, they monitor the paths and altars, and they scold people who misbehave. I was told that there are eighty-eight registered tour guides, approximately fifty of whom are active regularly; they are listed as volunteers, but they do receive some modest financial compensation for their work. Most are elderly or middle-aged residents of Nanjō City, and there is a strong hierarchy within the group, based on seniority—those who have been around the longest get to choose when they want to give tours, whereas those who have just joined first have to do menial tasks in the forest. They are all affiliated with a non-profit organisation named Amamikiyo Roman no Kai, named after the Ryukyu primordial goddess, which is coordinated by the Nanjō City authorities. Although Amamikiyo Roman no Kai is a non-profit organisation with an educational purpose (at least nominally), it is embedded within the larger tourist infrastructure of Okinawa, and its tour guides have contributed to the creation of a new "Ryukyu spirituality" narrative. Nevertheless, there appears to be significant variety when it comes to the contents of their tours. Some guides consider it their responsibility to educate tourists on the difference between Okinawan sacred sites (*uganju*) and Japanese Shinto shrines, stating explicitly that Sēfa Utaki "is not a powerspot" (Rots 2019b). Others are more reluctant to make statements regarding the sacred nature of the place, pointing out that everybody is entitled to their own interpretations and prayers, as long as they obey basic etiquette rules (e.g., no littering).

Thus, at Sēfa Utaki, the role of the tour guides is threefold. First, they are the site's main storytellers, at least vis-à-vis mainland Japanese tourists; they are the ones primarily responsible for introducing Okinawan religion and history to Japanese visitors, most of whom know little about the topic. Second, they function as a cheap labour pool, used by the municipal authorities to perform tasks such as checking entrance tickets and cleaning the path. And third, in the absence of a clerical institution, some of them have assumed the role of stewards, preventing "bad manners." They tell visitors off for "trespassing" on sacred *ibi* or talking loudly, but also for not holding the hand of their child on the slippery path, as I personally experienced. However, it is not only tourists who are addressed: one of the tour guides to whom I spoke (on a different occasion) complained about the behaviour of Okinawan *yuta*, some of whom leave their ritual offerings (e.g., paper spirit money) in the forest. To some worshippers, bringing the offerings home may undermine the validity and efficacy of the ritual. The authorities and tour guides, by contrast, perceive these objects as litter, which makes the forest look untidy and has a negative environmental impact. Similarly, *yuta* and other worshippers are no longer allowed to burn their offerings, as this poses an environmental and safety risk (Kadota 2012, 93); thus, they have had to adapt their ritual practices in accordance with the demands made by the current management. As the conflicting attitudes to leaving behind or burning ritual offerings illustrate, there are some profoundly

different understandings of what it is that constitutes the "proper" use of the *utaki*, not least among Okinawans themselves.

Yuinchi: contested nature

We follow the path to the innermost *ibi*, the Yuinchi.[12] It is a clearing in the forest, surrounded by high rocks; underneath one of them, stone altars are placed. This is where the path ends. There are various signs warning people not to go any further, as there are venomous *habu* snakes (*Protobothrops flavoviridis*) in the forest. A bite of this snake, which is endemic to the Ryukyu Islands, can be lethal, and authorities have long attempted to eradicate it—with limited success. For this purpose, in 1910, the small Asian mongoose (*Herpestes javanicus*, a predator native to South and Southeast Asia that is famous for its ability to kill snakes) was introduced to Okinawa. In subsequent decades, it gradually spread throughout the island. Its effect upon the *habu* population has been limited, however, not least because mongooses are daytime hunters and *habu* are mostly nocturnal. Today, it is considered one of the world's worst invasive species (Yamada and Sugimura 2004), and it constitutes a significant threat to Okinawan ecosystems, especially endemic amphibians and birds, the eggs of which are easy prey to them.

At Sēfa Utaki, I have spotted mongooses running by on more than one occasion. I have also come across a mongoose skull and bones. When I asked a tour guide, whose group I had joined on this occasion, she said that these were indeed the remnants of a mongoose, confirming my suspicion that these animals had indeed invaded the forest. She also said that traps had been placed to catch them, hidden from view. They were spotted fairly regularly, also by tourists, who often mistake them for squirrels. One of her colleagues later denied that mongooses are killed at Sēfa Utaki, but a closer look at Nanjō City's mainten- ance report reveals that "the removal of invader species" (*inyū dōbutsu no jokyo*) is indeed one of the conservation activities carried out of the site. This concerns not only mongooses, but also feral cats (Nanjō-shi Kyōiku Iinkai 2018, 96).

Nature conservation at Sēfa Utaki is not limited to culling mongooses and cats. The forest also suffers from invasive flora, which is removed by foresters. This only happens after opening hours, however, so as not to spoil the image of a "natural" sacred forest, frozen in time. Like sacred groves elsewhere, Sēfa Utaki has captured the attention of biologists and nature conservationists, but it is not a primeval forest. In reality, the forest has gone through some serious transformations in the course of its modern history, and a significant proportion of the trees that make up today's lush forest were planted in the postwar period (Chinenson Kyōiku Iinkai 2002, 106–107; Nanjō-shi Kyōiku Iinkai 2018, 77– 78). Reforestation activities have also been conducted at later occasions; in 1999, for instance, local elementary school students took part in a tree-planting ceremony at which eighty *tsubaki* (*Camellia*) saplings were planted (*Ryūkyū*

shinpō 1999).Today, too, the authorities are active in forest management, felling trees that are not native to the area. But they are not the only ones who have an interest in trees. Conflicting notions about proper uses of space not only concern ritual practices, but also nature conservation; in some cases, the ecological state of the forest is seen as symptomatic for its perceived spiritual decline.

In December 2018, a middle-aged Okinawan woman went off the path, into the forest, and angrily pulled out plants with her bare hands. She was clearly agitated, and talking to herself, but it was impossible for bystanders to hear what she was saying.Two (male) tour guides were watching her, but they did not go in to stop her. Sometime later, a policeman arrived and escorted her out of the forest. They sat down on one of the benches in the new green area near the entrance and engaged in conversation there before the woman was asked to go home. In the next days, the incident was the main topic of conversation among the tour guides.Apparently, the woman was disturbed by what she perceived as the messy state of the forest; she claimed that she had been ordered by a god (or by God)[13] to tidy up (i.e., remove weeds).Those who have lived in the area for a while remembered the event of December 1997, when approximately twenty followers of a small Okinawan religious movement went into Sēfa Utaki and felled as many as four hundred trees, apparently for spiritual reasons (*Ryūkyū shinpō* 1998). The movement still exists but is now registered as a non-profit organisation (*NPO hōjin*) devoted to "spiritual support" (*seishinteki sapōto*) and to "making pilgrimages to heritage sites in the prefecture for the purpose of care of the heart" (*kokoro no kea o mokuteki to shita kennai no bunkazai meguri*). In sum, it is one of the many "spiritual counselling" enterprises on the island (Rots 2019a), but one with an unusual interest in heritage sites. Peculiarly, in the 1990s they considered it their spiritual duty to chop down trees deemed unsuitable for a sacred grove—not only at Sēfa Utaki, but also at another famous worship site, Kubō Utaki on Kudakajima.

Unusual though these incidents may have been, they illustrate two things. First, as I have argued elsewhere, different actors may agree on the importance of nature conservation, but that does not mean they agree on the shape nature should have. To some, a proper sacred grove should be kept tidy, and "weeds" and fallen branches and leaves must be removed; to others, it should be left wild. High trees may be desirable to some but detested by others, and different actors can have different ideas about which species are preferable (Rots 2017, 2019c). Second, these incidents show that Sēfa Utaki is not just a disenchanted tourist site, but, to some at least, a place of significant spiritual power that should be maintained properly.Yet, as we have seen, there is no clerical institution that has the power to prescribe ritual practices or decide on doctrinal matters. Sēfa Utaki is visited by a variety of Okinawan worshippers (spirit mediums as well as "ordinary" pilgrims), by mainland Japanese spiritual tourists, and of course by tourists who have little or no affinity with spiritual matters.This regularly leads to tensions and, occasionally, conflicts.

Sangūi and Chōnohana: a question of power

Returning on the same path, then turning left before reaching the Ufugūi, visitors come to another clearing next to a high rock with two stalactites. The water dripping down from these stalactites is collected in two jugs, called the Shikiyodayuru and Amaduyuru. During the Ryukyu Kingdom period, water from these jugs was used for the purification of newly inaugurated *kikoe-ōgimi*. A sign in Japanese warns visitors not to touch them; provisional signs in Korean and Chinese have recently been added, suggesting that it was not only Japanese visitors who misbehaved. Today, the jugs are surrounded by people who try to take a picture at the exact moment a new drop touches the water's surface. Next to this is the most iconic site of Sēfa Utaki, shown in numerous travel guidebooks, websites, and brochures: two large rocks leaning against each other, leaving open a triangular, tunnel-like space, known as the Sangūi (see Figure 5.5). On the other side of the Sangūi is a small square area surrounded by rock walls, called Chōnohana. On the east side, through an opening in the trees, Kudakajima Island is clearly visible.

This may not actually have been a place of worship during the Ryukyu Kingdom period; rather, it was here that preparations for rituals were made. Significantly, it was also here that many historical objects were found (coins, jewels, and ceramics) during the excavations preceding the World Heritage nomination, which was one of the main reasons why the grove was deemed worthy of World Heritage status. Prior to the war, Kudakajima was not visible from here; it was during the Battle of Okinawa that part of the rock was destroyed, creating the opening that now captures the imagination of worshippers and package tourists alike (Nanjō-shi Kyōiku Iinkai 2018, 65). Today, however, the place serves a triple function as a popular worship site (*uganju*) for Okinawan visitors, as a spiritual "powerspot" for some Japanese visitors, and as a popular "picture spot" for most—few tourists can resist taking a photo of Kudakajima surrounded by the trees of Sēfa Utaki. This view has gained fame as it has been used widely for advertising purposes, not least by the municipal authorities.

Small as it is, the Sangūi and the Chōnohana area is currently the most popular, the most crowded, and consequently the most contested. It is common for tourists to sit on the stone steps in front of the opening in the trees (the "heart window," as it is called) and take a selfie with Kudakajima in the background. In fact, one is not supposed to sit on these steps, which are used by worshippers for placing their ritual offerings; it is this kind of behaviour that angers local residents and exemplifies the "problem of manners." Until recently, however, it was not very clear that one is not allowed to sit here. When I first visited the site in 2015, there were few signs, and none of them were in foreign languages. Three years later, this had changed significantly; all *ibi* now have signs telling people to stay out of the prayer area, and a sign at the Chōnohana tells people not to sit on the steps. Here, too, Chinese and Korean translations have been added (Nanjō-shi Kyōiku Iinkai 2018, 93).

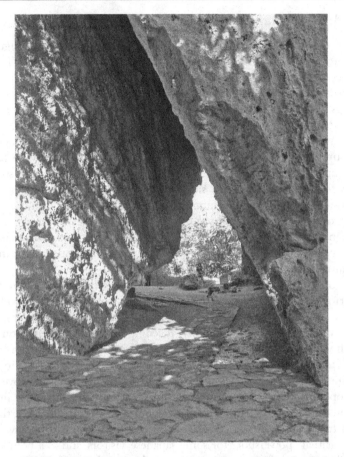

Figure 5.5 The Sangūi, Sēfa Utaki's most iconic sight, seen from the Chōnohana. Photo by the author.

Such signs are clearly necessary, but they may not be enough. In 2016, I witnessed a conflict between two ritual practitioners—spirit mediums (*yuta*), most likely—and some tourists. The two women had placed their ritual offerings on the steps facing Kudakajima Island and started their prayer ritual, when a handful of tourists entered the space and moved behind them. Apparently, they had violated their ritual space: by the time I arrived at the spot, one of the two women was yelling at them and sending them away, while her companion was sitting on the steps, apparently unwell. Such things have happened often since the World Heritage registration, the first woman explained to the remaining bystanders. There were so many tourists who "could not feel it," she said; however, those who do have the capacity to feel would know that there was "a large god" (*ōkii kamisama*) inside the rock wall. Somehow, the tourists had blocked the flow of energy between the Chōnohana rock and Kudakajima

Island, causing the deity to get angry and the woman carrying out the prayer ritual to become unwell.[14]

According to some of the tour guides with whom I have spoken, such incidents are not uncommon. On the part of Okinawan worshippers, there is a strong sense that their sacred site has been taken away from them, and incidents such as this add fuel to the fire. Reportedly, some of them have stopped coming altogether; according to some of my interlocutors, the site has lost much of its previous spiritual power. Ironically, such complaints coincide with popular mainland Japanese "spiritual counsellors" recommending Sēfa Utaki as a superior powerspot, and with Japanese spiritual tourists coming to the site to "feel" its unique energy, experience chakra healing, et cetera (Rots 2019a). This raises the question as to who has the power to define spiritual power, and, by extension, to set boundaries and define the rules.

How can such conflicts be prevented? How can Sēfa Utaki be an inclusive site, open for all visitors regardless of religious orientation, while continuing to function as a place of worship for Okinawan pilgrims and spirit mediums? This has been debated extensively by local residents, in committees established for that purpose, and at the municipal level. One suggestion, made by the former mayor of Nanjō City, has been to reintroduce the gender ban that formerly existed, no longer allowing men entry (*Ryūkyū shinpō* 2013).[15] This reflects the opinion held by some female spirit mediums, who consider the presence of men in the sacred grove undesirable. Most of the people with whom I have spoken, however, were sceptical about the feasibility of this proposal. A more realistic solution would be to fence off the *ibi*—including the Sangūi and the Chōnohana—to anyone who does not go there to engage in worship practices. This would pose challenges similar to the entrance fee issue: who is going to police the site, and decide what counts as proper worship? Will foreigners or mainland Japanese be denied entry, even if they wish to pray, because their rituals are not "authentically Okinawan" enough? Furthermore, the municipal authorities and local tourism office have more prosaic reasons for not fencing off the Sangūi and Chōnohana: it is this part of the grove that has been marketed as the most "powerful" sacred site, and, accordingly, it is central to "the tourist gaze" (Urry 2002). It is this place that tourists expect to see and are most eager to visit, in order to feel its spiritual energy, or simply to take the perfect picture. Denying them entry to the most popular place in the grove would not be good for business.

Recently, a new solution has been proposed. It has been suggested that the first hour in the morning—say, from eight a.m. to nine a.m.—the site should be only accessible for people who come to do worship, that is, to make Okinawan-style ritual offerings. Tourists do not usually get up so early anyway; they can visit the site afterwards, when the worshippers have left. Still, this would require a staff member to judge on whether visitors count as "worshippers" or "tourists," and deny entry to those who do not fulfil the criteria. From a legal perspective, this is not unproblematic: how can a secular government employee

or volunteer decide what does or does not count as "proper" ritual practice? For instance, will groups of mainland Japanese powerspot pilgrims, or members of new religious movements, be denied entry during this first "worship hour"? These are questions that remain unanswered, for the time being; the authorities have not yet decided whether or not to implement this new policy. Several of my interlocutors, however, have expressed their support for it, as they believe this may solve some of the site's current problems.

Concluding remarks

Following the steps of a visitor to Sēfa Utaki from Ganjū eki to the Sangūi, we have encountered a number of issues and conflicts that have emerged after the site's inscription on the World Heritage List. Of course, it would be too simple to assume that problems such as ecological degradation and conflicts between different users are all a direct consequence of World Heritage registration, as there are a number of other variables involved. In the minds of many local residents, however, such a causal relationship certainly exists. As they see it, the acquisition of World Heritage status has led to a sharp increase in tourist numbers, which has caused today's problems. Even though UNESCO may not have played a large role in this, they hold the organisation accountable for the recent developments. The loss of insect species may not be directly related to the perceived loss of spiritual power, and the influx of mongooses has little to do with the increase in tourist numbers. In the minds of most of my interlocutors, however, these issues are all related. They all point to a general sense of disentitlement: a growing realisation that, "universal value" though it may have, this most sacred of Okinawan sites is no longer owned by the Okinawan people.

As a World Heritage Site, Sēfa Utaki is subject to strict conservation rules. No changes can be made that affect the visual appearance of the site without the explicit permission from the ACA. The site is managed by the Nanjō City municipal authorities, who have to negotiate demands from local residents and businesses while complying with official regulations. Although they are aware of some of the problems posed by mass tourism, they are reluctant to implement concrete, far-reaching measures. Moreover, local actors hardly speak with one voice; there is a variety of opinions on what should happen, not least on the part of ritual practitioners, who are not represented by any formal religious institution. In practice, much of the daily management of the site is left to the tour guides affiliated with Amamikiyo Roman no Kai, but there are divergent opinions within this organisation as well. Thus, understandably, the municipal authorities are cautious when it comes to making changes to the site.

Nevertheless, changes do take place. In the past four years, shops have come and gone. Ganjū eki now features an attractive film room. The path to the Urōkā has been fixed and made accessible to visitors. The former parking area next to Midori no Yakata Sēfa has undergone a remarkable makeover. Inside the forest, signage has been improved. In sum, although listed as a World Heritage

Site, Sēfa Utaki is by no means frozen in time. On the contrary, it is a site in flux, subject to continuous negotiation and transformation. It remains to be seen if a good balance can be found between the needs of different actors—local worshippers, tourists, businesses, and not least plants and animals.

Notes

1 This chapter is based on ethnographic fieldwork conducted during three periods in Okinawa: December 2016–January 2017, June–July 2017, and December 2018. I wish to thank all my interlocutors in Okinawa for their support and trust.

2 On the category "Cultural Landscapes," see Aplin (2007). "Cultural Landscapes" often contain historical buildings, such as the shrines and temples inscribed on the World Heritage List under the label "Sacred Sites and Pilgrimage Routes in the Kii Mountain Range" (listed in 2004). World Cultural Heritage Sites or World Heritage Cultural Landscapes that do not have buildings are few and far between, in Japan as well as elsewhere. This even applies to the Mt. Fuji listing (inscribed in 2013), which does not in fact consist of the mountain as a whole, but which is basically a list of Shinto shrines on the flanks of the mountain—that is, buildings.

3 On the problems of UNESCO World Heritage classification models, and the arguably outdated distinction between "nature" and "culture," see Lowenthal (2005) and Harrison (2015).

4 I borrow the term "bracketing" from William Underwood, who uses it to describe the discursive strategy used by Japanese authorities to dissociate Meiji-period industrial heritage sites and corresponding narratives of "national ·progress" and "modernisation" from the forced labour that took place at those sites during the post-Meiji, pre–World War II period. I think this notion of "bracketing" is useful for understanding the selective nature of historical narratives, especially with regard to the preservation and production of heritage. See Underwood (2015).

5 For discussions of this process, see the chapters by Lindsey DeWitt, Tze Loo, and Ian Reader in this volume.

6 In this chapter, I use the words "Okinawa" and "Okinawan" to refer to the island Okinawa Hontō, not the prefecture with the same name (which includes Okinawa Hontō and several nearby islands, as well as the western Ryukyu Islands).

7 In recent years, *yurukyara* have been created by many Japanese municipalities (and other organisations, such as corporations and NGOs) for promotion purposes, and Nanjō City is no exception. The municipality was created in 2006 as a merger of Sashiki, Chinen, Tamagusuku, and Ōzato. Although nominally a city, most parts of it have a rural character.

8 For discussions of the role of *noro* in the Ryukyu Kingdom, see Prochaska-Meyer (2013), Røkkum (1998), Smits (2000), Wacker (2003). For more detailed descriptions of the *oaraori* inauguration ceremony and other rituals conducted at Sēfa Utaki during the time of the Ryukyu Kingdom, see Iyori (2005, 429–447), Wakugami (1982). On the *agari-umāi* pilgrimage, see Beillevaire (2007); Nakasone (2002). On the modern meanings of *utaki* and other sacred sites, see Nakamatsu (1990), Rots (2019a).

9 Chinenson Kyōiku Iinkai 2002 is the original research report, which includes all the scientific findings. Chinenson Kyōiku Iinkai 2003 is a lavishly illustrated

popular-scientific book on the history and ecology of Sēfa Utaki, targeted at high school students and the general audience.

10 Data produced by Nanjō City (January 2019), available online at www.city.nanjo. okinawa.jp/about-nanjo/news/2019/02/post-1368.html.

11 Sacred springs (kā) can be found all over Okinawa, and fresh water has long been associated with local gods; the Urōkā is one such site.

12 Like Ufugūi, the name Yuinchi refers to a room in Shuri Castle, reflecting the close connections between the royal institution and Sēfa Utaki's sacred geography. Yuinchi was the name of the kitchen in Shuri. In Okinawa, the kitchen is traditionally seen as the most important room in the house, as it is here that the fire deity hii nu kan is worshipped. On the sacred geography of the Ryukyu Kingdom, see Iyori (2005).

13 By kamisama, that is. Whether kamisama here refers to the singular "God" or to "a god" is not entirely clear. Although I saw her pulling out plants from the forest and being escorted out by a policeman, I did not have the opportunity to talk to the woman myself.

14 I have discussed this incident in more detail, and analysed its significance, in Rots (2019b).

15 Historically, men were not allowed to visit Sēfa Utaki (or other utaki, for that matter), and there are still many Okinawans who think that men ought to refrain from visiting sacred groves. Reportedly, prior to the World Heritage application, local residents in Chinen were informed that the ban on men would be incompatible with World Heritage status, and therefore had to be abandoned. It was not until after Sēfa Utaki's inscription that they found out that UNESCO is rather indifferent to gender bans: Mt. Ōmine in Nara Prefecture and Okinoshima Island in Fukuoka Prefecture were listed as World Heritage Sites in 2004 and 2017, respectively, despite the fact that women are not allowed entrance. On this topic, see the chapter by Lindsey DeWitt in this volume.

References

Aplin, Graeme. 2007. "World Heritage Cultural Landscapes." *International Journal of Heritage Studies* 13 (6): 427–446.

Arakaki Gen'yū. 2002. "Maboroshi no Sēfa Jinja." In *Kunishitei shiseki Sēfa Utaki: Seibi jigyō hōkokusho (kōji/shiryō hen)*, edited by Chinenson Kyōiku Iinkai, 138–139. Chinen: Chinenson Kyōiku Iinkai.

Beillevaire, Patrick. 2007. "Agari-umāi, or the Eastern Tour: A Ryūkyūan Royal Ritual and Its Transformations." In *Pilgrimages and Spiritual Quests in Japan*, edited by Maria Rodríguez del Alisal, Peter Ackermann, and Dolores P. Martinez, 104–116. Abingdon: Routledge.

Carter, Caleb. 2018. "Power Spots and the Charged Landscape of Shinto." Japanese Journal of Religious Studies 45 (1): 145–173.

Chinenson Kyōiku Iinkai, ed. 2002. *Kunishitei shiseki Sēfa Utaki: Seibi jigyō hōkokusho (kōji/shiryō hen)*. Chinen: Chinenson Kyōiku Iinkai.

Chinenson Kyōiku Iinkai. 2003. *Sēfa Utaki to shizen: Sekai isan fukyū tosho*. Chinenson Kyōiku Iinkai.

Foster, Michael Dylan. 2011. "The UNESCO Effect: Confidence, Defamiliarization, and a New Element in the Discourse on a Japanese Island." *Journal of Folklore Research* 48 (1): 63–107.

Harrison, Rodney. 2015. "Beyond 'Natural' and 'Cultural' Heritage: Toward an Ontological Politics of Heritage in the Age of Anthropocene." *Heritage and Society* 8 (1): 24–42.

Higa Yasuo. 2000. *Nihonjin no tamashii no genkyō: Okinawa Kudakajima.* Tokyo: Shūeisha Shinsho.

ICOMOS. 2000. *Ryukyu sites (Japan), no. 972.* Advisory Body Evaluation. Accessed 14 January 2020, http://whc.unesco.org/document/154726.

Ivy, Marilyn. 1995. *Discourses of the Vanishing: Modernity, Phantasm, Japan.* Chicago: University of Chicago Press.

Iyori Tsutomu. 2005. *Ryūkyū saishi kūkan no kenkyū: Kami to hito no kankyōgaku.* Tokyo: Chūō Kōron Bijutsu Shuppan.

Kadota Takehisa. 2012. "Sēfa Utaki: Kyōdō kūkan to shite no seichi e." In *Seichi junrei tsūrizumu,* edited by Hoshino Eiki, Yamanaka Hiroshi, and Okamoto Ryōsuke, 90–93. Kōbundō.

Kadota Takehisa. 2017. "Seichi to girei no 'shōhi': Okinawa/Sēfa Utaki o meguru shūkyō tsūrizumu no gendai minzokugakuteki kenkyū." *Bulletin of the National Museum of Japanese History* 205: 255–289.

Knight, John. 1997. "A Tale of Two Forests: Reforestation Discourse in Japan and Beyond." *Journal of the Royal Anthropological Institute* 3 (4): 711–730.

Loo, Tze May. 2014. *Heritage Politics: Shuri Castle and Okinawa's Incorporation into Modern Japan, 1879–2000.* Lanham, MD: Lexington Books.

Lowenthal, David. 1998. "Fabricating Heritage." *History & Memory* 10 (1): 5–24.

Lowenthal, David. 2005. "Natural and Cultural Heritage." *International Journal of Heritage Studies* 11 (1): 81–92.

Morris-Suzuki, Tessa. 1998. *Re-Inventing Japan: Time, Space, Nation.* New York: M.E. Sharpe.

Nakamatsu Yashū. 1990. *Kami to mura.* Tokyo: Fukurōsha.

Nakasone, Ronald Y. 2002. "Agari-umaai: An Okinawan Pilgrimage." In *Okinawan Diaspora,* edited by Ronald Y. Nakasone, 142–156. Honolulu: University of Hawai'i Press.

Nanjō-shi Kyōiku Iinkai. 2018. *Kuni shitei shiseki Sēfa Utaki hozon katsuyō keikaku.* Nanjō: Nanjō-shi Kyōiku Iinkai.

Okaya Kōji. 2016. "Utaki o meguru mondai." In *Shūkyō to gendai ga wakaru hon 2016,* edited by Watanabe Naoki, 88–91. Tokyo: Heibonsha.

Ōshiro Hideko. 2001. "Sekai isan tōroku o iwau." *Sēfa no mori* 10: 16–17.

Prochaska-Meyer, Isabelle. 2013. *Kaminchu: Spirituelle Heilerinnen in Okinawa.* Vienna: Praesens Verlag.

Røkkum, Arne. 1998. *Goddesses, Priestesses and Sisters: Mind, Gender and Power in the Monarchic Tradition of the Ryukyus.* Oslo: Scandinavian University Press.

Rots, Aike P. 2017. *Shinto, Nature and Ideology in Contemporary Japan: Making Sacred Forests.* London: Bloomsbury.

Rots, Aike P. 2019a. "Strangers in the Sacred Grove: The Changing Meanings of Okinawan *Utaki*." *Religions* 10 (5): 298. https://doi.org/10.3390/rel10050298.

Rots, Aike P. 2019b. "'This Is Not a Powerspot': Heritage Tourism, Sacred Space, and Conflicts of Authority at Sēfa Utaki." *Asian Ethnology* 78 (1): 155–180.

Rots, Aike P. 2019c. "Trees of Tension: Re-Making Nature in Post-Disaster Tohoku." *Japan Forum.* https://doi.org/10.1080/09555803.2019.1628087.

Rots, Aike P., and Mark Teeuwen. 2017. "Introduction: Formations of the Secular in Japan." *Japan Review* 30: 3–20.

Ryūkyū Shinpō. 1998. "Kuni shitei shiseki Sēfa Utaki: Jumoku 400-pon mudan de kiru." 14 January 1998.

Ryūkyū Shinpō. 1999. "Sēfa Utaki ni tsubaki shokuju." 18 June 1999.

Ryūkyū Shinpō. 2013. "Danshi kinsei o kentō: manā ihan zō, seichi hogo de." 21 September 2013.

Satō Mirai. 2016. "Manā mondai kara kangaeru Sēfa Utaki no genjō to kadai." In *Seikatsu no naka no kankō: Okinawa-ken Nanjō-shi no esunogurafi III*, edited by Kadota Takehisa, 84–95. Tokyo: Rikkyō University.

Smith, Laurajane. 2006. *Uses of Heritage*. Abingdon: Routledge.

Smits, Gregory. 2000. "Ambiguous Boundaries: Redefining Royal Authority in the Kingdom of Ryukyu." *Harvard Journal of Asiatic Studies* 60 (1): 89–123.

Smits, Gregory. 2018. *Maritime Ryukyu, 1050–1650*. Honolulu: University of Hawai'i Press.

Underwood, William. 2015. "History in a Box: UNESCO and the Framing of Japan's Meiji Era." *The Asia-Pacific Journal: Japan Focus* 13 (26/2): 1–14. https://apjjf.org/-William-Underwood/4332/article.pdf.

Urry, John. 2002 [1990]. *The Tourist Gaze*. Second edition. London: Sage.

Wacker, Monika. 2003. "*Onarigami*: Holy Women in the Twentieth Century." *Japanese Journal of Religious Studies* 30 (3/4): 339–359.

Wakugami Motoo. 1982. "Sēfa utaki no saishi to denshō." In *Okinawa ken shizen kankyō hozen chiiki shitei kōhochi gakujutsu chōsa hōkoku sho: Chibana gusuku/Sēfa utaki to sono shūhen chiiki*, edited by Okinawa Shizen Kenkyūkai, 125–130. Naha: Okinawa-ken.

Yamada, Fumio, and Ken Sugimura. 2004. "Negative Impact of an Invasive Small Indian Mongoose *Herpestes javanicus* on Native Wildlife Species and Evaluation of a Control Project in Amami-Ohshima and Okinawa Islands, Japan." *Global Environmental Research* 8 (2): 117–124.

Chapter 6

What does it mean to become UNESCO Intangible Cultural Heritage?

The case of aenokoto*

Kikuchi Akira
(Translated by Mark Teeuwen)

The ritual procedures of *aenokoto,* performed in the Oku Noto region, begin on 5 December. On that day, heads of farming households invite the kami of the rice fields (*ta no kami*) into their house, entertain it with a bath and food offerings, and convey their gratitude for the harvest. On 9 February, in the following year, the kami is plied in the same manner once more, and then accompanied out to the fields with prayers for a bountiful harvest in the coming season.

The archaic appearance of this ritual has made it famous as an archetypical expression of the ancient faith of Japan's rice farmers. Indeed, it has been branded as the archetype of the imperial ritual of *niiname.* Yet it goes without saying that *aenokoto* as it is performed today is a living practice that cannot be separated from its present-day setting. Its modern caretakers struggle to deal with visiting researchers and journalists; they lament the current state of agriculture; and at times, they hold faint hopes of tapping into a potential tourism market. The interplay between the performers of *aenokoto* and outsiders, within an ever-fluid political, economic, social, and cultural context, inevitably brings constant change, at times slow, at times instantaneous.

In 2009, *aenokoto* was inscribed in the Representative List of the Intangible Cultural Heritage of Humanity (ICH). The ICH Convention differs from the more famous World Heritage Convention in a number of important ways, and much remains unclear about the impact of ICH listings. The aim of this chapter is to map the main developments of *aenokoto* in the first few years after its

* This chapter is based on Kikuchi Akira, "Yunesuko mukei bunka isan ni naru to iu koto: Oku Noto no aenokoto no 21seiki," in *Sekai isan jidai no minzokugaku: gurōbaru sutandādo no juyō o meguru Nik-Kan hikaku,* edited by Iwamoto Michiya, 149–178, Tokyo: Fūkyōsha, 2013. The original chapter includes a section that introduces the Convention for the Safeguarding of the Intangible Cultural Heritage; in this translation, this part has been replaced with a short introduction to the history of *aenokoto* before it emerged as a candidate for UNESCO listing.

listing as ICH. The essay on which this chapter is based was written in 2013; after this, no notable new trends have emerged, and it would seem that the events of these first few years (2009–2013) continue to define the direction of *aenokoto*'s development until the present day. First, I will briefly sketch the process of *aenokoto*'s post-war "discovery" and signification. I will then survey the responses of national, regional, and local authorities to the ICH Convention, and explore some of the reactions to that listing of people in Oku Noto who are the caretakers of *aenokoto* today. On what course will *aenokoto* embark in the near future, now that it has entered the global stage as a representative of "Japan"?

Aenokoto as "the *niiname* of the people"

Aenokoto first caught the eye of folklorists as a popular parallel to the court ceremony of *niiname*, a classical harvest ritual that was at the core of imperial ritual already in ancient times. The 1908 Rules for Imperial Rituals (*Kōshitsu saishi rei*) listed *niiname* as one of the "major rites" personally performed by the emperor, who offers sake, porridge and steamed rice to Amaterasu before partaking of it himself. The first *niiname* by a new emperor, called *daijōsai*, is a grand national occasion, and the *daijōsai* of the Taishō and Shōwa emperors (in 1915 and 1928) were public events of nation-building, celebrated throughout the country on an unprecedented scale—as indeed were those of the Heisei and Reiwa emperors in 1990 and 2019. *Niiname* even survived the war: in 1948 the date of *niiname* (23 November) was established as a national holiday, now called Labour Thanksgiving Day. It was the link to this imperial ritual that propelled *aenokoto* to fame as the most Japanese of folk rituals (Kikuchi 2001). How did this happen?

The earliest field report on *aenokoto* was compiled in 1934, in the context of the first national survey of folklore known as the "survey of mountain villages" (Kodera 1938). This project was carried out by the founder of Japanese folklore studies, Yanagita Kunio (1875–1962), and his students. Yanagita himself had learned of *aenokoto* through a volume on local history and customs already in the early 1920s. At the time, Yanagita noted that *aenokoto* excited him as "material that appears to corroborate my very vague hypothesis" (Yanagita 1934, 50). Later, *aenokoto* would indeed serve as a key element in his theory about what he called Japan's "unique religiosity" (*koyū shinkō*).

Japanese folklore studies (*minzokugaku*) was established in the 1930s. In this decade, the first systematic surveys were conducted, the first works of theory published, and academic associations for this field founded. Another important accomplishment was the publication of reference works titled *Burui goi* (Terms of Categorisation). *Aenokoto* was included in one such work, *Saiji shūzoku goi* (Terms of Categorisation Concerning Seasonal Customs, 1939). It was Yanagita who picked up the term *aenokoto* for this collection—a term that up to that time had been used only in one single field report. Locally, *ta no kami* ("the

kami of the rice fields") was much more current. Drawing on his broad historical knowledge, Yanagita furnished this term with the meaning "ritual (*koto*) of feasting (*ae*)." *Terms of Categorisation*, generated from the privileged perspective of Yanagita who had access to data from all corners of Japan, soon became the standard for interpretations of rituals by folklorists around the country. Yanagita went on to add new elements to the image of *aenokoto* in his books *Nihon no matsuri* (Japanese Festivals, 1942) and *Yamamiya kō* (Thoughts on the Mountains as Shrines, 1947). His elaborations were not based on field reports; they were inspired by his developing ideas about ritual, and designed to meet the theoretical needs of his discourse on Japan's "unique religiosity."

It was a local teacher of social studies, Yotsuyanagi Yoshitaka (b. 1922), who would put Yanagita's discourse to the test by means of fieldwork. Yotsuyanagi conducted an *aenokoto* survey in the region of Oku Noto. His fieldwork was the result of a series of coincidences. "Social studies" (*shakaika*) was a new school subject, introduced as part of the education reforms after the war. In 1950, when Yotsuyanagi began working as a teacher in this subject, a colleague persuaded him to join the Kaga-Noto Folklore Association (Kanō Minzoku no Kai). Acting on the request of one of Yanagita's leading disciples, Ōtō Tokihiko (1902–1990), Yotsuyanagi began his *aenokoto* survey in the same year. In June 1951 Yanagita visited Kanazawa and encouraged Yotsuyanagi. Using weekends and holidays for field trips, Yotsuyanagi collected a massive amount of new materials. He presented his results at a conference in honour of Yanagita's seventy-seventh birthday in October. His conclusions, however, were a mere echo of Yanagita's ideas (Yotsuyanagi 1951).

The image of *aenokoto* became irreversibly fixed by the so-called Niiname Research Association (Niiname Kenkyūkai). In July 1951, just a few months before the signing of the San Francisco Peace Treaty, Prince Mikasa (the younger brother of the Shōwa emperor) and Yanagita founded this Association after the Imperial Household Agency had decided to make some of its archival materials available to the public. The Association's aim was to "identify the origins of the emperor system in the ritual of *niiname*," as the Association's chief secretary Matsudaira Narimitsu put it (Matsudaira 1964, 244); it pursued the typically postwar agenda of rebuilding the emperor system on cultural grounds. Yanagita contributed to this project by offering arguments for the "unity of the emperor and the people" by way of a shared faith in the spirit of rice (*inadama shinkō*). *Aenokoto* served as anecdotal evidence of this unity: it was now positioned as the "*niiname* of the people," corresponding to the court ritual of the same name.

A year later, in 1952, nine different academic associations organised a large-scale "joint Noto survey." Here, too, the focus of attention was on unearthing agricultural rituals related to the same "origins." Matsudaira now travelled to Noto to observe the *aenokoto* in person for the first time. He used a local middle school teacher as his guide, and reportedly told him: "The atmosphere of this ritual was very moving, and it helped me imagine the secret rites of the court"

(Wajima 1997, 298). In this way, the interpretations of the Niiname Research Association were transported to the *aenokoto* heartland of Noto itself.

The results of the joint Noto survey were published by the religious studies scholar Hori Ichirō in *Niiname no kenkyū* (Research on Niiname, 1955), the concluding report of the Niiname Research Association. Hori's essay, "On agricultural rituals in Oku Noto," carried the full weight of his academic authority, and it fixed the meaning of *aenokoto* as a folk version of the court's *niiname* once and for all. The field reports on which it was based did not interpret the ritual as it was actually practiced; rather, they confirmed Yanagita's ideas. The result was an understanding of *aenokoto* that denies or ignores historical, local, and social differences and transformations. Rather, Hori creates an image of an unbroken tradition, running from the records of ancient court ritual to today's Labour Thanksgiving Day. This signification was a product of the circumstances of the postwar years.

Aenokoto's modern place in the discourse of folklore studies positioned it for designation as an Important Intangible Folk Cultural Property in May 1976. It was among the first group of elements to receive this designation, established in the revised Law for the Protection of Cultural Properties of 1975. This, in turn, placed *aenokoto* in the first row for inscription as UNESCO Intangible Cultural Heritage.

The response of the Japanese government to the ICH Convention

The 2003 Convention for the Safeguarding of the Intangible Cultural Heritage (ICH) went into effect in 2006, and a new Intangible Heritage List was established in 2008. In Japan, a "Special Committee of the ICH Convention" within the Cultural Properties Department of the Agency of Cultural Affairs (ACA) finalised its inventory of candidate elements for a future ICH listing on 18 July 2008. Included were the following fourteen candidates:

1. *Gagaku* (Important Intangible Cultural Property since 1955; category of performing arts)
2. *Ojiya chijimi, Echigo jōfu* (Important Intangible Cultural Property since 1955; crafts, textile)
3. *Sekishū banshi* (Important Intangible Cultural Property since 1969; crafts, paper)
4. *Hitachi furyūmono* (Important Intangible Folk Cultural Property since 1977; Ibaraki, festival)
5. *The yamahoko parade of Kyoto's Gion matsuri* (Important Intangible Folk Cultural Property since 1979; Kyoto, festival)
6. *The toshidon ritual of Koshikijima* (Important Intangible Folk Cultural Property since 1977; Kagoshima, seasonal event)
7. *The aenokoto ritual of Oku Noto* (Important Intangible Folk Cultural Property since 1976, Ishikawa, seasonal event)

8. *Hayachine kagura* (Important Intangible Folk Cultural Property since 1976; Iwate, *kagura* dance)
9. *Taue* dances of Akiu (Important Intangible Folk Cultural Property since 1976; Miyagi, *dengaku* dance)
10. *Chakkirako* (Important Intangible Folk Cultural Property since 1976; Kanagawa, *furyū* dance)
11. *Dainichidō bugaku* (Important Intangible Folk Cultural Property since 1976; Akita, stage performance)
12. *Daimoku-tate* (Important Intangible Folk Cultural Property since 1976; Nara, storytelling)
13. *Repair of wooden statuary* (Selected Preservation Technique since 1976)
14. *Traditional Ainu dance* (Important Intangible Folk Cultural Property since 1984; Hokkaido)

When I saw this inventory, I was at first very surprised. After all, there are many intangible cultural properties that offer more of a spectacle, such as Yamagata's *Kurokawa nō* folk theatre, or the festivals of *Hanamatsuri* in Aichi and *tanadui* in Okinawa. The reasoning behind this list became clearer when the ACA published a document "concerning our response to the ICH Convention" (30 July 2008). Here, the ACA explains that

> in contrast to the World Heritage Convention, the value of ICH candidates will not be determined by a panel of experts. The value of intangible cultural properties in our country will not be affected by UNESCO's decision whether or not to list the candidates in our inventory.

With this in mind, the ACA adopted a policy of submitting Japanese Important Intangible Cultural Properties (since 1955), Important Intangible Folk Cultural Properties (since 1976), and Selected Preservation Techniques (since 1976) for ICH listing in chronological order, according to the date of their domestic designation. Minor adjustments were made to include candidates from different regions within Japan; notably, Ainu heritage was added to this first application to reflect the diversity of Japanese culture.

The ACA, then, regarded all national Important Intangible Cultural Properties as potential ICH, and intended to submit all of them for ICH listing in the chronological order of their domestic designation.[1] This "mechanical" method of selection had the advantage that it avoided competition for priority between candidate elements.

Responses of regional authorities

Inscription is decided

On 30 September 2009, UNESCO presented the results of its first round of ICH listings, containing seventy-six newly inscribed elements. Thirteen of the

fourteen proposed Japanese elements were included in the list; *Repair of Wooden Statuary* was withdrawn from the application after the Agency had been advised that further explanation would be necessary. Three "Masterpieces of the Oral and Intangible Heritage of Humanity," noh, bunraku, and kabuki (originally listed in 2001, 2003, and 2005), were transferred to the ICH list, bringing the total to sixteen Japanese ICH inscriptions. One of these sixteen was Oku Noto's *aenokoto*.

The mechanical method that the ACA had used to select the candidate elements was not widely known, and this gave rise to various misunderstandings across the country including Ishikawa Prefecture, where Oku Noto is located. A citizen of Wajima City, for example, exclaimed in a blog: "That organisation called UNESCO! So they checked even a tiny rural ritual like that … Respect!"[2] In fact, it was not UNESCO that had selected *aenokoto*; the organisation merely accepted the proposals of the Japanese government. A farmer, also from Wajima, wrote in a local newspaper:

> *Aenokoto* in our household is a bit different. I invite the kami of the rice fields and perform the ritual as the head of our household. But I have been a bit too tempted to try to make my family laugh by escorting the kami in a funny way. I could never show my performance to UNESCO, and my family is also growing tired of my antics. Now, *aenokoto* has been listed as Intangible Cultural Heritage. I will take this opportunity to start guarding our tradition in a more solemn manner that won't put me to shame in UNESCO's eyes.
>
> (*Hokkoku shinbun*, 7 October 2009)

Contrary to what this farmer appears to have expected, however, UNESCO does not seek to standardise heritage or to restore it to an "original" or "proper" format. Also, it leaves the preservation of the listed heritage entirely to its member states. There is no need to worry about UNESCO inspections.

Equally striking were local ambitions to secure an ICH listing for *Wajima-nuri* lacquerware (an Important Intangible Cultural Property since 1977). In December of 2007, the governor of Ishikawa Prefecture, Tanimoto Masanori, visited the minister of Education, Culture, Sports, Science and Technology, as well as the commissioner of the ACA, to request that *Wajima-nuri* be selected as a candidate for ICH listing, reportedly surprising the ACA with his swift action (*Hokkoku shinbun*, 31 July 2008). When the inventory of fourteen candidate elements was published, including *aenokoto* but not *Wajima-nuri*, the local authorities welcomed the selection of the former but also expressed the expectation that *Wajima-nuri* might be listed at a later occasion (*Hokkoku shinbun*, 31 July 2008). Two years later, the prefectural assembly was informed of the possibility that *Wajima-nuri* might be listed in 2013 (*Yomiuri shinbun*, digital edition, 8 February 2010). The reason for this local ambition is clear: *aenokoto* may be an ancient tradition, but its economic potential is much inferior to that of *Wajima-nuri* lacquerware.

It was in the midst of such expectations and misunderstandings that *aenokoto* started its career as ICH.

The response of local authorities

Aenokoto is performed in four municipalities at the tip of the Noto peninsula: Wajima City, Suzu City, Noto Town, and Anamizu Town. Since the national designation of 1976, the preservation of *aenokoto* has been managed by the offices in charge of cultural properties in these municipalities, in cooperation with the Preservation Association of Aenokoto in Oku Noto (Oku Noto Aenokoto Hozonkai). In most cases, the groups who stage folk performances double as the preservation associations of those same performances as Intangible Folk Cultural Properties; a group performing a *kagura* repertoire, for example, will form its own *kagura* preservation association (Hyōki 2018). But *aenokoto* is practiced not by a group but by households, without much contact between individual caretakers (performers). Therefore the option of using an existing group to serve as the Preservation Association of Aenokoto in Oku Noto was not available. Instead, this Association was newly constituted, with the mayors of the four municipalities, municipal employees in charge of cultural properties, and the caretakers themselves as its members. The main activity of the Association is not the actual performance of *aenokoto*, but rather conducting surveys and making records of performances. For this, the Association can apply for funding from the national government. In 1978, these activities resulted in the publication of the volume *Oku Noto no aenokoto*, which recorded the status of *aenokoto* at the time. After this publication no more funding was forthcoming, and the Association went dormant for a long period of time. The UNESCO listing restored it to life, but even now, the Association has no budget and limits itself to responding to inquiries from various authorities and from the media. The present head of the Association is the mayor of Noto Town, Mochiki Kazushige.

The ICH listing created the need to obtain accurate knowledge of *aenokoto* caretakers around the region. The Education Committee of Ishikawa Prefecture instigated a survey, which revealed that there were not just eleven caretakers, as previously thought, but as many as eighty-five. It also became clear that there was a large variety in the ways *aenokoto* was performed. Procedures ranged from a full, formal version, where the household head dresses up in *kamishimo* ceremonial garb and prepares both a bath and offerings for the kami, to simple offerings of rice wine preformed in everyday clothes (*Hokkoku shinbun*, 22 October 2009). The caretakers were asked to fill out a questionnaire, which included the question: "What do you find troublesome when performing *aenokoto*?" One respondent wrote: "With the present LDP agricultural policies of Asō Tarō, I can't perform *aenokoto* at all."[3] The prefecture's aim with this exercise was to design measures for *aenokoto*'s preservation.[4]

Much effort was invested in advertising *aenokoto* and making it more widely known.[5] Banners were hung from municipal buildings, the ritual was introduced

in public printed materials and on websites, and there were broadcasts about it on cable television. In the course of 2009 and 2010, exhibitions of photographs and ritual implements were put on display at the prefectural office, Noto Airport, Wajima City Community Centre, Noto Town Hall, and the Anamizu Municipal Museum of History and Folklore. A dolls' scene of *aenokoto*, originally displayed at the recently closed Wajima Municipal Museum of History and Folklore, was given a new lease of life in Wajima Airport. Noto Town spent 1.8 million yen on replicas of *aenokoto* offerings and ritual implements. In addition there have been regular public talks, and members of the Preservation Association have been actively promoting *aenokoto* in various forums.

Most preservation associations focus their efforts on nurturing the next generation of caretakers and passing on the skills of the performances that they transmit, but what is at stake in the case of *aenokoto* is not particular skills, but rather the motivation of new generations to continue the practice. Therefore, the Aenokoto Preservation Association concentrates its efforts on various initiatives to raise awareness and spread knowledge.

Performances of aenokoto

World Heritage listings often raise expectations of increased tourism, with positive effects for the local economy. The same applies to ICH, but intangible heritage offers particular challenges. World Heritage Sites consist of tangible real estate, while ICH consists of the actions of living people. Developing these into a "show" for display to visitors is by no means easy. *Aenokoto* presents particular difficulties because it is performed in people's private homes, on a schedule that is not necessarily convenient for outsiders. Packaging *aenokoto* for tourists has therefore proved problematic.

Noto Town has been most active in this regard. In this municipality, volunteer guides provide tours to *aenokoto* performances; the third-sector public corporation *Fureai no sato*, which organises tourism events in Noto Town, has initiated the sale of *aenokoto* offerings; and local hotels and other accommodation facilities offer a special "*aenokoto* plan" to visitors. However, none of these initiatives have met with much success. In the winter season of 2010, the only user of the *aenokoto* plan was the author of this chapter.

The most successful effort at opening up *aenokoto* for tourists is the public performance of this ritual in the Yanagida Botanical Garden. For more than two decades, a traditional thatched-roof house (moved to this garden in 1986) has been used as the stage for *aenokoto* enactments. During all these years, Tanaka Noboru, a farmer from Omō in Yanagida Village, has performed the role of household head (*gote*). When he began performing *aenokoto* in the botanical garden, Tanaka ceased practicing it at home.

On 5 December 2009, the kami of the rice fields was worshipped at Yanagida for the first time after the ICH listing (see Figure 6.1). More than a hundred people had gathered to witness it—triple the number of normal years.

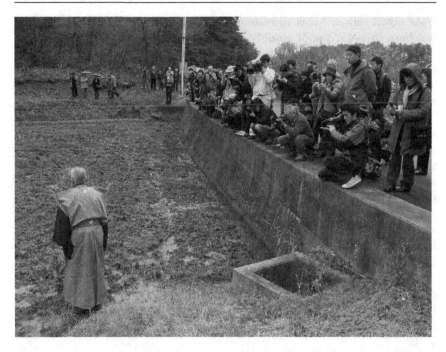

Figure 6.1 Tanaka Noboru performs *aenokoto* in the Yanagida Botanical Garden in 2009. Photo by the author.

Mayor Mochiki gave a speech before the event started, announcing his joy at *aenokoto*'s new status and promising to support agriculture as Noto Town's primary industry. Tanaka Noboru explained the proceedings and the offerings to the kami, welcomed the kami into the thatched house, offered tea at the hearth and a bath in a bucket in the earth-floor section of the house, and finally invited the kami to partake of the feast he had prepared. After the ritual Tanaka was interviewed by prefectural television. He admitted that he did indeed feel more pressure now that UNESCO had inscribed the ritual, but more important to him was the fact that *aenokoto* might serve as a reminder of the gratitude that we all owe to nature and to our fellow human beings. As before, samples of the dishes offered in the *aenokoto* ritual were on sale after the event.

I noticed that, compared with ten years ago, some new elements had been added to Tanaka's narrative. In an interview published in *Mainichi shinbun* (3 December 2009), Tanaka mentioned a meeting with Yanagita Kunio:

> One day, a stranger came to ask my father about the ritual. Later I was told that he was the late folklorist Yanagita Kunio. In his book *Nihon no matsuri*, Yanagita wrote about *aenokoto* as an important expression of the harmony between the kami and mankind.

As noted earlier, *Nihon no matsuri* was published in 1942, so Tanaka, who was born in 1945, cannot possibly have been present at this scene. Maybe the visit that Tanaka remembers was by one of the scholars who participated in the "joint survey of Noto" of 1952–1953 (e.g., Ikegami Hiromasa, Sakurai Tokutarō, Hirayama Toshijirō, or Miyamoto Tsunekazu). However that may be, it is clear that Tanaka's narrative about *aenokoto* is gradually expanding.

In the first three months of 2010, the tourist market was plied with seven one-day bus tours that combined "an experience of *aenokoto*" with a visit to the Jōmon-themed Mawaki spa. Departing from Komatsu or Kanazawa in the morning, the participants started the day by viewing Tanaka's perform-ance of *aenokoto* at Yanagida. They then enjoyed a lunch based on *aenokoto* offerings at the scenic Hyakurakusō resort, moved on to the baths at Mawaki, and on the way home stopped at a bodega where they tasted Noto wine and local sake. *Aenokoto* also featured as one of the "three main winter events" in the Winter 2010 tourism campaign marketed by the Prefectural Tourism Division. On 9 February 2011, this Division invited event organisers from Japan's three leading travel companies to a guided *aenokoto* tour, aiming to develop it as a new product for tourism in Noto. The power of the trademarks of UNESCO and ICH was slowly pulling *aenokoto* into the con-text of tourism.

Generation shifts

Around the time of the UNESCO listing, a number of *aenokoto* caretakers were facing a succession. The fact that *aenokoto* survived these generation shifts is undoubtedly an indirect effect of the ICH listing and the heightened status that it conferred on the ritual.[6]

The Nakatani household (Wajima City, Machino-machi, Tokunari)

The Nakatani household is well-known for its elaborate transmission of *aenokoto*; it featured already in the opening scene of a 1971 programme of the NHK series *Shin Nihon kikō* (New Japanese Travels), and it has long attracted attention from both the media and researchers. In 1971 the role of household head was performed by Nakatani Kōji, but in 1978 Kōji's health declined and his son Shōichi (b. 1928) took over. Thirty years later, when Shōichi learned that *aenokoto* was a candidate for ICH listing, he commented that he was "happy that the spirit of Japanese agriculture will now become known to the world" (*Hokkoku shinbun*, 31 July 2008). In the summer of 2009, soon after the listing had been decided, Shōichi suffered a stroke that left him partly paralyzed. He had difficulties speaking, but a few days before that year's *aenokoto*, he nevertheless managed to say, "*Aenokoto* is soon, I have to do it…"

Up to that moment, Shōichi's son Shōji (b. 1956) had no intention to take over the tradition, but now his father's determination swayed him. An emotional Shōichi witnessed his son's performance from a wheelchair; he died peacefully a month later.

Due to mourning Shōji did not conduct the "sending off" (*kami okuri*) rite in February of 2010. Before his debut a year later he studied footage of his father, broadcast on television a long time ago. Yet he did not feel that he had mastery of the words and the choreography of the rite, and when he had to perform it in front of the cameras of a local television station, he was "so nervous that I almost forgot my lines." Although he feels that he has a long way to go before he can conduct the *aenokoto* with as much dignity as his grandfather and his father, he is making an effort to live up to his late father's expectations. He has made a pamphlet featuring drawings by his own hand, which he distributes among viewers.

At the entrance of the Nakatani house, there was already a wooden plaque with the inscription "Oku Noto's *aenokoto*: National Important Intangible Cultural Property." This is now joined by another plaque reading "Oku Noto's *aenokoto*: World Intangible Cultural Heritage." In the garden there is a stone monument, erected at the insistence of Shōichi, with the inscription: "*Aenokoto*: worship and folklore."

The Tanaka household (Suzu City, Wakayama-machi, Himiya)

The Tanaka household is famous for the range of agricultural rituals that are transmitted and practiced there, including the *kariage* harvest rite; rites to invite and send off the kami of the rice fields (5 December and 9 February); the *tauchi* ploughing rite (11 February); and the *minakuchi* planting rite. The historical value of these transmissions has been widely recognised. A diorama showing the central section of the Tanaka house has long been part of the permanent exhibition "Japanese folklore" (opened in 1985) at the National Museum of Japanese History near Tokyo, which also included a simulation of the rituals.[7] Every year, the solemn performance of *aenokoto* at the Tanaka household attracts a considerable number of journalists, researchers, and local enthusiasts.

In December 2010 the Tanaka household head Ushio (b. 1928) was hospitalised, and his son Shigeyoshi (b. 1953) took over his role. Although Shigeyoshi had for many years assisted his father in performing *aenokoto*, he felt that things did not go as well as he could wish, now that he had to do it himself. His wife, too, remarked that when it came to preparing the offerings they felt like bumbling amateurs. The main change was that Shigeyoshi decided to perform both the *kami okuri* and the *tauchi* rites on the same day, 9 February, due to his working schedule as an employee of the agricultural cooperative JA. This change of generations, then, led to a subtle simplification of the rituals of the Tanaka household.

The Kawaguchi household (Wajima City, Shiroyone)

Shiroyone in Wajima City is famous for its "thousand rice paddies" (Senmaida), which have been designated as a national Site of Scenic Beauty and, more recently, as a Globally Important Agricultural Heritage System. It is here that Kawaguchi Yoshinori (b. 1965) has performed *aenokoto* since he took over from his father Kiyofumi (b. 1939) in 2006. This *aenokoto* was "revived" in December 2000.

The *aenokoto* of the Kawaguchi household is closely connected to developments around the Shiroyone Senmaida site. Since the 1970s, this area has struggled with the effects of depopulation, low birth rates, aging, and a diminishing work force. From the late 1990s onwards, there were moves to preserve and utilise this landscape of 1,004 small terraced rice fields, inspired by the 1992 introduction of the category of "cultural landscapes" into the World Heritage Convention, and by new domestic agricultural policies that stressed "multi-purpose use" of farmland (Kikuchi 2007, 2010). In 1999, the Foundation for Global Peace and Environment organised an international forum in Wajima, and in 2001, the National Council of Terraced Rice Paddies held a summit there. In this setting, calls were made to designate Senmaida as a national cultural property. In support of such calls, the Tourism Division of Wajima City organised various cultural events there, including traditional rituals connected with rice planting, insect repelling, and harvesting. In this connection Kawaguchi Kiyofumi, who was the administrator (*kuchō*) of Shiroyone at this time, was asked to organise a performance of *aenokoto*; this was realised in December of 2000. Local media reported that "more than half a century" had passed since *aenokoto* had disappeared from this area (*Hokuriku Chūnichi shinbun*, 7 December 2000).[8]

Little was known about the details of the old ritual, so advice was gathered from various places. There were quite a number of novelties. The offerings used in Shiroyone included apples, bananas, and oranges, foodstuffs that are never seen in traditional *aenokoto*. Kiyofumi had intended to conduct the ritual wearing traditional working gear, but was urged to use a formal *kamishimo* instead. Yet he felt that wearing such a high-status costume was inappropriate with regard to his family's standing, and would constitute an insult to the kami of the rice fields; in the end, he used a less high-class combination of *haori* and *hakama*, covered with a peasant-style straw coat (*mino*). After the 2000 revival, Wajima City's marketing of *aenokoto* shifted from the Nakatani performance in Tokunari to that of the Kawaguchi one in Shiroyone. Their performance, in terraced rice fields looking out over the waves of the Japan Sea, made for a more impressive photo opportunity (see Figure 6.2).

Kawaguchi Kiyofumi continued to perform the ritual also after he had retired from the post of administrator. In this way, he wanted to "express his gratitude to the volunteers, the city, and the media" for their support of Senmaida. Kawaguchi Yoshinori, who has since taken over from his father, works in the prefectural office in Kanazawa while growing vegetables in the weekends. He

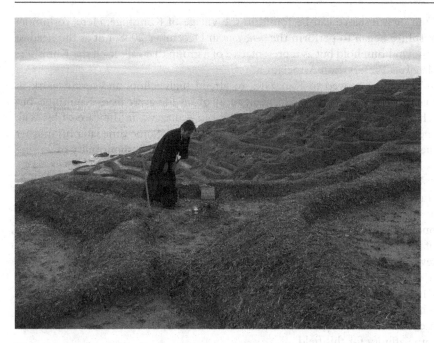

Figure 6.2 Kawaguchi Kiyofumi performs *aenokoto* in Shiroyone, 2009. Photo by the
author.

tells that the pressure of dealing with visiting journalists and researchers is
"growing year by year."

On 5 January 2011 the Kawaguchi house was struck by lightning, and both
the main house and the storehouse next to it burned to the ground. Nobody
was hurt, but the ritual implements and the costume that were used for *aenokoto*
were lost in the fire. Yoshinori almost gave up the idea of continuing *aenokoto*,
but in the shed that was used to store agricultural tools, he found a bale of rice
seeds grown by his father. This appeared to him as a message, urging him to con-
tinue his efforts to take care of the rice fields and the rituals. It strengthened his
resolve to carry the tradition forward, even if some simplification was unavoid-
able. People who heard about the fire donated implements, and a person in
Kanazawa who engaged in straw weaving as a hobby made a round seat for the
kami of the rice fields. With the help of these well-wishers, Kawaguchi Yoshinori
saw off the kami from the surviving shed to the terraced rice paddies below.

Aenokoto becomes a community ritual

The Aenokoto Preservation Association in Kunishige, Noto Town

Among the changes that occurred in *aenokoto* after the ICH listing, the most
striking are cases where it has been transformed into a community ritual.

One such instance can be found in the village of Kunishige. Here, Yoshimura Yasuhiro began to perform the *aenokoto* in December 2008, not as the head of his own household but as representative of a group that calls itself the Kunishige *Aenokoto* Preservation Association.

Yoshimura moved to Kanazawa to attend high school and found work in that city after graduating. He spent most of his life away from Kunishige, but when his mother fell ill he left his house in Kanazawa in the care of his wife and returned to his place of birth at the age of sixty. Some time later his mother died, but in the meantime, Yoshimura had taken on the responsibility of serving as Kunishige's administrator, and he decided to stay.

Village meetings are conducted in Kunishige on the fifteenth of every month at the meeting house. It was in one of these meetings that the proposal to revive *aenokoto* was aired and agreed upon. Yoshimura himself had performed *aenokoto* once, when his father was ill and Yoshimura was in the fourth or fifth grade of primary school. Because of that experience, he felt attracted to the idea of reviving *aenokoto*. It was very helpful that the ritual procedures of the Yoshimura household are described in detail in the volume *Oku Noto no aenokoto* (1978), which contains an article about his mother's performance. When he was a high school student, one of Yoshimura's teachers had been Ogura Manabu, the later president of the Kaga-Noto Folklore Association, and Yoshimura already felt some affinity for this field.

It was with the backing of the Kunishige *Aenokoto* Preservation Association that Yoshimura embarked on his revival initiative. During the ritual, the members of this Association sit behind Yoshimura while he explains the offerings to the kami, and they all join in the presentation of offerings. In this way, they all share in the role of household head. Yoshimura is living alone, and since it is difficult for him to prepare this feast on his own, elderly ladies from the neighbourhood come over to help him out. The fish used in the offerings is not the traditional sea-perch (*hachime*) but cod—a unique feature. In the first year, the ritual was kept simple, and Yoshimura performed it wearing a sweater. Already in the second year, however, the media showed an interest in his performance, and he changed to a combination of *haori* and *hakama*.

The main reason why *aenokoto* had been abandoned in Kunishige was that households no longer managed to make a living out of agriculture alone, and many left the village for the city in the winter to find seasonal work there. As in so many other places, the population dwindled and aged, and it became impossible to sustain the rituals on a household basis. Faced with this situation, it was a young leader of the community, Yoshida Yoshinori (b. 1971), who first proposed to restore this tradition as a village practice, with the added benefit that this would create an opportunity for the inhabitants to gather and socialise over a drink after the performance. The main objective behind the revival of *aenokoto* in Kunishige, then, was to activate the local community; neither the UNESCO listing nor hopes for increased tourism had much to do with it.

Aenokoto is not the only new initiative in Kunishige. In 2010, the old but long-abandoned tradition of charcoal burning was revived. The charcoal burners' cabin is now used for community activities, and the coal that is produced plays a role in the feasting of the kami of the rice fields. The inhabitants seek to link various activities together into an organic whole,,all in the interest of community building.

The Mii Ta no Kamisama Preservation Association

In December 2009, the Mii Ta no Kamisama Preservation Association staged a ritual of inviting the kami of the rice fields to an old thatched house in Miimachi in Wajima City. The role of household head was performed by Yamamoto Yoshiaki (b. 1940), the director of the local community centre (*kōminkan*).

Yamamoto tells that the idea to "develop some preservation activities" began to emerge "here and there" after the UNESCO listing. In 2004, a large traditional house with a thatched roof, called Kayabuki-an, had been moved to a scenic spot for public use; this house, located in a wooded valley and bordering on rice fields, offered an ideal site for enactments like those in the Yanagida Botanical Garden. A survey of all five hundred households in Miimachi revealed that a simple rite of inviting the kami of the rice fields was practiced at a hundred households, while three families in Sue (Miimachi's largest settlement) conducted the full ritual. This result confirmed the need for preservation activities and led to the founding of the Mii Ta no Kamisama Preservation Association. The Association chose to call the ritual *ta no kamisama* (the kami of the rice fields) rather than *aenokoto*, following local custom so as to stress the roots of the practice that it preserves in Miimachi in particular. The Association has some twenty members, whose tasks revolve around investigating existing traditions and making them better known.

Traditionally *ta no kamisama* is not designed for viewing by outsiders, but the Preservation Association considered that public enactments would serve to raise awareness. The ritual procedure of the revived performance was based on transmissions from Sue as well as information from the 1978 volume *Oku Noto no aenokoto*. The principle behind the reconstruction was to "merge" the many variants of *ta no kamisama* in Miimachi into a single performance, while adding new elements to adapt the ritual to its particular setting.

One such new element is that pupils from Mii primary and middle school are invited to participate, in the hope that this will increase the likelihood that the ritual will be continued by the next generation. In December 2010 eight children followed the "household head" Yamamoto into the rice fields to invite the kami (see Figure 6.3). As Yamamoto chanted "Kami of the rice fields, today is the day of *aenokoto*...," the children toned in and repeated his words. Yamamoto told that when he returned to the house, it felt "as though the kami was carried by the linked hands of the children." The way of addressing the kami was also modernised, so that the children could easily understand the

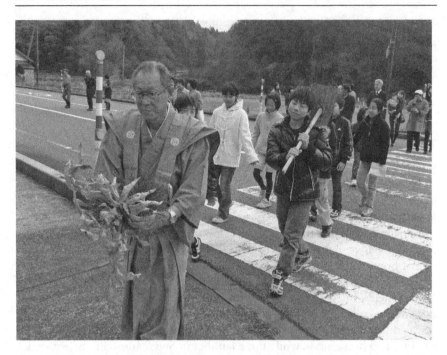

Figure 6.3 YamamotoYoshiaki leads primary and middle school pupils into the rice fields to invite the kami. Miimachi, 2009. Photo by the author.

meaning: "We are now crossing the road, *kamisama*, please take care"; and when arriving at the bath: "*Kamisama*, is the water too hot or too cold? If you turn the nob to the left the water will become hotter, and if you turn it to the right it will become colder. Please adjust it the way you prefer ..."

The *ta no kamisama* rituals are further integrated in other local events. In February, Miimachi stages *kaya ate*, an event named after the traditional local products of *kaya* thatch and *ate* wood. Started in 2008, *kaya ate* features stands selling local products, talks, folksongs, a lottery, and much else, and it offers locals an opportunity to mingle. The *aenokoto* ritual of returning the kami to the rice fields (*kami okuri*) is now performed as the opening of *kaya ate*. Again, this setting has inspired the introduction of novelties. Rather than on 9 February, *kami okuri* is now held on a Saturday, because that is when *kaya ate* takes place. In 2011, the "household head" was accompanied by a farmer in straw rain gear (*minogasa*) who sang *Ise ondo* as the kami was led back to the fields.

Yamamoto, who performs the role of household head, is not actually engaged in farming but works as a teacher. His father was an engineer who worked at a navy wharf in Kure (Hiroshima). Yamamoto's only experience of agricultural work dates back to the difficult times after the war. His family returned to Miimachi, where his grandmother's family lived, and he helped out in the fields. He learned about the existence of *aenokoto* not in Miimachi but in

Machino-machi, where he worked as a middle school teacher. The first time he heard about it was when his school asked him to go and see *aenokoto*, to find out whether it could be used in classes about local culture and history.

Yamamoto reflected on the future of the *ta no kamisama* ritual in a context where agriculture is in decline, and where rice is no longer grown by households but by corporations. He suggests that although the ritual is primarily about praying and giving thanks for a good harvest, it can be rendered meaningful also for those who do not grow rice themselves but consume it. Even though the agricultural character of the ritual may fade, it could continue to serve as a medium to pass down precious cultural knowledge. This may imply that the ritual must be "modernised" to suit the social circumstances of the present day. These views are reflected in the activities of the Mii Ta no Kamisama Preservation Association.

The Maruyama-gumi (Wajima City, Miimachi)

On 12 December 2010, a group called Maruyama-gumi performed *aenokoto* in Miimachi. Their *aenokoto* was unique in the sense that it was staged not by a group based on family or local ties, but by an association whose members participated in a survey of "life in the *satoyama* biotope." *Satoyama*, meaning "village hills," is a term for the zone where fields and forests meet; conservation of such landscapes became a widely shared concern in the 1980s and 1990s, and the so-called Satoyama Initiative lifted the concept to a global level in 2010.

The organisers of the Maruyama-gumi, the architect Hagino Kiichirō (b. 1964) and his wife, the designer Hagino Yuki (b. 1966), are both born and raised in Tokyo. They worked in the US for an extended period of time, and even considered applying for a Green Card. Six years ago, however, they moved to Miimachi. They were interested in Japanese crafts such as plastering and paper-milling, and had earlier visited Miimachi to investigate paper-milling traditions there. Two years ago, they moved into a wooden house that they had designed and built themselves in the middle of the *satoyama* landscape. Besides his work as an architect, Kiichirō runs a study circle that investigates traditional plastered storehouses (*dozō*), and he is actively involved in the repair of old storehouses that suffered damage in the Noto earthquake of 2007.

Yuki develops new products and packaging based on local traditions, and contributes to the marketing of Oku Noto's charms in that manner. In 2010, she participated in the so-called "Noto Satoyama Meister Training Programme" organised by Kanazawa University.[9] The aim of this programme is to "foster new talents who can develop environmentally friendly agriculture, forestry, and fishery as new *satoyama* and *satoumi* businesses" (*satoumi*, or "the village sea," is the marine equivalent of *satoyama*, referring to the nature-culture interface in coastal waters). In cooperation with local organisations, this university has established a research station and a "satellite school" in Oku Noto, to enhance the study and development of local resources together with the people of the

region. After she became a "Satoyama Meister," Yuki linked up with researchers and local inhabitants to conduct a survey of the ecosystem of the Maruyama area, a site that became famous when the last Japanese crested ibis (*toki*) on the Japanese mainland perished there in 1970. In the first year of that survey, 229 participants identified 252 species in the course of eight field trips. Impressed with this result, Yuki began to feel that perhaps this ecological diversity itself was what people call the kami of the rice fields. This inspired her to take an interest in *aenokoto*.

I attended this group's ritual of sending off the kami on 20 February 2011. On this day, some thirty people gathered in the Hagino house. It was an impressively varied group, including a botanist, farmers, fishermen, a dyer, a gardener, a kindergarten teacher, a social worker, and local elders. There were multiple families, and the age range was from two to seventy-seven. The role of household head was performed by Arai Hiroshi (born in 1980), a man from Saitama Prefecture who was renting an abandoned field near Maruyama to experiment with non-tillage cultivation. Arai had been employed as a delivery worker for the cooperative, but he was not satisfied with selling other people's rice as "safe" and went into agriculture himself. Two years earlier, he had set up the "Wajima Ecological Nature Garden," where he was growing rice. Wearing a jumper, Arai was now ready to start the ritual proceedings of *aenokoto* in front of a sizeable audience.

The kami of the rice fields first savoured the newly built bath of the Hagino house, with its view of the *satoyama* landscape. The kami then proceeded to the living room, where a feast was served. It was Yuki who, representing the women who had prepared the dishes, explained the offerings to the kami. These offerings were truly unique. They included not only traditional dishes such as rice with adzuki beans and *nishime* (a stew of cooked tubers, vegetables, *konnyaku,* and the like), but also bread baked with rice flour from Arai's farm, fried sardines, chicken–garlic sauté, and much else that must have been a first for the kami.

After the feast, the kami was ready to be seen off to the rice fields. Again, this was done in an innovative manner. As customary, the household head carried a *sakaki* branch that served as a medium for the kami; but here, also all the other participants received *sakaki* leaves wrapped in a sheet of paper, and participated in the return of the kami to the fields. This sheet was designed by Yuki and contained a list of the 252 species found at Maruyama, as well as the following text:

> People say that the kami of the rice fields manifests itself in the form of rice seeds. But perhaps the kami is the connection between all living things of the fields, who all join together make the crops grow? Whether you are a farmer or not, whether you live in the *satoyama* or not—we in the Maruyama-gumi invite you to join us in taking care of this rich natural environment and its traditional culture.

The rice field where we were heading was behind Maruyama hill, and the snow was still deep. The participants slowly made their way along the gentle slope, wearing high boots, snowshoes, or cross-country skis. When we reached the field from where the kami had been welcomed last year, the "household head" set up his *sakaki* branch at the edge. We all bowed and clapped our hands twice, and someone motioned with a hoe to mime the coming tilling season. With the words *medetai na* ("how lucky, how propitious"), the kami was safely returned to the field.

When we returned to the Hagino house it was time for *naorai*, the traditional feast where the participants enjoy the food that has been offered to the kami. The people gathered here talked about the future of the Maruyama-gumi and of Oku Noto, as well as much else, while praising the delicacies. Afterwards, Yuki, who as host had carried the responsibility for most of the preparations for the day's events, wrote in Maruyama-gumi's blog: "From this outermost corner of Japan, I am thinking that *aenokoto* is not just UNESCO or World Heritage— it is the seed of the Japan of tomorrow."[10]

Summing up

By way of a conclusion, let me spell out some characteristics of the developments we have seen and place them in context.

First of all, I must point out the many "misunderstandings" that exist concerning UNESCO and the ICH Convention. The stated aim of this Convention is not to measure heritage against a standard of "outstanding universal value," as in the case of the World Heritage Convention, but rather to present "representative" elements of Intangible Cultural Heritage to the world, so as to raise awareness of cultural diversity and stimulate its preservation. The "mechanical" method adopted by the Japanese government to compose its applications is a response to this characteristic of the ICH Convention, and no new evaluation of the candidates is carried out. This, however, has not necessarily been clear to outsiders, and in many cases both caretakers and others have jumped to the conclusion that their tradition has won "the recognition of the world"—a trend that has been stimulated by peaks of media attention in the wake of ICH inscriptions.

Another focus of my attention has been changes in the ritual procedures of *aenokoto*. As more and more caretakers become part-time farmers, the ritual is often simplified. The bath and the feast take on modern forms. The food that is offered changes, too: now the kami of the rice fields is served bananas, oranges, kiwis, and even bread, fried foods, and sautés. If the essence of *aenokoto* is that farmers feast the kami with whatever they have at hand, it is only natural that such changes should occur. The kami will have to adapt to the circumstances of its worshippers.

Particularly striking in this situation of flux is the transformation of *aenokoto* into a community ritual, as we have seen in Kunishige, Miimachi, and in

the case of the Maruyama-gumi. In all these cases, revivals or recreations of *aenokoto* expressed a new awareness among local people of the resources and the traditions of the region. It is striking that the volume *Oku Noto no aenokoto*, compiled in 1978 after the ritual was designated as an Important Intangible Folk Cultural Property, was invariably used as reference material for such recreations. Another new phenomenon that will be of great importance for the survival of *aenokoto* is that new connections between previously isolated caretakers have been created in the course of this process.

Like most of the Japanese countryside, Oku Noto is hit hard by depopulation, low birth rates, and a rapid aging of the people who remain there. The phrase "settlements on the brink" (*genkai shūraku*) is already a harsh reality in many places in this region. Agriculture and fisheries are in decline, and even tourism is stagnating; passenger numbers at Noto Airport, which opened in 2003 with local hopes that this facility might break the region's relative isolation, are on the way down. Within Ishikawa Prefecture, the gap between the regions of Kaga and Noto is real and growing. Yet there are quite a few individuals and organisations who defy the pessimists and launch new initiatives to build on the resources and traditions of Oku Noto (Takeda 2008). *Aenokoto* is one such resource. The trademark of "UNESCO Intangible Cultural Heritage" may not be of decisive importance to such initiatives, but it does have value.

As *aenokoto* is entering the twenty-first century, it would appear that more than anything else, it is about "being there" and about "being connected."

Notes

1 For the response of the Japanese government, I am relying on the homepage of the Agency for Cultural Affairs (www.bunka.go.jp).
2 http://monzenblog.active01.jp/?eid=1278228.
3 The questionnaire was made available to me at the Oku Noto regional office. I express my thanks for this here.
4 This report was published as Ishikawa-ken Kyōiku Iinkai (2011).
5 This section is based on reports in the newspapers *Hokkoku shinbun* and *Hokuroku Chūnichi shinbun*.
6 One example of an *aenokoto* that was discontinued prior to the ICH listing is the case of Ume Shōji (b. 1916), who stopped performing the ritual without a successor in 2006 due to his high age. Kikuchi (2011, 108).
7 This diorama has recently been removed as part of a renewal of the exhibition.
8 Kawaguchi Kiyofumi, however, holds that the ritual was continued in a simplified format, and was merely restored to its classical form, rather than revived after a long break in the tradition.
9 On the usage of satoyama for regional revitalisation in Oku Noto, see Nakamura and Kada (2010).
10 http://maruyamagumi.blog102.fc2.com/blog-entry-50.html.

References

Hori Ichirō. 1955. "Oku Noto no nōkō girei ni tsuite." In *Niiname no kenkyū* 2, edited by Niiname Kenkyūkai, 201–221. Tokyo: Yoshikawa Kōbunkan.

Hyōki Satoru. 2018. *Bunkazai/bunka isan to shite no minzoku geinō: mukei bunka isan jidai no kenkyū to hogo.* Tokyo: Bensei Shuppan.

Ishikawa-ken Kyōiku Iinkai, ed. 2011. *Ishikawa-ken mikuei ninzoku bunkazai tō chōsa hōkokusho, Heisei 21–22nendo, mukei minzoku bunkazai mukei bunkazai chōsa: hozon to keishō ni mukete.* Kanazawa: Ishikawa-ken Kyōiku Iinkai.

Kikuchi Akira. 2001. *Yanagita Kunio to minzoku no kindai: Oku Noto no aenokoto no 20seiki.* Tokyo: Yoshikawa Kōbunkan.

Kikuchi Akira. 2007. "Cosmetic Agriculturalism: Ishikawa-ken Wajima-shi 'Shiroyone no Senmaida' no baai." In *Furusato shigenka to minzokugaku,* edited by Iwamoto Michiya, 88–106. Tokyo: Yoshikawa Kōbunkan.

Kikuchi Akira. 2010. "Tanada no koto, aenokoto no koto: Ishikawa-ken Wajima-shi 'Shiroyone no Senmaida' kara." In *Bunkateki keikan kenkyū shūkai (dai2kai) hōkokusho, Ikita mono to shite no bunkateki keikan: henka no shisutemu o ika ni yomi ka,* edited by Nara Bunkazai Kenkyūjo, 106–118. Nara: Nara Bunkazai Kenkyūjo.

Kikuchi Akira. 2011. "Jiichansama no ie: Ume Kayo no 'hihyōteki' minkan shinkō eizō." In *Eizō ni yadoru shūkyō, shūkyō o utsusu eizō,* edited by Iwatani Ayako, 106–108. Tokyo: Serika Shobō.

Kodera Renkichi. 1938. "Oku Noto no Ta no Kami gyōji." *Tabibito* 6 (1): 14–17 and 6 (2): 21–26.

Matsudaira Narimitsu. 1964. "Yanagita sensei no omoide." *Teihon Yanagita Kunio shū geppō* 31: 243–245.

Nakamura Kōji and Kada Ryōhei. 2010. *Satoyama fukken—Noto kara no hasshin.* Tokyo: Sōshinsha.

Oku Noto no Aenokoto Hozonkai, ed. 1978. *Oku Noto no aenokoto.* Oku Noto: Oku Noto no Aenokoto Hozonkai.

Wajima Shunji. 1997. *Oku Noto no kenkyū: Rekishi, minzoku, shūkyō.* Tokyo: Heibonsha.

Yanagita Kunio. 1934. "Nenjū gyōji chōsa mokuhyō 10." *Tabi to densetsu* 7 (2), 49–64.

Yanagita Kunio. 1939. *Saiji shūzoku goi.* Tokyo: Minkan Denshō no Kai.

Yotsuyanagi Yoshitaka. 1951. *Noto hantō ni okeru aenokoto no bunpu to keitai: Toku ni Fugeshi-gun o chūshin to shite.* Private publication.

Chapter 7

Kyoto's Gion float parade as heritage

Between culture, religion, and faith

Mark Teeuwen

Urban festivals proliferated in early modern Japan with the proliferation growth of towns and cities in that period. The Gion festival of Kyoto served as a model for many of these festivals. Characteristic of what one might call the Gion-type festival is the combination of two elements:

1. The deities from the shrine are carried to a site in the centre of the city in portable shrines (*mikoshi*);
2. Elaborate floats, prepared by streets or neighbourhoods that support the shrine as its *ujiko* (parishioners), are paraded through town on the days when the deities are moved.

Festivals of this kind require great investments of time and resources. The floats, in particular, became ever more splendorous as city culture blossomed. A shared timeframe defines the extent and the structure of such festivals as coordinated events, but below the surface they have fostered entire ecosystems of sub-festivals, engaging a bewildering array of actors. Every *mikoshi* and every float has its own social and economic base and casts glory (or shame) on a different configuration of stakeholders. In the past, as in the present, urban festivals speak to issues of faith—notably prosperity and protection against illness—but serve also as stages for the display of power and prestige, as occasions to advertise businesses, and as touristic events, attracting visitors from far and wide.

The Edo shogunate actively supported such festivals; in Kyoto, too, the Gion festival was held on orders of the city magistracy. It was by no means clear, however, that urban festivals would survive Japan's entry into the modern age. Most, in fact, did not, while others had to be reinvented, reorganised, and provided with new rationales to convince the authorities that they were not mere remnants of a superstitious past, a waste of time and money, and a hindrance to modernisation. The first decades of the twentieth century saw the demise of many festivals, and Kyoto's Gion festival too was pushed to the brink. Such crises added urgency to the quest for new ways to establish the value of festivals in a modern context. In Kyoto, a 1912 campaign to save the Gion festival created a new rhetoric about the festival's value that would echo through

the halls of power for decades to come. Therefore, this chapter will begin in that last year of Meiji.

More crises followed. In 1943, the festival was stopped in its tracks by the escalation of the war. It was revived in stages between 1947 and 1952, under foreign occupation, a new Constitution, and very difficult economic and social circumstances. This revival was sealed with the designation of the parade of floats—but not the *mikoshi*—as a national Intangible Cultural Property (*mukei bunkazai*) in 1952. This was the beginning of this festival's career (in fact, of *any* festival's career) in the developing heritage system of postwar Japan. Kyoto was a pioneer in extending public funding to its festivals, and Kyoto's solutions would later shape heritage policies across the nation. The inscription of the floats parade in the Representative List of the Intangible Cultural Heritage of Humanity (ICH) by UNESCO in 2009 came at the end of this long process of domestic heritage-making, and took a form that was determined by the solutions that had already been negotiated in preceding decades.

This chapter seeks to understand UNESCO's entry into Japanese heritage politics in the context of those decades, including the prewar years. The focus will be on the postwar policy of identifying religious and secular aspects of festivals, and of isolating the latter for designation as cultural properties (and, thus, for subsidies). I argue that this practice originated with Kyoto's Gion festival during the occupation period, and I discuss largely unsuccessful attempts in the 1960s and 1970s to extend state safeguarding (and subsidies) to "faith events" (*shinkō gyōji*). Has this regime of selective funding and marketing had an impact on festivals and the ways both stakeholders and visitors understand and value them? How can we understand the changing narratives that have defined the value of the festival in different periods, and how are they related to the postwar policy of separating "cultural" from "religious" elements and supporting only the former?

Crises of modernity: the Gion festival and the city tram

Kyoto's infrastructure was radically modernised after the end of the Russo-Japanese war in 1905. One key element of this modernisation programme was the enlargement of main roads and the construction of tramlines. As in many other Japanese cities, these years also saw the appearance of electrical and telephone lines, hung from poles placed in the middle of the street. These trappings of modernity presented physical barriers for the towering festival floats of many urban festivals. This was the case also in Kyoto. In 1912, in the midst of festivities to celebrate the completion of "three great ventures" (*sandaijigyō*) that would bring Kyoto into the modern age,[1] the leading Kyoto newspaper *Hinode shinbun* reported that "Kyoto Prefecture will not permit a temporary suspension of tram traffic and bans the parade of floats" (11 June 1912). The Kyoto police argued that public transportation was more important than the

"rowdy chaos of the festival" (*omatsuri sawagi*), and pointed out that Kyoto was only one of many cities where new infrastructure necessitated some sacrifices. The newspaper reported that the police advised the float streets to replace the parade with a "sitting exhibition" (*imatsuri*) in Maruyama Park, where visitors would be able to view the immobile floats at their leisure on festival days (13 June 1912).

Arguments now had to be found to impress the value of the festival on the local authorities. The float organisers, who also dominated the local Chamber of Commerce, made a pact to boycott any attempts to replace the parade with a mere exhibition and petitioned city and prefecture to lift the ban. The newspaper took the side of the festival organisers and ran a concerted campaign, with daily articles by professors from the Imperial University of Kyoto condemning the decision of the prefectural governor.

Four themes stood out in the debate. First, commentators took issue with the authorities' denigration of the festival as "rowdy chaos" and "mere child's play" (*jigi*). The newspaper objected that the festival offered the kind of "social play" (*shakaiteki yūgi*) that is essential to the functioning of society. A second argument was the economic benefit accruing to the city from the festival as a "splendorous spectacle" that attracted many visitors. One professor wrote: "If the Gion festival is gutted in this manner, who would suffer the heat to come to a place like Kyoto? The demise of the Gion festival will be the demise of Kyoto" (14 June 1912). A third argument focused on the "art" displayed on the floats in the parade, notably in the form of imported Gobelin tapestries. Another professor stressed the importance of this display for edification purposes, because it reminded the people of Japan's international vigour in the sixteenth-century Momoyama era, before the suppressive slumber of the Edo period (16 June 1912). Finally, much was made of foreign visitors. It was pointed out that "Westerners would certainly deride the narrow-mindedness of Japanese bureaucrats" who insisted that the trams had to keep running; in places like Munich, after all, trams were routinely stopped for the annual Carnival parade (14 June 1912). The splendour of the floats was valuable because they were appreciated so highly by foreign visitors as a hallmark of Japanese civilisation: "The enthusiasm of foreigners (*gaijin*) who flock to watch the floats as emblems of Japan is far beyond our imagination" (18 July 1912).

In the end the governor caved in, and the parade was never again threatened. This opened the way to a more active involvement of the city in the running of the parade. In 1923, the city agreed to subsidise the maintenance of floats. In preparation for this, most floats were reorganised as "preservation associations" (*hozonkai*), fit to handle public subsidies. Establishment documents of these associations formulated their aims in terms of the arguments that had carried the day in 1912. The association behind the float Tenjinyama, for example, set itself the goals to foster the "appreciation of art" among the general public; to aid the study of "our country's ancient art," directed "especially at foreigners"; and to "contribute to the development of Kyoto" (1926).[2] The Floats Association

(Yamahoko Rengōkai, 1923) was founded as an umbrella organisation of all floats, with the aim of coordinating and facilitating communication with the city authorities. City support was expanded further in 1939, when the city supplemented maintenance subsidies with a "subsidy to encourage the [Yasaka] private festival" (*shisai shōreikin*). In 1941, for example, the city awarded 1,352 yen for float repairs and subsidised the parade with two thousand yen, about one tenth of the total budget.[3]

The crisis of 1912, then, proved to be the initial impetus towards city involvement in the Gion festival. Two points are worth noting in this process. First, at no juncture was the festival valued as an opportunity to further the aims of "state Shinto," and no reference was made to questions of faith or national morality. The official rituals of Yasaka Shrine, an imperial shrine of medium (1871) and later major rank (1915), were "non-religious" and purely Shinto events, while the Gion festival was treated as a private event that was, if not explicitly "religious," at least open to idiosyncrasies according to the preferences of the *ujiko*, and therefore allowed to retain many Buddhist and even Shugendō elements. This constellation may have contributed to the avoidance of "non-religious" questions of faith and morality in appeals for permission and subsidies for the "private" Gion festival.

The crisis of wartime suspension and postwar revival

By the time of the war, the value of the Gion festival for the city of Kyoto was already accepted to the extent that it motivated public funding. Also during and after the war, the city and prefecture actively sought to protect and support the festival even under very difficult circumstances.

Fear of air raids began to affect the city in 1943, and the Floats Association chose to suspend the parade, in spite of city pressure to stand firm. In 1944 also the *mikoshi* procession was cancelled. Firebreaks were created by pulling down entire blocks of houses, notably along Oikedōri street, and mass evacuations emptied the city centre. Yet even in the midst of escalating war, Kyoto City went out of its way to preserve the Gion floats. In March 1945 the head of the Culture Department, Doi Tsugiyoshi, arranged for the most precious float treasures to be evacuated to storage in the municipal museum (today's National Museum). On 10 August, days after the atomic bombings of Hiroshima and Nagasaki, Doi offered to secure also the floats themselves in the same manner (Teeuwen forthcoming).

Even though the worst calamity had been prevented and both the streets and their floats survived, the road to restarting the Gion festival was beset with problems. The economic situation was desperate, with shortages of even basic necessities. The social setting was also changing rapidly, as many evacuated inhabitants never returned and their businesses and houses were taken over by "immigrants" from places like Osaka. Then there was the allied occupation and its efforts to democratise Japan. As an imperial shrine Yasaka was now banned

from public life, and this also had an effect on the Gion festival. In 1942, the parade had been dedicated to military success; *Kyōto shinbun* wrote: "Every beat of the *Gion-bayashi* musicians was filled with prayers for victory in this sacred war."[4] Fukami Shigeru, who served as the head of the Floats Association from 1996 until 2011, recalls that in the immediate postwar years, there was a real fear that "the Americans" would ban the entire festival. Float tapestries were hidden away to prevent confiscation or theft, and sometimes lost forever.[5] Such fears were not ungrounded. The US propaganda film *Japan and Democracy* (1949) includes footage from the Gion festival with the following narration:

> the ancient festivals of Shintoism were being revived once more. And it was the very existence of this religion which made it possible for the militarists to establish the perverted cult of state Shintoism, fostering the belief that all mankind must be brought under the rule of the emperor.

Clearly, if the festival was to be revived, it would have to be done in a way that dissociated it from "Shintoism" and that followed the new norms of separation of state and religion.

The implications of those norms, enshrined in the 1947 Constitution, were not immediately obvious to the local authorities. Kyoto City showed an active interest in the festival's revival already in 1945. In October of that year, Doi proposed to exhibit treasures from the floats at a Kyoto museum "to show soldiers of the occupation army the culture of peaceful Kyoto (*heiwa Kyōto no bunka*)."[6] In 1946 the Floats Association decided to perform "indoor rites" only. There was however a spontaneous performance of *Gion-bayashi* music at Yasaka Shrine, which pulled large crowds and inspired both Yasaka's head priest and the float streets to step up their efforts for a fuller revival in 1947.

Such a revival was impossible, however, without permission from the Occupation Headquarters and external funding. The Tourism Division of Kyoto City (newly restored in April 1947) was central in the negotiations, which took place in June, only two months after the new Constitution had come into force (3 May 1947). It proved that as long as traffic would not be impeded, the Occupation Headquarters saw no problem; in return for their cooperation, tickets for viewing stands were made available to military personnel and their families. Perhaps surprisingly, no questions were asked about the use of public funding for this shrine event.

Such funding was generous, but it was well disguised. In 1947, there were plans to revive the *mikoshi* and two floats, Naginatahoko and Tsukihoko. This, however, was a costly affair. The Floats Association pointed out that prices had risen "a hundredfold" since 1943, from about 1,200 to 120,000 yen per *hoko*.[7] It was no longer possible for the streets to raise such a large sum on their own; either the city or the shrine would have to step in (19 June 1947). The harsh reality was that some way had to be found to pay for the parade with either public or "religious" money.

The city's solution was presented to the Association in a meeting on 24 June. The Kyoto Tourism Alliance (Kyōto Kankō Renmei), founded at the initiative of Kyoto City in October 1946, proposed to incorporate the Gion festival in its calendar of "touristic events" together with the Daimonji bonfires, an "international dance party," an "international grand tea ceremony," a "tourism sports festival," and similar happenings. If the Tourism Alliance took over as the official organiser of the Gion festival, it could raise money to fund both the float parade and the *mikoshi*.

In the end, circumstances proved difficult, and most of the festival bill still ended up with the float streets and the *mikoshi* groups. The expenses of the three *mikoshi* were largely covered by the shopping streets (*shōtengai*) of central Kyoto, supplemented with contributions from the shrine's *ujiko* association. The two *hoko* had to cut costs, and as things turned out, only the Naginatahoko was drawn along Shijō street, while the Tsukihoko remained stationary because there was no budget to pay pullers. The floats drew the largest crowd since the end of the war, estimated by a newspaper reporter at four hundred thousand people, which came as a great surprise to the Occupation Headquarters.[8]

Support from the Tourism Alliance was even more modest in 1948, but both the *ujiko* association and the city stepped in with donations and subsidies (24 July 1948). City support was channelled through the Tourism Division, which also took on a lot of the work that had previously been done by the president of the Floats Association. All correspondence with the Occupation Headquarters, for example, was drafted by the Division, with the Association president called in afterwards to put his stamp on the paperwork prior to submission. There was still a lot of tension around the Shinto nature of the festival. Among the floats selected for revival in 1948 was the Funehoko, with a design based on the legend of Jingū Kōgō's conquest of Korea.[9] People in the Funehoko street worried that this float was "not suitable for the new Japan as a nation of peace." The street was particularly worried about complaints or even "incidents" from Kyoto's League of Koreans (Chōsenjin Renmei). The head of the Tourism Division, however, pointed out that this legend had not been mentioned to the Occupation Headquarters, nor cited in that year's newspapers; he told residents to stop worrying and set up their float as planned. It is a sign of the authority of the Tourist Division that the street acted on this advice without further ado. The newly drafted explanation of the float's meaning was subject to approval by the Tourist Division (13 July 1948). In the end, nothing untoward happened.

In these first two years of revival, an important precedent had already been set. As posters from the 1950s would duly indicate, the parade was now organised by the Kyoto Tourism Alliance and the City Tourism Division in cooperation with the Floats Association, rather than by the shrine. Dodging the Occupation's suspicions against "Shintoism" and working around the new Constitution with great agility, Kyoto City had managed to find a "secular" way to revive the Gion festival. The city's main objective was to use the festival as the centrepiece of

its strategy to develop the city as Japan's grandest tourist destination—a project that would be pursued with renewed vigour in the 1950s.

The Kyoto mayor and the reform of the Gion festival

In 1950, Kyoto elected a new and exceptionally vigorous mayor: Takayama Gizō (in office 1950–1966). One of Takayama's first initiatives was the establishment of a law that aimed to develop Kyoto into an "international city of culture and tourism" (*Kyōto kokusai bunka kankō toshi kensetsu hō*, May 1950). As with the Tourism Alliance in 1947, he envisioned that the Gion festival would have a central role to play; but it needed work. The summer and autumn of 1950 saw the birth of a more effective fundraising operation, named the Float Parade Support Association (Gion'e Yamahoko Junkō Kyōsankai). It was led by Naiki Seibei (1878–1955), the son of Kyoto's first mayor, one of Kyoto's leading industrialists, and the head of Yasaka's *ujiko* association. Subsidies from the city, the prefecture, and the Tourism Alliance were channelled to the float streets through this Support Association (Kyōto-shi 1967, 22). This gave a decisive boost to the parade, and by 1952, all twenty-nine floats that had been active before the war had been restored.

The year 1950 also saw the birth of the Law for the Protection of Cultural Properties, which, as we shall soon see, added another tool to the city's kit (Nakamura 2013). In August 1952, the Support Association convened a meeting about the preservation of the floats, attended by the top of the Tourism Divisions of both city and prefecture, experts from the Kyoto Museum and the Industry Research Centre, and representatives of the float streets. This meeting resulted in the launch of a "movement" in support of the parade, with the aim of "adding substance to Kyoto as an international city of culture and tourism by preserving and cultivating these precious cultural properties [that is, the floats], which are such a source of pride in our hometown" (4 August 1952). This was the first time the floats were referred to as "cultural properties" (*bunkazai*) that represented the culture of their "hometown" (*kyōdo*)—both terms from the folklore studies discourse that permeated the language of the new law. In 1912, when the tram threatened to stop the parade in its tracks, *ujiko* leaders had conceded that "the floats are of course not National Treasures";[10] now, under the 1950 law, this was no longer so obvious.

As noted in the introduction to this volume, the 1950 law not only combined three different existing heritage preservation laws into one but also added three new categories of cultural properties, two of which are relevant here: Intangible Cultural Properties (*mukei bunkazai*) and Folk Materials (*minzoku shiryō*). The first category was initially designed for "classical arts" such as traditional theatre, music, and crafts, while the second comprised customs related to daily life, work, faith, or seasonal festivities, folk performances, folk crafts, and objects (costumes, implements, buildings) used in these customs, performances, and crafts. In practice, however, there was a great deal of overlap, and both these categories were

understood to cater to the new field of folklore studies. Criteria for the selection of Intangible Cultural Properties that "qualify for subsidies" (published in May 1951) mentioned "folksongs, *kagura* dances, folk performances (*kyōdo geinō*), folktales, and ritual events (*gyōji*)."[11]

While designations in the category of Folk Materials began only in 1954, after a revision of the law, the category of Intangible Cultural Properties was operative already in 1952. The Gion festival was among the very first designations; the meeting of August 1952 was clearly held to prepare for this new status. At that meeting, expectations from the float streets were expressed in very concrete terms: their highest priority was to obtain funds for much-needed repairs to storage facilities for the floats. However, it was the parade that was designated as an Intangible Cultural Property, not the individual floats, and it soon became clear that the benefits of this designation were to remain equally "intangible." Yet the parade's new "rank" was proudly displayed on posters and brochures that advertised for the festival; there was clearly an expectation that it could boost the standing of the event. The fact that the "Gion festival floats" had been designated as an Intangible Cultural Property was announced at a board meeting of the Floats Association on 2 June 1953, but is not otherwise mentioned in the Association's records. Tellingly, the same meeting began with notice that the year's budget would be unchanged from 1952.

Even so, this designation was perhaps useful to the city in other ways. The fact that the Gion festival was heavily subsidised with the use of public funds was catching the attention of other municipalities. In June 1952, Kyoto City received an enquiry from the mayor of Kagoshima City. Kagoshima has its own Gion festival, also celebrated in July. Kagoshima was struggling to find ways to support its festival, and since its mayor assumed that Kyoto had received permission from the central government to do just that, he asked for more information. In its reply, Kyoto specified that no permission had been asked, nor had it been granted.

> The rituals are organised by Yasaka Shrine, but the float parade, which is the main event of the festival, is organised by the Float Parade Support Association. The shrine rituals and the *mikoshi* procession are by nature religious events, and the city does not touch them at all, but we regard the float parade as an annual touristic event and are actively engaged with it.[12]

The designation of the float parade as a national cultural property appeared to grant the government's seal of approval to this interpretation of the parade, and also of the *mikoshi*. The *mikoshi* was to be religious, while the float parade was not. While this was of little help to the Kagoshima Gion festival (which has six *mikoshi* but no float parade), it was to become a very useful model for other cities that sought to support their float festivals.

It should be pointed out that this way of applying the postwar separation of state and religion to festivals was, and remains, arbitrary. It is true that the *mikoshi*

carry the gods of Yasaka Shrine; the gods are solemnly transferred to and from the *mikoshi* by Yasaka's priests on 15 and 24 July. However, the floats, too, carry deities: the "god children" (*chigo*) and figurines (*ningyō*) carried by the floats are treated as "kami bodies" (*goshintai*) in the same manner as the deities of Yasaka Shrine. The *chigo* are transformed from primary school boys into embodied kami by ritual means: they are dressed up, not allowed to eat food prepared by women, and (at carefully selected times) carried on men's shoulders because they "may not touch the ground." On the days before the parade (*yoiyama*), the figurines are displayed for worship in so-called street houses (*chōie*) with their faces covered, and the crowds who mill through the float streets on these days are encouraged to pray to them. Organisationally, too, the *mikoshi* are no more closely linked to the shrine than the floats are: they are funded and run by three independent organisations (*shin'yokai*), with minimal interference or financial support from the shrine.

A structural difference between Kyoto's Gion festival and the large majority of float festivals elsewhere is that the float parade does not enter the shrine precincts. The floats stay on the western side of the Kamo River, and only the *mikoshi* cross that river to and from Yasaka Shrine. This circumstance may well have supplied the original rationale behind the separation of the "religious" *mikoshi* procession, allegedly staged (*shusai*) by the shrine, from the "secular" float parade, staged by the Support Association and the Tourism Alliance. It was through enquiries like that of the Kagoshima mayor that the distinction created in Kyoto spread across Japan. As we shall see, separating float parades from shrine ritual (understood to include the *mikoshi* procession), and selecting only the former for designation as cultural properties, was to become a standard model in subsequent decades.

City-led reforms

The restoration of the full parade in 1952, and its designation as a national Intangible Cultural Property, marked the beginning of a new phase in the postwar history of the Gion festival. Now that the parade was defined as a secular event organised by associations that cooperated closely with the city authorities, the door was open for further adaptation of the parade to the city's needs—that is, as a tourism resource. The dependence of the float streets on city and prefectural subsidies left them with few possibilities to resist city pressure, while the shrine was effectively sidelined.

The first step was the rerouting of the parade. From 1952 onwards, both parades once more followed their traditional course: on the seventeenth, east along Shijō, then south on Teramachi, and west along Matsubara, and on the twenty-fourth, east along Sanjō, south on Teramachi, and west along Shijō. However, Teramachi and Matsubara were narrow streets with little space for viewers. The year 1953 saw the completion of Oikedōri, an east-west running street that had been broadened into a grand avenue after serving as a firebreak

during the last year of the war. The City Hall is located at the eastern end of this street. Oikedōri figured prominently in Mayor Takayama's plans for Kyoto as a tourist city. Over two hundred zelkova trees were planted along this street, which was to serve as Kyoto's own Avenue des Champs-Élysées. Takayama argued that moving the Gion float parade to Oikedōri would add substance to the status of this avenue as Kyoto's main street; it would make it possible for more visitors to view the parade; and accidents with floats crashing into the eaves of roofs would be avoided.

The records of the Floats Association mention the proposal to reroute the parade for the first time after the festival of 1954. On 5 August, the Association discussed a possible route change as "a personal idea of the mayor" (*shichō no fukuan*). It was accompanied by a proposal to increase subsidies substantially. When the matter was put to a vote in the Association's general assembly of June 1955, twenty-two out of twenty-nine floats voted in favour (*Kiroku*, 22 June 1955). Already at this point, Takayama proposed to merge the parades of the seventeenth and the twenty-fourth by abolishing the latter; he also launched the idea of rerouting the *mikoshi* to Oikedōri. Yasaka Shrine's head priest Takahara Yoshitada,[13] who was present at meetings of the Floats Association but had no vote, was vociferously opposed both to the route change and the merger of the two parades. The Yasaka Women's Association (Yasaka Fujinkai) went to the newspapers, and when this had no effect, the group cut relations with the Floats Association over the matter (*Kiroku*, 11 April 1956). The inhabitants of Matsubara street threatened to cease all contributions to Yasaka Shrine (*Kiroku*, 28 February 1956). The Teramachi Prosperity Association submitted a petition signed by hundreds, arguing that rerouting was unacceptable because the parade was a protected cultural property, and also because "it is a religious event of the parishioners, not a happening for people's entertainment."[14] Most float streets, however, saw distinct benefits in Takayama's proposals. Floats of the second parade (on the twenty-fourth) felt that the event was declining (*Kiroku*, 24 February 1956). Also, textile merchants based along Shinmachi and Muromachi streets preferred a shorter festival period, with less disruption to their businesses.[15]

In the end, financial concerns carried the day. It is striking that only Naginatahoko, the most affluent of all floats, was unequivocally opposed to the rerouting; this street could afford to forego the increased subsidies. The new route implied left turns, while the old route had only right turns. This was pounced upon as the rationale for a large application for city subsidies. To make left turns, the *hoko* floats had to be overhauled. The Floats Association proposed a five-year plan with a total budget of 2.55 million yen, out of which half a million would be covered by city subsidies. This would come on top of significantly increased annual subsidies to all floats, including the wheel-less *yama*. Another novelty introduced in 1956 were viewing stands along Oikedōri; the takings from this rental seating would provide the floats with a sizeable income (see Figure 7.1). Yasaka's priests were given ample opportunities to present their

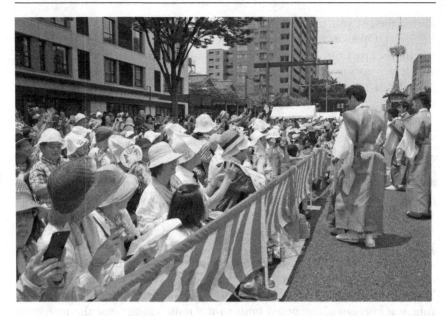

Figure 7.1 Rental seating (*yūryō kanranseki*) along Oikedōri street. Earlier, seating was on high stands, blocking the view for the general public. Photo courtesy of Miyake Tōru.

point of view, but their arguments were respectfully ignored. A phrase that recurs in the records of the Floats Association in connection with these changes is *yamu o ezu*, "it cannot be helped." There was a distinct sense that the float streets had little choice but to comply with the mayor's plans.

In the meantime, the parade's heritage status was beginning to bear fruit. In 1962, the twenty-nine Gion floats were designated as Important Folk Materials (*jūyō minzoku shiryō*). This designation came at the very moment that the five-year maintenance plan, introduced in 1956, was coming to an end. This time, it was the physical floats that were recognised as cultural properties, rather than the intangible parade. Subsidies, now also from the central government, alleviated the burden of managing the floats considerably. The designation did not, however, stop the merging of the second parade with the first, which was arguably a radical break with the "folk traditions" that the new designation sought to preserve. The second parade was abandoned in 1966, with only modest protests.[16]

New meanings

In 1964, *Kyōto shinbun* described the situation of the festival as "in crisis." There were practical issues, such as the "collapse of street communities" and a "severe lack of hands" (14 July 1964). More fundamentally, however, the intense involvement of Kyoto City raised questions about the festival's meaning and authenticity. Already in 1963, the newspaper had contrasted the view of the

Floats Association with that of the shrine under such headings as "Tourism or faith?" and "Between show and faith." Head priest Takahara insisted that "rituals for the gods" (*shinji*) cannot be changed without losing the faith that constitutes their essence. A spokesman for the Floats Association retorted that the parade was organised by them and not by the shrine, and pointed out that the old route was unsafe due to growing crowds. The festival was now part of the new face of Kyoto as an international tourism city, and the system of rental seating was necessary to make the festival economically sustainable (16 July 1963). This debate cemented the image of the parade along its new Oikedōri route as a faithless, inauthentic show for tourists. The stands with rental seating, which were mostly bought up by travel companies and filled with tourist groups, became the ultimate symbol of the displacement of locals and the decline of the festival into a mere money machine. Was the Gion festival still a real *matsuri* now that it was devoid of faith?

Yet, as the newspaper also argued (14 July 1964), looking for the meaning of the festival *only* in faith would "render it unattractive to the young." On the same page, moreover, Takeda Chōshū (a Dōshisha University professor of religious folklore, who was in charge of the investigation that was initiated when the floats were designated as Important Folk Materials) pointed out that "there are limitations to the public funding of specifically religious activities." Such social and legal problems made the reasoning of head priest Takahara both unattractive and unrealistic in the eyes of most of the festival's actors. How to escape the squeeze that the festival seemed to be caught in, between a meaningless "show" and unworkable "faith"?

In the same *Kyōto shinbun* issue, the head of the Floats Association, Tanaka Tsuneo, offered a new opening. He pointed out that the festival had gone through many crises in its thousand years of history, but each of these had been overcome thanks to "the energy of the townspeople (*machishū*)." Here Tanaka was tapping into what was to become the most persuasive signification of the festival in the postwar years, soon to be officially adopted by both the city and the Agency for Cultural Affairs. The word *machishū* had been an obscure historical term until the 1950s, when the Marxist historian Hayashiya Tatsusaburō adopted it as a key concept in the burgeoning field of social history. Hayashiya built on the pioneering work of historians such as Akiyama Kunizō, who had focused on the political and economic agency of the common people in his studies of medieval peasants' uprisings (Takagi 2006, 168–170). Hayashiya saw the rise of a similar "consciousness of the masses" in the development of semi-autonomous townspeople's blocks in medieval Kyoto. Inspired by Hayashiya's vision, members of the History Section of the Kyoto Association of Scientists for Democracy created a booklet about the Gion festival, celebrating it as the emblematic showcase of *machishū* culture. This booklet, designed for use in schools, took the form of a picture show "narrated" by Hayashiya himself (Minka Kyōto Shibu 1953). It highlights the Gion parade as a monument to the emergence of *machishū* consciousness by focusing on an incident in 1533,

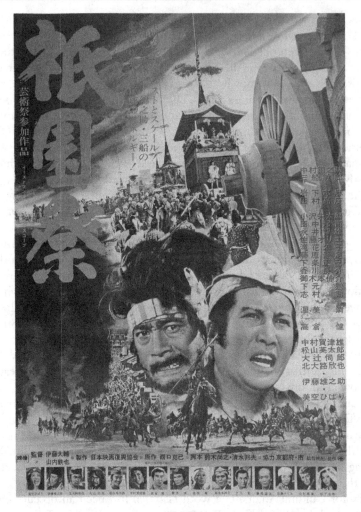

Figure 7.2 A poster for the film *Gion matsuri*, showing the famous actors Nakamura Kinnosuke (on the right) as the hero of the *machishū* and Mifune Toshirō as leader of the horse drivers, who eventually sided with the townspeople against the shogunal forces. Photo courtesy of The Museum of Kyoto.

when, according to Hayashiya, the townspeople stood up to the shogun and the shrine by defying a ban on staging the parade.

The same story was elaborated further in a 1961 novel by the Communist novelist Nishiguchi Katsumi and, even more grandly, in a large-scale feature film, also titled *Gion matsuri*, in 1968.[17] This film was planned to add lustre to the centennial anniversary of Kyoto Prefecture and heavily subsidised (see Figure 7.2). It featured some of the greatest names of the film world and included a number of stunning mass scenes, shot using the real Naginatahoko

and involving many locals as extras; it turned out to be a spectacular hit. Even more clearly than the original picture show, it represents the Gion parade as a *machishū* act of resistance. The parade is framed as a demonstration of democracy and pacifism, backed up by solidarity with the suppressed peasants of the surrounding countryside and with outcasts within the city itself, and directed against a violent military and a weak-kneed priesthood. The parallels with the situation in Japan during the war need no further elaboration.

The notion of the float parade as a monument to *machishū* culture offered a way out of the "show versus faith" dilemma. Also, it facilitated the city's strategy of separating the "secular" float parade from the "religious" rituals of the shrine. Historians such as Kawauchi Masayoshi have since demonstrated that Hayashiya's reading of the 1533 incident bears no resemblance to actual historical events.[18] In the present, too, the notion of a democratic *machishū* culture required ignoring the strong presence of hierarchies of class and status in the festival, sometimes described as the "tyranny of the *dannashū*" (the heads of the commercial houses in the float streets)—and also of the exclusion of women, who have been barred from the floats, the *chigo*, and other ritual spaces. Yet, the idea that the parade represents the culture of the "common people" of Kyoto was less beset with problems than significations based on faith, let alone religion. This secular discourse was a perfect fit for the aims of city, prefectural, and national authorities in their efforts to shape the parade as heritage.

Faith as intangible heritage

This debate also inspired the supporters of the "faith" line to organise themselves. The decade of 1965–1975 was a period of reform within the field of heritage policy for multiple reasons. In this era of rapid economic growth cultural properties were under threat around the country. The car was taking over Japanese cities, changing urban landscapes at an alarming pace. Nostalgia for a traditional Japan that was being lost inspired *furusato* romanticism, fed by such media campaigns as *Discover Japan*, run by the Japanese National Railways since 1970. Ideological battles about Japan's prewar legacy, most notably about Yasukuni Shrine, dragged on in the Diet. And in the global context, interest in heritage conservation was building up rapidly, culminating in the establishment of the UNESCO World Heritage Convention in 1972. In Japan, cultural policies were centralised through the creation of the Agency for Cultural Affairs (Bunkachō, hereafter ACA) in 1968; strengthening the preservation of traditional culture was one of the objectives behind this reform (Kikuchi 2001, 45).

It was in this atmosphere that the now established policy of separating out "secular" folk performances (*minzoku geinō*) from "religious" shrine festivals and designating them as cultural properties began to inspire protests. The first to dispute this policy was the Association of Shinto Shrines (Jinja Honchō). Already in 1966, this Association appealed to the government to "revise the Law for the Protection of Cultural Properties so as to provide a legal basis for

the preservation of traditional shrine events" (Jinja Honchō 1971, 40–45). In 1968, Jinja Honchō presented a full draft of such a revision, while at this same time encouraging Yasaka Shrine in Kyoto (and also Miho Shrine in Shimane) to apply for the designation of their kami rituals (*shinji*) as cultural properties. No doubt, this was a reaction to the discontinuation of the second parade in 1966. These attempts, however, met with determined opposition from Tokyo. Already in 1966, Tahara Hisashi of the Cultural Properties Division of the Ministry of Education replied that extending public preservation subsidies to shrine events was "impossible under current law"; the same line would be repeated on many subsequent occasions.

Another group that felt uncomfortable with current practice were folklorists, many of whom sat on national, prefectural, and municipal cultural proper-ties committees. A central figure on this scene was Honda Yasuji, a student of Yanagita Kunio and a *kagura* specialist who served on the national Committee for the Protection of Cultural Properties from 1950 until 1986. From the time the Law for the Protection of Cultural Properties came into force, the notion of intangible culture had emphasised cultural ideas and skills as the inherent meaning of physical objects, particularly in the case of Folk Materials. Such immaterial ideas and skills formed the essence of the material objects, which in themselves seldom possessed unique artistic or historical value; their value lay in the fact that they embodied the cultural knowledge of their makers and users. In a 1974 article, Honda argued that the same is true of folk performances. Merely preserving the outer appearance of such performances is meaningless because "*matsuri* is a matter of the heart." That heart, Honda argued, consists of the faith that gives rise to these performances to start with (Honda 1974, 44–46). This implied that the isolation of performances from their context of faith undermines their true value: the immaterial faith that they embody.

Priests and folklorists made common cause in 1971 by founding the Conference for Research on Folk Cultural Properties (Minzoku Bunkazai Kenkyū Kyōgikai). Jinja Honchō coordinated this organisation. In a 1975 radio talk, a Conference spokesman explained: "The goal of our movement has been to revise the law, so that the whole of the Gion festival can be designated as an intangible cultural property, and not only the floats."[19] The "whole" here included the "religious" rituals performed at Yasaka Shrine, as well as the *mikoshi*. The stated aim of the Conference was to press for a legal framework for the preservation of "faith events." In 1975, when the revision of the Law for the Protection of Cultural Properties was approaching its conclusion, Honda Yasuji appeared before the Diet's Subcommittee for the Protection of Cultural Properties to argue for this cause. Here, he referred to the disappearance of the second Gion parade as an example of the detrimental effects of current policy, which undermined or at least failed to support "ancient folk faith."[20] He stressed that diffuse folk "faith" is not the same as organised "religion," and argued that it is this faith that constitutes the inner value of folk performances and festivals.

In the end, the revised law did indeed include a new category named *sairei (shinkō)*, "festivals (faith)." Initially, the Conference hailed this as a victory, but it soon became clear that the constitutional problems had not been solved and that the ACA would not change its practice. In 1979, it was not "the whole of the Gion festival" that became an Important Intangible Folk Cultural Property in the category "festivals (faith)," but only the parade of floats.[21] The same policy was followed in the annual designations in subsequent years of festivals from all corners of the country, totalling sixty-nine at the time of writing.

The floats parade as UNESCO Intangible Cultural Heritage

As noted in the chapter by Kikuchi in this volume, the Japanese government aimed to register all domestic Important Intangible Cultural Properties as Intangible Cultural Heritage (ICH) after the Convention for Safeguarding of the Intangible Cultural Heritage had come into effect in 2006. The approach was, in Kikuchi's terms, "mechanical": existing Important Intangible Cultural Properties would be nominated in roughly chronological order. This put "the *yamahoko* parade of Kyoto's Gion festival" in the first row, and it was indeed among the first group of thirteen Japanese ICH elements inscribed in 2009.

In a public lecture, held in that same year, Murakami Tadayoshi of the Cultural Properties Preservation Division of Kyoto City explained the process and the thinking behind the application (Murakami 2010). In 2007, an internal committee at the ACA had decided on its general policy; Kyoto City began to work on the application after that committee had announced its decision. The Floats Association was asked for its consent, but was not directly involved in the framing of the application.

The Kyoto City team used the nominations for "Masterpieces of the Oral and Intangible Heritage of Humanity" as a model. Japan's nomination of kabuki in 2005 had drawn criticism for being concerned with "professional art" rather than "popular" intangible heritage. Looking back on this experience, the team members thought of the Gion float parade as a perfect fit for an ICH application, because as an event that is carried by "ordinary people" and yet has great qualitative value, it "made sense both internationally and domestically."

Murakami also comments on the problem of religion. When the Gion festival was designated as an Important Intangible Folk Cultural Property in 1979, "the rituals that focus on Yasaka Shrine were excluded. Japan lost the last war, state Shinto was abolished, and in the world of cultural properties, all matters with a religious colouring have been barred—especially in the intangible category." In the Gion festival, Murakami explains, the *mikoshi* carry the kami of Yasaka Shrine, while the floats serve to "entertain other gods that may otherwise obstruct the parade."

The floats are tools for entertaining those other gods. We excise such things and refrain from designating Shinto or Buddhist rituals as cultural properties, for the reason that they are religious. We merely isolate the performances (*geinō*) and select those for designation. When there is a faith that is given a particular form as intangible culture, we separate [culture from religion] and designate only the former ... Preserving cultural properties is not a matter of science; it is a matter of administrative policy.

(Murakami 2010, 144)

Such frank testimony of the secularising dynamics of heritage policy is rare.

In this context, it will not come as a surprise that in the official description of the float parade, as submitted to the Committee, questions of faith were marginalised. The floats are described as "moving museums," using a term that can be traced back to the 1912 debate about the parade and the tram. The festival is "held by the Yasaka Shrine," but the floats "are built by the residents of the city's self-governing districts." The *hoko* floats were "originally intended to summon the Plague Deity" but "today, the *yamahoko* parade is a representative urban summer festival showcasing the creative spirit and artistry of the float-building districts and providing entertainment for the entire city." The phrase "residents of the city's self-governing districts" here translates *machishū*; in fact, the Japanese original adds that the parade of floats, when it first emerged, "became an important means to secure the continuity of the *chō* street and the unity of the *machishū*" (Kyōto-shi 2011, 56). As Intangible Cultural Heritage, then, the floats parade is ascribed meaning as a monument to enduring *machishū* culture, which is represented as creative, autonomous ("self-governing"), and egalitarian or democratic ("unity"), while aspects of faith and religion are relegated to the past and rendered irrelevant to the present.

Back to tradition—and faith?

In 2014, five years after the ICH listing, the second parade was revived, almost half a century after it had been abolished in 1966. This revival required lengthy negotiations within the Floats Association, between the Association and the city and prefecture, and with the Prefectural Police. It was an immensely costly affair, and the outcome was uncertain. Would the revived parade be a success, or would it attract so few viewers that the floats would be bankrupted? Would there be enough solidarity among float streets that those involved in the first parade would be willing to pick up part of the bill for the second parade? Were the arguments for returning to pre-1966 practice strong enough to face up to all these problems?

The driving force behind the revival was Yoshida Kōjirō, who became president of the Floats Association in 2010. From the day he took office, Yoshida pursued the restoration of the second parade as his mission. In a 2011 lecture Yoshida identified some of his reasons (Yoshida 2012). Reminiscing about the

merger of parades in 1966, he describes the decision to go along with mayor Takayama's plan as an error, forced upon the float streets out of economic necessity, even if it meant abandoning the basic premise that the two parades are linked to the two *mikoshi* processions. When his own float capitulated (Kita Kannonyama, which was part of the second parade), this was upon the advice of head priest Takahara who set aside his own opinions by arguing that it was wisest not to fight the inevitable. Yoshida recalls that after the merger, the joint parade proved to be too long; by the time the last floats would arrive at Oikedōri, many of the tourists in the rental seating areas had already left for lunch. Now that everything (including the *yoiyama* evenings before the parade) happened at the same time, crowding became an acute problem, forcing streets to adapt in a way that affected the festival negatively. Therefore, he appealed for drastic reform: "The original purpose of the festival is being lost, and people are just enjoying the bustle. It is now that we must rethink the Gion parade" (Yoshida 2012, 209).

Yoshida's appeal was all the more cogent because it was grounded in concrete issues caused by recent developments in the festival. The Floats Association channels subsidies from various sources (most importantly, the Support Association) to the float streets—breaking the hundred million yen mark in the early 2010s.[22] This enabled streets that had lost their floats as long ago as the late Edo period to restore them, enlarging the parade from twenty-nine to thirty-two floats. The year 2014 saw the restoration of the thirty-third, the grand Ōfunehoko.[23] With the Ōfunehoko, the second parade would gain a star attraction; also, fitting this last float into the joint parade caused serious logistic difficulties. Yoshida's idea to restore the second parade would solve the problem of the parade's length, spread the crowds by lengthening the festival period, and allow for the Ōfunehoko to shine. Crucially, mayor Kadokawa Daisaku expressed his support for Yoshida already in early 2011. Although the Prefectural Police had many objections, and a minority of float streets remained doubtful, the second parade was finally reintroduced in 2014. It has since proven sustainable and reasonably successful (Fukumochi 2017).

How can this "return to tradition" be explained? In a volume about the effects of UNESCO, one is tempted to argue that the heightened status of the parade as ICH created a climate that facilitated the return to the original format of two parades. The timing fits; Yoshida's push for revival started in earnest in 2010, a year after the ICH listing. The debate leading up to this change, however, shows little evidence of a UNESCO effect. Yoshida has studiously avoided all references to UNESCO. In a 2014 interview in *Kyōto shinbun* (4 July 2014), Yoshida frames his mission as an act of gratitude towards the late Yasaka head priest Takahara. He tells that he "folds his hands" every morning in front of a hanging scroll with Takahara's calligraphy ("Quiet like a mountain is the benevolent man; pure like the wind is the sage"). Yasaka Shrine and the dimension of faith as the inner meaning of the festival are recurring themes whenever Yoshida discusses the revival; about the ICH listing he is consistently silent.

I conducted fieldwork in Kyoto in the spring and summer of 2018. Talking to a variety of actors (ranging from float representatives and leaders of the Floats Association, *mikoshi* groups and Yasaka's *ujiko* organisation, to shrine priests and Kyoto City bureaucrats), I did not encounter a single person who would endorse my initial assumption that the ICH listing had made a difference. More common was a dismissive attitude; as one float leader and member of the board of the Floats Association quipped, "if UNESCO becomes bothersome, we will just pull out." UNESCO is primarily associated with inbound tourism, and many actors see excessive tourism as a threat, echoing the 1960s debate on the festival's decline into a mere "show."

The status of the Gion parade's ICH listing was negatively affected by developments after 2009. Japan's application for the listing of two new float festivals (in Chichibu and Takayama) was "deferred" at the Bali Session in 2011, on the grounds that they were too similar to the already inscribed Gion and Hitachi float festivals. In 2016, Japan countered this objection by withdrawing Gion and Hitachi as stand-alone elements and resubmitting them as sub-elements of a serial nomination consisting of thirty-three float festivals around Japan. In contrast to World Heritage sites, which must have "outstanding universal value" to qualify, ICH are selected to "represent" the diversity of human cultural heritage, and the criteria state explicitly that "no hierarchies should be established among elements of the intangible heritage on the basis of their intrinsic qualities" (UNESCO 2005, 5). In the case of Kyoto's Gion festival this can be perceived as a demotion, from one of the "three great festivals of Japan" to just another one among many.

The 1979 listing made a real difference to the management of the floats, and ever since, the Floats Association has cooperated closely with ACA experts. When the Ōfunehoko was restored, the design was decided by a committee of the Floats Association with detailed input from the ACA. A similar process is currently underway for the restoration of a thirty-fourth float, Takayama, lost in 1829. Without ACA approval no structural changes can be made to the cultural property. Compared to earlier revivals of floats,[24] standards of craftsmanship and historical accuracy have been raised to dazzling levels, and the ACA now demands that all details of the floats must be of the highest quality. While local actors complain about the costs involved, it has proved possible to comply with the help of donations from such organisations as Kyoto JC and Kyoto Lions Club. In the end, the results are impressive and add to the authenticity of the parade.

In contrast, UNESCO has no concrete presence on the ground; it is only a label and a trademark. UNESCO, therefore, was often described to me as a threat to the festival's authenticity. This is all the more ironic in light of the fact that the 2003 ICH Convention in fact avoids all mention of the term "authenticity," which is associated with fossilisation (Silverman 2015, 75–76). This is typical of the often skewed preconceptions that many actors have about the

abstract and absent UNESCO; it would appear that the organisation is often thought of as a global version of the ACA—only even more imposing and, potentially, arrogant.

Conclusion

In a recent article, Elisabetta Porcu notes that in the video submitted to the ICH Committee in 2009, "all Shinto rituals at the Yasaka Shrine, the procession of the portable shrines (*mikoshi*), [and] the fact that the floats are portable shrines in themselves, are omitted and only the 'cultural' side of the festival has been highlighted" (Porcu 2012, 95). She suggests that this was a strategy chosen for this particular nomination process, but as will now have become clear, the policy of separating of the "religious" from the "cultural" in the interest of public heritage preservation is much older, stemming from the 1950s. Porcu argues that the increased participation of non-*ujiko* volunteers and tourists has had a secularising effect, causing "some religionists" to feel that entertainment has replaced religion, and she shows how in 2011 some of the "original 'religious' meaning" of the festival resurfaced in the context of the Tōhoku earthquake and tsunami (Porcu 2012, 101–102).

This essay offers two new perspectives on the dichotomy of "religious versus secular" and its role in the Gion festival. First, I have explored the origins and the repercussions of the implementation of the separation of state and religion in the management of the festival. Even in the 1920s and 1930s, the festival depended on active support from Kyoto City and Prefecture, including subsidies. Postwar revival, too, was unthinkable without public funding. In occupied Kyoto, under the new Constitution, a formula was worked out to continue such funding for at least part of the festival: the parade of floats. This was important, because this formula was subsequently applied to many other festivals throughout the country. This policy split the festival into "secular" and "religious" events, cutting the former off from the shrine, and the latter from access to subsidies and other assistance from local and national authorities. Radical changes in the "secular" part of the festival (the rerouting and merger of the two parades) were initiated by Kyoto City, and are thus a direct result of the separation.

Secondly, I explore the consequences of this separation policy for the signification of the festival by different groups of actors. We have seen that by the early 1960s, the "secular" parade was suffering from what one might describe as a crisis of authenticity: it was widely felt that the parade had lost its original meaning and had degenerated into a show without "faith." This development was all the more surprising because before the war, when Yasaka Shrine was an imperial shrine, the parade was never validated in terms of faith, but as social play, art, and tourism. The stress on faith as a requirement for authenticity was a postwar phenomenon, and in a roundabout manner, another effect of the separation policy that secularised the parade.

As an alternative validation, the parade came to be seen as an expression of *machishū* culture. Although this term became current only after the war, the idea had antecedents in the colonial-era celebration of the "international" Momoyama period in Kyoto. After the war, the links to empire were replaced by a stress on pacifism and democracy as *machishū* traditions, making this an ideal narrative for the secular cultural policies of Kyoto City and the ACA. At the same time, basing the value of the floats on the idea of unbroken *machishū* traditions seemed risky, as many float streets were (almost) depopulated from the 1980s onwards, and the running of the floats passed to preservation associations (*hozonkai*) whose members live elsewhere. Yet it was as *machishū* culture that the floats of the Gion parade were designated as Important Intangible Folk Cultural Properties in 1979, and listed as UNESCO Intangible Cultural Heritage in 2009.

During my fieldwork in 2018, it struck me that the float streets placed great value on acts of faith. Visitors were encouraged to pray and offer coins or candles in front of the float deities before boarding the floats. Many people stressed that it was such worship that made the festival "real"—that is, more than just a show. This is also stressed by Christoph Brumann, who in a 2009 article reports that "weak as supporting beliefs may be ... all the required religious rites are performed painstakingly" in the float street where he did his fieldwork; this street had "even extended its ritual roster in recent years" (Brumann 2009, 290). In my conversations with various actors I found that tourism and faith are no longer seen as mutually exclusive (as they had been in the 1960s); members of the Floats Association explained to me that they see it as their main challenge to make sure that there is room for both. A leader of one of the *mikoshi* groups said that the revival of the second parade has done wonders for the reintegration of the festival: now that both *mikoshi* processions are again coupled with a float parade, there is a renewed sense of joint identity and purpose.

Looking back on the modern history of the Gion festival, one can only admire its resilience in the face of numerous crises. Many of those crises were caused by practical and financial difficulties; but below the surface, there were always issues of validation and authenticity—or, more accurately, negotiations between multiple competing notions of authenticity.[25] "Authenticity" has meant different things to the float streets, the shrine priests, Kyoto City officials, ACA experts, and visiting tourists; but all are concerned with its preservation and its physical performance. The administrative issues around the place of religion in the public sphere can be pointed out as particularly problematic, and I propose that it is *resistance* to the secular discourse of heritage that is currently fuelling a new emphasis, among both organisers of the floats and visitors, on performing authenticity through acts of faith. UNESCO is a neutral party in this Japanese battle about the place of religion in the public sphere, but it appears that most stakeholders in the Gion festival distrust it as a global force of secularisation and touristification.

Acknowledgements

I would like to express my gratitude to the Institute for Research in Humanities at Kyoto University and its director Takagi Hiroshi for making this research possible.

Notes

1 A water tunnel from Lake Biwa to Kyoto, a new system of water supply, and the broadening of main thoroughfares, including the opening of municipal tramlines.

2 From the "Provisions Concerning Donations for the Founding of the Preservation Association of Tenjinyama" (*Kyōto Tenjinyama hozonkai setsuritsu kifu kōi ni kansuru kitei*) held at Kyoto City Library of Historical Documents.

3 *Gion yamahoko rengōkai kiroku* (unpublished record, kept at the office of the Floats Association), June 1941. I thank the Association for making this record available to me, and Murakami Tadayoshi for his mediation. See Teeuwen (forthcoming).

4 *Kyōto shinbun* 17 July 1942. Kyōto-shi (2011, 48) carries a photograph from 1942 showing the Niwatorihoko with a large banner reading "May the Imperial Army be eternally victorious."

5 Fukami (2018). A new property tax promulgated in November 1946 greatly exacerbated this problem.

6 *Gion yamahoko rengōkai kiroku* 4, 29 October 1945. This initiative was not brought to fruition because the museum itself was requisitioned by the occupation army.

7 Most of this sum went to hiring float pullers, recompensing musicians, executing minor repair work, and buying sake, rice, lanterns, and candles. *Gion yamahoko rengōkai kiroku* 4, 19 June 1947.

8 *Asahi Shinbun* 18 July 1947, quoted in Kyōto-shi (1967, 2).

9 According to *Nihon shoki* (720), this legendary empress led an invasion of Korea in ancient times. A figurine of Jingū Kōgō is enshrined in the Funehoko ("ship float") during the parade.

10 *Hinode shinbun*, 12 June 1912. "National Treasures" (*kokuhō*) first denoted a category of heritage preservation in the Law for the Preservation of Ancient Shrines and Temples of 1897.

11 Kikuchi (2001, 62 n17).

12 *Kyōto-shi einen hozon kōbunsho* 1657–8, quoted in Itō (2010, 2840).

13 Takahara (1892–1989) served as Yasaka's head priest from 1938 until 1976. He was a leading figure in the shrine world, who also served as the president of Kōgakkan University (a private Shinto university located in Ise) and as a member of the board of trustees of the Association of Shinto Shrines.

14 Teramachi Han'eikai, *Gion matsuri yamahoko junkōro henkō hantai riyūsho*, an unpublished document preserved at the Floats Association office.

15 Fukami (2018, no pagination) suggests that that

> the merger of the two parades was the result of the willing collusion of the townspeople with the tourism policies of Kyoto City, out of fear that they might miss out on the so-called Itohen boom [triggered by the Korean War].

16 Among the floats of the second parade, Suzukayama signalled its displeasure by boycotting the merged parade in 1966; it rejoined in 1967 (Yoshida 2012, 207). The shrine responded by initiating a new pageant (*hanagasa junkō*) to replace the second parade, designed to represent "an older, original form that later developed into the floats of today" (Yoneyama 1974, 181).

17 On this film and its many troubles, see Tanaka (2015).

18 A more accurate reading of the 1533 incident is that the Muromachi shogunate issued orders for the parade to be staged, but had to concede to threats from Mt. Hiei at the last moment. The townspeople, who had already made preparations, argued that because of the costs and effort involved, the parade should go ahead as planned, rather than later in the year after the conflict with Mt. Hiei had been resolved. Mt. Hiei, which does not figure in Hayashiya's narrative at all, won the day. In the end, the parade was postponed until the eighth month, after Mt. Hiei's issues had been resolved, and the townspeople had to set up their floats twice in this year. Kawauchi (2007, Chapter 2).

19 Ono (1975). Ono worked for Jinja Honchō in various positions, while serving as a priest at a number of shrines.

20 *Bunkyō iinkai bunkazai hogo ni kansuru shōiin kaigiroku* 3, 4 March 1975, 5.

21 *Hitachi furyūmono*, floats with mechanical dolls displayed during the festival of Kamine Shrine in Ibaraki, were designated in 1977. Also here, the shrine rituals were not part of the cultural property. Kyoto's Gion float parade was included in the second round of festival designations, together with six others.

22 In 2015, floats categorised as "large" received "parade subsidies" (*junkō hojokin*) of 4,825,600 yen and those in the "small" category 1,352,000 yen. Satō (2019, figures 6.5 and 6.6) calculates that in that year, the rate of dependence on subsidies varied between 8 and 43 percent for large floats and 11 and 44 percent for small floats.

23 Ōfunehoko was lost to fire in 1864 (as were many other floats). On the process leading to its revival, which began with the creation of a new *hayashi* music repertoire in 1997 and gathered pace with the founding of the Ōfunehoko Preservation Association in 2010, see Ōfunehoko (2015).

24 Kikusuihoko was revived in 1952, Ayagasahoko in 1979, Tōrōyama in 1981, and Shijō Kasahoko in 1988. These floats disappeared from the parade in the late Edo and early Meiji periods.

25 On the "simultaneity" of different conceptualisations of authenticity, see Theodossopoulos (2013).

References

Brumann, Christoph. 2009. "Outside the Glass Case: The Social Life of Urban Heritage in Kyoto." *American Ethnologist* 36 (2): 276–299.

Fukami Shigeru. 2018. "Shōnen ga kenbun shita shūsengo no Gion matsuri tenbyō: Rejime ni mo nokosenai ohanashi." Public lecture (handout), Miyako no Matsuri Bunka Kenkyūkai, 21 April 2018.

Fukumochi Masayuki. 2017. "'Kyōto Gion matsuri no yamahoko gyōji' no UNESCO mukei bunka isan no tōroku to sono go." *Bunka isan no sekai* 28. Accessed 13 January 2020, www.isan-no-sekai.jp/feature/201701_03.

Honda Yasuji. 1974. "Kokumin seikatsu no henka to mukei bunkazai no hogo." *Monbu jihō* 1170: 41–47.

Itō Setsuko. 2010. "1956-nen no Gion matsuri yamahoko junkōro no henkō ni kansuru kōsatsu: Kyōto-shi no seisaku dōkō ni chakumoku shite." *Nihon Kenchiku Gakkai keikakukei ronbunshū* 75 (658): 2837–2843.

Jinja Honchō, ed. 1971. *Jinja Honchō 25-nen shi.* Tokyo: Jinja Honchō.

Kawauchi Masayoshi. 2007. *Gion matsuri to sengoku Kyōto.* Tokyo: Kadokawa Shoten.

Kikuchi Akira. 2001. *Yanagita Kunio to minzokugaku no kindai: Oku Noto no aenokoto no 20-seiki.* Tokyo: Yoshikawa Kōbunkan.

Kyōto-shi, ed. 1967. *Gion matsuri: Sengo no ayumi.* Kyoto: Kyōto-shi Bunka Kankōkyoku Bunkaka.

Kyōto-shi, ed. 2011. *Shashin de tadoru Gion matsuri yamahoko gyōji no kindai.* Kyoto: Kyōto-shi Bunka Shiminkyoku Bunka Geijutsu Toshi Suishinshitsu Bunkazai Hogoka.

Minka Kyōto Shibu Rekishi Bukai. 1953. *Gion matsuri*, narrated by Hayashiya Tatsusaburō. Tokyo: Tōkyō Daigaku Shuppanbu.

Murakami Tadayoshi. 2010. "UNESCO mukei bunka isan to minzoku bunkazai: Kyōto Gion matsuri no yamahoko gyōji tōroku ni mukete no torikumi." *Ritsumeikan seisaku kagaku* 17 (2): 141–146.

Nakamura Jun. 2013. "Nihon ni okeru bunkazai hogohō no tenkai." In *Sekai isan jidai no minzokugaku: Gurōbaru sutandādo no juyō o meguru Nik-Kan hikaku*, edited by Iwamoto Michiya, 61–85. Tokyo: Fūkyōsha.

Nishiguchi Katsumi. 1961. *Gion matsuri.* Tokyo: Chūō Kōronsha.

Ōfunehoko (Kōeki zaidan hōjin Shijō-chō Ōfunehoko Hozonkai). 2015. *Gion matsuri Ōfunehoko fukkō no kiseki.* Tokyo: Sōkyūsha.

Ono Michio. 1975. "Omatsuri to bunkazai (Nippon tanpa hōsō kōwa yori)." *Minzoku bunkazai kenkyū kyōgikai kaihō* 6: 6–10.

Porcu, Elisabetta. 2012. "Observations on the Blurring of the Religious and the Secular in a Japanese Urban Setting." *Journal of Religion in Japan* 1: 83–106.

Satō Hirotaka. 2019. "Kyōto Gion matsuri no yamahoko junkō no sonritsu shisutemu ni kansuru kenkyū: Gendai toshi ni okeru sairei no keishō." PhD dissertation, Ritsumeikan University, Kyoto.

Silverman, Helaine. 2015. "Heritage and Authenticity." In *The Palgrave Handbook of Contemporary Heritage Research*, edited by Emma Waterton and Steve Watson, 69–88. Basingstoke: Palgrave Macmillan.

Takagi Hiroshi. 2006. *Kindai tennōsei to koto.* Tokyo: Iwanami Shoten.

Tanaka Satoshi. 2015. "Eiga *Gion matsuri* no kōsō o meguru tairitsu: *Kinema junpō* shijō no ronsō kara." In *Kyōto Sengoshigakushi Kenkyūkai kenkyū seika hōkokusho*, edited by Kyōto Sengoshigakushi Kenkyūkai, 115–145. Kyoto: Kyōto Sengoshigakushi Kenkyūkai.

Teeuwen, Mark. Forthcoming. "*Gion'e Yamahoko Rengōkai Kiroku* ni miru senji-senryōki no Gion matsuri: hendōki ni okeru toshi sairei no igi to kachi o kangaeru." *Jinbun gakuhō*.

Theodossopoulos, Dimitrios. 2013. "Laying Claim to Authenticity: Five Anthropological Dilemmas." *Anthropological Quarterly* 86 (2): 337–360.

UNESCO. 2005. *Report of the Expert Meeting on "Criteria for Inscription on the Lists Established by the 2003 Convention for the Safeguarding of the Intangible Cultural Heritage."* Accessed 13 January 2020, https://ich.unesco.org/doc/src/00035-EN.pdf.

Yoneyama Toshinao. 1974. *Gion matsuri: Toshi jinruigaku kotohajime.* Tokyo: Chūō Kōronsha.

Yoshida Kōjirō. 2012. "Sengo Gion matsuri no hensen." In *Kyōto no bunka to seisaku: Mamori, sodate, tsukuru tame no torikumi,* edited by Kyōto-shi Bunka Seisakushi Kenkyūkai, 201–224. Kyoto: Yamashiro Insatsu.

The story beyond UNESCO

Local Buddhist temples and the heritage of survival in regional Japan

Paulina K. Kolata

Introduction: the story

The current era represents an important moment of uncertainty and change for Buddhist heritage in depopulating regions of Japan. From timeworn Buddhist statues and ritual paraphernalia to weathered architecture and spiritually charged landscapes, the Japanese countryside is peppered with markers of local religious histories at the brink of demographic upheaval. In recent years, national and local governments have actively sought UNESCO World Heritage and domestic cultural property (*bunkazai*) designations. According to governmental briefs, heritage designation aims to preserve cultural properties, revitalise local communities, and strengthen people's sense of identity (Bunkachō 2018a). In 2015, Japan's Agency for Cultural Affairs (Bunkachō, hereafter ACA) launched the Japan Heritage Promotion Project, aiming to utilise local heritage for tourism development. The initiative focuses on fostering collaboration between various local actors, including religious institutions such as Buddhist temples.[1] The project is centred on the creation of "stories." These stories, which engender nostalgia for a romanticised past, must be convincing enough to gain recognition as "Japan Heritage" (*Nihon isan*) at both local and national levels.[2] Among examples of stories listed in the Japan Heritage Programme pamphlet (Bunkachō n.d.) are the Shikoku pilgrimage route and the World Heritage Site "Hidden Christian Sites in the Nagasaki Region." Both are presented as success stories in which heritage tourism has contributed (or is expected to contribute) to the revival of local communities.

The Shikoku pilgrimage has yet to secure UNESCO World Heritage status,[3] but there is evidence suggesting that the practice and associated tourist activities have already played a role in safeguarding strategies for the socio-economic development of the Shikoku region (Reader 2014, 174–178). The Nagasaki World Heritage Site is spread over twelve locations, including small villages where people secretly practised Christianity. What came to the fore in the public debate are the challenges that shifting demographics are posing for the preservation of living religious heritage and the survival of the religious communities that transmit it (Tominaga 2018). The properties in the Nagasaki

region, especially those on remote islands, face difficulties, amid a greying and shrinking population, in securing a sufficient number of people to preserve the sites. Without a community of practitioners, and without the human and economic resources to sustain it, any story is likely to be forgotten—particularly in regional municipalities where investment in heritage funding has remained consistently low and continues to fall (Bunkachō 2018a, 23–26, 44–45).[4]

The Japanese government is shifting its agenda from mere protection to a combination of preserving and utilising heritage beyond such famed sites as, for example, Nikkō and Kyoto.[5] For every supposed "success story," however, there are numerous examples of stories of disappearing religious heritage. In this chapter, I explore such "forgotten stories" of heritage cared for in depopulating Buddhist temple communities in Hiroshima Prefecture. In Japan's shrinking regions, shifting demographics have led to a reduced availability of the human and economic resources required to preserve heritage. While religious communities are losing members and facing uncertain futures, their temple halls and gardens abound in objects and landscapes that the communities strive to preserve as heritage.[6]

In order to broaden the emerging discussion on the impact of heritage-making in Japan beyond the UNESCO debate, my two case studies focus on regional, city-level designations. In recent years, cultural properties have become more integrated into local development policies. However, the financial resources allocated by governments for the actual implementation of robust heritage preservation and utilisation programmes are limited. The examples discussed in this chapter serve to question the deliverability of the "development through heritage" agenda.

My first case study is a designated Natural Monument (*tennen kinenbutsu*) referred to as the "Peacock pine tree," which grows within the grounds of a local temple, Kōtokuji.[7] The name of this monument derives from its supposed resemblance to a peacock spreading its tail. According to the temple's current head priest, the tree dates back to the mid-seventeenth century. My second example is a statue of Amida Buddha from the late Heian period, which has been designated as a City Important Cultural Property (*shi jūyō bunkazai*). Both examples of heritage are property of local Jōdo Shinshū temples in the mountainous north of Hiroshima Prefecture.[8] It is worth noting here, however, that the issues discussed in this chapter are not unique to this school of Buddhism, to Buddhist institutions alone, or to Hiroshima Prefecture. The Jōdo Shinshū sect of Japanese Buddhism represents the largest denomination in Japan today in terms both of the number of affiliated members and the number of temples. Recent government figures indicate that the number of affiliated members of the Jōdo Shinshū (Nishi Honganji) sect alone is 7.91 million, while the number of registered temples stands at 10,182 temples (Bunkachō 2018b).

This chapter draws on data collected during a twelve-month period of ethnographic fieldwork in Hiroshima Prefecture.[9] What interests me are the ways in which the politics of "forgotten" cultural and religious heritage speak

to the people's sense of survival and shape local narratives on belonging and identity in contemporary Japan. What I hope to reveal are the anxieties and socio-economic tensions that accompany efforts to take care of heritage, especially in the case of heritage so damaged that it is past the point of saving. I focus on local efforts and opportunities to preserve cultural and natural heritage in Japan's shrinking regions, where efforts to preserve heritage serve as a means of coping with psychological and physical anxiety and loss, and as sources for resilience and the strengthening of social relations.

Through my ethnographic examples, I ask what the meaning and impact of heritage are for local Buddhist temple communities. Can the process of the disappearance of communal history truly be countered without the responsibility of care being laid at the feet of the institutions that select and designate heritage? I argue that demographic challenges intensify the burden on the living to care for the heritage of the soon-to-be-absent next generation. I thus explore what the economic realities of heritage preservation in depopulating religious communities are. Before investigating my individual case studies, I discuss the relationship between the economics of local Buddhist temples and local and national heritage policies.

Heritage and the economy of local Buddhist temples

Hiroshima Prefecture is home to over eight hundred Jōdo Shinshū temples. Their size, wealth, number of parishioners and geographical circumstances vary, but most of them belong to the category of *bodaiji* temples (also referred to as *dannadera*): local family temples whose survival continues to depend on the remnants of the long-established parishioner-temple affiliation system (*danka seido*).[10] Such temples rely economically on the socio-religious bonds with their communities and on donations from their parishioners for religious services. This is certainly the reality for most temples in rural communities such as those in northern Hiroshima Prefecture, where shifting demographics, invasive administrative mergers, shrinking regional budgets, and insufficient (or non-existent) public transport links are having profound consequences for heritage preservation and survival of local communities in general. *Bodaiji* temples centre their activities on household-based loyalties, as well as funerary and memorial services for the dead. They are rarely regarded as centres of cultural splendour and are hardly ever in possession of objects and structures that can hope to be officially recognised as cultural properties.

Local Buddhist temples are often perceived by my interlocutors as storehouses of local histories and markers of local identity. In some cases (including my two case studies), these roles are validated through an official designation as cultural properties of objects, structures, and landscapes belonging to their estate. The head temple of Jōdo Shinshū, Nishi Honganji temple in Kyoto, has been listed as a UNESCO World Heritage Site as part of "Historic Monuments of Ancient Kyoto" in 1994. For most family-run local Buddhist temples, being awarded the

status of an important cultural property or even a World Heritage Site is perhaps an envy-worthy prospect. However, most regional Buddhist temples can only attain cultural property status at a prefectural or municipal level, or not at all. This recognition (or lack of thereof) is rarely accompanied by sufficient public funding even for cleaning and restoration work. Therefore, local temple communities are left with the financial and emotional burden of preserving local heritage, while depopulation is crippling the local economy and thus also public spending.

This is also due to the laws surrounding the ownership and upkeep of heritage in Japan. The principle of property rights and, by extension, the burden of care, was laid down in 1897 when the Law for the Preservation of Ancient Shrines and Temples (*koshaji hozonhō*) was passed by the Meiji government. This law stipulated that the protection of objects does not assume a responsibility for the maintenance of historic art and structures. In other words, a designation is a marker of protection and places restrictions on alternations, repair, and the export of such designated objects. However, despite the availability of financial support from the contemporaneous Ministry of Internal Affairs, it put the onus on the local authorities and owners to restore and preserve the designated objects. This principle was then mirrored in the 1950s Law for the Protection of Cultural Properties as approved by the Occupation Authorities (SCAP).[11] Restoration works were still financed at that point through the central government's budget. In 1999, however, protective authority was principally transferred to prefectures and designated cities. In recent years, individual local governments have been encouraged to participate actively in the development of a "system for local heritage" (Yamakawa et al. 2017). Although the policy development and funding investment in the area has certainly aided the discovery of local heritage, a robust and fully integrated system that would support the implementation of conservation and utilisation efforts is still lacking or simply unachievable.

In her study of historical treasure hunting in Japan's regional communities, Bridget Love argues that a move towards the (re-)discovery of local histories can reveal untapped resources and mobilise civic energies (2013). However, as a result of governmental reforms leading to decentralisation and devolvement of powers in areas such as cultural management and education, the demand for greater autonomy and self-reliance of Japan's regions leads to greater pressure on local budgets already stretched by social welfare provisions (Yamamoto 1996; Tanimoto and Hosoi 2012; Nōsangyōson Bunka Kyōkai 2015).[12] This is of consequence for fiscal planning related to the utilisation of cultural properties. Prefectural and municipal heritage preservation plans drafted by local education boards (*kyōiku iinkai*) are often limited in scope and exclude lesser known and less accessible objects and landscapes from funding due to restricted resources and legislative constraints concerning property rights. As noted previously, heritage and cultural property designation in Japan has never placed the responsibility of maintenance on the designating party. The legal responsibility

for preservation thus rests with the "owners" of the heritage (Jimura 2011; Yamakawa and Ito 2017; Yamakawa et al. 2017).

In the case of Buddhist temples, ownership often rests with the temple's head priest, who is responsible for the administrative management of a temple with the legal status of a "Religious Juridical Person" (*shūkyō hōjin*).[13] The administrative running of a temple is supported by a temple board consisting of affiliated *danka* members, while the temple's financial wellbeing, which includes maintenance costs and repairs, depends on the generosity of supporting members. The *danka* system that legally imposed compulsory donations on affiliated households was officially abolished between 1871 and 1873 and formally delegalised by Japan's postwar constitution, but even today a sense of obligation, rooted in the old affiliation system, to provide regular financial support for the upkeep of one's family temple is still what keeps most Buddhist temples afloat.

The expectation that affiliated households provide temples with socio-economic support are covertly mentioned in sects' bylaws governing religious observances and social order, which instruct members how they ought to support their local Buddhist institutions and the sect in general. Financial contributions are thus expected. It is up to a head priest of a temple to drum up support from parishioners and neighbours for any restoration and maintenance work. The ultimate result of this legal setup is private ownership of publicly recognised and supported heritage. In practice, this also means that roles of social and economic stewardship are informally assigned by the collective choice of the community, whose members are entrusted with a legally non-binding responsibility and authority for the maintenance of the temples and its heritage as a self-governing community.[14]

What further complicates the picture is Japan's strict legal separation of religion and the state, which forbids public expenditure on religious organisations. Heritage preservation programmes constitute an area where the boundaries between religion and contiguous semantic fields such as "culture," "tradition," and "customs" are blurred. On the one hand, the legal status of recognised heritage introduces restrictions in the areas of craftsmanship, the expertise required for restoration work, and the degree of alteration permitted, which is often reflected in the cost and duration of maintenance work.[15] On the other hand, the legal separation of the categories "heritage" and "religion" limits the available sources of funding that can be obtained from the local government. If, for instance, a Buddhist priest wants to use a statue in his temple that has been designated as a cultural property at a municipal level for tourism purposes, the priest can seek local governmental funding for the cleaning or restoration of the statue itself, but not if the statue is to be used for "religious" purposes. She or he would then have to seek private corporate and community sponsors to support the development of viable transport links and marketing to make the statue accessible to the public. There are many examples of Buddhist temples collaborating with travel and tourism companies to develop infrastructure and attract visitors (Reader 2014, 106–108). Yet, for most rural temples—even those

in possession of recognised heritage objects—the daily struggle for basic survival is of far greater importance than fulfilling the government's agenda for developing a heritage story.

With the exception of some temples that have benefited from other temple closures, Buddhist temples in the north of Hiroshima Prefecture all face declining membership numbers. This applies especially to "active membership": members who are willing and physically able to provide the economic and social capital required for sustaining temple operations. This decline is having a severe impact on temples' activities and finances. Other challenges include issues of succession, in relation to both the next generation of priests and temple membership. For the people dependent on these temples, the question of heritage is equally a matter of financial sustainability and a broader issue of survival. Therefore, a peek into the lives of Buddhist temples and their depopulating communities increases our understanding of what cultural heritage is, for whom it is intended, and what impact it has on local communities.

A proud peacock and amateur tree surgeons

The peacock-shaped pine tree "monument" is part of the garden grounds surrounding the mid-size Kōtokuji temple, which is run by a female head priest in her sixties. I will refer to her as Ishii-san. She is the only daughter of her now-deceased parents, and always knew that she was going to take over her parents' temple. As she asserted in our interview (18 May 2017), Ishii-san is very committed to her role, and she followed in her father's footsteps as a Buddhist priest in accordance with her parents' and temple supporters' expectations. She never married and continued to live at the temple on her own after her parents' deaths. The temple is located in an area where there is no public transport, except for a bus service that runs twice a week to the nearest city, a thirty-minute drive away.

The local population is largely elderly (with some community members in their fifties, sixties and seventies usually referred to as "young"). According to municipal statistics, no children have been born in the village in the past three years (2016–2018). Changes to the local educational system that came with an administrative merger in 2004 resulted in the closure of four out of five primary schools, and there are plans for further mergers in the near future. Ishii-san's temple cooperates with another local temple to organise events for children still living in the area. To keep the local community connected to the temples, a ceremony known as shosanshiki (meaning "a first visit to a Buddhist temple"), which is traditionally intended for newly born babies, and a summer school event are held jointly every two years. During my time in the field, both events were postponed until the following year due to the lack of new children joining the community.

At the beginning of my fieldwork, I visited Kōtokuji temple to observe the temple's study sessions. During those study sessions, parishioners and other

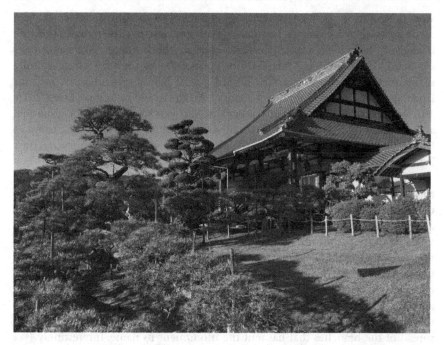

Figure 8.1 The "peacock" pine tree at Kōtokuji temple. Photo by the author, May 2017.

local community members came together to study Jōdo Shinshū teachings, copy sutras, drink tea, and chat. The head priest of another local temple where I lived was the one delivering the teaching, which is how I became involved. The teaching sessions took place every two months in the evenings. During those visits, the temple grounds were wrapped in complete darkness. It was not until I went to interview the head priest in May 2017 that I finally noticed and fully appreciated the beauty of meticulously trimmed pine tree branches decorating the temple grounds. Seeing the tree in its full glory explained the name of this Natural Monument, which was coined by the previous head priest. The shape of the tree branches resembles a peacock proudly spreading its tail (see Figure 8.1).[16]

The peacock tree sprawls across two hundred square meters of the temple grounds and is believed to date back to 1662, when the temple was built. According to the temple records, the original *kuromatsu* pine trees that covered the slope of the hill where the temple now stands were used as building material for constructing the original temple structures. According to the current head priest, the tree was planted to celebrate the completion of the construction work and "to restore the natural landscape of the slope" (interview with the author, 18 May 2017). This explanation, however, is likely to be a nostalgic narrative rather than based on historical evidence. Most of the temple's records

were destroyed in a fire a few years ago and many of the historical details were reconstructed by Ishii-san's late father. Although no records remain, the tree is likely to have been planted because of its aesthetic appeal. *Kuromatsu* trees can hardly be considered "natural" or "primeval," as they are often skilfully maintained (as with the peacock shaped tree at Kōtokuji) and are typical for landscapes that have experienced significant human intervention (Tsing 2015, 155–163). Yet, they have long featured in the Japanese cultural imagination, and, through their nostalgic appeal reiterated through traditional arts, *satoyama* landscapes, and traditional practices such as *matsutake* mushroom picking, they have a considerable tourist appeal (Knight 2010; Tsing 2015, 179–189).

In April 1977, the municipal Education Committee (*kyōiku iinkai*) decided to designate the tree as a Natural Monument under the Law for the Protection of Cultural Properties.[17] The application was initiated by Ishii-san's father around the time when narratives of nostalgia were driving Japan's domestic travel industry.[18] A number of factors contributed to the city's decision to grant the status. The original application and decision focused on two major factors. One was the age of the tree, dating back over 350 years; the other was its unprecedented shape and the width of its branches. The tree is only 5.26 meters high, and its branches crawl approximately one meter above the ground, engulfing the temple with a lush carpet of floating greenery. It is this majestic and elegant spread of the branches that has lent the monument its name. Interestingly (yet not surprisingly), although the application was submitted by the head of the Kōtokuji temple and the tree legally belongs to the temple's estate, words such as "Buddhism" and "religion" do not appear in the documentation, except for the word "temple" that is used to refer to the location of the "monument."

An advertising pamphlet was produced with the support of the Association for the Protection of the Peacock Pine Tree, which was set up a few years ago by a collective of about thirty dedicated parishioners and neighbours to ensure that the tree is properly cared for. The head priest, Ishii-san, is also a member of this association. Following a community-led tree pruning and weeding session in June 2017, I interviewed six members of the association. Individually and collectively they expressed that the pine tree is both "a treasure of the temple" (*otera no takara*) and "a treasure of the region" (*chiiki no takara*); and, as such, is cared for by temple members and non-affiliated neighbours alike. Takahashi-san, one of the affiliated members in his late sixties, explained that for him the act of weeding and pruning is a form of religious practice. It is a reflection of the way of life in this community—a community built on a Buddhist sense of gratitude and obligation to preserve the heritage and the story of the village, with the local temple as an integral part of it.

The head priest, a keen gardener herself, takes responsibility for and enjoys tending the tree. It carries a personal meaning for her as well: since her father was the driving force behind the bid, she feels obliged to cultivate it as an expression of "gratitude" and as a way of caring for her ancestors. However, she is aware that she could not do so without the support of the association and

help from the local population. With everyone getting older and weaker, it is hard enough to keep the temple going, never mind the upkeep of the monument that must be kept in impeccable condition and often requires specialised care, such as the instalment of wooden support structures to ensure that the branches keep their shape and to prevent them from breaking, particularly during the winter season when a heavy blanket of snow covers the branches.

The head priest is facing the serious issue of securing a successor. So far, she has been unsuccessful in finding someone to take over the role of head priest. The temple, with its vanishing community and its burden of responsibility for the preservation of local cultural and natural heritage, offers few economic prospects. The donations that are offered currently provide sufficient means to support Ishii-san, who lives alone, but would not be adequate to support a family. Until now, the temple and the tree have been blessed with a small but committed group of supporters. Gardening work is written into the annual calendar of temple and community events, and into the temple budget. Supporters' contributions cover most of the costs and labour associated with the upkeep of the garden area. Occasionally, when the professional intervention of a tree surgeon is required (at greater cost), the association and the temple apply for additional funding from the city. However, no such application has been made in recent years, and it is the temple and the parishioners who bear the brunt of most of the costs (money, time, and labour).

Ishii-san's father believed that a move towards a formal recognition of the tree as a Natural Monument would help the temple survive by developing a link to the tourism industry. His daughter, however, is less optimistic, especially, as she pointed out in our interview (18 May 2017), because this strategy has not worked so far. For her, there is no real benefit to such recognition for temples in depopulated areas. In the case of the peacock tree, there is no formal support plan or initiative from the city to help with the upkeep of the monument or to direct tourists to the site. Other than commemorative and information boards outside the temple and a brief mention on the municipal heritage website and the city-sponsored local tourism portal, publicity surrounding the site is scarce. The pamphlet advertising the tree I mentioned earlier was available only at the temple, and in short supply at that. When I visited local travel agencies in the municipal area, they neither possessed the pamphlet nor had any information about the monument itself. The tourism infrastructure and investment that Ishii-san's father had hoped for had not materialised.

Despite this lack of publicity, I discovered a few online reviews of the site. According to the head priest, a tourist bus parks outside of the temple grounds twice a year, and a group of twenty to thirty tourists disembark to visit the garden. However, no entry fee is collected and there is no cooperation between the association, the temple, and the travel companies in arranging those visits. The head priest explains to me that fleeting visitors to the garden do not visit the temple, apart from an occasional polite bow in front of the temple's main hall as they stroll through the garden. No donations are made to the

temple during those visits, and it does not lead to participation in any religious service. There are no souvenir stores or coffee shops in the temple's vicinity. Visitors have no opportunity to spend any money locally, whereas the lack of transport links means that the chartered whistle-stop visits prevent them from exploring the area any further. Similar patterns of meagre tourism spending can be observed elsewhere, despite the existence of official heritage designations (Jimura 2011, 293–294; see also the chapter by Aike Rots in this volume).

Opportunities to spend money at Kōtokuji are equal to zero due to the lack of any visitor-focused facilities, which the temple and its members are unable to fund or attract funding for, in spite of the government's recent tax rebates offered to businesses that set up operations in depopulating regions. Without outside investment and a better integrated infrastructure that would create employment opportunities and provide basic support structures such as education, transport, and medical support to address regions' universal sustainability, tourism-motivated heritage-making in depopulating regions is unlikely to spark regional regeneration. As for the local community, other than a personal and shared feeling of pride and accomplishment, there is no tangible benefit to those limited visits by tourists. In such demographically challenged communities, cultural property designations can easily turn out to be a burden rather than an asset.

I sense, however, that for this community the peacock tree's Natural Monument status does not have much to do with tourism, and even less with potential financial benefits for the temple and the community (no matter how welcome that would be). The responsibility to take care of the tree has brought this community even tighter together, united by the shared task of preserving this monument, and, by extension, preserving their local temple and their community more broadly. It stimulates a sense of agency and resilience among the community members. The establishment of the Association for the Protection of the Peacock Pine Tree is a collective initiative to preserve the landscape and the practice of care in a communal sense. There is a social aspect to this grassroots-level agency. Involvement draws people out of their homes and allows them to gather for a shared purpose; it creates a community with a collective and an individual sense of pride inscribed in the act of caring and preservation. Yet, at the same time, it removes urgency and responsibility from the municipal and religious authorities, which remain unable to stifle the demographic decline in their communities and are often unable or unwilling to invest in heritage preservation—be it for the purpose of tourism or the preservation of regional (religious) histories.

Amida beyond saving

In the case of the peacock tree, the heritage object is well and truly "on show," an integral part of the local landscape. In contrast, the statue of Amida at the small Zenkōji temple is hidden away in a side alcove of the main temple hall.

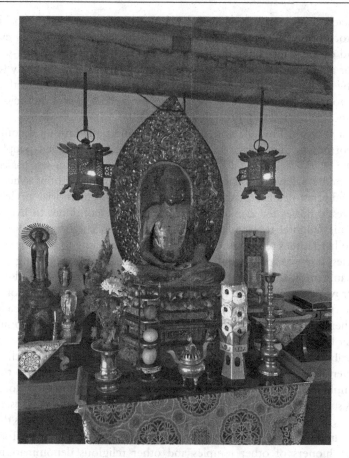

Figure 8.2 The statue of Amida Buddha at Zenkōji temple. Photo by the author, August 2017.

During my first few visits to temple I did not notice the statue, until a group of parishioners introduced me to it. It is standing inconspicuously to the left of the main altar, with a huge temple drum and other temple paraphernalia obscuring the view (see Figure 8.2).

This statue, an 86.4-centimeter sculpture carved using the joined block technique (*yosegi*),[19] dates to the end of eleventh century. It represents Amida Buddha sitting in a lotus position. On 29 October 2001, the statue received formal recognition as a City Important Cultural Property. The designation came following a research project run by the Hiroshima Prefectural Museum of History in Fukuyama that investigated the statue and its history in 1994. The process of research and nomination was initiated by the head priest of Zenkōji temple at the time (whom I will refer to as Fujita-san). In the early 1990s, he returned from Tokyo to take over the temple from his father, and by using

personal contacts that he had developed during his employment in Tokyo, he started the process of trying to gain recognition for the statue. In my interview with the head of the temple board (21 August 2017), I learnt that Fujita-san had hoped for a designation at the prefectural level, which was more likely to be followed by some financial investment and opportunities to develop further research and tourism links. However, the designation came at the municipal level, and no governmental support followed.

Zenkōji is a very small temple with a committed and tight-knit local community supporting it. The village has a population of five hundred people, making it one of the smallest villages in the municipality. Fujita-san passed away unexpectedly a few years ago, and the temple remains without a head priest. The head priest of a nearby temple currently performs memorial services and other priestly duties for Zenkōji. Fujita-san's widow continues to live at Zenkōji, and his daughter returned to the temple with her daughters to ultimately step into her father's priestly shoes. She started her training to become the next head priest a few years ago, but four unsuccessful attempts at passing the qualifying examination later, she has yet to transition into the role. She is also a single mother working full time in the social welfare sector. Although the community is determined to help with the running of the temple until she is ready to take over, her employment outside of the temple is essential to the economic survival of her family.

Economically, the temple relies heavily on its members' donations, which—although generous—are constrained by the small size of the village and the shrinking employment and income opportunities in the region. The local community's support for Zenkōji (in the form of donations for memorial services, monetary support towards temple events and seasonal food gifts) keeps the temple afloat financially. The support offered represents a truly collective effort, involving parishioners of other temples and other religious denominations (including a family of Sōka Gakkai members)[20] who reside in the area and contribute financially and otherwise towards the temple's upkeep and the running of temple events. As such, the temple is one element in a bigger community landscape, and its preservation is a crucial part of the collective narrative of continuity. It is a story of survival of the entire community, and both the temple and the statue that it accommodates are symbols of this unity. It is also important to note that the statue represents an important object of worship and is regularly presented with offerings. Despite its material deterioration (or perhaps because of it), the statue continues to inspire people.

However, the costs of maintenance of Buddhist traditional structures and art are a burden, and the financial circumstances of this temple are gloomy. Tied to this broader picture of uncertainty and anticipated decline of the temple community is the ominous future of the Amida statue itself. Caitlin DeSilvey (2017) used the phrase "palliative curation" to describe the process of caring for heritage that is so far gone that the only sensible thing is to allow it to gradually decay (2017, 161). The term seems fitting here, both in relation to the statue

of Amida and, to an extent, to the temple community that cares for it. If we accept that objects have lives (Appadurai 1986), we must also accept that they have deaths (Lowenthal 1994; DeSilvey 2017). This is one thing communities, individuals, and heritage objects have in common: material objects change and eventually decay. As for the Amida statue, the anticipatory sense of inevitable gradual demise appears to symbolically unite community members and provide them with physical and psychological currency to strive for some kind of future.

Members and neighbours supporting Zenkōji represent one of the most mobilised temple communities I witnessed during my fieldwork. The temple has an enthusiastic temple board (*gojikai*), as well as a whole range of groups (Buddhist women's, men's, young men's, and elders' groups) that organise and sponsor events at the temple. The membership of different groups overlaps at times, but the members make a point of running separate events and meetings for different associations. Those mobilising efforts for the temple are also reflected in the "secular" realm of community life, including local groups such as a young people's association for the preservation of tradition, a mountain hut association, and a group for the preservation of performing arts, among others. The head of the young men's group, Nakata-san (currently in his late fifties), believes that as a community, they have a responsibility to keep the collective going and ensure that there is a shared history and "heritage" to hand over to the next generation.

The next generation is small in numbers, but not non-existent. In August 2017, eighteen children attended the local primary school (first to sixth grade). Keeping the school afloat is part of the same agenda as the support afforded to the local temple. The local government's profile on the city website states that the local community centre, primary school, regional revitalisation centre, post office, two local shops, as well as the local shrine and temple are at the heart of the community. Many of my lay interviewees, whose children and grandchildren attend the summer school organised annually at Zenkōji temple, were in agreement that participating in Buddhist events educates the next generation about the religious practice as a form of local cultural heritage, and as part of being Japanese. "Supporting your local temple here is as obvious as supporting the Carps," Nakata-san told me during one of the *obon* dance practice meetings, while pointing at a white towel with the Hiroshima Carps baseball team logo. All primary school children are involved in community-focused temple events such as a regional summer school, the temple's summer school (organised by the members of Zenkōji's Buddhist women's association), and the *obon* celebrations.

Temple activities are only one example of how the community mobilises to remain socially and economically viable. Despite its shrinking population, there are initiatives to develop local brand farm products to attract culinary tourists.[21] A soba noodle producer runs a small establishment where people can either experience soba making or enjoy a bowl of made-to-order noodles; a small-scale sake brewer uses rice grown locally and renowned nationally for its quality

of grain and taste. Cultural events are another area of engagement. During my stay, there was an open-air concert that attracted a considerable number of people and an *obon* festival at Zenkōji during which food and entertainment stalls filled the temple grounds.

Despite its designation as a cultural property and its presumed potential to attract tourism to the area, the Buddhist statue that is kept at the temple is currently not utilised as an economic and development resource. A few parishioners remarked that with the death of the previous head priest, leadership momentum to drive the process forward was lost. For instance, children attending the temple's summer school used to be educated about the statue's history, but since Fujita-san's passing no one appears to have the confidence and knowledge to continue the practice. This is bound to weaken the next generation's sentimental attachment to the statue and, by extension, their willingness to provide for its upkeep.

Thus far, there has also been no interest from the municipal authorities to restore the statue and tap into its tourism potential. Some information about the statue and an appeal for funding its restoration feature on the local primary school website. The announcement openly seeks the municipal authorities' budgetary contribution towards it. The message is clearly directed at the municipal board of education, which awarded the statue its cultural property status. It is striking that the appeal hints at the city's responsibility to provide financial assistance as part of the process of designation as a City Important Cultural Property. Legally, such responsibility—beyond provision of subsidies and loans—does not exist. Financial constraints present a real issue for the temple, for the community, and, equally, for the municipal government. As things stand, none of the parties are able to cover the expense of restoration. For that reason, information about the statue does not feature on the city's tourism website. Takeda-san, a governmental official from the local tourism section, admitted that this is mainly because the statue is not deemed to be in a "displayable state" (interview with the author, 29 May 2017).

Although Buddhist statues are usually expected to undergo repairs every fifty years, there is no record in the temple's archive of when the last repairs of the statue took place at Zenkōji. Upon visual evaluation, Yabuuchi Satoshi, a sculptor and restorer of Buddhist art, deemed it likely that most of the damaged parts of the statue were repaired in the Edo period, when a mixture of bad quality grey mud and glue was used to fill in the cracks. With time, however, the unattractive grey filler deteriorated and the surface layer that was covered with gold leaf flaked off (Yabuuchi, personal correspondence, 19 December 2018). The statue represents a great example of Buddhist art from the late Heian period, but in its current state it does not appear to meet the aesthetic standards that would qualify it for commercial public display. Partnering with a museum would offer an alternative provision of professional curatorship, but it would also mean removing the statue's symbolic and religious capital, limiting the community's access to that capital and its mnemonic and religious value.

Heritage is often said to obscure or beautify the less presentable parts of history (Brumann 2009, 2014). However, in this case, the "cultural property" label itself does little to embellish the local history. It articulates the predicament of entities designated as heritage, often wedged in-between various political, economic, and affective structures. As for the local government, the statue's aesthetic potential and utility value as an economic resource remains unappreciated—especially because it is paired with issues of accessibility.[22] There are no public transport routes linking the temple to anywhere in the region. In fact, the nearest bus stop is a thirty- to forty-minute walk from the temple. Access has worsened further in recent years, when floods and landslides forced the municipal traffic department to close some of the roads to the area. While residents are likely to attach the highest value to the heritage that is most familiar to them (Yamakawa and Itō 2017), municipal authorities often prefer to fund "stories" with genuine potential for regional revival and socio-economic profitability (Kakiuchi 2016, 7). Although there are pockets of tourism potential here, there is a reluctance from the local government to support the restoration of the statue and generate publicity about it. As such, municipal decisions related to investment and subsidy allocations in the areas of heritage preservation, tourism, and transport (among others) may render some communities and their histories more likely to be forgotten.

From the point of view of the community custodians, their heritage offers community-building potential, but at the same time also constitutes a burden and a source of further anxiety. On the one hand, there is a sense of failure among some of the Zenkōji supporters, who blame themselves for allowing the statue in their care to deteriorate. They openly and realistically acknowledge a lack of leadership and economic resources, preventing them from restoring the statue and developing a robust strategy to utilise it as a tourist resource. On the other hand, there is a notable effort directed at keeping the temple afloat, to ensure continuity and stability at least for the storage of the statue. However temporary it may be, there is a conscious determination to care for an Amida that may well be beyond the point of saving.

Again, economics play an important part here. Since the 1950s, the ACA has been running a programme to subsidise 60 percent of the cost of repairing heritage objects designated as National Treasures (*kokuhō*) and Important Cultural Properties (*jūyō bunkazai*) at a national level. In the 2018 fiscal budget, the ACA earmarked 108 million yen to support the rolling out of the new subsidy system that would also support the cleaning (but not necessarily the repair) costs of Buddhist statues and other kinds of cultural properties. Despite this investment at a national level, within prefectural and regional municipal budgets there are no equivalent programmes reflecting the trend from protection to mass preservation and utilisation. Ultimately, the hands of the ACA and local authorities are tied. If "ownership" of cultural properties were to be shared with the awarding bodies, this would not necessarily have guaranteed greater financial support by the government. But it would likely lead to budgetary restrictions

and, by extension, to limiting a number of heritage (*isan*) and cultural property (*bunkazai*) designations at all levels. As a result, cases such as the peacock tree and the Amida statue discussed here would likely never have made it to the designation list.

If the community members supporting the temple were to fund the repairs of the statue out of their own pockets, they would be forced to follow the official guidelines regarding restoration and the degree of permissible alteration. The employment of a specialist with the necessary expertise and craftsmanship would also be required, which is bound to inflate the cost of repairs. According to Miyamoto Gakyū, a sculptor and a restorer of Buddhist art based in Kyoto, restoration of the statue at Zenkōji could amount to anything between 300,000 and 1.5 million yen (Miyamoto, personal correspondence, 18 December 2018). A temple that is barely able to sustain itself is in no position to cover such a sum from its maintenance budget without external sources of funding.

Temples are not likely to receive funding for these purposes from their sect's headquarters either. Buddhist priests whom I interviewed often complained about a lack of institutional support to preserve the sect's heritage. Local temples' financial ties often amount to a one-way traffic of taxes in lieu of institutional affiliation, sent on annual basis to administrators at Nishi Honganji in Kyoto.[23] Temple communities in Hiroshima Prefecture have long constituted a Jōdo Shinshū stronghold of faith, practice, and fundraising.[24] As far as I was able to ascertain, there is no notion of sect-level responsibility in the form of a programme to support Jōdo Shinshū cultural heritage. There is also little institutional support for temples that are struggling economically in depopulated regions, unless they are at the brink of bankruptcy—at which point it is often too late. Individual temples can apply to Nishi Honganji for financial assistance in the form of repayable loans, which are intended for major and expensive repairs of temple structures that are deemed essential. These, however, cannot be used for maintenance of cultural properties in temples' possession. This reiterates the arbitrary separation of religious vis-à-vis secular remits of responsibility in temple management.

Questions of responsibility and agency, as well as the lack thereof, are central here again. In contrast to the peacock tree, the economic burden of the statue's upkeep is not currently shared with external actors and rests solely with the local temple community. Beyond quiet activism on the local school website, there are no focused efforts to restore the statue anytime soon (if ever). Even the most committed community requires a leader and a pool of resources to draw upon in order to develop a convincing and viable "heritage story." Top-down calls for creativity are likely to fall on deaf ears in communities struggling for basic survival. My interlocutors' anxieties over the socio-economic burden of a cultural property designation reveal rather unrealistic expectations, which inspired the efforts to get the local heritage officially recognised in the first place. This finding reinforces the argument that with or without governmental support, "heritage" designation alone does not possess the magical power to trigger regional revitalisation.

Living yet "forgotten" local heritage

Through my ethnographic examples, I have drawn attention to two dimensions of heritage in regional Buddhist temples. First, there are concrete objects, landscapes, and structures designated or locally recognised as heritage. Second, there is a living religious tradition that surrounds the temple, and a host of socio-economic dependencies that shape communities of heritage caretakers. UNESCO guidelines often apply the term "living heritage" to examples of intangible heritage such as oral traditions, performing arts, local knowledge, and traditional skills. However, scholars have argued that the definition of this term should be broadened to recognise that tangible heritage, too, derives its value from the intangible dimensions of the living traditions that surround it (Alexopoulos 2013, 3) and their transformative nature (Brumann 2009, 284–286). In other words, heritage is always in the process of "being made" (Brumann and Cox 2007; Weiler and Gutschow 2017; Maags and Svensson 2018), and therefore should be understood as a verb related to human action and agency, rather than an object (Harvey 2001, 327). The notion of agency is essential for understanding the relationship between official recognition of historical objects as regional heritage and the local meanings of heritage as a vessel for preserving the psychological and physical memory of people's socio-religious ties as well as individual and communal histories.

Living religious heritage, in my definition, is a conflation of processes that include material religion—for instance, a late Heian Buddhist statue or a peacock-shaped pine tree—and the socio-economic and religious practices of local communities that are its caretakers. In this chapter, I investigated "heritage" as something that is practised, and is valued locally, not merely because it is old but because it carries within it a notion of traditional value, that is, something passed from one generation to another that fosters a sense of community and belonging. Heritage objects and landscapes—when recognised as such—are "infilled with official memory and asked to perform as an object of heritage" (DeSilvey 2017, 2), akin to a mnemonic device or a repository of some sort, holding material and symbolic memories of the religious past and personal histories of the generations who cared for them. Such objects have the potential to inspire hopeful futures, but also to reveal the futility of practices of caretaking and preservation, which are often constrained by scarce human and economic resources.

This chapter considered "forgotten" heritage within local Buddhist temple communities in the context of issues relating to bottom-up and top-down responsibility of care, ownership, and the emotional and economic burden that comes with heritage preservation at a local level. The case studies I focused on represent a category of "forgotten" local heritage. I place the word "forgotten" in quotation marks to highlight that even while they are recognised officially as local heritage objects, they are hardly known to anyone beyond the communities caring for them. The adjective "forgotten" also refers to the fact that, despite

their formal and informal recognition as heritage, the economic burden of their upkeep is rarely supported externally, while the scope for providing meaningful public support is legally and fiscally restricted at all levels. In effect, the Japanese countryside is peppered with cases of such forgotten Buddhist heritage, and with local communities who bear testimony to the systemic failure of writing "stories" of regional revival.

"Japan Heritage" stories are not intended as mere explanations of cultural properties or local histories. A successful story must represent something that has been passed down through generations, that is rooted in the personal and communal history of the region, and that offers a clear theme for promoting what the ACA calls "historical charms" (Bunkachō 2017). Developing and utilising such a story for regional revitalisation requires a considerable investment of human, economic, and time resources, which my interlocutors felt they did not possess. For many local temple communities, concerns over safeguarding basic markers of vitality in their villages and towns render heritage preservation unfeasible. The unfortunate reality of those forgotten stories is framed and dictated by the constraints of shrinking and ageing communities, the absence of a next generation of custodians, as well as the wider issues of regional socio-economic survival.

Demographic changes continue to reshape the landscape of rural communities, while at the same time, the political climate of devolving responsibility poses challenges to the municipal management of heritage-related policies. As a result, the efficacy and value of utilising heritage designations as a regional development tool must inevitably be called into question.

Notes

1 This policy is based on two recent pieces of legislation. First, the government introduced the law on the maintenance and improvement of historical landscapes in Japanese regions in May 2008 (*Chiiki ni okeru rekishiteki fūchi no iji oyobi kōjō ni kansuru hōritsu*, popularly known as *Rekishi machizukuri hō*). This law was meant as an encouragement for municipalities to identify, enlist, and develop utilisation plans for locally available heritage resources. The second is an ACA initiative related to tourism promotion and rural revitalisation through cultural heritage (*Bunka isan o ikashita kankō shinkō chiiki kasseika jigyō*) that was introduced in 2011.
2 The mechanism behind the concept of a heritage "story" relates to what Hobsbawm and Ranger 1983 termed "invention of tradition." See Gluck (1985), Antoni (1997), Vlastos (1998), and Brumann (2009) for discussions of historical and contemporary inventions of tradition, imagining the nation and producing Japaneseness, and Labadi (2010) on the question of authenticity in heritage studies.
3 See the chapter by Ian Reader in this volume for a discussion of the (thus far) unsuccessful nomination of the *Shikoku henro* (Shikoku pilgrimage) as a World Heritage Site.
4 Compared to the level of spending in the mid-nineties, local investment in heritage conservation has almost halved. The total amount of investment at the local level in 1995 was 87.5 billion yen, which dropped to 40.5 billion in 2016 (Bunkachō 2018a, 44).

5 The Japanese government has long fostered the idea of preservation and utilisation of heritage for political reasons (see Tze M. Loo's chapter in this volume). However, these efforts were mostly focused on famous sites such as Nikkō, Kamakura, and Kyoto. The recent shift has led to a greater emphasis on utilising less-known heritage across the country.

6 On rural depopulation, see Yamamoto (1996), Matanle and Rausch (2011), Dusinberre (2012). On the decline of religious communities, see Reader (2012), Watanabe (2014), Ukai (2015), Sakurai (2017), Baffelli and Reader (2018).

7 In an effort to maximise participants' anonymity, I use pseudonyms for all my interlocutors and names of temples. I acknowledge the public nature of my two case studies, which are examples of recognisable cultural property and, as such, figure on the municipal and prefectural heritage and cultural property registers. However, I have decided to anonymise the names of the objects and the temples that host them in order to protect the anonymity of my collaborators. For this particular publication, anonymising the places means obscuring some contextual details about the heritage objects discussed. Therefore, while allowing a discussion of "place," I refrain from revealing details concerning specifics of geographical locations including names of towns and villages.

8 The Jōdo Shinshū (True Pure Land) school is one of the eight main denominations of traditional Japanese Buddhism in contemporary Japan. The sect developed in the Kamakura period (1185–1333) and follows the teachings of Shinran. For the history of the sect, see Dobbins (2002).

9 The fieldwork that informed this essay was conducted thanks to funding provided by the AHRC's North West Doctoral Consortium Doctoral Training Partnership and ESRC's North West Social Science Doctoral Training Partnership (Overseas Fieldwork Fund).

10 The *danka* parishioner system is an affiliation system of Buddhist temples and households in Japan. *Danka* is etymologically related to the Sanskrit term *dāna* (meaning "giving"), which refers to affiliated households as supporters of a temple. See Marcure (1985) for an overview of the *danka* system.

11 The Allied occupation authority ruled that any limitation to property rights over cultural properties would be undemocratic and unconstitutional. See Trifu (2017), and the Introduction to this volume.

12 Such social welfare provisions include not only support for the elderly such as medical and care assistance, but also mental health provisions and suicide-prevention initiatives. See particularly Chapters 2–4 in Yamamoto (1996, 29–92).

13 The "Religious Juridical Persons Law" (1951) aimed at conferring juridical personality to religious organizations, thus allowing them to secure a material basis to conduct their free and autonomous activities, based on the principles of the guarantee of freedom of religion and the separation of religion and state as provided in the postwar constitution. The law does not aim at overseeing religious organizations or regulating their religious activities.

14 With the introduction of the Religious Juridical Person Law, religious and secular duties involved in the running of religious institutions were formally separated. The financial management of a temple rests with the head priest, supported and validated by a board of directors, often including the head priest's wife (see Covell 2012). For examples of similar individual and community-based preservation systems for local heritage in non-religious settings, see Brumann (2009), Jimura (2011), and Yamakawa et al. (2017).

15 At present, techniques of restoration and conservation (as well as techniques for the productions of materials required for it) are not designated as Cultural Properties but classified as Conservation Techniques for Cultural Properties, a form of protection for skilled craftsmen enshrined in legislation in 1975. Current Japanese government efforts to include traditional architectural craftsmanship as UNESCO Intangible Cultural Heritage (*The Japan Times* 2019) may further impact the costs of repairs.

16 All photographs were taken by the author.

17 The Law for the Protection of Cultural Properties (*bunkazai hogohō*) was introduced in 1950. Under this law, the national government and local governments are ordered to take necessary measures for protecting heritage. At the same time, owners and custodians are expected to make efforts to protect heritage, while the general population is expected to cooperate with the government. It should be noted that, unlike the prewar era, when only the national government could designate cultural heritage, local governments also became able to designate their own cultural properties.

18 See Reader (1987) and Robertson (1991, 13–37).

19 This carving technique was introduced in the latter half of the tenth century. It uses small hollowed blocks of wood (often as many as eight or ten) joined together with animal glue to create an overall design. See Matsuhisa et al. (2011).

20 Sōka Gakkai is a new religious movement based on the teachings of the Buddhist monk Nichiren (1222–1282). Members of Sōka Gakkai usually follow the tradition of "Nichirenist exclusivism" (Stone 1994) and do not customarily participate in and support any other religious practices and institutions.

21 In recent years, this regional development strategy has resulted in countless regional farm brands, and numerous successful regional branding campaigns surrounding food produce have been developed nationwide. One such example is the Yūbari King or Yūbari melon, which is a cantaloupe cultivar farmed in the small town of Yūbari near Sapporo in Hokkaido. For further discussion of the complementary relationship between local brand farm products and rural tourism, see Ohe and Kurihara (2013), and on place branding, see Rausch (2008).

22 Ian Reader (2014) makes similar observations in his study of pilgrimage sites. He notes that access and transport are significant factors in drawing people to places of worship.

23 This amount is calculated annually based on the number of affiliated households, and the seniority and the number of priests residing at the temple.

24 Local heritage in this region has roots in the history of people referred to as Aki *monto*, a collective name for the Jōdo Shinshū followers living in Aki province (the western part of modern Hiroshima Prefecture) who migrated to the region in the Kamakura period. See Asaegu (1973) and Mizuhara (1996) for an overview of Aki *monto*'s history.

References

Alexopoulos, Georgios. 2013. "Living Religious Heritage and Challenges to Museum Ethics: Reflections from the Monastic Community of Mount Athos." *Journal of Conservation and Museum Studies* 11 (1): n.p. http://doi.org/10.5334/jcms.1021208.

Antoni, Klaus J., ed. 1997. *Rituale und ihre Urheber: Invented Traditions in der japanischen Religionsgeschichte*. Hamburg: Lit.

Appadurai, Arjun. 1986. *The Social Life of Things: Commodities in Cultural Perspective*. Cambridge: Cambridge University Press.

Asaegu Ryūun. 1973. *Aki monto: nenbutsusha no ningenzō.* Hiroshima: Hiroshima Bunka Shuppan.

Baffelli, Erica, and Ian Reader. 2018. *Dynamism and the Ageing of a Japanese "New" Religion: Transformations and the Founder.* London: Bloomsbury Academic.

Brumann, Christoph. 2009. "Outside the Glass Case: The Social Life of Urban Heritage in Kyoto." *American Ethnologist* 36 (2): 276–299.

Brumann, Christoph. 2014. "Heritage Agnosticism: A Third Path for the Study of Cultural Heritage." *Social Anthropology* 22 (2): 173–188.

Brumann, Christoph, and Rupert A. Cox, eds. 2007. *Making Japanese Heritage.* London: Routledge.

Bunkachō. n.d. *Japan Heritage: Nihon isan.* Accessed 8 October 2018, https://japan-heritage.bunka.go.jp/en/img/about/nihon_isan_pamphlet.pdf.

Bunkachō. 2017. *Cultural Properties for Future Generations Outline of the Cultural Administration of Japan.* Accessed 21 May 2019, www.bunka.go.jp/tokei_hakusho_shuppan/shuppanbutsu/bunkazai_pamphlet/pdf/pamphlet_en_03_ver05.pdf.

Bunkachō. 2018a. *Nihon isan (Japan Heritage) ni tsuite.* Accessed 7 November 2018, www.bunka.go.jp/seisaku/bunkazai/nihon_isan/index.html.

Bunkachō. 2018b. *Shūkyō nenkan Heisei 29 nenban.* Accessed 7 November 2018, www.bunka.go.jp/tokei_hakusho_shuppan/hakusho_nenjihokokusho/shukyo_nenkan/pdf/h29nenkan.pdf.

Covell, Stephen G. 2012. "The Temple/Juridical Person: Law and the Temple in Japan." In *Japanese Religions Vol. II: The Practice of Religion,* edited by Lucia Dolce, 3–21. London: Sage.

DeSilvey, Caitlin. 2017. *Curated Decay: Heritage beyond Saving.* Minneapolis: University of Minnesota Press.

Dobbins, James C. 2002. *Jōdo Shinshū: Shin Buddhism in Medieval Japan.* Honolulu: University of Hawai'i Press.

Dusinberre, Martin. 2012. *Hard Times in the Hometown: A History of Community Survival in Modern Japan.* Honolulu: University of Hawai'i Press.

Gluck, Carol. 1985. *Japan's Modern Myths: Ideology in the Late Meiji Period.* Princeton: Princeton University Press.

Harvey, David C. 2001. "Heritage Pasts and Heritage Presents: Temporality, Meaning and the Scope of Heritage Studies." *International Journal of Heritage Studies* 7 (4): 319–338. https://doi.org/10.1080/13581650120105534.

The Japan Times. 2019. "Japan seeks UNESCO heritage list recognition for traditional architectural craftsmanship." *The Japan Times Online,* 25 February 2019. Accessed 25 February 2019, www.japantimes.co.jp/news/2019/02/25/national/japan-seeks-unesco-heritage-list-recognition-traditional-architectural-craftsmanship/#.XH1JOYj7SUm.

Jimura, Takamitsu. 2011. "The Impact of World Heritage Site Designation on Local Communities: A Case Study of Ogimachi, Shirakawa-Mura, Japan." *Tourism Management* 32 (2): 288–296.

Kakiuchi, Emiko. 2016. "Cultural Heritage Protection System in Japan: Current Issues and Prospects for the Future." *Gdańskie Studia Azji Wschodniej* 10 (1): 7–27.

Knight, Catherine. 2010. "The Discourse of 'Encultured Nature' in Japan: The Concept of Satoyama and Its Role in 21st-Century Nature Conservation." *Asian Studies Review* 34 (4): 421–441.

Labadi, Sophia. 2010. "World Heritage, Authenticity and Post-Authenticity." In *Heritage and Globalisation*, edited by Sophia Labadi and Colin Long, 66–84. London: Routledge.

Love, Bridget. 2013. "Treasure Hunts in Rural Japan: Place Making at the Limits of Sustainability." *American Anthropologist* 115 (1): 112–124.

Lowenthal, David. 1994. "The Value of Age and Decay." In *Durability and Change: The Science, Responsibility, and Cost of Sustaining Cultural Heritage*, edited by Wolfgang E. Krumbein, 39–49. Chichester: Wiley.

Maags, Christina, and Marina Svensson. 2018. *Chinese Heritage in the Making*. Amsterdam: Amsterdam University Press.

Marcure, Kenneth A. 1985. "The Danka System." *Monumenta Nipponica* 40 (1): 39–67.

Matanle, Peter C. D., and Anthony Rausch. 2011. *Japan's Shrinking Regions in the 21st Century*. Amherst, NY: Cambria Press.

Matsuhisa Kayū, Masaki Miyano, and Matsuhisa Sōrin Bussho. 2011. *Amida nyorai o horu: Butsuzō chōkoku*. Kyoto: Tankōsha.

Mizuhara Fumitake. 1996. *Aki monto*. Second edition. Hiroshima: Chūgoku Shinbunsha.

Nōsangyōson Bunka Kyōkai, ed. 2015. *Sōryoku shuzai, jinkō genshō ni tachimukau shichōson*. Tokyo: Nōbunkyō.

Ohe, Yasuo, and Shinichi Kurihara. 2013. "Evaluating the Complementary Relationship between Local Brand Farm Products and Rural Tourism: Evidence from Japan." *Tourism Management* 35 (1): 278–283.

Rausch, Anthony. 2008. "Place Branding in Rural Japan: Cultural Commodities as Local Brands." *Place Branding and Public Diplomacy* 4 (2): 136–146.

Reader, Ian. 1987. "Back to the Future: Images of Nostalgia and Renewal in a Japanese Religious Context." *Japanese Journal of Religious Studies* 14 (4): 287–303.

Reader, Ian. 2012. "Buddhism in Crisis? Institutional Decline in Modern Japan." *Buddhist Studies Review* 28 (2): 233–263.

Reader, Ian. 2014. *Pilgrimage in the Marketplace*. London: Routledge.

Robertson, Jennifer Ellen. 1991. *Native and Newcomer: Making and Remaking a Japanese City*. Berkeley: University of California Press.

Sakurai Yoshihide. 2017. *Jinkō genshō jidai no shūkyō bunkaron: shūkyō wa hito o shiawase ni suru ka*. Sapporo: Hokkaidō Daigaku Shuppankai.

Stone, Jacqueline. 1994. "Rebuking the Enemies of the 'Lotus': Nichirenist Exclusivism in Historical Perspective." *Japanese Journal of Religious Studies* 21 (2): 231–259.

Tanimoto Keishi, and Hosoi Yoshihiko, eds. 2012. *Kaso chiiki no senryaku: arata na chiiki shakaizukuri no shikumi to gijutsu*. Kyoto: Gakugei Shuppansha.

Tominaga, Takaki. 2018. "Japan's Focus on Christian Persecution Helped Green Light UNESCO Site." Kyodo News, 15 July 2018. Accessed 17 July 2018, https://english.kyodonews.net/news/2018/07/19098bf4691b-feature-japans-focus-on-christian-persecution-helped-green-light-unesco-site.html?phrase=nagasaki%20UNESCO&words=UNESCO,UNESCO%27s,Nagasaki.

Trifu, Ioan. 2017. "Reform in Late Occupation Japan: The 1950 Law for the Protection of Cultural Properties." *Zeitschrift für Japanisches Recht* 22 (1): 206–230.

Tsing, Anna Lowenhaupt. 2015. *The Mushroom at the End of the World: On the Possibility of Life in Capitalist Ruins*. Princeton: Princeton University Press.

Ukai Hidenori. 2015. *Ushinawareru "chiiki" to "shūkyō": jiin shōmetsu*. Tokyo: Nikkei BP sha.

Vlastos, Stephen, ed. 1998. *Mirror of Modernity: Invented Traditions of Modern Japan*. Berkeley: University of California Press.

Watanabe Masako. 2014. "Shinshūkyō ni okeru kaso, kōreika no jittai to sono taiō: Konkōkyō to Risshō Kōseikai o jirei to shite." *Shūmu jihō* 117 (1): 1–26.

Weiler, Katharina, and Niels Gutschow, eds. 2017. *Authenticity in Architectural Heritage Conservation: Discourses, Opinions, Experiences in Europe, South and East Asia.* Cham: Springer International.

Yamakawa Yukinori, and Itō Hiromu. 2017. "Jūmin dantai to chiiki seido e no torikumi no kankei: Iwate-ken Tōno-shi Tōno isan nintei seido o jirei to shite." *Journal of the City Planning Institute of Japan* 52 (3): 1206–1211.

Yamakawa Yukinori, Itō Hiromu, and Take Masanori. 2017. "'Chiiki isan seido' no jittai to seika." *Randosukēpu kenkyū* 80 (5): 537–540.

Yamamoto Tsutomu. 1996. *Gendai kaso mondai no kenkyū.* Tokyo: Kōseisha Kōseikaku.

Omissions, stratagems, and dissent

The Shikoku pilgrimage and the problems of applying for World Heritage status

Ian Reader

Introduction

What could be more traditional than the Shikoku pilgrimage (*Shikoku henro*), with its white-clad pilgrims, ancient temples, moss-covered buddhas, tinkling pilgrim bells, and mountain footpaths? The *henro* is, after all, commonly projected in the media as the most "traditional" pilgrimage in Japan. It has been the focus of numerous television documentaries, notably by the national broadcaster NHK, which has a remit to publicise Japanese culture and traditions, in ways that emphasise it as an exemplar of Japanese tradition, cultural heritage and identity (Hoshino and Asakawa 2011; Mori 2005; Reader 2005, 2007). Moreover, images of pilgrims dressed in what is commonly portrayed as traditional pilgrimage clothing form a common theme in guidebooks and promotional literature published by the pilgrimage temples and by transport firms soliciting clients for pilgrimage tours. Pilgrims have often commented that they were attracted to the Shikoku pilgrimage because of its associations with Japanese tradition (Reader 2005). In addition to such associations, the pilgrimage is linked—for example, in its symbolic dimensions as a journey to enlightenment and as journey in the realms of death—with universal Buddhist themes and the Buddhist tradition that has been such a seminal force in Japanese history. It has an extensive history; pilgrimage foundation stories claim it was founded in 815, and the temples celebrated its 1200th anniversary in 2015. While this date is legendary rather than historical, the pilgrimage certainly has deep historical roots associated with Japanese religious structure and national and island history (Kondō 1982; Reader 2005, 107–186; Shinjō 1982, 479–492 and 1020–1103).

It is no wonder, then, that in a country where the wish to attain UNESCO heritage status for Japanese places and traditions is widespread and encouraged by the government, the Shikoku pilgrimage is being promoted as a candidate for UNESCO World Heritage inscription (see Figures 9.1 and 9.2). The Shikoku pilgrimage is also seen as a viable candidate since other famed pilgrimage routes, notably the Santiago de Compostela pilgrimage in Spain and the Kumano Kodō pilgrim trail through the Kii Peninsula in Japan, have previously received UNESCO World Heritage accreditation.

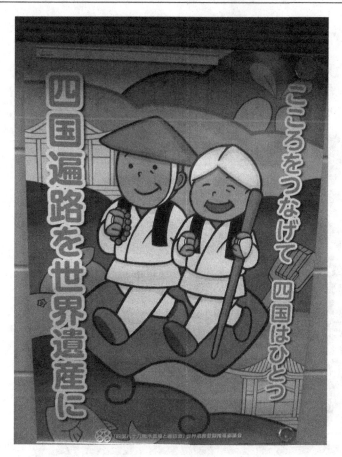

Figure 9.1 Promotional poster for the first Shikoku pilgrimage World Heritage campaign. Photo by the author.

There is political will at local, regional and national levels behind its promotion, plus support from the tourist and commercial sectors and civil society interest groups and local universities in Shikoku. However, there are also problems and ironies regarding the Shikoku case, ranging from Japanese constitutional questions that have impacted on how regional authorities have portrayed the pilgrimage, to the concerns of the institutions and interest groups (the temples and pilgrims) most closely associated with the pilgrimage as a living religious practice, who worry about the potential impact of heritagisation and its potential results. Such problems raise wider questions about the politics of heritage when related to living religious institutions and sites. It is on such matters that this chapter primarily focuses.[1]

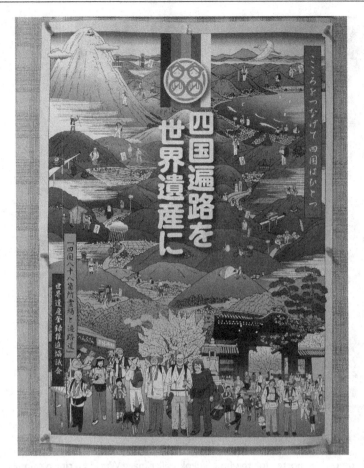

Figure 9.2 Promotional poster for the second Shikoku pilgrimage World Heritage
 campaign. Photo by the author.

Applying for World Heritage status: origins, motivations, and ambivalence

It is not entirely clear when the idea of seeking UNESCO accreditation first
emerged. The idea is attributed, according to some interviewees, to Oyamada
Kenshō, the head priest of one of the pilgrimage temples (Sennyūji, Temple
58[2]). Oyamada told me, in 2008, that he mooted the idea in the mid-1990s
because he wanted to boost the local economy by bringing in more visitors,
to preserve local culture, and to promote his view that doing the pilgrimage
could ameliorate social ills and bring peace of mind. Shinbayashi (2016) also
portrays Oyamada as a primary instigator, although both Shinbayashi's and
my studies indicate that Shikoku's political and commercial spheres were also
interested in the idea from early on. There was less immediate enthusiasm

in religious circles, however. Oyamada told me that his call resonated more among the island's political and commercial agencies—concerned as they were with Shikoku's ailing economy and depopulation—than with other temple priests. This imbalance continues to provide an underlying current of dissent and tension.

It is important to note that applying for inscription on the UNESCO World Heritage List is political and bureaucratic in nature. The application must be made by the national government of the country where a candidate site is located. In Japan applications have to be put forward by local civil authorities to the Agency for Cultural Affairs (Bunkachō, hereafter ACA), the government branch that is the conduit (and initial vetting agency) of applications to UNESCO. This meant that the Shikoku application had to go through the island's political authorities rather than the temples. Thus far two applications have been submitted to the ACA, the first in 2007 and the second, after the ACA requested amendments to the initial one, in 2016. Both have been under the names of the four prefectural and fifty-eight municipal administrative authorities through which the pilgrimage passes, with the Association of Shikoku Pilgrimage Temples (Shikoku Reijōkai), the coordinating body for the eighty-eight pilgrimage temples, one of a number of supporting interest groups. The political nature of the process has caused unease for civic authorities and temples alike. While civil and religious bodies alike were aware that inscription on the World Heritage List was liable to boost visitors to the island and its temples—something that they knew, had been a factor in the massive growth of people doing the Santiago pilgrimage (Roseman 2004)—their concerns about the application were very different.

Temple priests worried that UNESCO accreditation would mean a loss of autonomy, and lead to interference in how they managed their temple precincts. Such fears, while perhaps overestimating the extent to which UNESCO can or does exert control over its accredited sites, remain strong and will be discussed further below. Some priests were concerned that accreditation would cause an influx of tourists unable to speak Japanese (and with whom their temples might not be able to cope), transform the pilgrimage into a tourist exercise, weaken the influence of the temples, and undermine the religious nature of the pilgrimage.

Temple priests also recognised that, although pilgrim numbers grew in the late twentieth century due to promotional campaigns portraying the pilgrimage as Japan's most "traditional" and "national" pilgrimage (Mori 2005; Reader 2005, 2007, 2014), difficult times might lie ahead. Depopulation was a threat, eroding infrastructure such as lodgings in rural areas, and reducing pilgrim numbers, since Shikoku residents have been one of the largest segments of the pilgrimage clientele (Kaneko 1991; Osada, Sakata, and Seki 2003). They knew that pilgrim numbers on other Buddhist oriented pilgrimages in Japan (notably the Saikoku Kannon pilgrimage and regional pilgrimages) were falling (Reader 2014, 5–8, 35–38; Satō 2004) and worried that their temples—heavily reliant

on pilgrims for their economic well-being—would face similar problems. This is now the case; in my visits to Shikoku in 2018 every official and priest I spoke to stated that pilgrim numbers have been declining for several years, apart from a small spike in 2016.

This concern about falling pilgrim numbers, plus an awareness that economic decline and depopulation were causing serious problems to the local communities the temples served, initially led the Association of Shikoku Pilgrimage Temples to support the heritage campaign (Reader 2014). This support was not entirely whole-hearted, according to sources I interviewed in 2008 and 2010, and was motivated more by worries about the long-term future of the pilgrimage than enthusiasm for inscription. Behind the scenes not every temple was positive about the application for the reasons cited above, and because many felt that it was primarily a political enterprise unconcerned with the pilgrimage as a faith-related religious practice—issues that were, unsurprisingly, important for the pilgrim community. In interviews in Shikoku in autumn 2018 several priests expressed the view that the whole process was driven by political and commercial interests, with the temples just dragged along in their wake. Several also commented that while the Association of Shikoku Pilgrimage Temples officially supports the campaign, privately many temples have opposed or been ambivalent to it. This ambivalence was epitomised by a priest who said to me in November 2018 that while accreditation would probably be good for the economy and counter depopulation, he feared that it would undermine the religious dimensions of the pilgrimage and thus hoped it would not happen.

Ambivalence of a different sort came from Shikoku's political authorities. They were driven primarily by the need to stem depopulation and economic decline, as were the island's commercial interest groups. Pressure on this front also came from the national government, which was pushing for island authorities to come up with regeneration plans for the whole island. These interest groups saw tourism as central to economic regeneration. As Shikoku regional government officials informed me, the pilgrimage occupied a central place in discussions about tourism, because it was something shared across the island and widely recognised as the island's main historical phenomenon.

In 2000 Endō Toshio, the governor of Tokushima Prefecture (one of the island's four prefectures, where twenty-three of the temples are located), made tourism central to his regional regeneration scheme and identified the Shikoku pilgrimage as a key asset in this strategy. This focus (reinforced by a national plan to increase tourism to Japan[3]) was picked up by the other prefectures, and by various commercial interest groups, from Japan Rail Shikoku to regional transport and tourist companies and other business concerns worried about the shrinking Shikoku economy. Thus it was perhaps inevitable that the idea of putting the pilgrimage forward for UNESCO's World Heritage List would take root among the island's political authorities.

However, Shikoku's political authorities worried about such an application, because of the contentious issue of the separation between state and religion,

and because of Japan's constitutional prohibition of the use of state funds to support religious institutions. According to Article 89 of the Constitution, "no public money or other property shall be expended or appropriated for the use, benefit or maintenance of any religious institution or association." Although the Association of Shikoku Pilgrimage Temples is an *ippan shakai dantai hōjin* (General Incorporated Association) in legal terms, rather than a religious association, its affiliated temples are legally registered religious associations, and hence any public money spent on an application for UNESCO inscription— something that could benefit the temples as a collective association—could easily be portrayed as a violation of this constitutional provision. This weighed on the minds of government officials throughout the initial application process; when Oyamada initially talked to government officials in Ehime, another of Shikoku's four prefectures, they felt it would be difficult to support an application because the pilgrimage had developed as a religious entity (Shinbayashi 2016, 22). In 2008 Ehime government officials and other campaigners told me that due to Article 89 of the Constitution, they felt they had to avoid any hint that what they were promoting had anything to do with "religion" (*shūkyō*).

Various linguistic stratagems were used to such ends, as they have been elsewhere in Japan. As Irit Averbuch (2011) has discussed, when it was Toyama Prefecture's turn to celebrate the annual National Cultural Festival (*kokumin bunkasai*) in 1996, the regional government, keen to revitalise the area and develop tourism, focused on Tateyama, a prominent pre-modern religious site. They also decided to re-enact an ancient Buddhist ritual, which was presented as a unique local tradition. At the same time the prefectural government, worried that this might be seen as using public money for religious purposes, presented the ritual not as "religious" but as an historical re-enactment and secular event (2011, 27). Although the ritual re-enactment was intended as a once-off event, public demand (including from volunteers who took part in the re-enactment and reported they had spiritual feelings as a result) led to further ritual performances in 2005, 2006, and 2009.

For the authorities, the purpose of these later performances was, as before, local regeneration. While these ritual performances continued to be portrayed as "events" (*ibento*), the rhetoric associated with them and with promoting tourism to Tateyama hinted at the spiritual experiences and sense of spiritual healing that participants felt in the earlier event. As Averbuch notes, the presentation of the 1996 event as wholly "nonreligious" had upset many participants, and civil authorities were keen to prevent such problems again (2011, 30–31). Therefore, when they described the event in 2005 and afterwards, they used different terms, portraying Tateyama as a place characterised by a "healing culture" (*iyashi no bunka*). Such terms sought to portray the ritual event as something not associated with a specific religion or religious institution, but with tradition and culture in general; healing was something available to all. The authorities also engaged Buddhist priests from different sects (Shingon and Tendai) for the ritual. By using these two stratagems—associating the ritual

with healing and culture, and going across sectarian religious lines by including different denominations—authorities sought to circumvent accusations that they were using funds to promote a specific religion or religious institution. They were thus utilising a common Japanese understanding of the term "religion" as something related to a specific unitary religious tradition and associated doctrinal beliefs. By presenting the ritual as traditional culture performed by priests from different sects, they portrayed it as transcending religious boundaries and therefore "nonreligious" (2011, 46).

A similar dynamic developed in Shikoku regarding the pilgrimage. In 1997, when it was the turn of Shikoku's Kagawa Prefecture to host the National Culture Festival, the prefecture highlighted the pilgrimage as one of its contributions to national culture and tradition. In so doing the local government made use of the same term—*iyashi*, "healing"—later used by Toyama Prefecture officials; the pilgrimage was a "route of healing" (*iyashi no michi*). Endō Toshio's prefectural government plan for developing tourism in Tokushima used similar terminology; its expenditure of public money to make the pilgrimage more attractive for visitors by providing toilets, coin laundries, and other facilities along the route was phrased as *iyashi no michizukuri* (creating a route of healing) (Shinbayashi 2016, 24). During the early years of the twenty-first century the term *iyashi* became a recurrent promotional buzzword for the pilgrimage (Hoshino and Asakawa 2011, 165; Mori 2005, 265–270) that was used to shift its image away from specific religious connotations and enhance its cultural and traditional credentials (Shinbayashi 2016, 25).

In other words, Shikoku government agencies were, like the authorities in Toyama Prefecture, using linguistic stratagems to justify spending state resources to improve pilgrimage infrastructure and promote the pilgrimage. They appear also to have been influenced by the view that by the twenty-first century, the main motives for doing the pilgrimage related less to religious faith than to seemingly secular or "nonreligious" elements, such as tourism, health, exercise, and self-reflection (Mori 2005; Shinbayashi 2016, 25).

The 2007 application: nothing religious in this pilgrimage

By the early 2000s numerous interest groups—including Chambers of Commerce and Rotary Clubs—had become involved in the campaign for World Heritage status (see Figure 9.3), along with the pilgrimage temples, worried about a future fall in pilgrim numbers coupled with a desire to help the local economy, and political authorities motivated by economic needs and regional tourist policies but constrained by the feeling that they had to present the pilgrimage through a "nonreligious" cultural lens. As a result, an initial application was submitted to the ACA in 2006, with a revised version (after the ACA provided initial observations) in December 2007.

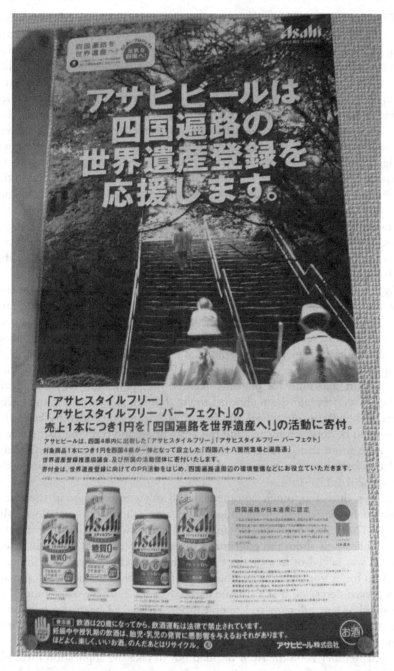

Figure 9.3 A beer multi-national declares its support for the Shikoku pilgrimage World Heritage application. Photo by the author.

The December 2007 application is striking in its avoidance of references to aspects of the pilgrimage that were important in its development and practice, such as faith in Kōbō Daishi, the Buddhist figure central to the pilgrimage, and the miracle stories central to the pilgrimage's development. The application even avoided the term *iyashi*, because at this stage regional government officials worried that even the slightest hint of terms that could have "religious" connotations might provoke legal objections. In order to avoid these problems entirely, as Ehime government officials explained to me, a strategic decision was made to focus entirely on the idea of culture and on the phrase "pilgrimage culture" (*henro bunka*) as the framing device. By portraying the pilgrimage through the lens of "culture" rather than faith (*shinkō*) or religion they hoped to avoid legal challenges about using state resources to promote religion. The term *henro bunka* became central to the campaign, even though to some—particularly devout pilgrims and temple priests—this appeared to downplay what they saw as central to the pilgrimage. It also sidestepped the reality that the eighty-eight temples are legally constituted religious institutions. Evading such issues, ironically, reduced the effectiveness of the application.

While the authors of the forty-four-page application could hardly deny that the origins of the pilgrimage were associated with faith in Kōbō Daishi and hence with "religion," they only mentioned them briefly early on, and did not develop such points any further. They avoided topics such as miracle stories, while scant mention was made of the religious art and statuary of the temples or of practices such as almsgiving (*settai*) that have been significant in the support structures for pilgrims. Rather, the application emphasised such things as scenery and the traditional towns, houses and streets through which parts of the pilgrimage passed, and factors such as regional identity. In essence, one could be forgiven for reading the application and thinking that the *henro* was little more than a long-distance route circling the island of Shikoku in order to savour various elements of island life and scenery (Application One;[4] Reader 2014, 179–180).

At this time, too, much commercial and other interest group rhetoric in Shikoku further distanced the pilgrimage from religious connotations. Mori Masato (2005, 252) has noted that from the 1980s onward media representations and publications about the pilgrimage barely touched on its "religious" elements. It was talked of as a product and a "brand," whose focus had shifted in modern times from faith to health, sports, and exercise; one heritage campaign group even described it as a "theme park" (Reader 2011, 96–97). None of this reassured ardent pilgrims and temple priests who had been drawn into the campaign reluctantly, and who feared that central elements in the pilgrimage were being jettisoned in the drive for UNESCO status.

In September 2008 the ACA decided not to take the application forward—partly because it felt other applications had a better chance of success[5]—but neither did it reject it. It graded it Category 1a, indicating that it had potential but that additional groundwork was needed. The two areas the ACA raised

publicly were that civic authorities needed to demonstrate that steps were being taken to protect the sacred sites (*fudasho*—literally, pilgrimage temples) and pilgrimage route as cultural properties (*bunkazai*), and that they should provide scholarly materials about the *henro* that demonstrated "evidence of outstanding universal value" appropriate for World Heritage status.[6] The ACA was in effect (especially in the first of these points) drawing attention to the fact that submissions for UNESCO status were expected to have already been recognised in Japan as national or regional cultural properties under the Law for the Protection of Cultural Properties. At this point only sixteen of the eighty-eight temples and only three sections of the pilgrimage route had any regional government recognition as important cultural properties. As observers have noted, relatively few of the temples are strikingly grand edifices of the kind that would normally be designated as cultural treasures; the significance of the route is in its cumulative nature, not in the individual temples (Reader 2005).

The 2016 application: in comes religion, in a "nonreligious" way

The recommendations from the ACA implicitly indicated that more had to be said about what might be termed the religious dimensions of the pilgrimage; demonstrating "universal value" could most readily be done by showing that the *henro* was a striking manifestation of a phenomenon, pilgrimage, that has universal dimensions and religious connotations. Such factors were clearly in evidence in UNESCO's listing of pilgrimage places such as Santiago and Bethlehem as World Heritage Sites. There may have been other off-record advice as well; sources in Shikoku informed me that there was additional informal ACA feedback that influenced how the regional authorities proceeded next.

As a result a new group was set up in 2010 to take the issue forward, the Shikoku Henro World Heritage Inscription Council (Shikoku Hachijūhakkasho Reijō to Henromichi Sekai Isan Tōroku Suishin Kyōgikai). Perhaps typical of the bureaucratic process involved, the Council then established four sub-committees, one of which, the Committee for Cultural Asset Protection (Shisan no Hogo Sōchi Bukai), was tasked with getting the temples as well as historic sites, places of scenic beauty, and cultural landscapes along the route designated as Japanese cultural properties. Another sub-committee, which included representatives from Shikoku universities and the Tokushima prefectural government, was to conduct comparative research on cultural assets elsewhere (domestic and international) and advance scholarly research demonstrating the value of the Shikoku pilgrimage.

While these committees included representatives of the pilgrim community and the temples, they remained in the minority compared to secular agencies. Besides the sixty-two municipal and regional administrations, there were eight other state institutions (including regional environmental offices

and the Shikoku Bureau of Economy, Trade, and Industry), three university organisations (representing the island's public and private universities), eleven economic organisations (such as Chambers of Commerce), eleven non-profit organisations, each with their own agendas, and just one entity, the Association of Shikoku Pilgrimage Temples, directly associated with the sacred sites themselves.[7] This again meant that the temples were somewhat marginalised; it did little to allay the worries of priests about the political nature of the application. At the same time, the ACA's advice meant that the new application needed more focus on the pilgrimage's history, values, and meanings. Here the project was aided by research programmes, supported by grants from the Ministry of Education and Science and other agencies, at universities in Shikoku, including Ehime University, that focused on the Shikoku pilgrimage within the wider world of pilgrimage globally and that examined its religious significance.

The new application (Application Two[8]) was signed off by the Shikoku Henro World Heritage Inscription Council and submitted to the ACA in August 2016. While the earlier application avoided anything related to religion, faith, belief systems, and religious practitioners, the 2016 one brought these topics very much to the fore. Here one can see a similar pattern to that described by Averbuch relating to the Tateyama ritual: while that was initially (in 1996) portrayed solely as a secular "nonreligious" event, by 2005 it was openly associated with notions of spiritual healing while being distanced from the notion of "religion" because of the involvement of priests of different sects in ways that transcended religious boundaries. In the Shikoku case the shift was even greater, with little attempt to skirt around the *henro's* religious dimensions; it was projected as a special representation of Japanese pilgrimage culture and as unique within the context of pilgrimage in general. The application stressed three themes that indicated that the pilgrimage demonstrated a unique heritage and universal value. These themes were *place*, with Shikoku and its pilgrimage depicted as a place of religious training (*shugyō*); *faith* in the figure of Kōbō Daishi, who is central to the pilgrimage's history and structure and who according to pilgrimage lore accompanies and protects every pilgrim on their journey; and *region*, in which Shikoku is portrayed as a "sacred island" (*sei naru shima*) whose culture sustains pilgrims on their journeys. In other words, the vocabulary used for describing pilgrimage and island drew extensively on religious terminologies.

While the second application also emphasises scenery and cultural traditions, these are nowhere near as central as they were in the first application, but instead appear supplementary to portrayals of the pilgrimage as strikingly unique in the world of faith. The narrative on the pilgrimage's historical development, for example, emphasises Japanese religious traditions of asceticism and figures such as mendicant priests and *hijiri* (ascetic wanderers). The pilgrimage is portrayed as uniquely drawing together various strands of Japanese religiosity, from mountain worship to Pure Land faith, within the framework of one practice. While there are other areas and figures of worship (e.g., the bodhisattva

Kannon) associated with pilgrimage in Japan, these are portrayed as having a sectarian orientation,[9] while Kōbō Daishi faith is pan-religious and unites all sects. Similarly, the *henro* is presented as pan-sectarian, combining mountain worship, folk faith, and Buddhist mandala imagery, originating in ascetic practices from the late twelfth century but developing into a popular practice in the seventeenth century. As such the pilgrimage is presented as "nonreligious" in the same way that the 2005 Tateyama ritual (performed by priests of different sects together) was: not associated with "religion" in the common Japanese sense of the term, because it is not centred on one specific sect or institution. The application reiterates generally accepted academic histories of the pilgrimage, stressing how the structure of the *henro* manifests and articulates Buddhist philosophy via the idea of a fourfold path to enlightenment, although it does not say that this may be a later sectarian invention.[10] The entire pilgrimage route is portrayed as a place for religious practice and is, unlike other pilgrimages, a unique totality. It is also portrayed as a vehicle for salvation (*kyūsai*) and healing (Application Two 2016, 8, 37, 43), with the latter emphasised as a recurrent, perhaps universal, aspect of pilgrim motivations around the world (p. 46).

The sections about universal value refer to other pilgrimages across religious traditions, while portraying Shikoku as having special qualities that make it stand out from sites such as Santiago de Compostela and Bethlehem already inscribed on UNESCO's World Heritage List (Application Two, 41). This is exemplified, according to the application, by the custom of *settai*, giving alms and sustenance to aid pilgrims, a practice that is portrayed as unique to Shikoku.[11]

The application pays far more attention to earlier history than to the modern era; the seven decades of the postwar period are covered in just four lines, which speak of a period of motorisation from the 1950s onwards, followed by an increase in walking pilgrims from the 1980s[12] and a growing number of foreign pilgrims. In other words, it emphasises foot and foreign pilgrims while only making passing reference to the point that the vast majority of pilgrims nowadays travel by car or bus. It also avoids discussing topics such as tourism or the point made earlier, that many who visit the temples nowadays have motivations unrelated to faith and religion. Such themes were central to the reasoning of Shikoku political authorities when they decided to support the initial inscription campaign and devote state resources to it, and had helped project (in the eyes of state authorities) the image of the pilgrimage as detached from religion and faith. They now appeared to be marginal to the nature of the pilgrimage as depicted in the second application.

The 2016 application attempts to address the ACA's concern that many elements in the *henro* have not been designated as public cultural properties (p. 10), but in so doing it indicates (inadvertently) some of the underlying problems surrounding such issues. It emphasises the length and complexity of the route (as a fourteen-hundred-kilometre-long route linking eighty-eight temples and passing through towns, mountains, and rural areas) and states that regional authorities have now designated sections of this route as cultural properties in

areas where it passes through forests, fields, and mountains (pp. 14–15). Fifteen sections of the pilgrimage route have been designated as cultural properties by the island's regional governments, all since 2010 (i.e., after the first application).

After outlining the various sights and buildings encountered along the route, the application argues that the *henro* fits the World Heritage notion of universal value because of its extensive twelve-hundred-year history and because it is a multi-religious phenomenon transcending sectarian boundaries (e.g., pp. 4, 8, 37). It refers to other pilgrimage sites inscribed by UNESCO while arguing that Shikoku has special characteristics (travel with Kōbō Daishi, almsgiving, asceticism and nature, Buddhist thought and symbolic meanings, mountain religion, and popular faith) that mark it out as a "sacred island" (pp. 1–3, 37) different from these other places. The application even uses the term religion/religious that authorities were so keen to avoid in the first application, when stressing the importance of preserving the temples as "religious spaces" (*shūkyō kūkan*, p. 39). The second application thus presents a different perspective from the first, shifting the focus away from scenery and evasions of "religion" and towards bringing themes associated with religion—from the idea of the temples as religious spaces, to talk of faith, asceticism, practice, healing, and salvation—to the fore.

There are clear reasons why this shift has occurred. In the first application, the authorities were worried about violating constitutional boundaries. In the second, however, they were responding to the ACA's advice to show that the pilgrimage has universal value and that its various components are viewed as important cultural entities in Japan. To do this, Shikoku authorities could hardly avoid acknowledging that the pilgrimage and its components developed historically because of religious practice; to show its universal value, they had to talk about it as a religious enterprise whose values resonated globally. Practices such as almsgiving can hardly be discussed without reference to the wider Buddhist notion of almsgiving (something that can be portrayed as "universal"), or to the belief that Kōbō Daishi accompanies every pilgrim and that by giving alms to a pilgrim one is doing so to Kōbō Daishi and thereby earning his grace.

As with the authorities in Toyama, the problem of "religion" was also dealt with by presenting the pilgrimage as transcending sectarian boundaries and incorporating all strands of religious faith. Hence it is a unitary cultural practice that goes beyond the idea of "religion" as it is often conceived in Japan, as something associated with one single sect or belief system. Because it incorporates all Japanese strands of religion, it specifies none, and hence reinterprets religion as an expression of Japanese culture. Faith, almsgiving, and religious practice are thus cultural expressions that can be included under the label of Japanese and universal heritage. Religion is thus "nonreligious" and cultural. In such ways Shikoku political authorities can promote the pilgrimage because of its religious aspects while attempting to avoid charges of infringing the constitution by presenting those same aspects as cultural.

Government support and cultural designations

National and regional governments have shown their support for the application. In 2015 the Japanese national government gave the designation of "Japan Heritage" (*Nihon isan*) to the pilgrimage, making it one of a first tranche of eighteen sites granted this acclamation. In 2016 plaques were erected at the eighty-eight temples identifying them as Japanese cultural heritage sites. This—like the aforementioned designation of sections of the pilgrimage route as cultural properties—helped deal with the need to provide evidence that national and regional government agencies consider the places they put forward as worthy of national recognition. It also, of course, raises a question about why it has only been recently—since the initial application—that Japanese political agencies have seen fit to designate the temples and parts of the route as cultural properties.

At present the application remains under consideration at the ACA, although (see below) there has also been some input from UNESCO—something that indicates its interest in the issue but has increased worries in Shikoku. Moreover, as the application process has proceeded further concerns have surfaced that raise deeper questions relating to the pilgrimage and the wider issue of declaring religious sites to be exemplars of a supposedly universal heritage. These issues especially came to the fore in interviews I conducted in my most recent visits to Shikoku. It is to their implications that I turn next.

Problems, omissions, and ironies in the heritage process

While the 2016 application addresses issues central to the pilgrimage that were evaded in the earlier application, it is also notable for its omissions and for some innate tensions between the images of heritage and tradition and historical reality. By discussing these I draw attention to problems underlying the notion of heritage—issues that will be considered further at the end of this chapter.

By portraying the pilgrimage as an enduring historical tradition weaving together multiple aspects of Japanese religiosity, the application clearly presents it as a central strand in Japan's cultural heritage. This fits with the common image of the pilgrimage as the epitome of Japanese tradition and heritage, depicted in the literature produced by the temples and tourist agencies. Yet this evades the point that many of the images associated with "tradition" are products of a modern era that, as I noted above, is barely touched on and partially misrepresented in the application.

Thus the image of pilgrims dressed in white pilgrimage clothing has repeatedly served to emphasise that tradition has endured in Shikoku while disappearing in other pilgrimages in Japan, and this perspective is evident in the application. Yet this image is the product of modernity and modern forms of pilgrimage. Photographs from the earlier twentieth century show that pilgrims

rarely wore white attire, instead dressing more commonly in black or even in colourful and fashionable clothing (Mori 2005, 25–26). The "traditional" white, as Mori Masato (2005) has shown, became prevalent from the 1950s with the advent of bus tours; the first bus companies to run such tours wanted to be able to create a feeling of communal belonging among their pilgrims, so they asked them to wear white to this end.[13] It was the development of organised bus tours that enabled an almost defunct pilgrimage in the early 1950s to develop into one that, by the 1970s, was Japan's most visually well-known pilgrimage (Reader 2005, 150–157). As this happened, the white pilgrims' shirts became a symbol of apparent traditionalism, invoking a sense of nostalgic reverence for its seemingly enduring qualities in the face of modernity (Hoshino 1981; Reader 1987).

The prevalence of motorised transport on the *henro* reflects a recurrent reality of pilgrimage: as new forms of transport are developed they are invariably incorporated into pilgrimage infrastructure and used by pilgrims. It is also a reason why the aforementioned designation of fifteen sections of the pilgrimage path as cultural properties is problematic. The fifteen together constitute around eighteen kilometres of the fourteen-hundred-kilometre pilgrimage route. In other words, the parts of the route recognised by the island's authorities as cultural properties cover little more than one percent of the route. While they are the places where the standard photographs in guidebooks, photo essays, and publicity posters are taken (Reader 1987, 2007), they are not even a significant minority element in the pilgrimage. Indeed, those who walk the pilgrimage repeatedly complain that ninety percent of the route is along roads, and that most of their time involves traipsing along asphalt with cars and trucks passing them by (Harada 1999, 49; Hirota 1999, 226; Takada 1985, 14). A particular contention is the eighty-kilometre coastal stretch between Temples 23 and 24, where the old pilgrimage path has been paved over with a highway that leaves little space for walkers (Hirota 1999, 225–226; Imai 1981, 37). It is ironic that elements so visually significant in the construction of images of heritage and tradition are products of the modern age, or, at best, unrepresentative traces of a vanished past.

Once banned, now heritage

Another irony that the application avoids is that pilgrims historically faced hostility from pubic authorities. While the application focuses on notions of unity, the reality is that the pilgrimage has historically been divisive and repressed. Unlike the Saikoku Kannon pilgrimage—promoted by Tokugawa political authorities as a form of national identity pilgrimage (Foard 1982)—the Shikoku pilgrimage was, until very modern times, regarded as a pilgrimage for the poor and dispossessed. Its pilgrims were widely seen as marginal figures that had—according to Shikoku oral traditions—fled their homes due to illness or transgressions (Reader 2005: 132–135). Tokugawa-era Shikoku

feudal authorities viewed pilgrims as a destabilising drain on local finances, especially as many pilgrims relied on begging. Many died on the route too, as the pilgrimage had a kill-or-cure reputation; the belief that one could acquire miraculous cures from doing the pilgrimage (or go straight to the Pure Land if they died) meant that many pilgrims alighted on the island in dire straits and died very shortly afterwards. In such cases island authorities had to bear the costs of body repatriation, cremation, or burial (Reader 2005, 132–133). The Tosa (present-day Kōchi Prefecture) regime was especially hostile to pilgrims and monitored them harshly. Pilgrims were only allowed to stay a set number of days in the province, with severe penalties for breaching these rules. Given that Tosa comprised almost half the total route in distance, pilgrims could easily fall behind the prescribed schedule if they had any even minor setbacks or illnesses. The Tosa domain also tried to suppress the practice of *settai*, to further dissuade people from doing the pilgrimage, although this led some local people to give alms as an act of defiance against their rulers (Hoshino 2001, 105–107).

The 1868 Meiji Restoration produced further repression. Pilgrims were seen as unruly, economically unproductive and following a path of superstition anti-thetical to the modern nation the Meiji rulers wished to construct. Several pilgrimage temples were wrecked during the *haibutsu kishaku* (anti-Buddhist) campaign of the early Meiji years, and during the 1870s newspaper campaigns urged that pilgrims be banned from Shikoku while pilgrims reported frequent police harassment (Reader 2005, 140–141), with *henro-gari* (pilgrim round-ups) a common feature of pilgrim experiences in Shikoku well into the twentieth century (Takamure 1987, 217–220).

These aspects of *henro*'s history may have helped shape its development but are not included in the application. The custom of almsgiving, for example, heralded in the application as a unique element giving the *henro* universal value, was seen as subversive by the authorities in earlier times and was strengthened because locals used it as a means of defying their overlords. The extent to which the pilgrimage was a refuge for the marginalised and ill, and the ways in which it was seen as antithetical to the nature of Japan (in the eyes of political author-ities and especially to Meiji modernisers), have also been disregarded. The application says nothing about the irony that what it presents as an exemplar of Japanese heritage and universal value was historically regarded in a different light by Japanese authorities.

Other concerns and problems

There are further issues that render the Shikoku application problematic—and that is before one even considers the wider issues of what heritage means and how it can be imposed. One is that while the Association of Shikoku Pilgrimage Temples acts as a coordinating body for the eighty-eight temples, for example by standardising fees for pilgrimage services and opening hours for temples, its authority to speak for all the temples is weak. Not all temples belong to

the same Buddhist sect. Eighty are from Shingon sects; the other eight include temples affiliated to Tendai, Rinzai, Sōtō Zen, and Jishū. While this means that the Association is interdenominational it also produces tensions between priests who want to portray the pilgrimage as a manifestation of Shingon practice (something intensified by the links between Shikoku and the Shingon sect head-quarters at Mt. Kōya) and others who worry that such projections could lead to the imposition of a Shingon agenda on their temples. Moreover, the Association operates with a rotating headship and governing body, and this almost inevit-ably produces complaints about leadership and direction—something I have heard often during my years of studying the Shikoku pilgrimage. Of course these complaints vary as different temple priests accede to the headship. One priest, a rare positive voice towards heritage accreditation during my last visit, bemoaned what he saw as the current coolness on this issue in the Association, while looking forward to a change when a new head, who he felt would be more proactively supportive of accreditation, took over.

Recent events show that the Association has neither legal authority nor col-lective control over the temples. One temple (Temple 62, Hōryūji) had in recent years changed its opening hours and fees, and had banned some bus com-panies that run pilgrimage tours. Its head priest also rejected the policies of the Association and seceded from it. The Association sought legal redress through the courts, but lost due to rulings that a head priest is the person with authority over a temple and can enact policies there. In other words, the Association was effectively a voluntary organisation, rather than one with authority over the individual temples within it.[14] Several priests I have spoken to thought this might damage the application, because it shows that the pilgrimage is not the unitary entity that the application projects it to be. While it appears that a settlement has now been agreed (as of December 2019) to resolve the dispute, it remains to be seen whether there will be any additional repercussions from what temple sources in Shikoku recognise as a damaging affair.[15]

Concerns about whether heritage status would lead to new types of visitors and changes in the ambience of the pilgrimage, as well as worries that inscrip-tion on the UNESCO list would remove autonomy from the temples and give UNESCO the power to control and regulate, also remain strong. The first of these involves worries that gaining UNESCO's imprimatur would lead to a large influx of international tourists with whom the local infrastruc-ture would not be able to cope. There are also concerns that the increase in international visitors (seen as inevitable after accreditation, and integral to the island's political and economic interest groups in promoting the idea in the first place) would turn the pilgrimage increasingly into a tourist phenomenon and diminish what—for priests and ardent pilgrims alike—are its key attributes as a religious activity.

This worry has been intensified by what has occurred at Mt. Kōya, the Shingon sacred centre and location of the mausoleum of Kūkai (the Buddhist priest whose posthumous incarnation, Kōbō Daishi, is central to the Shikoku

pilgrimage), which was designated a UNESCO World Heritage Site in 2004. As Ian Astley (2015) indicates, since Mt. Kōya's incorporation in the UNESCO World Heritage List, international visitors have increased while Japanese visitors and the number of rituals performed there have fallen. Foreign visitors come to view the temples and soak up the atmosphere, rather than to make pilgrimages and perform memorial services, as many Japanese visitors do. As such, the fall in Japanese visitors has meant a decline in religious activity at Mt. Kōya—as well as a concomitant decline in the number of priests there. Meanwhile the temple lodges where visitors stay have upgraded their facilities to cater for the new visitors, even drilling for thermal waters and turning themselves into hot spring resorts—a further sign of tourist transformation (Astley 2015).

Since many Shikoku temples have links to Mt. Kōya, and many pilgrims visit it after their pilgrimages, the transformations resulting from UNESCO accreditation are well-known in Shikoku, fuelling concerns about a similar impact on the pilgrimage. Such views were expressed to me in an interview in October 2018 with a well-known *sendatsu* (pilgrimage guide). *Sendatsu* is a rank accorded by the Association of Shikoku Pilgrimage Temples to those who perform the pilgrimage multiple times and who work with the Association of Shikoku Pilgrimage Temples to promote the pilgrimage and preserve its religious orientations (Reader 2005, 167–175). There are several thousand *sendatsu*, and they constitute an important interest group. The *sendatsu* in question has written a guidebook for pilgrims and actively promotes the pilgrimage and Kōbō Daishi faith. He visits Mt. Kōya regularly, and this has made him irrevocably opposed to the Shikoku UNESCO campaign. It would, he argued, undermine the pilgrimage and turn it into a tourist activity, something he has seen occur over the past fourteen years at Mt. Kōya. He was adamant that this was a common view among the high-ranking *sendatsu* he knew. A survey by Takekawa (2013, 156–160) also suggests that experienced *sendatsu* tend to oppose World Heritage status.

In addition to fears that the pilgrimage might be turned into an international tourist spectacle, there are concerns that it would become subservient to UNESCO's authority, with a loss of autonomy for the temples and the surrounding community. Jacob Kinnard, in examining UNESCO's activities at Bodh Gaya, the Buddhist centre in India designated a UNESCO World Heritage Site in 2002, states that UNESCO has firm views on how sites are managed and normally wants a "buffer zone" around heritage sites where development is restricted (2014, 141). In interviews with various interest groups, including temple priests, in 2008 and 2010 the "buffer zone" issue came up frequently. Much of the *henro* runs along roads and through towns, and some people worried that the idea of a "buffer zone" would restrict new development. Temple priests were concerned that they would not be able to make alterations to their temple precincts, for example, by putting up halls of worship, statues, lodging facilities for pilgrims, and commemorative stones—all common activities spurred by new donors—or removing or replacing older buildings.

These worries were exacerbated by the visit to Shikoku in March 2017 of Guo Chan, a Chinese former deputy chairman of ICOMOS (an expert body that offers UNESCO advice on World Heritage Sites), to take part in a symposium about World Heritage. He was also taken to see some of the temples in Tokushima Prefecture and at one site, according to an informant, he remarked that an unused three-storey former lodging at one temple needed to be removed and that the two stone staircases leading up to one temple did not match.[16] Many of those involved with the Shikoku campaign regarded his comments as indicative of the likely attitude of ICOMOS; the comments certainly reinforced local fears that UNESCO might seek to make amendments to the temples in ways that fitted a UNESCO vision of what they *ought* to be like. They raise questions about the extent to which the *preservation* of heritage might be accomplished by reshaping existing landscapes. If one is intent on preserving heritage, then why do old buildings, even if unused, need to be removed? Why is it a problem that temples in mountainous areas have non-matching staircases—something often found at temples where older steep paths have been supplemented by newer, more easily accessible ones suitable for elderly pilgrims?

It may be that these worries are misplaced and overstate the extent to which UNESCO is able or likely to interfere in the sites it includes in its list. At the same time, however, there are signs that when, as in Shikoku, local political agencies are primarily interested in using religious sites to promote tourism, this can create scope for such interference. A good example can be seen at Bodh Gaya, Buddhism's birthplace in Bihar, India, where the Mahabodhi Temple, erected where the Buddha is said to have attained enlightenment, has UNESCO World Heritage status. The regional Bihar government is eager to develop Bodh Gaya as an international tourist site and thus cooperates with UNESCO to this end. Studies have shown how UNESCO's management processes have impacted on the religious life of the temple, with ritual practices that were commonly carried out there, such as placing oil lamps by the sacred Bo tree, now banned (Kinnard 2014, 123). As Kinnard (2014, 118–125) comments, UNESCO's policies focus on preserving (or reconfiguring) the historic nature of the site in a way that supersedes contemporary practice and its nature as a living religious site, and he notes that UNESCO has sought to dictate how the temple is managed. UNESCO is seeking a one-kilometre-wide buffer zone around the temple from which all mercantile activity is removed—something that excludes the local community that was there before UNESCO moved in, and whose livelihood is dependent on providing services for visitors (Kinnard 2014, 141; Geary 2017, 12–13).

UNESCO's plan tries to evoke (or imagine) what the area looked like in Buddha's time and includes a deer park; as David Geary comments, what UNESCO envisions is a "nostalgic production of an ancient forest hermitage and a progressive model of city growth that could unite local needs with international tourism" (2017, 155). Both Kinnard and Geary note that UNESCO

plans, even as they exclude local people (with a wall being erected around the temple, parts of the village razed, and its population expelled), involve increased visits from overseas. Such policies have been supported by the regional Bihar government, which wishes to exploit Bodh Gaya as the state's primary tourist resource and by various international Buddhist groups who want to have a presence at the sacred centre of their tradition. An airport for international visitors has been built nearby, along with a golf course. Kinnard (2014, 142–143) argues that UNESCO has displayed a hegemonic vision at Bodh Gaya, and that this has exposed the "ambiguities of preservation" in which concepts of global ownership, through the lens of world heritage and universal value, override, and suppress the people who actually live in the place—an issue he claims is evident at other UNESCO World Heritage Sites. Geary (2017, 193) also draws attention to the ambiguity underlying the idea of World Heritage; while seductively appealing to a sense of "global humanity and our common cultural heritage," it develops at the expense of local communities. These issues cannot be laid solely at the door of UNESCO as other agencies, such as the Bihar government and international Buddhist groups, have also been influential in shaping what has happened at Bodh Gaya. However, it is also evident from Kinnard's and Geary's studies that UNESCO's imprimatur has facilitated such developments and been central to the reconfiguring of Bodh Gaya as an international tourist destination and to the marginalisation of the site's local Hindu population.

Heritage, living religious sites, and the "unfinished" dynamic of pilgrimage sites

Bodh Gaya illustrates a fundamental problem relating to UNESCO heritage designations. The Mahabodhi Temple is a living site, a place where people come to worship and perform rituals. Yet the demands of preservation, heritagisation, and UNESCO authority appear to eliminate some of the elements that have until now been part of its dynamic, including some of the rituals practised by visitors. The vast increase in visitor numbers since UNESCO accreditation has triggered exponential growth in the numbers of hotels and businesses around Bodh Gaya.[17] Such growth has led to increased noise and crowds around the main temple—something that adds impetus to UNESCO's wishes for a buffer zone, but also raises questions about the extent to which a site can be both preserved as heritage and remain a dynamic living site.

This is a vital question for pilgrimage sites that, as numerous studies have emphasised, are fluid entities (Naquin and Yu 1992, 22) and constantly developing phenomena in which numerous interacting parties played roles in a continual process of pilgrimage making (Reader 2005, 2014). Others, too, have discussed pilgrimages as places in motion (Coleman and Eade 2004) constantly transformed by changes in infrastructures, transport opportunities, and new waves of pilgrims with differing motivations and orientations. Katherine

Rousseau (2016) has drawn attention to how material and architectural culture operate as dynamic entities shaping pilgrim perceptions and behaviours, which in turn impact on the visual environment of shrines, thereby continuing the process of continually making and remaking sites to the extent that they are "never finished."

Such issues are relevant to the Shikoku pilgrimage especially in the light of UNESCO's notion of buffer zones and the remarks of the ICOMOS representative cited above. Examples such as that of Bodh Gaya (where the regional government is primarily concerned with increasing tourism, as in Shikoku) reinforce fears that UNESCO is inclined towards imposing its visions on living sites and editing them to fit with what it thinks is appropriate. The Bodh Gaya and Mt. Kōya examples, where international tourism has been encouraged at the seeming expense of religious practices, are also unlikely to assuage the concerns of pilgrims and priests.

Concluding comments

David Lowenthal (1998, 7) has written that "[h]eritage should not be confused with history … heritage exaggerates and omits, candidly invents and frankly forgets, and thrives on ignorance and error." The Shikoku applications, with their exaggerations and omissions, bear this observation out. The first application was a fabrication with multiple omissions and evasions of elements that shaped the pilgrimage historically and in the present. In the second application, secular authorities acknowledged the religious elements of pilgrimage, in order to demonstrate aspects of universal value and enduring cultural heritage. However, it also contained many omissions (of the pilgrimage's history of suppression and marginalisation), obfuscations (overlooking how modernity has been a driving force in the construction of some of the pilgrimage's "traditional" elements), and evasions (talking about the mountains, nature, and cultural heritage while not mentioning how so much of the route involves asphalt).

In both cases, the process has been driven far more by political, economic, and commercial agencies than by the temples, something I heard more about from priests in my most recent field visit to Shikoku (October–November 2018) than before. Some priests said that they engaged in the heritage campaign mainly out of a sense of duty to help the island's economy, and have accepted that the Association of Shikoku Pilgrimage Temples' support for it addressed worries about falling pilgrim numbers. My general feeling, however, is that there has been a cooling among priests to the idea of UNESCO accreditation. In March 2018 I noted that banners supporting the heritage campaign were visible at perhaps half the temples (around thirty) that I visited. In October–November, when visiting over thirty temples, I saw only one such banner within temple precincts. While this is just a superficial impression, I was also struck by how the majority of the priests I spoke to in October–November 2018 expressed unease about UNESCO accreditation.

This disjunction between civic agencies and temple views was clearly evident in comments made to me by a priest in Kōchi Prefecture, outside whose temple was a billboard erected by a Kōchi businesswomen's organisation supporting the heritage campaign. Despite the billboard, he firmly hoped that the application would be unsuccessful. Indeed, I only talked to one priest who seemed to feel otherwise, saying that he thought opponents would come round to the idea if pilgrim numbers continue to fall. Others, however, were more worried about the potential impact of UNESCO and political intrusions into their domain, and the ways this would affect the orientations of the pilgrimage. Examples such as Mt. Kōya and Bodh Gaya do not necessarily encourage them, while fears about how a nonreligious external agency, UNESCO, might acquire control over aspects of their temple environments and how this could affect their nature as living religious sites, remain evident. Other worries—such as concerns that the local infrastructure might not cope with an influx of non-Japanese speaking visitors, or the disjunctions caused by temples that refuse to follow Association of Shikoku Pilgrimage Temples rules—are also cited as reservations on the part of priests, but these appear to be less central than this issue of control and its implications.

In 2008 a senior figure in the Ehime prefectural government in the heritage campaign told me that because of the amount of work needed to get facilities right and to get through the various bureaucratic hoops needed, it would take at least ten years for the application to be successful. In November 2018 a temple priest I interviewed listed numerous requirements being put forth by different government and international agencies before inscription would be possible. These included conducting more research on issues of cultural history, providing more historical evidence of the pilgrimage's cultural impact and about culturally important sites along the route, and doing more work on the infrastructure to ensure sites fulfilled UNESCO requirements. He wondered whether people in Shikoku would have the energy and determination to continue with the campaign that long. Certainly the unease that many priests expressed in my most recent interviews indicates that he might well be right on this point.

All of this indicates that while there might appear to be nothing simpler than deciding whether a particular pilgrimage is truly something that reflects human heritage, there may be nothing more complex either. The Shikoku pilgrimage is a living entity that—like Bodh Gaya—reflects the tensions that exist between notions of World Heritage and its preservation, on the one hand, and the nature of religious sites as unfinished entities that are constantly changing and evolving, on the other hand. Heritagisation could be seen as yet one more aspect of this process of constant evolution. However, UNESCO's gravitational agenda towards preservation seems to imply freezing places in time and managing them according to an image of what UNESCO thinks they should be, rather than acknowledging their dynamic as incessantly transforming entities constantly being made and remade by pilgrims, priests, and other interested

parties. In such tensions lie many of the differences between the attitudes of priests whose concerns may be more focused on the religious aspects of the pilgrimage and the faith that they see embedded in it, and the political authorities for whom the *henro* is a cultural asset to be promoted in order to boost the island's economy.

Notes

1 Interviews related to this chapter were conducted initially between 2008 and 2010 in Shikoku with those involved in the Shikoku heritage campaign (from government officials, to media, transport and commercial companies, tourist agencies, and public relations firms), as well as temple priests and pilgrimage activists. In March and October–November 2018, two further field visits allowed me to conduct additional interviews, mainly with temple priests and pilgrims who have done the pilgrimage multiple times and have close connections with the pilgrimage temples. I have kept the names of interviewees anonymous (unless they specifically indicated that their names could be cited) because some spoke with the understanding that they would not be identified. This is partly because their personal views conflict with the official public stance of the institutions they are associated with.

2 All eighty-eight temples on the pilgrimage have names but they are also referred to numerically, related to the most commonly followed pilgrimage route that circles the island clockwise.

3 I discuss the Japanese national tourism strategy in Reader (forthcoming), which is a study of Buddhist temples and tourism.

4 In the text I label this Application One. The subsequent 2016 application is Application Two. In the reference list I provide details of where they can be accessed.

5 Over thirty applications were sent to ACA that year, indicative of a highly competitive field.

6 These comments can be found in publications by heritage campaign groups in Shikoku; see, for example, the various pamphlets produced by the Shikoku World Inscription Council and its website www.88sekaiisan.org.

7 See www.88sekaiisan.org and also various pamphlets and informational guides put out by this overarching body for further information on the bodies involved.

8 See footnote 4.

9 This is contentious, given that Kannon is popular in a number of sectarian traditions and temples on Kannon pilgrimages such as Saikoku and Chichibu include, like Shikoku, temples of different Buddhist sects.

10 See Reader (2005, 52–54) and Hoshino (2001, 329–331) regarding this symbolic structure, and on how this is probably a twentieth-century framework developed by the pilgrimage temples to assert a Buddhist (and especially Shingon) orientation to what was essentially a folk practice.

11 It is a custom rarely found nowadays in other Japanese pilgrimage contexts—or indeed in other pilgrimage contexts worldwide (see Asakawa 2008; Reader 2005).

12 This is not accurate; in the 1980s the number of walkers was minimal. It was not until the 1990s that this new growth of foot pilgrims became evident.

13 The Iyo Tetsu company—the pioneer of Shikoku bus tour pilgrimages—was the first to do this and it continues to ask those on its tours to dress in this way.

14 Several sources in Shikoku have given me details of this issue and the repercussions of the court ruling, notably during an interview in March 2018 with at Kōonji (Temple 61), which was, with the support of the Association of Shikoku Pilgrimage Temples, serving as an alternative site for Temple 62.

15 Since this chapter was written, a settlement has been reached and formally declared in December 2019 between the temple concerned and the Association of Shikoku Pilgrimage Temples. As a result Temple 62 now has rejoined the Association and follows its rules. However, during my most recent visit to Shikoku in November 2019, although this agreement was on the horizon, several priests remained worried that the impact of the dispute had been damaging to the pilgrimage.

16 I was not in Japan when this visit took place, and my comments here are based on the account of a trusted informant.

17 I emphasise this as a result of my own visits to Bodh Gaya, initially in 1978, 1980, and 1983, and more recently in February 2019.

References

Shikoku Applications to the Agency for Cultural Affairs

Application One: Ehime-ken et al. 2007. *Shikoku hachijūhakkasho reijō to henromichi.* Accessed December 2007 and downloaded in 2008 (no longer available at this site), http://www1.pref.tokushima.jp/002/01/0801henro/teiansho/1-mokuji.pdf; accessed 7 May 2019, www.pref.ehime.jp/h14400/gakujutsu/henro/sekai/saiteian. html.

Application Two. 2016. *Shikoku hachijūhakkasho reijō to henromichi.* Accessed 3 December 2018, http://88sekaiisan.org/report/pdf/teiansyo_dl.pdf.

Other references

Asakawa Yasuhiro. 2008. *Junrei no bunkajinruigakuteki kenkyū: Shikoku henro no settai bunka.* Tokyo: Kokon Shoin.

Astley, Ian. 2015. "Space, Time and Heritage on a Japanese Sacred Site: The Religious Geography of Kōyasan." In *The Changing World Religions Map: Sacred Places, Identities, Practices and Politics,* edited by Stanley D. Brunn, 523–544. Dordrecht: Springer Netherlands.

Averbuch, Irit. 2011. "Discourses of the Reappearing: The Reenactment of the 'Cloth-Bridge Consecration Rite' at Mt. Tateyama." *Japanese Journal of Religious Studies* 38 (1): 1–54.

Coleman, Simon, and John Eade. 2004. "Introduction: Reframing Pilgrimage." In *Reframing Pilgrimage: Cultures in Motion,* edited by Simon Coleman and John Eade, 1–26. Abingdon: Routledge.

Foard, James. 1982. "The Boundaries of Compassion: Buddhism and National Tradition in Japanese Pilgrimage." *Journal of Asian Studies* 16 (2): 231–251.

Geary, David. 2017. *The Rebirth of Bodh Gaya: Buddhism and the Making of a World Heritage Site.* Seattle: University of Washington Press.

Harada Nobuo. 1999. *Kanreki no niwaka ohenro: 35nichi, 1200kiro o aruite watashi ga mitsuketa mono.* Takarazuka: Shinfū Shobō.

Hirota Mio. 1999. *Shikoku ohenro nazo toki sanpo.* Tokyo: Hōzaidō Shuppan.

Hoshino Eiki. 1981. *Junrei: sei to zoku no genshōgaku.* Tokyo: Kōdansha Gendai Shinsho.
Hoshino Eiki. 2001. *Shikoku henro no shūkyōgakuteki kenkyū.* Kyoto: Hōzōkan.
Hoshino Eiki, and Asakawa Yasuhiro. 2011. *Shikoku henro: Samazama na inori no sekai.* Tokyo: Furukawa Kōbunkan.
Imai Misako. 1981. *Oyako henro tabi nikki.* Tokyo: Tōhō Shuppan.
Kaneko Satoru. 1991. *Shinshū shinkō to minzoku shinkō.* Kyoto: Nagata Bunshōdō.
Kinnard, Jacob N. 2014. *Places in Motion: The Fluid Identities of Temples, Images, and Pilgrims.* Oxford and New York: Oxford University Press.
Kondō Yoshihiro. 1982. *Shikoku henro kenkyū.* Tokyo: Miyai Shoten.
Lowenthal, David. 1998. "Fabricating Heritage." *History and Memory* 10 (1): 5–24.
Mori Masato. 2005. *Shikoku henro no kindaika: Modan henro kara iyashi no tabi made.* Osaka: Sōgensha.
Naquin, Susan, and Chün-Fang Yü. 1992. "Introduction." In *Pilgrims and Sacred Sites in China,* edited by Susan Naquin and Chün-Fang Yü, 1–38. Berkeley: University of California Press.
Osada Kōichi, Sakata Masaaki, and Seki Mitsuo. 2003. *Gendai no Shikoku henro: Michi no shakaigaku no shiten kara.* Tokyo: Gakubunsha.
Reader, Ian. 1987. "Back to the Future: Images of Nostalgia and Renewal in a Japanese Religious Context." *Japanese Journal of Religious Studies* 14 (4): 287–303.
Reader, Ian. 2005. *Making Pilgrimages: Meaning and Practice in Shikoku.* Honolulu: University of Hawai'i Press.
Reader, Ian. 2007. "Positively Promoting Pilgrimages: Media Representations of Pilgrimage in Japan." *Nova Religio* 10 (3): 13–31.
Reader, Ian. 2011. "The Shikoku Pilgrimage Online." In *Japanese Religions on the Internet: Innovation, Representation and Authority,* edited by Erica Baffelli, Ian Reader, and Birgit Staemmler, 80–100. New York and Abingdon: Routledge.
Reader, Ian. 2014. *Pilgrimage in the Marketplace.* New York and London: Routledge.
Reader, Ian. Forthcoming. "Turning to Tourism in a Time of Crisis? Buddhist Temples and Pilgrimage Promotion in Secular(ised) Japan." In *Buddhist Tourism in Asia,* edited by Courtney Bruntz and Brooke Schedneck. Honolulu: University of Hawai'i Press.
Roseman, Sharon R. 2004. "Santiago de Compostela in the Year 2000: From Religious Center to European City of Culture." In *Intersecting Journeys: The Anthropology of Pilgrimage and Tourism,* edited by Ellen Badone and Sharon R. Roseman, 68–88. Chicago: University of Illinois Press.
Rousseau, Katherine. 2016. "Pilgrimage, Spatial Interaction, and Memory at Three Marian Sites." PhD dissertation, University of Denver. Accessed 21 January 2020, https://digitalcommons.du.edu/cgi/viewcontent.cgi?article=2129&context=etd
Satō Hisamitsu. 2004. *Henro to junrei no shakaigaku.* Kyoto: Jinbō Shoin.
Shinbayashi Noriyoshi. 2016. "'Shikoku henro' no sekai isan tōroku undō ni miru bunka keikan no imi hen'yō." *Chirigaku hōkoku* 118: 17–29.
Shinjō Tsunezō. 1982. *Shaji sankei no shakai-keizaishiteki kenkyū.* Tokyo: Hanawa Shobō.
Takada Shinkai. 1985. *Sutete aruke.* Tokyo: Yamanote Shobō.
Takamure Itsue. 1987. *Ohenro.* Tokyo: Chūō Bunko.
Takekawa Ikuo. 2013. "Gendai ni okeru Shikoku henro no yōsō: kikitori chōsa o moto ni." In *Junrei no rekishi to genzai: Shikoku henro to sekai no junrei,* edited by Ehime Daigaku "Shikoku henro to Sekai no" Junrei Kenkyūjo, 145–162. Tokyo: Iwada Shoin.

Index

Printed in the United States
By Bookmasters